THE House

Its Origins and Evolution

Other books by the same author

Introduction to Architecture

Le Corbusier

Epstein: Artist Against the Establishment

THE House
Its Origins and Evolution

STEPHEN GARDINER

CONSTABLE • LONDON

Constable & Robinson Ltd
3 The Lanchesters
162 Fulham Palace Road
London W6 9ER
www.constablerobinson.com

First published in the UK by Constable and Company Limited 1974

This revised and updated edition published by Constable,
an imprint of Constable and Robinson Ltd, 2002

A copy of the British Library Cataloguing in
Publication Data is available from the British Library

ISBN 1-84119-244-9

Printed and bound in the EU

Acknowledgements

I am indebted to the following who have given their views and information:

Ian & Etrenne Baker; H.T. Cadbury-Brown; Lone Britt Christensen (Cultural Attaché, Danish Embassy); Hillary Clarke (RIBA Press); Charles Correa; Oliver Cox; Louisa Creed; Geoffrey Darke; John Donat; Robert Elwell (RIBA); Peter Gresswell; Martin Hartung; Nicholas Lacey; Richard Lavenstein; Commander Peter Marshall; Leonard Manasseh; Rick Mather; Marie Moller (Press Officer, Danish Embassy); Hidalgo Moya; Tim Nicholson; Edward Potter; Geoffry Powell; Sir Philip Powell; Alan Powers; Martin Richardson; Joan Scotson; Sir Richard Sheppard; Herbert Tayler; Jørn Utzon; Derek Walker; Sam Webb; Heidi Weber; Anthony Whishaw.

'Time present and time past
Are both perhaps present in time future
And time future contained in time past.'

T. S. Eliot, *Burnt Norton*

To Philip Powell

This is a book about architecture.
It is like the building of a single house
for the human race, focusing on the
continual search man has made to discover
an aesthetic order within the disciplines
of different circumstances, traditions,
customs and materials which in turn mean
different indigenous styles. In each case
the discovery of such an order leads to
an architectural frame of great distinction
– but one which is, in effect, no more
than a background to surround you, a floor
to raise you up, a roof to cover you.

SG

Contents

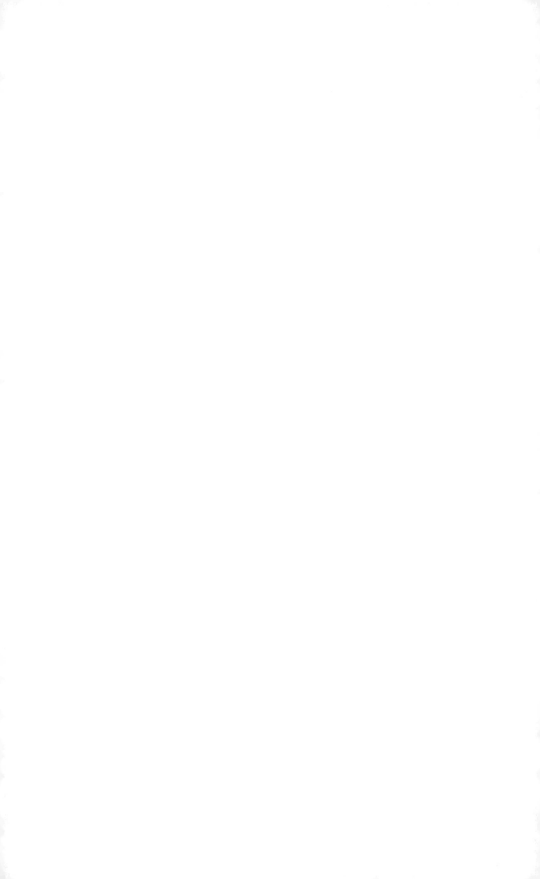

Preface

As Petrarch saw it, there was a crisis in Italy in the fourteenth century – ignorance and narrow-mindedness excluded the human freedom to perceive the world around, and Petrarch linked this freedom with the understanding of nature. But in order to discover the realities of life he had to have first-hand experience of what had gone before, so he went back to the Greeks, and in this way had a vision of the future which inspired the Renaissance. Palladio was another artist with a great mission. He travelled on horseback in dangerous times in search of classical knowledge, and it was from his houses that the West inherited architectural order. The Georgians in England, for instance, saw the classical order as a background to community life, thus adding something that was specifically their own – the community frame. But at the end of the nineteenth century there was another crisis involving human freedom which was caused by materialism. Le Corbusier, who led the twentieth-century architectural movement and devised realistic and imaginative solutions to human problems in the face of this materialism, accepted the Greek discipline to which he returned, and then studied the mind that lay behind it. And so a pattern emerges: the greater the step forward in knowledge, the greater is the one taken backward in search of wisdom. The more adventurous the advance, the more important become the sources from which it stemmed; and the further forward we go, the further back we have to explore

in order to go forward again. There is a parallel for all this in modern educational thought: intelligence, rather than knowledge, is the aim, and to seek ways in which intelligence may be developed we now investigate pre-birth situations. The purpose of this book is to go back into the past and the mind behind it, in order to indicate how the tremendous advances that are with us now might be used. For the time being at least, until we perceive the meaning of our past in these terms, we remain the mere carriers of ideas, like the nomads.

ONE | # Outlines

People used to live in caves. This is common knowledge; one is talking of a time about 11,000 years ago or more, in the Near East.

The cave suited their way of life – as we know, these people hunted animals. They were safe in caves. They lit fires in the entrances which kept them warm and kept the animals away while they cooked their meat. It was a simple life, the basis of all human existence.

The mystery that has always puzzled archaeologists and historians is: what, in particular, prompted man to leave the caves, to come out of the womb of nature and, so to speak, to stretch and to begin the long business of making progress. There is no conclusive evidence, although a number of theories have been put forward; primarily we have to use our imagination. Climate may have been a reason; as the glaciers retreated north, weather became warmer and wetter and plants grew; and sunshine draws people out of doors just as it makes flowers open. At the same time, the glaciers took the lid off other fertile lands, and vast herds of animals followed, emptying the plains; this meant that hunting became unreliable as a source of food.

Agriculture, on the other hand, is the reverse. But it is thought that the changeover from hunter to farmer, and thus from cave to house, was a slow, gradual process. To begin with, people followed the animals and became more familiar with the world around them.

Then, as hunting became more difficult (the mammoth and the reindeer, for instance, died out), it is likely that they took a closer interest in the natural resources of the land. True to much of life, it was probably women who first thought in terms of cultivation; while men were out catching game, fishing and so on, women had the time to collect seeds and grow them. It is thought, therefore, that in the beginning, at any rate, temporary settlements were established near rivers, streams and in woods, but that people returned to the caves in winter. This ritual may have ceased eventually when it was discovered that crops and plants returned in the spring and that cultivation did better when people were on the spot and constantly in attendance. And in time it was found that certain animals responded to attention, that they could be tamed with food, trained and used, and their habits studied. Thus animals became domesticated and the farm settlement was born. We are now talking in terms of about 10,000 years ago.

Settlements mean houses: the cave is obsolete, largely abandoned. Houses mean a creation, something new, a shelter freed from the idea of a cave. This ability to extract the essentials from a hole in a rock and to reproduce them as an isolated man-made structure is startling. But this is what people must have done, since the cave was the only available example. What they did was observe the minimum structure required to make the space, and then translate this into different elements. Thus it is possible to see how the house was, and has always been, inspired by natural forms. These forms were made from the materials of the land – mud and reeds. The inspiration, then, for the shape of the house was derived from the cave. It was rounded; the cave, in cross-section, is roughly semicircular, and from this it follows that the plan of the house had to be circular.

The first evidence of permanent settlements, between 9000 and 7000 BC, betrays signs of frequent rebuilding. From this it can be deduced that the houses were occupied temporarily, and that the inhabitants were still partly cave dwellers. It required great confidence to abandon permanently the patterns and laws of the past and to replace them with new disciplines. True, they were inspired by the many possibilities thrown up by mixed farming, but courage and faith were needed to venture out into a wholly untried

existence. So we may suppose that they were not concerned with the lasting qualities of their houses. For instance, at the village of Zawi Chenui, in Shanidar (in the foothills of the Zagros Mountains on the Turkish–Iranian border) (dated around 9000 BC), the houses had oval or circular stone bases containing hearths and supported a flimsy superstructure of daub and wattle, or reeds, or matting. But it seems probable that this village was occupied only for half the year, since nearby was the cave of Shanidar which offered greater protection during the winter months. There was another settlement at Eynam, in Jordan, and here there were three successive permanent villages, each containing about fifty houses; all were round, up to seven metres in diameter, and arranged around a central area which contained a large number of plastered bell-shaped pits (probably for food storage). As with the houses at Zawi Chenui, the houses represent the bare essentials of existence – shelter, cooking and warmth – but the details of this construction are worth noting. There was a curious wall, one metre high from the base, which was built of stone. This, presumably, was created to make a stiffening frame for a conical roof of reeds. It is interesting, architecturally, that a plan was made in relief from which a three-dimensional space sprang. It is clear, therefore, that while these builders were still thinking in the 'flat', a significant stage had been reached: a physical outline had been drawn around privacy. This was a bigger step towards civilized life than may immediately be realized. In the cave these people lived in a kind of dormitory, or dosshouse. Suddenly, families began to live separately. The reason for this change may have been connected partly with structure, partly with possessions. So far as structure is concerned, they could have been larger, but small dwellings could be managed more easily. Thus it would seem fairly certain that they exploited the move from the cave to gain privacy for their family groups, which is a human, and indeed an animal, instinct. This development towards a more organized existence also indicates the human need for order. But there is another point – the desire for possessions. These strengthen individual feelings of identity because of the element of cooperation between a person and the things he possesses. For instance, a man will look after his hammer because the hammer is useful to him; or a woman will take good care of her jewellery

because it may enhance her social position or make her appear more attractive. In these circumstances, people enjoy the responsibility of possessions and want to increase their range. A house is just such a possession; it orders the lives of groups of people – families – and it provides shelter for them. In this way the house became an extension of the group responsible for it.

Let's take a few more examples. For instance, the development of Natufian culture (a name given to the culture of people who lived in caves) took place, not in cave sites, but in the Jordan valley. At Jericho the early Neolithic shrine was born and a settlement run up above it, forming a mound, or tell (an important point, since the names of villages in the Near East often incorporated this word) about four metres (13 feet) high. This is important because a village had been sited in a place with individual identity – not just anywhere on a plain. This suggests another advance: the house had replaced the cave, and the mound replaced the mountain which had contained the caves. Thus the caves had had a framework which the first houses lacked. As far as a sense of 'place' is concerned, they did not hang together as a whole – rather, each house looked down to the individual group or family (in much the same way as the modern suburb does) instead of looking up to the scale of the community. So the mound put back a most important element that had been lost in the move from the cave. However, information about the first settlement at Jericho is vague; no clear house plans have been found, and the walls were made of lumps of clay. But during the ninth millennium there was a startling development: the settlement became a town which occupied hectares (ten acres). As early as 8000 BC bricks, baked from mud, were being used. They were of a curious shape, curved on one long side, straight on all the others, and rounded shapes in building followed from this form. The houses were built on stone foundations, and so a much greater permanence creeps into the picture. In fact, the picture as a whole suddenly becomes considerably more elaborate. The houses had door openings and the openings had wooden jambs. The floors were sunk well below ground level, and steps led down from the entrance, usually into a single room of, perhaps, five metres (16.5 feet) in diameter. On occasion the houses were larger, consisting of three rooms, which indicates the emergence of an

elite – another advance in identity and organization. The rooms had conical domes – still primitive, still constructed of wattle and daub – and the walls and floors were covered with mud plaster. Thus, while general appearances remained crude, the construction was strengthening. So was the feeling for possessions.

The Jericho houses of this time were round, like the mound they were built on, and the domed roof stressed this architecturally. Burrowed well down into the earth, the houses protected people, but this greater contact with the ground also emphasized the sense of place and possession. Settlements like this had started in various places in Palestine – at Wadi Fallah (Nahal Oren), Mount Carmel; at Abu Suwan, near Jerash; and at Beidha, near Petra, 320 kilometres (199 miles) south of Jericho, there was a village of 0.8 hectares (4.9 acres). The date of this was 7000 BC, and, perhaps for the first time, a rectangular plan appears. Houses were roughly straight-sided, with rounded corners. But they were also partly subterranean. Therefore, the cave form – the semicircle – had been discarded in one sense, but recalled in three-dimensional terms of depth. This suggests a greater consciousness of space. But these people were also exploring other materials and colour and were becoming interested in good construction and the value of appearance. The lower parts of the buildings were carefully laid in stone slabs; walls and floors were finished in lime plaster instead of mud and, what is more, it was coloured – sometimes cream, buff, brown or red. Finally, each house stood by itself and had kitchens and storerooms attached. So each house was becoming more important and self-sufficient within the larger framework of the community. And all these things, taken together, establish the importance of the house through the greater complexity of its parts.

The advent of the rectangular plan is, of course, tremendously significant; it is the theme which runs through the whole history of the house, and the break from the curved or circular form marks the beginning of a true structural consciousness that is related to simplified building methods. This meant that work could be delegated. This was progress – progress on a broad front. It was a breakthrough, and from here on there was a tremendous surge forward. The new form was based on the shape of the brick. The wall had been analysed, taken apart, reduced to separate pieces, and had then

been put back in a wholly different form. This development was accompanied by a much wider comprehension of the meaning of the wall, and what it could do. But it meant, too, that far more people could be involved, more ideas exchanged, a greater quantity of building possible, and, from the point of view of expansion, it meant ambitious operations. Thus a widespread and varied experience was gained — of scale, shape and composition — and we know, looking back at history, that it is through personal research, and the practical application of it, that experience and knowledge are gained. But while Beidha was being built, new settlers were spreading into the Jordan valley from the north, bringing with them a tradition of rectangular rooms with plaster floors that can be traced back to Ras Shamra (on the north Syrian coast), and beyond that to the Anatolian plateau. In the course of the move south an interesting variation in the rectangular house form appears to have taken place. The separation of the rectangular house which had been joined together as rooms — like the Neolithic settlements of Hacilar and Çatal Huyuk of around 7000 BC — meant that individual houses were formed.

Meanwhile, in Jericho, the brick component had already arrived, and it had been improved upon. It was cigar-shaped, mortar was used, and rows of finger impressions on the upper surface of the brick helped to hold it in place. Other interesting ideas appeared here as well. Besides the frequent adoption of the stone foundation, floors and walls were carefully plastered, and the burnished lime plaster was often painted red, probably to a height of about one metre (39 inches), thus forming a dado. It is thought that there could have been paintings above this level, but it is likely that this upper part was cream-coloured, to help make the room lighter. But the colour of the dado is in itself interesting — red could easily represent the red earth. This recalls, in symbolic and pictorial form, the earlier tradition in which houses were sunk a few feet into the ground for protection. The dado also suggests, again in a symbolic and pictorial form, some kind of ground plan on which, say, the figures in a painting could stand or a base upon which the design of a continuous decorative frieze could be constructed. Thus old building methods — as at Zawi Chenui — may have been carried on to provide a source of inspiration for more varied interior

experiments of a strongly architectural nature. Some floors were pale pink, cream or white, but mostly they were painted the same red as the dado, giving each the appearance of a tray. This, too, recalls the sunken floor, and suggests a profound preoccupation with the earth. It is hardly surprising that these people should have felt so close to the ground for it was, in a way, all they had: it provided building materials and crops, thus shelter and food. Nor was it unreasonable that they should have wished to pay some homage to it, and reproduce it in an architectural or decorative form. Possibly the caveman drew animals for the same reasons – they were a source of food and clothing, and using their skins for tents was another way of making a simple shelter.

This growing consciousness of structure and use of space shows itself in details. Take the hearth, for example. This was a neat, rectangular basin sunk in the floor and lined with plaster. The doorways were wide, frequently double, and door jambs were rounded. Ovens and hearths were also found in the courtyards. It is thought that the large areas discovered in the middle of communities were, in fact, courtyards, although they may have been covered in the same kind of light construction that is commonly used in hot countries today, and was certainly widely used in ancient Egyptian palaces where streets were often markets. But the courtyard itself was an innovation. It introduced a new planning element on a community scale, integrating public means of communication with individual houses. It was also a landmark in the development of the architectural language which is still in use. It has become the most common of all building forms. It is found all over the world, and – because it is so satisfactory in firmly establishing the identity of a community and privacy for the community, and is, further, a method of breaking down towns into small, comprehensible and self-contained groups of people – it is unlikely to be abandoned. But even today the primitive need for some close association with the ground that was demonstrated in the Jordan valley in 7000 BC has not entirely disappeared from the scene, and the subterranean towns and villages in provinces of China recall both the entrances from above – as at Anatolia – and the courtyard – as at Jericho – as means of communication.

In the settlements on the Zagros Mountains in the Iraqi

Kurdistan, things moved more slowly. The site at Qual'at Jarmo (circa 6750 BC) covered 1.2 to 1.6 hectares (7.5 to 9.8 acres). It was a small settlement of between twenty and twenty-five houses. Bricks were still unknown but later buildings had stone foundations. Still, they were now rectangular and presumably had been influenced by the settlements in the valley. This suggests that, while this people had noticed the unfamiliar shape of the rectangle, they had not grasped how it was built, and had made their copies in clay. What is surprising is that they abandoned the stone base they had first used to support their light roof constructions, and went back to this only when they realized the value of the stone foundation. All the same, they were developing details and these – the fine mud-plastered floor reinforced with matting that made a soft finish, the mud-plastered walls and the hearth – were borrowed from the new style. Later the oven and the chimney were introduced. Plans became more complex; there were several rooms instead of the single space of the original dwelling, and roofs were made of clay reinforced with reeds. Thus the shape and details of more advanced buildings were copied, and in the process the principles that had governed the design of the prototype were missed. This follows the general pattern of a style's influence spreading to other places. For it is not the structure that is noticed first – that is, how the buildings of a particular period work – but the surface appearances that can be rapidly digested. And it is only after these have been incorporated in another style of another place that the forces which produced such details are slowly comprehended, and finally absorb the whole fabric of this other style. One of the clearest examples of the process was the infiltration, at the beginning of the sixteenth century, of the Renaissance style from northern Italy into French architecture. It was only the fashionable surface characteristics – the scrolls, ceilings, curtains and lavish details – of this style that first decorated the walls and doors of the châteaux. But it took the French much longer to accept the principles of classical disciplines, and thus absorb them into their structural system.

At this point, let us shift our attention to Cyprus, where the early Neolithic round house can be seen in its most highly developed form. The settlement was called Khirokitia, and it covered a hill with possibly thousands of individual houses, although only

forty-eight have been found. The plan of the settlement was start-
ling because of an extraordinary and tremendous discovery – the
paved road. It went through the middle of the village, over the hill,
and down the other side to the river. Since Khirokitia was certainly
the largest known settlement at that time, size was obviously the
force that produced the road, and common sense fixed its posi-
tion: from the top of the hill, for instance, it would be possible for
an inhabitant to see both the river and his house – this helped
him to know where he was. In addition, the fact that the road was
paved, a proper piece of building, stressed its importance as a line
of communication. There were courtyards too, however, and since
these were also public routes, the road may be seen as a develop-
ment that gave the town its centre; as such, it was symbolic of
contact between people.

This arrangement of the road on the top of the hill and the
houses below seems to have been both organic and functional. The
courtyards, particularly the large ones, were joined to the road by
corridors; it was as though the little family groups were clinging
to it for a lifeline. Some of these corridors were covered, and led
down a ramp into the courtyard, which was paved like the road,
giving the place an architectural continuity. But here again, a natural
longing for protection is evident; one left the public road, burrowed
through the tunnel, and emerged, lower down, among friends. There
are obvious parallels in animal life, and others which are still with
us today. Look, for example, at typical plans of almshouses, which
were expressly designed for the protection of old people.

The houses at Khirokitia were as revolutionary as the town plan;
they were round, but the rooms (kitchens, workshops, stores) were
expressed as separate forms grouped together around the larger
sleeping and living space. All were solidly built, frequently with
double walls made of local limestone. Their superstructure consisted
of a dome made of stone, brick or light materials. And so, though
they recall the mud dado and the conical, reed dome of the Zawi
Chenui house in the Zagros foothills, the actual evolution of the
house at Khirokitia, from primitive to more sophisticated forms,
can be seen together. One type had a dome of reeds, but most had
progressed to brick or stone. Entrances had high thresholds to keep
out rain and mud, and several steps led down into the interior. The

interiors of the larger houses were also interesting: in one, two stone pillars supported an upper storey that was reached by a ladder; it was probably a sleeping platform. There were similar arrangements in the workshops at Beidha that were used for grinding corn and so on. But the sleeping platforms, sunken hearths and pits for storing food were commonplace in Khirokitia. Even the stone supports for the platform and the double walls were cut into for storage, seats and windows, and it amazes us, who are so utility-minded, to learn of the uses these people made of their structures. Yet it is not so much the details that are striking; rather, it is the people's ability to comprehend clearly the different departments of living which were freed from each other as decisively as the house was freed from the cave at Zawi Chenui at roughly the same time. Thus, sleeping goes upstairs and the kitchen, with its mess, goes outside with the other workshops. This culture ended as suddenly and as mysteriously as it had begun, and the people vanished, abandoning the town and leaving it deserted. The only known development of it is thought to have been at Troulli, on the north coast, where refinements of Khirokitia are represented in the stage that followed the earlier first-level remains. But one suspects – looking back again at the curious shapes, the stone domes, and the closely knit family building groups – that Khirokitia had an influence which may have travelled much further than Cyprus.

Khirokitia, however, was a backwater, a kind of isolated happening, not a part of the mainstream developments that were going on elsewhere. In the seventh millennium in Syria, Lebanon and Palestine, the Syrian tradition, with its rectangular architecture and plaster floors, overran the native Natufian/Palestinian tradition, with its round houses. But there was more movement because of trade with pottery (which had just been invented), and this involved larger groups of people who came down from the Anatolian plateau. Many new settlements were founded and newcomers mixed in with local populations on the way; all this happened at the end of the seventh millennium. In the remains we find that the rectangular plan was the rule; an example of this is at Byblos, located in a defensive position on a sand dune on the coast. Although rectangular, the houses (and there were several hundred of them) resembled those of the earlier settlements of 8000 BC in that they were

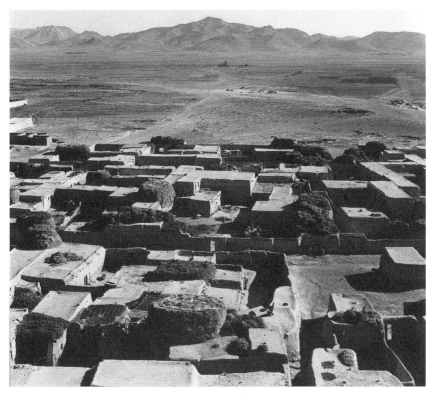

Aerial view of Sultaniye village, north Iran. Mud-brick houses, the mud brick reinforced with straw and wall surfaces rendered with earth. c.3000 BC.

small, with stone foundations which supported a light super-structure. They differed, however, in other ways: they had white-plastered floors which were frequently renewed, and some had more than one room. But there was no particular relationship between the houses, which stood apart from each other and were scattered about in plenty of open space on either side of a deep wadi. Thus there is no evidence of the embryo architectural order that is found in some other places. Progress was varied, often so slow as to be imperceptible, so it should be kept firmly in mind that the evolution of the rectangular house from the circular one took a long time.

Another movement connected with this was from the Iranian mountains into the plain, and there can be little doubt that the Iranians were influenced by what they found there. For instance,

in 5000 BC there was a settlement near Hasanlu and south of Lake Urmia (Rizaiyeh), and here the houses were of the familiar Jordanian kind: rectangular in plan and built around common court-yards. But at Jeitun, near Ashkhabad, across the Turkmenian–Iranian border, there was an interesting development on Hasanlu – an open village with freestanding houses, but each within its own yard. Thus here a house seemed to be the first conscious attempt to relate a single building to the space around it. Earlier, the space in the middle, or courtyard, had been enclosed by separate buildings to provide a method of communication among them. At Jeitun the house stood in its own space, and this was a completely new con-ception. The houses were large, varying in area between twenty and thirty-five square metres (24 and 42 square yards), with farm and storage rooms adjoining the main living area. They were rectangular, as before, and had one room, a hearth, and opposite this a projecting buttress with a niche near floor level. At first sight the buttress seems an incongruous feature because it appears to have no purpose, and it is possible that it was copied, along with so many other details, from Çatal Huyuk in Anatolia. But those houses were all joined together as one vast structure, like rooms in one house. Moreover, they were built like terraces on a mound, and leaned against each other down the slope. Thus the buttress was a purely functional device needed and developed to stiffen internal walls. At Jeitun, on the other hand, one finds the same process of evolution that is to be found in the Iraqi Kurdistan: features were borrowed without any understanding of the principles that underlay their development. The Iraqis took the rectangular form from, say, Jericho, but not the brick component that defined it. The Iranians also ignored the brick when they took the rectangular and courtyard forms, and the functional buttress at Çatal Huyuk is, at Jeitun, whittled away to a decorative feature with no structural significance; that they cut a niche out of it, and painted it different colours such as red-brown or black, implies this. The pattern of imitation can be traced in other ways; it continued, for example, in the floor covering of lime plaster stained red-brown. After all, the floor finish did not *have* to be stained, although it is true that a dark colour is always more serviceable than a light one; however, it is also likely that the dark colour was a symbol of the profound and persistent desire for a close association with the earth.

The decisive Anatolian influence, however, showed in the rectangular plan; this was the contribution of Neolithic settlements such as Hacilar and Çatal Huyuk which gave the slowly evolving house a distinct shove forward. As a matter of fact, these settlements were the source of houses that we see today, so they must be examined carefully. The structures at Hacilar came first, and the form was much the same as those of the later Çatal Huyuk – they were joined together but grouped around open courts, and entry was from the roof. But unlike the subterranean towns and villages that still exist in China, where the house and courts were dug out of the ground, Hacilar was superimposed on the ground. So the approach was up a ladder on to the roof of the village. A completely blank outer face served as a defence – all the people had to do, if attacked, was to pull up the ladder. Then they went down a ladder into their individual houses or, alternatively, down a ladder into the courtyard. There were no doors between the house and the courtyard, or at least none were found when Hacilar was excavated. The plans of the houses were rectangular, and the walls, about a metre (39 inches) thick, were built of mud brick with stone foundations; as the date of the settlement was around 7000 BC, they were fairly advanced.

Çatal Huyuk, which was begun about 500 years later, covered 13 hectares (32 acres) and was the largest settlement in the Near East; it was rebuilt on similar lines twelve times during the next thousand years. The rectangular houses were made of shaped bricks – like those occasionally used later at Jericho – on brick foundations; no stone was used. But Çatal Huyuk was built on a slope and the changes of level from house to house provided the opportunity to slip a window in under the eaves between the different heights. The placing of windows, however, obviously followed no particular pattern, and arrangements inside the houses varied accordingly. It could be argued, therefore, that a form of functionalism defined the plans. They were adjusted, apparently rather haphazardly, to suit the slopes of the hill. The fact remains, though, that the internal form of the houses was related to external factors. They were single-storeyed and, as at Hacilar, entered from the roof, and the smoke from the hearth escaped via this entrance hole and through the unglazed windows – an economical system – though

sometimes the houses did have ventilation shafts. The interiors were, in any case, a considerable advance over those at Hacilar, which did not have windows; the invention of these was another architectural breakthrough. There were at least two platforms in each room, or house. Mats covered the floors. Then there was the buttress, a crucial structural element for building on a large scale up a slope. It appeared very early in Çatal Huyuk during the first rebuilding operation, and at Hacilar during the sixth. At Çatal Huyuk these buttresses were required to deal with the slope; at Hacilar, which was on a flat site, they supported double-storey constructions. In both settlements, the roof was most important to the life of the community, for it was used like a modern street. This tradition still persists in Anatolia: the general appearance of these villages hasn't changed very much over eight or nine thousand years; consequently today one can get a glimpse into the past from the roof life of the people and their ladders – the communities of houses and the courts there are much the same as ever.

This brings us to the later settlement at Hacilar where buttresses had just been introduced. The houses were larger – larger than at Çatal Huyuk – and the brick, single-storey base (they used square bricks) supported a first floor which was built largely of wood with rubble infill: large posts held up the roof. They had doors (which they had not had before) to the courtyard, and this meant that the courtyard was accessible only to the houses grouped around it. At the same time parts of the main room were screened off, which seems to indicate that an element of privacy was creeping in. Cupboards cut into the thickness of the wall or built up in brick were details that have an obvious reference to the arrangements made by the Iranians 500 years later as well as a resemblance to what people had been building in Cyprus at Khirokitia a thousand or more years before. Mud-brick steps up to the second storey of the Hacilar house were an advance on ladders, for they were more permanent; back-to-back houses in blocks were entered from courtyards and narrow lanes. Overhead access was therefore dispensed with, and it was likely, in consequence, that the entire settlement was surrounded by a defensive wall which replaced the old, blank, windowless façades. Thus from a few changes fundamental to the development of the life of the people – entrances,

the introduction of the door, and streets – a radically different architectural form had evolved.

The influences of one place on another always seems to follow a familiar pattern. A person looks at something, likes it and decides to adopt it. Now why does he like it? Probably because he has been working on a similar problem and finds that someone else has devised a more satisfactory solution. He also likes it because the solution is a sympathetic one and the elements have a familiar shape which he has, from experience, come to like. However, he does not duplicate the solution exactly; instead, he exaggerates what he likes about it and adapts it for his own purposes. If the problem concerns a building, for instance, the solution may have to be adapted to meet his own requirements or the requirements of a different site or climate. The change of place and purpose then adds something new and personal to the original and, in the process, further possibilities for adaptation and improvement are seen and developed. Of course, in primitive times the exchange and

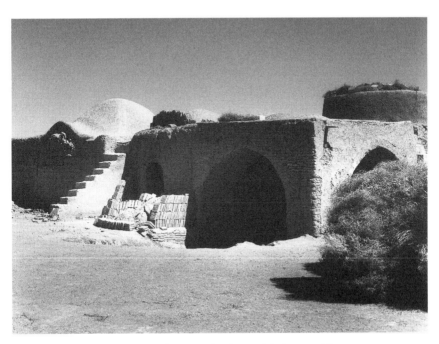

Close-up of houses in the aerial view, p. 13.

borrowing of ideas was an accepted part of life, unlike today when far too much importance is placed on originality or the pretence of it, and a stigma is attached to imitation. Certainly the practice was followed when early Neolithic Anatolia influenced early Neolithic Greece. A good example of this is at Nea Nikomedeia in Macedonia, where the influence of local tradition brought a porch built of wooden posts and plaster, like the upper storey of houses at Hacilar and the timber frames and plastered platform inside the Çatal Huyuk room. Here is a good example of how things happen: a form is borrowed, altered and improved upon to suit local needs. What evolved was the embryo of a framed building, and we know what that led to: not just the Parthenon, but, eventually, the modern architecture of the twentieth century.

All these developments in Anatolia, Jordan and Syria were the foundations from which the inspiration of the Mesopotamian culture sprang. It is generally acknowledged that civilization began here, and what this means, in very simple terms, is that Mesopotamian culture represented an epoch in which people became preoccupied with things that extended beyond mere means of survival. Prosperity brought security and leisure, and, most important, time for thought. We know, for instance, that writing was invented during the fourth millennium, and this meant increased communication and more widely exchanged knowledge, involving more people. And time to think enabled architecture to be transferred from the sphere of building to the sphere of design. The evolution of the brick had its parallel in another time: the composition of the wall was analysed and it was found that by breaking it down into its components, more people could be involved in construction; this, in itself, led to a greater variety of ideas. The overwhelming undertaking of constructing a wall was eliminated by the brick. People stopped thinking about the wall and how to make it, and thought instead about what they could do with a wall, which led to a greater variety of enclosure. By inventing writing and having more time to think, ideas could be discussed, developed and passed on. Therefore what happened with the discovery of the brick now happened on a far larger scale, involving creative ideas that transcended purely utilitarian needs. The link between writing and the spread of architectural ideas and

architectural developments is clear. In the very early stages, writing began in the form of pictures: this is not surprising because, long before settlements and the concept of writing were ever thought about, people drew the world about them. Architecture is, after all, a visual art, and since the designs of buildings have always been conveyed by pictures and drawings, rapid progress from this point was to be expected.

Yet before the invasion from South Mesopotamia around 4400 to 4300 BC – the invasion that was to begin the Sumerian civilization – the Halaf culture had existed in the area between the late sixth and the fifth millennia. Architecturally, this culture had no connection with the rectangular forms that had continued from the earlier periods in surrounding areas, either in Sicily or in the Syrian province west of the Euphrates. At Tell Turlu, also west of the Euphrates, and other villages such as Arpachiyah, houses had two rooms and were set alongside paved roads. At Arpachiyah the largest house had walls about two metres (six feet) thick, a domed chamber ten metres (32.8 feet) in diameter and an anteroom twice as long. On the face of it, nothing about the houses suggests the source of the strange combination of forms. But we should look further than the mainland. Is it possible that these villages were connected, even indirectly, with the settlement of Khirokitia in Cyprus from which the inhabitants so mysteriously and suddenly disappeared? There are some definite similarities: at Khirokitia there was the circular room with its dome of stone or brick; the raised threshold, deliberately designed to keep out the weather, mud and rain; and the outer paved road and paved courtyard around which the houses were grouped. This courtyard was not an entrance to a house but it was, unquestionably, the equivalent of an entrance to a group of houses, since it was a preparation for them. Moreover, this corridor was covered, thus protecting the ramp from rain as a porch protects a step and keeps it from being slippery. In addition, the Khirokitian roof also screened the view of the courtyard from the approach, as a porch screens the entrance to a house. It seems, therefore, that these people were conscious of constructional devices which were concerned with the entrance and its protection. But the fact remains that, having created surroundings which were, in some ways, far in advance of their time, the people of Khirokitia disappeared. Where

did they go? Across the water to Tell Halaf? – and it *was* only just across the water. The answer to that question may well reveal a new link in Neolithic history, and in the evolution of the house.

If there was a connection between the people of Khirokitia and the people of the Halaf culture, the introduction of the circular, domed room in Mesopotamia would be explained. What is not explained, however, is the anteroom with its pitched roof and gable end, although it would not be unreasonable to assume that this had been conceived as an extended porch, since it was at the gable end that the house was entered, and from the outside the inner round room could only be reached by this door. But while the concept of a porch may be related to the corridor and threshold at Khirokitia, the structure of the anteroom roof must have come from somewhere else. Porches had made their appearance in Greece at Nea Nikomedeia and in Macedonia, and the materials and shape of these had been influenced by the upper-storey wooden constructions of the later settlements of Hacilar in Anatolia, with their pitched roofs. The people of Khirokitia may have been influenced by the Greek porch and may have eventually taken it to Tell Turlu in Mesopotamia. This would explain the odd, somewhat incongruous, combination of forms: the pitched structure attached to the circular dome. It might also explain the presence of the rectangular plan – this, too, could have come from Anatolia. This reconstruction of events is supposition, but at least it illustrates how these countries were continually in touch with each other, and it shows how ideas spread and then develop or become intermixed.

Among all sites for houses and settlements of houses, the rectangular form eventually predominates, but with variations. A continuous strand throughout is the importance and size of the living room. To begin with, of course, everything – living, cooking, sleeping – took place in a single space. And Khirokitia is interesting because, rather like a modern circulation diagram, it separates the activities into circles, allotting each a space. In other examples, the kitchen, stoves and so on are attached to the main room. And at Tell Turlu activities are visually separated by shape and size, as well as by approach, but again the living space remains the most important element in the composition. This is interesting, particularly when it is compared to house designs in more recent periods

of history. It is the lack of its importance today which shows, as much as anything else, our failure to understand the needs of people. When other activities were separated from the living room, this space became associated with a single purpose – one connected with leisure. But leisure also means that there is the opportunity to think, talk and discuss ideas. The space to do this became important later on because, in the Mesilim period of the Sumerian civilization, there was a radical change in the attitude of people towards their gods. They came to believe that these gods were not necessarily there to safeguard their interests, that human beings were not immortal, that they had only one life – the length of which depended upon the goodwill of the gods – and that they had to make the most of it. Accordingly, they focused their attention on what they could create out of their day-to-day existence. The Sumerian ruler, Gilgamesh, believed that only great deeds could outlive the death of a hero; and his people, too, now felt that something of permanence must be left behind to show that they had existed – a similar idea. It was in the time of Gilgamesh that this attitude arose. Kenneth Clark says, in *Civilisation*, talking about the transient culture of the Norsemen: 'Civilised man, or so it seems to me, must feel that he belongs somewhere in space and time; that he consciously looks forward and looks back.' Later he goes on to say that 'for this purpose it is a great convenience to be able to read and write'. It is also important to pass on the visual creation of the time, and buildings in which ordinary people live fulfil this purpose: to contribute something of importance to the present is a source of experience and inspiration for others in the future.

Before this time Near Eastern man believed that nothing was final and all was ephemeral: building, and rebuilding, to put a roof over your head was an accepted part of existence – a chore, but a necessary one. He knew about stone but did not use it: the permanence of the material did not conform to his experiential outlook. Although the mud brick was now sun-dried – and therefore harder, more durable and capable of supporting larger constructions – it remained a convenient material which was disposable. Even monumental temples, which were put in imposing positions on tops of hills where they dominated cities, were built of sun-dried bricks. But there were attempts, in temple buildings, to improve the

durability of the sun-dried brick. Matting was laid over the mud walls to protect them from knocks and damage, and this indicates how structurally weak the material was. Later this protective cover became a crust consisting of thousands of cone-shaped clay nails set closely together. The cones have flat heads, or heads decorated with incisions, and were coloured black, white or red. These colours were carefully arranged in patterns to make a detailed mosaic that resembled the textile of the earlier matting. It seems to be a laborious method of achieving a slightly more permanent structure: the early Sumerians might just as well have used stone. But obviously they did not want to scrap their traditional systems and preferred to perfect existing methods. In this assembling of small pieces of coloured material, Sumerian man was in his element, and similar treatment prevailed in Sumerian architecture and art until the end of its history. It seems that, to a Sumerian, the complete picture was not in view at the start but was arrived at through a process of trial and error, and a concentration on elaborate details.

The ziggurat was a large-scale example of this approach. The Anu ziggurat, topped by the White Temple (circa 3200–3100 BC) of the Jamdat Nasr period, looks what it is: a structure created out of parts. First a temple was erected, and when the high priest died he was buried there, and the temple was then filled in. But instead of abandoning the structure, they built on it; in other words, instead of abandoning the past, they preferred to add to it. It was as though they wished to preserve a situation, a piece of history, and to hold on to it. It suggests a flashback to the burial ritual of Çatal Huyuk in Anatolia, in which the dead person was placed under the bed to continue to sleep endlessly in peace. In the ziggurat the tradition persists; their past survived to influence the present, and this construction consciously expressed this relationship. So they built another temple on the priest's tomb and this remained until another high priest died; then the whole process began again. The heights of ziggurats vary and were related to sizes of the plan, but the finished structure made a complete object because it was symmetrical. Therefore, although they worked in bits, function operated in the background to give the shape order: that is to say, the succeeding temples had to be set in from the perimeter of the structure below to allow people and processions to move around freely.

In the Mesilim period which followed, no attempt was made to express structure – even the structural properties of the brick were lost. These bricks, known as plano-convex, were rounded on one side and looked much like the brick once used in Jericho. They had to be laid sideways in a herringbone pattern and there was, therefore, a tendency to round off the corners of the rectangular plan. The character of the building had, until now, been conveyed two-dimensionally by the plan and decoration of wall surfaces. The plan had an order that was directly related to activities. This definition was lost because the wall could no longer be built straight: these bricks were basically unsuitable for construction. Exploiting the possibilities of brick for making patterns was preferred to exploiting its possibilities for making forms. Thus pattern transcended content, and the confusion that followed was a reflection of the confusion in this people's minds at the time. For they had lost faith in their gods as protectors and in their beliefs in the prospect of immortality. So they were forced to turn in on themselves and to seek security in their own lives as a support for this sudden independence from the father figures. This sense of disillusionment must have been shattering, and it is not surprising that all the mosaics which covered their temples like a lovely embroidery, all their discoveries about the brick, all the different ways in which they decorated their existence, were abandoned. It is perhaps significant that they turned their attention to building foundations. Until now their structures had been raised off flat land and the stonework which supported the mud brick, or the mud brick itself, was set on the ground. They began digging again, as they had dug when they had, for the first time, left the safe, womb-like interior of the cave. There was the Oval Temple at Khafaje, for instance. Here a trench, eight metres (26 feet) deep, replaced normal wall foundations, and the complete complex was built in a basin which had been filled with pure white sand. It would seem that the object of this operation was to isolate this sacred building from the threats and mundane influences of everyday existence. A fear of evil spirits, or at least superstitions about them, possibly not unconnected with their day-to-day influences, was responsible for this elaborate form of defence. There was also the custom of building the outer wall beyond the foundation wall. This, called the 'Kish', suggests a moat.

It is interesting that the dangers seemed to come from underground rather than from many different directions, as the Chinese, for instance, believed. Bad harvests, through lack of agricultural knowledge, were bound to have made them think that there were evil spirits at work in the land. Earthquakes, common enough there, would have the same effect. So perhaps they dug into the ground to find protection, and having done this, found that they were not safe even there. They tried to cut themselves off from that, too, and the courtyard house was developed. They had to look to themselves now, they had to have some physical form of defence that they could see – their feelings of insecurity must have been immense. It brought about the enclosure of sanctuaries, palaces and cities, and a remodelling of the temple, which became a sort of courtyard house. Could it be that they were trying to bring their gods down to earth, and so make them more secure symbols? At any rate, the first palace found of this period was in this form, and it was at a place called Kish.

Agglutinative settlement illustrated in a painting of Pueblo IV, Spain, by Anthony Whishaw RA.

The plan looked completely in upon itself, attention focused on the square courtyard at the heart of it. The outside walls were blank, and showed signs of being heavily fortified. The shape was rectangular and exact – gone were the indecision, confusion and chaotic formlessness which had begun in the Jamdat Nasr period and had continued throughout the transitional and Mesilim periods. The square courtyard, the blank walls and the plain order of the plan are evidence of some fundamental decision having been taken, a decision which in some way affected all their lives. Having cut themselves off and having established their boundaries, people were able to see forms as a unity, buildings as whole. Before this they had been an assembly of parts: now the structure arose from definite plans: ad hoc building was, at last, a thing of the past.

TWO | Solids

When the people from the south invaded Mesopotamia they brought the knowledge of the mud brick with them. They could have got no further than this primitive method since there was no stone to build with. But it was the limitations of the place which forced them to see beyond the mud hut. In this marshy place there were reeds, and these were strong and very tall. They were also pliable, although thick. And so at first this material was adopted for domestic houses, and it taught people a lot about structure. Gilgamesh lived in a reed house, and these houses must have been similar to those the marsh Arabs build today. But these houses must now be examined in detail: they had a far-reaching structural influence on future architectures, for out of these little houses developed the column, the frame, the arch and the vault.

It is possible to perceive these developments from the techniques that were used. To begin with, a number of reeds were tied together in bundles. These fascines, as the bundles are called, were planted firmly in the ground in two rows at equal distances facing each other. In each row lighter fascines were lashed horizontally to the uprights to make a rigid framework. This means that the rows had to be straight, and the building was thus rectangular. The tops of the uprights were then bent inward and each was tied to the head of its opposite number, forming a series of arches. Reed matting was attached to the inside of the framework and securely fixed to

the uprights and horizontal members: this made an open-ended tunnel. One end was then blocked with fascines and matting, in the same way, with uprights and horizontal members complete with matting. At the other end two especially tall and thick bundles of reeds made door jambs, which carried up above the roof-line. This emphasized the importance of the doorway, and decorated it. The space on either side of the door, and above it, was filled in with matting. But for better protection the outside was covered with a thick coat of mud plaster. This simplified the appearance of the house: all that could then be seen of the fascines and horizontal members was their outline – the uprights being expressed as shapes that resembled half-columns, and the horizontals showing as fine ribs. The total effect, therefore, was a sculptural one in which the surface of one arched roof was relieved vertically by the half-round column and was horizontally divided by smaller, half-round ribs into panels. The mud-brick temples appear to have taken their inspiration from these reed houses. Because of the attractive effect of half-columns, walls were constructed imitating this form, and this imitation is shown in the use of buttresses at regular intervals. A perfect facsimile of the half-column was usually attempted in mud brick, but considerable time was required to make a curve out of a rectangular component, and so sometimes these buttresses were square, which was an easier job, and resembled pilasters. And it is worth noting that, down to the last days of Babylon, walls of sacred buildings were decorated with half-round, or square, ornamental buttresses. The arch was also used in this way.

The 'colonnade', another example, was a mud wall with half-round columns butt-jointed and shown in relief along both faces. These columns, unlike the fascines in the reed house, had no structural purpose and were purely decorative. The appearances which characterized the tradition of the earlier houses had been borrowed without regard to their original meaning. The Sumerians even went back to the decorative clay cone mosaic which had long since been abandoned, and the surfaces of the columns were encrusted with spots of colour. This decorative approach showed that the Sumerians did not really understand the structural properties of the elements which were in front of their eyes – Ctesiphon was, after all, the climax of temple building in Mesopotamia. The column and the

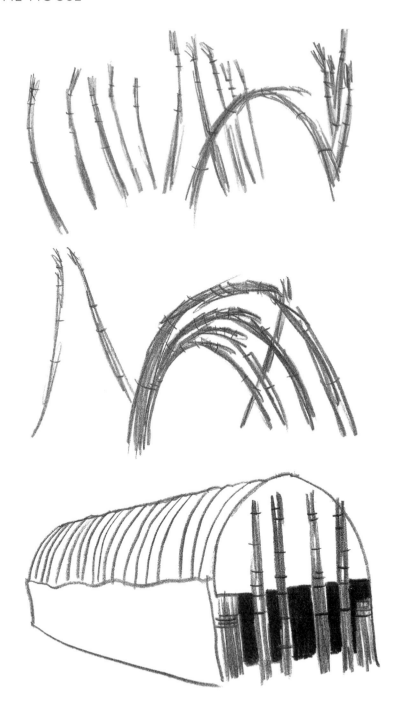

The reed structure from which the vault developed.

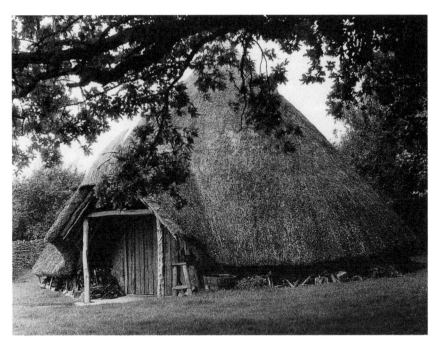

A faithful reconstruction of a Neolithic house in a reconstructed Neolithic village, Dorset, employing the authentic structure. Photographer Tim Nicholson.

arch were not exploited, nor even used to their maximum advantage. It was not merely that the Sumerians were intellectually unequal to the task of grasping the possibilities of such forms; it was also true that the materials available were not suitable and that these people had become so embedded in the mud-brick tradition that they were unable to deviate from it: they were too late. The Sumerians knew about the structural possibilities of the column, the frame and the arch, but none of these forms ever became a decisive influence in the architecture of the classical period of the ancient Near East. Sumerian architecture does not attempt to express the interplay of stresses of load and support to overcome the force of gravity. The architecture was expressed in the plan, always in the plan, and in the decoration of wall surfaces. For instance, trcc trunks were used in column form in temples but there is no evidence to suggest that they had any real function other than a decorative one: they were either sheathed in copper or covered with polychrome of clay nails which reproduced the

texture of the natural trunk. One cannot help feeling that the Sumerians were more concerned with comprehending the world about them than with architectural conquests.

It must not be forgotten, however, that they did develop the dome and the vault, if only on a limited scale: but while the dome was probably reserved for special buildings, the vault was widely used domestically where the sizes involved were not large. The arch was possibly discovered accidentally when the reeds that supported the casing of mud were removed by fire. The heat of such a fire would have hardened the mud and consequently the portions of the roof that would have remained standing would have been those immediately related to the thick uprights – these would take longest to burn. The horizontal ribs, being thinner, would be the first to go, bringing down the centre part between the uprights with them; very simply, the mud would not have had time to harden in the heat. But at first they didn't try to develop the arch because they found that they could build a vault without the reed framework to support it, and this vault was more useful to them because it covered more space: it instantly made a roof over their heads, which was what they wanted. This technique of using the vault without framework was used throughout Babylonian history. At Ctesiphon, for example, in the great court of the Sassanian palace these vaults spanned twenty-six metres (85.3 feet) – a great achievement in mud brick, a great achievement for any period that was without the advantages of steel and reinforced concrete. And, as though to acknowledge the exciting new discovery of the vault, the builders printed patterns of strings of arches in relief. One really cannot blame them for taking the easy way out at this stage.

The dome came from the same source: the early reed house. Not all houses of this time were set out longitudinally with rows of fascines. Some were small, and the module was limited to one, producing a square form with only four uprights, one at each corner. If one imagines that the height of the fascines was in excess of those required for the house it is possible to imagine how these could be bent over, then lashed together at the centre and covered with matting and mud plaster to form a dome. It was from this that more sophisticated domes were developed later on in the first dynasty (between 3000–2300 BC). In a cemetery at Ur one of the

royal tomb-chambers was roofed with a hive dome with penden-tives rounding off the angles of the square chamber. It was built of stone rubble – in itself an advance on the mud brick – set in mud mortar over a timber framework (an advance over the reed framework). In several later buildings, for example the Shrine of Dublalmakh and the Temple of Nin-gal of Kuri-galzn's time (four-teenth century BC), the ground plan shows unmistakably that the dome was employed (and this means, obviously, a huge span). But the dome was not used in domestic houses; only the arch and the vault were reserved for this area of building. And both of these structural forms were regularly used in the Larsa period in the eighteenth century BC.

At this point the 'megaron' house fits in. It had various sources. It was developed in northern Mesopotamia, which took the lead in domestic architecture. It was a large hall with four columns to support its roof which clustered around a central hearth. The construction was half-timbered with stone foundations. A frame-work of timber kept an infill of rubble in place, and this method of building originated from Anatolia where there was an abun-dance of all the necessary materials and it was the obvious solu-tion. They could use stone in foundations with a timber frame since dry stone foundations are suitable where there is not much rain. But a framework of timber would also be a safety valve where earthquakes are likely, remaining intact to hold up the roof while the rubble was shaken out. Earthquakes were common, so the method of construction was the normal one throughout Asia Minor. Clearly, it was a later development than the reed house, but, equally clearly, it was influenced by the embryonic frame and panel of that period. This is not to say that the half-timbering was part of a logical structural line which started with fascines and matting; what is likely, however, is that the sculptural form of the mud covering put forward, in diagrammatic terms, an aesthetic idea which was later seen to be a structural method. So one of the sources of the style was that the effect of the frame and the panel was liked. It was also liked in Syria where important structures were always built with timber frames. But this kind of structure was a luxury beyond the means of ordinary people; for the better off, however, it became so popular an idea that, in the private houses of the fourteenth

Early megara in Thessaly: *top,* Dimini, backed by the curved town wall; *bottom,* Sesklo.

century BC at Alalakh (Tell Atchana), it was imitated in the decorative frescoes of the walls that were mud throughout: from a distance it must have looked as though the frame was painted on.

But the megaron house, having originated in Anatolia, then infiltrated west and formed the basis of the Greek Homeric plan: an example is the arrangement of columns around the hearth in the palace of Alcinous. Once out of the Near East, it was subjected to other influences; clues lie in various directions. There was the Nordic house, and the established domestic plan of this centred on the hearth: where the climate is cold it is natural for heat to be concentrated in the middle so that it can be enjoyed equally by the people in the surrounding space. The people from the East, on the other hand, brought the courtyard, which was the natural centre of a house in a hot climate. Many reasons inspired the courtyard form – cultural, social, defence – but it has persisted because it is practical: it makes an excellent means of communication in dry, sunny

places and helps to ventilate the plans from the centre. Where a house in the north contracts round its hearth to keep warm, the house in the south expands around its courtyard to keep cool. These two domestic movements – the hearth from the north, the courtyard from the east – met in Troy, where the Greek central hearth megaron of the mainland abutted on to a courtyard. At first sight, this coexistence and dual importance of hearth and court-yard may seem odd. It is not really, because the hearth was used in Mesopotamia for cooking. Thus its arrival from the north was accepted and, for a period, its importance in the plan was main-tained. And since timber construction was so common in Asia Minor, this megaron form turns up, not only in Troy, but in Alishar in eastern Anatolia and at Beycesutlan in the west. But time corrects incongruities of this kind and, in due course, without a cold climate to cling to, the hearth eventually dropped out of the picture as a focal point and retired to its secondary function as just a place for cooking; then the courtyard resumed the dominant role, deter-mining the order of the plan. Its position in the Greek domestic conception gained strength from this point, finally becoming the central theme for which house architecture of the classical period is, above all else, remembered – from the Cretan palaces of the Minoan Age to the Hellenistic houses of the second century BC, and the tradition of the courtyard with rooms opening off it (or off a balcony in the case of a second storey) still persists in Greece today. In the same way, the tradition of the Nordic house persists in forms similar to those of the farmhouses of Schleswig in Scandinavia of the sixteenth, seventeenth and eighteenth centuries, and there are farmhouses like these today in the neighbourhood of Hamburg, in Alsace and Hanover.

The mud-brick house, which was developing about the same time as the megaron, reached Greece (circa 2000–1600 BC); it had a central courtyard as well, which began as a large room in the middle of a number of smaller rooms. This house plan was like the temple, but its walls lacked the panels, buttresses and niches. The main room was surrounded on both sides by smaller rooms from which steps led to an upper storey and the roof. The central part of the building was probably higher than the double-storeyed side rooms and recalls the windows of Çatal Huyuk where the

windows were placed in the upper part of the wall; that is, the part above the roof of the next-door neighbour. But the stairs, leading up to the roof, also seems like a throwback to the Anatolian villages. Later, at Ur, in the Larsa period, the better house had a more spacious plan; one of the ground-floor rooms that surrounded the open court served as an entrance lobby, another as a stairwell, where stairs led to a wooden balcony around the court, off which were the individual rooms of the upper floor. Similar houses are in use in Baghdad today. Sometimes a room was set aside as a house chapel, and this was distinguished by a mud-brick altar decorated with miniature buttresses and recesses. The street plans made use of every corner that could be found, and the layout of each individual house was determined by the shape of the plot of land available to the builder. Cities consisted of conglomerations of houses placed along narrow, crooked streets and lanes. By this time houses were seen in a much wider context, and the concept of the individual structure and living space was replaced by an urban identity. Was this loss of individual identity a reflection of the instability of the city-states? There was no overall administration in Mesopotamia, as there was in Egypt where the pharaoh was absolute, and was regarded as a god, not as an agent of god; this gave stability to a national character and to the country as a whole. In Mesopotamia each city was a kingdom on its own, and these cities were constantly scrabbling for supremacy. Thus self-advancement had to take second place because the constant wars and invasions used up so much energy that there was little left for constructive progress. A similar situation exists in the Middle East today – money is spent on armaments and high-speed jets when it could be spent on education and housing. But another reason for the eventual failure of the Mesopotamian civilization was the loss of faith in the gods, and consequent disillusionment. There is plenty of evidence of the same kind of disillusionment now. We are back to the materialism of day-to-day living and have lost faith in the need for things which are outside ourselves and outside pure convenience, and little time, energy or expense is spared for matters of the spirit: this is reflected in our buildings. And like the Mesopotamians in their cities, we too are rapidly losing our individual identity, shut away – as a lot of us are – in repetitive blocks

of flats. But today the situation seems much worse because there are so many more of us.

The three oldest centres of civilization were Mesopotamia, Egypt and the Punjab. All were in alluvial valleys and had an economy that was based on agriculture. In each, irrigation was necessary although regular rainfall could be relied upon. The climates of these three centres were different then to what they are now. The Sahara was not always a desert, and at this time there was rainfall there. Northern Europe was covered in ice as far as the Harz Mountains, and the Alps and the Pyrenees were capped with glaciers. But the rainfall was not sufficient to feed the glaciers and they retreated. And the Near East was eventually affected by these glacial increments. Places like Mesopotamia gradually dried up, crops became scarce, the rain less and life harder. And if the Sumerians and others hadn't been quarrelling among themselves they might have continued to develop, to adjust their way of life to these changes, and to solve the problems they raised. But instead the climate beat them, and their civilization was doomed. And so whole populations moved off and migrated west and east, following the glaciers.

The difference between Egypt and Mesopotamia was that Egypt was geographically more secure because it was more inaccessible; second, its administration was more stable. There may have been the odd raid across its borders but it was not being constantly invaded as was Mesopotamia, which was very exposed. So outsiders could not impose their ideas on the Egyptians; instead new ideas and techniques, rather than a style, filtered through, were welcomed and were enthusiastically absorbed into the Egyptian system. In the first and second dynasties there was a childlike restlessness (like children who discover new toys and soon throw them away) when the Egyptians experimented with new forms. But as soon as they felt perfection had been reached in each and the solution had been recognized, there was no further development; a new convention had been added to the stockpile of acceptable traditions. Before these foreign influences arrived, the Egyptians built in much the same way as the first settlers in Mesopotamia had done – they used reeds, matting and wattle and daub, and in similar forms. The Egyptians began to be influenced just before the beginning of the dynasties, for in late Gerzean times (3400–3200 BC) there was

the sudden introduction of a monumental style of building in mud brick: apparently no prototypes led up to this, and it almost certainly came from Mesopotamia. Consequently their architecture gradually abandoned the previous form of construction in perishable vegetable materials, and adopted a purely tectonic form determined by the use of sun-dried mud brick struck from rectangular moulds. Again, the form of their hieroglyphics began at a fairly advanced stage without evidence of the rudimentary developments which had led up to this stage in Mesopotamia. These, too, must have come from across the frontier.

Building in early dynastic times had progressed beyond the mud hovels and reed shelters of prehistoric days, although these were still used by peasants. The introduction of mud brick and massive timbers imported from the Lebanon encouraged a change in the type and size of more important buildings like temples and palaces. But decorative features – decorative buttresses, the capitals which imitated the flowering top of the papyrus bundles (tied together near the top, they splayed out like the capitals they suggested), the half-round column in relief – were copied in the new medium. Half-round columns with simple capitals were attached to walls at Saqquara. The houses were built of wood, mud and brick (the timber frame with an infill). Since these were down in the valley dangerously near the river, signs of them have almost entirely disappeared, and a picture of them has been reconstructed from drawings found in tombs. One colony that did survive was at Kalun. Possibly it was for the workmen who constructed the Illahun pyramid (Usertesea II's tomb), built around 2650 BC. It had a rectilinear layout and exhibited a capacity to plan cities with houses of a limited size – and they were limited. They had a uniform plan, no gardens; each had a small court and at least three rooms besides the court, and some had as many as six rooms, with sheds on the flat roof. Larger houses had two storeys with a staircase. High officials had mansions with more than fifty rooms and with several courts and a garden – one was 60 metres (196.6 feet) long by 42 metres (137.7 feet) wide. That the Egyptian workmen were treated with respect – the stonemason's skill was as near-perfect as the Greek counterpart – can be measured from the few existing remains of their dwellings. At Tel-el-Amarna, a village was built in straight

parallel lines (not as a chequerboard like the Graeco-Roman plan which came later) and the houses had a more efficient courtyard and plan – kitchen at the front, bedrooms at the back – which was not unlike the dwellings of the industrialized nineteenth century AD. But by the fourteenth century BC, middle-class houses had a more sophisticated plan with a hall, two floors and a garden behind a perimeter wall – this characterized their towns as well, to judge from Tel-el-Amarna: a high wall surrounded its square plan.

The ground plan was always rectangular. The house was often set in a court or garden, and this was surrounded by the high crenellated wall which gave a domestic touch inside but presented a blank and barren exterior to the world, like Moorish architecture in Spain. The entrance court led to a paved space, sometimes with columns; various rooms opened off it, with the reception at the far end. And this often overlooked a second courtyard filled with trees; straight corridors led to further rooms. The house was normally two storeys, but some of the bigger houses in Thebes had four or even five storeys. The streets between were regular and narrow. As at Çatal Huyuk (and in Anatolian villages nowadays), and in the Sumerian cities which directly influenced the Egyptian plan, great use was made of the roof – they had awnings for shelter from the sun – while ground-floor rooms were used for storage (because of flooding); the storeys above were used for living. Otherwise, the ground-floor plan distinctly resembled the Greek form: court, rooms off it, a hint of a peristyle in the colonnades, and the whole leading up to the most important living space at the end. There was surely a link here.

This method of building was employed for both the living and the dead – tombs were 'houses of eternity'. These tombs resembled houses, as they had done earlier (in Neolithic times) in North Africa and the west Mediterranean basin which was nearer to Egypt than other centres of civilization. In Greece, too, in the Cyclades, people's ashes were kept in urns that were designed to look like houses, porch and all. This is not unreasonable – it is comforting to think of the dead kept warm in friendly and familiar surroundings. Nor is it in any way unique. For instance, if one imagined archaeologists 2,000 years hence investigating the vanished civilization of the twentieth century blown up in a hydrogen bomb

holocaust, they might well come upon some baffling remains such as the mausoleum of the famous Highgate Cemetery in London where there are tombs in the tail-end house style of the Greek Revival. For this reason – to perpetuate human existence – the development of architecture during the early Old Kingdom was largely concerned with the search for more permanent materials, wood and mud brick replacing the earlier reeds for houses. Stone began to be used in the parts of the house which received the roughest treatment – lintels, thresholds and doorposts – but it was not exploited structurally. The next step of building entirely in stone was taken for the dead, not the living; not unreasonably in the circumstances, but that was as far as it went.

Yet as the Egyptians were influenced in so many ways by Mesopotamia it is probable that they were affected by the religious disillusionment of the Sumerians during the Mesilim period. It seems as if they were confused by a duality in their lives; that is to say, they did not know which way to turn for guidance. Their beliefs were split between a faith in the gods and a faith in man: and this shows in their architecture – in, for instance, the symbolic separation of their temples from the ground. In the house, on the other hand, there was the development of the internal courtyard, and this reflected the other half of the duality – man's attempt to rely on himself. In Egypt, this loss of faith led to monumental buildings, and the pyramids and mastabas that were constructed to last forever. The fear of death, which was central to the duality, was reinforced by the natural division of the country into two distinct parts. There was the region around the Upper Nile, which was set between cliffs and desert, and which was less hospitable than the lower, and considerably more fertile, region around the Delta. They regarded the north as the productive and cultural centre, and the south as the more spartan and disciplined political leader. All quite logical. So in this way they saw the world – their world, Egypt – as consisting of a duality, and this was reflected architecturally in an equal recognition of both, and the ability to do this was, doubtless, owed to the unifying strength of the pharaoh-figure. This equal recognition of the two parts resulted in symmetrical design. But it was a literal symmetry resulting in architectural dualities of a kind never found in Greece or Rome. A duality in a building means an

elevational situation where the eye cannot focus on one or the other of two identical halves that are placed on either side of a centre line. And while it is possible to trace the origin of Greek and Roman symmetrical conceptions back to Egypt, these conceptions were never trapped by dualities, because the Greeks and Romans saw in symmetry a method of unification, which meant the discipline and order of surroundings, an impossibility with a duality. In a Greek temple, for instance, the eye can settle or move freely about the composition. The Romans were more directly influenced by the Egyptians. They claimed legitimate ownership of the Nile from the Ptolemaic rulers who had, in turn, taken over from the pharaohs and had developed five composite capitals to columns. And this partly explains the Roman obsession with symmetry – in their houses particularly: but they never created a duality.

So the Egyptian contribution to architecture was more concerned with remembering the dead than the living, with tombs rather than with houses. The wish to make everlasting monuments was the incentive which produced the tools and technical devices that made them possible. The Egyptian tomb was the outcome of the Mesopotamian influence and followed from the religious crisis the country had undergone. Briefly, they were faced with a choice: the ziggurat or the courtyard house, or both. The first would presume that they looked to the gods for support; the second that they looked to themselves. One can understand why the Mesopotamians turned to the courtyard house for help; they had nothing – no coherent system of administration to rely on – only themselves. But this was not the case with the Egyptians. They had the pharaoh: they were not alone – or so they believed. They mistook symbolism for reality, and concentrated on it to the exclusion of reality. So they made the wrong choice. In adopting the idea and shapes of the ziggurat, the Egyptians, in their enthusiasm, missed the point of it. For the ziggurat was a construction which could be used, as a church can be used, and formed part of the Mesopotamians' ordinary way of life. But the Egyptians, as so often happens with imitators, took the shape without understanding the principles that had created it. They then proceeded to simplify this shape; the temple on the top platform was replaced with a point,

and the stepped sides became smooth stone. Surely, if they had understood the principles that governed the ziggurat, they would not have turned it into an object? True, there was one stepped pyramid – the earliest one – that was at Saqquara; the idea for it, of course, had come straight from the ziggurat. It was designed by Imhotep, a king in the Third Dynasty who was also an architect. Though the stepping never appeared again, it at least shows how the pyramid was constructed – it is not quite the miracle it seems at first. It was built up layer by layer until the peak was reached and capped; then the sloping sides were brought down from the top, like a finishing trade. Thus a perfect, pyramidal object was created. An object was all that it was. The meaning of the ziggurat was entirely gone, and its potency removed. If the pyramid had a function the secret of it was locked away forever within its unassailable walls. There these pyramids stand: huge monuments that lead nowhere. What they left behind was a legacy of knowledge and techniques; everything, in fact, that went into their creation – everything except the original aim.

The pyramid was huge, remote, heroic. It suggests the vast space to which it belonged: it had to be large to establish an identity in such a space, and this is another way of saying that man is attempting to establish his identity where no other means of doing so is at hand. In Egypt, the living were subordinate to the dead, since the dead required more protection than the living, and death seems everlasting while life is known to be ephemeral. Thus pyramids make sense: they were intended to be everlasting, and in the context of the shortness of life, they were just that. They were there, they were permanent, they were a symbol of security – they have never disappeared like the mud-brick house. Like the ancestors, their presence gave confidence to those working afterwards. They were a measure of man's ability to create and construct; they witnessed the development of this ability, and would do so in the far distant and precarious future. In a way, too, the pyramids suggest the significance of a house: as the walls of a house protect a family, so the pyramids protected the community. And like a house, they provided an order to the domestic background, and this, once recognized, could be taken for granted – an essential if people are to progress, experiment and discover. If no such order exists, and can be taken

for granted, the energy required for progress is diverted into coping with disorder. Comfort is another aspect of this background order: if the rain gets in, we spend valuable time stopping up the hole when we could be doing something more constructive; but by stopping up the hole we keep faith with this order, and will go to great lengths to maintain it.

In the youngest of these three civilizations – in the Punjab – there was another example of man-made order. The Sumerians had established their consciousness of existence by relating man to his house; the Egyptians had established theirs by creating an everlasting monument; but the people of the Indus, while looking to themselves, like the Sumerians, and to the house for an ordered background, related the plan of the town to the rhythm of living. At Mohenjo-Daro, beside the Indus in Sind, and at Harappa, 645 kilometres (400 miles) to the north-east in the Punjab, they accomplished this by making their main streets coincide with the cardinal points of the compass, and thus a connection was established between the orientation of the town and night and day, dark and light. There was a precedent for this arrangement – the ziggurat. And more recently it persists, in a slightly different way, in the church form: the altar faces east. In achieving this form of order then, the people of the Indus looked beyond themselves. The house was centred on the courtyard, and they related this to the natural order of things, the regularity of which fixed man's position in time and space. This natural order obviously follows through the town: streets relate to streets, houses relate to streets, houses relate to houses.

But when we reach the details of the house – its plan and construction – we find no progress comparable to the advances made in town planning. The house was very like the house in Mesopotamia: it consisted of rooms around the familiar courtyard, had stairs which led to a flat roof (or upper storey), baked-brick walls and mud-brick floors (the floors were constantly moved up to avoid rising flood levels), and they had lavatories similar to those found in Mesopotamia. But at Mohenjo-Daro they also had bathrooms, which is new, and sometimes a well. Public wells supplemented the private well, a fact which suggests an enlarged community sense which was reflected in the design of the town as a whole. Then there were the shops, another example of community growth

– a considerable advance on Mesopotamian towns, and a symptom of prosperity. Under Greek influence, the majority of the buildings lining the main street were small shops raised slightly above the level of the street which is similar to the sort of thing one finds later on (particularly in the eighteenth century which exploited separation with colonnades to great effect), and was an excellent idea. This arrangement, which was of superficial Parthian origin, occurred at Taxila (first century AD) but took its plan, probably, from the Indo-Greek city of the second to first century BC which exists beneath part of it.

This brings us back to the chequerboard plan, the squares of which were densely packed with houses behind the shops. This means that – in the relationship of houses to shops, shops to streets, and streets to the plan of the town – an entity had been created. But, additionally, the town was related to the space outside it, achieved by its deliberate orientation of main streets towards the cardinal points of the compass: it was dictated by the sun. And so the plan worked on two important levels, both of which are representative of human needs. The one belongs to a life which is bigger than ourselves and which is, like the pyramid, everlasting; the other is central to the home and day-to-day security; in other words, the house and its courtyard.

Thus the town, as conceived on the Indus, had an order and inspiration which recalled its function – to look outwards to something big, inwards to something human – in other words, what living is about. But it is interesting that a special characteristic of this town was the reservation of one of the rectangles in the chessboard for a mound. This might suggest that the Egyptian pyramid had not been entirely forgotten, although, perhaps, relegated to a relatively unimportant position. It might also suggest that the possibilities of the form had been rediscovered. But the top could be reached (it could not in the case of the pyramid). At its peak was the citadel, as the temple had crowned the ziggurat. This citadel provided a focus for the cultural life of the town. But it was also a symbol of something much larger. From the streets of the town and from the courtyard of every house there would have been this view of the citadel above; there would have been this fixed image of the sentry guarding the spiritual beliefs of the people. But this

mound, with the citadel on top of it, poked up like a periscope through the dense, back-to-back houses. From the top, it would have been possible to look down, in one direction, at the town and see the architectural and social order that had been created; while in the other direction it would have been possible to observe the country and enjoy the space of it or, alternatively, the relationship of the walled town to it. Thus this human conception of the small, semi-isolated community was, both spiritually and architecturally, complete.

However, the architecture of the Indus civilization which survived was a plain one, although it is likely that the parts which have disappeared (those of timber, for instance) may have been highly elaborate. These people came from the Iranian plateau, up in the mountains. Clearly they were fascinated by the vast possibilities of this fertile valley. They must have been both exceedingly tough and exceedingly clever: it must have taken more than mere ambition to exploit the opportunities of these great, empty, lush plains; their courage and determination must also have been extraordinary. They had to face the elements, turbulent floods had to be overcome. Moreover, the space was much more vast than in either Mesopotamia or Egypt, and this was a big problem in itself. So had they not possessed from the start, in their system, a skill and genius to conquer this land they would have gone under, defeated by nature. It could not, in the circumstances, have been a slow, methodical growth where progress was made steadily and by trial and error; instead, the challenge of nature was so great that it made these people respond rapidly with solutions to considerable problems, extracting every quality and every particle of vitality that was in them. This is a normal and known human reaction under pressure when people are confronted by crises: man's instinct for survival is revealed at its most vigorous in such situations.

It would be unimaginable, otherwise, to see how they could have approached their own problems with such confidence; perhaps it is enough to accept that at certain times in history man has made sudden, huge advances because the genius that makes such advances possible has always required merely the faintest spark to set it into high-speed motion, and that the resistance made by great adversity simply accelerates the engine. Their village or small-town

community was the ultimate triumph of the first phase of the Indus civilization, exemplified by the way the people strove together to make a single act succeed as part of the whole operation. And make no mistake about it, this operation was indeed astonishing. The extent of the civilized area stretched, on what might be called the Indus axis, 1,600 kilometres (995 miles) from Sutkagen Dor, near the shores of the Arabian sea, 480 kilometres (298 miles) west of Karachi, to the neighbourhood of Rupa at the foot of the Simla hills. It stretched south-east along the coast for more than 685 kilometres (425 miles) from Karachi, through Kathiawad, or Saurashtra, to the estuaries of the Narbada and the Kim on the Gulf of Cambay. It has also been discovered that the Indus culture jumped the barriers of desert and jungle which had previously been thought to exclude this civilization from the Yamuria, or Jumna, basin and had reached Alamgirpur. The fringe of Indus sites is now expected to be discovered on the northern plains. This civilization was extensive.

But, with internal decay setting in well before 1700 BC, the action shifts to the Ganges where civilization was revived and continued by the discovery of copper and iron, and this led to industry and important urban developments. Here was the beginning of a developing civilization which was supplemented, in the latter half of the sixth century, by new cultural movements in the north-west corner of India. These movements, or influences, were derived from Persia and given special impetus by the arrival of Alexander the Great. Colonization from this direction brought security to the trade routes and prosperity to towns along them and around the Ganges – for example, Begram near Kabul, Charsada near Peshawar, and Taxila near Rawalpindi; and improved techniques, including coinage. The importance of trade as a method of communication and for exchanging ideas cannot be stressed too strongly. The Persian influence spread to the cities of the doab, which flourished. But new fashions and techniques implied no radical revolution in the life of the great plains; they were consolidating civilizing trends which were already growing. The period after 500 BC and, particularly, after 300 BC, was one of enrichment both economically and culturally, culminating in the rise of the Mauryan Empire which succeeded the Persian Empire after Alexander, who arrived in 327 BC.

Alexander brought the Persian influence to India, and this was the beginning of India's later culture and architecture. Bala Itisar was attacked by Alexander's troops (who then pushed on from Persepolis to claim the Persian provinces of India). After Bala Itisar had fallen it came under the control of Indo-Greek rulers who had themselves been driven out of Bactria by Alexander, and had taken over the frontier region and the Punjab in the second century BC. Then Bala Itisar was moved – in fact, the moving of towns from time to time to new ground at the will of changing dynasties or fashions was an Oriental habit. But this town of Bala Itisar, having been moved, was laid out on the chessboard lines which sub-Greek Bactria had probably inherited from the Hellenistic West. Obviously, the original chessboard towns of the Indus civilization were influenced in the same way – trade had been going on with the Greeks since the first century BC. The general character of the layout was similar to that of the West, but it had Eastern features incorporated within it. Like Taxila, or Sirkap, it was another example of a chessboard plan, originating from Parthian on the one hand, Indo-Greek on the other, with a good many Persian influences thrown in.

Among later findings of stone were the Ashokan pillars: the Indian custom was already in existence of erecting a pillar to commemorate a victory or special sacrifice. Timber posts were normally used, and behind this practice seems to lie the Indian cosmic idea of a world axis conceived as a pillar separating heaven and earth; it was only subsequently that these pillars were made of stone. Ashoka, the grandson of the first Mauryan emperor, set up these pillars in the middle of the third century BC after his conversion to Buddhism. But the wider architectural significance of these pillars was the so-called bell-shaped or 'inverted lotus' capital, on the one hand of Persian origin, on the other entering the construction of the Indian architectural 'orders' from the time of the Mauryans until far into the Middle Ages. The elaborate and enriched column capitals, those hewn out of square piers in the sixth century AD by the rock-cutters of Badami, south of Bombay, retain elements of this form more than eight centuries after its introduction into India, and even the plain, faceted capitals of Pallara and Chola architecture in the far south are derived ultimately from the same remote

source. The architectural link with Persia does not end here. In India, as in Persia, the weight of the architrave beam is commonly transmitted to the column through an oblong impost-block, or bracket, spread laterally to take the strain, rather than through the square impost of the more classical orders of the West. These shapes suggest the historical link between Persia and India where the architecture was enriched by borrowed forms, and disciplined by the continuity that this borrowing produced. Unlike the classical architecture of the West, however, the Indians chose a decorative expression for their bracketed capitals rather than the Western purely structural one. For instance, the spreading of the bracket laterally to take the load was logical enough but not strictly necessary, and it was this decorative aspect of the capital that was continually emphasized; hence the tremendously complex web of brackets that were built up and up at the head of the columns. This web, in the end, was like the assembly of a very elaborate jigsaw construction, yet all it was in fact doing was performing the simple task of propping up a beam. As we know, similar methods were employed by the Chinese (sharpened with bright colours), and by the Japanese later on, and it is in the different approach to structure that some of the really fundamental differences between East and West architecture lie.

So in the north-west corner of India trade, war and conquests created a mixture of bloods – Iranian, Indo-Greek and Greek – which combined to establish the Persian influence, and this spread across the top of the country to the Ganges and beyond. Looking at a map, one can see how this could have happened without much difficulty. At least one main line of communication followed the Indus and the Ganges and, relatively speaking, the source of the Ganges is not far from the Indus. But in the south, on the peninsula of India, civilization came on the scene later, gradually filtering down from the north. From the first century BC, however, there were much more potent injections of culture through Graeco-Roman trade: the invading traders not only called in on the western ports, but on those of the east coast as well; this flurry of activity seems amazing now. It was an invasion of contacts and European goods into central and peninsular India in exchange for local Indian clothes, semiprecious stones, pearls, and especially spices, and

occasionally Chinese silks. These silks were a key link between East and West: Mediterranean countries were fascinated by them and the Romans actually set up trading posts on the borders of China (the rush of Roman gold out there to buy the silks so weakened the Roman economy that it contributed to the eventual collapse of the empire). But the east- and west-coast ports remained most receptive to these foreign influences.

The Frame

And so, inevitably, one returns to the centre of Western culture, Greece, and we have never, in any sense, lost our ties with the architectural concepts that this country's ancient civilization explored and demonstrated, nor with the political and social freedom that lay behind them.

But to go back to the beginning again: this civilization, like that of the Sumerians and, subsequently, of the Egyptians, can be traced to Anatolia. The earliest style of house in Greece was usually the round hut constructed with a frame of poles with walls of inter-twined reeds, daubed with clay. Later there were the rectangular houses of mud bricks, at first with no stone base; then there was the megaron type which consisted of a rectangular room with an entrance on one of the shorter sides in front of which was an open porch supported by two posts. This type originated in the Near East but acquired a characteristic Aegean quality because of its open porch with columns, projecting *antae,* or both. Both of these features survived in early Greek architecture and became an important element in the classical temple. Another type of rectangular house which had far-reaching effects in later times, also with parallels in Anatolia (Hacilar), had buttresses placed inside the walls to provide a more effective support for the flat roof of beaten clay, and houses in these villages were arranged close together in straight rows.

The Cretan civilization began at about the same time as the

Le Corbusier Centre, Zurich, Switzerland: architect Le Corbusier, 1967.
Structure and glass façade facing the Municipal Park: the classical frame
revived.

Greek civilization, but while the first round huts were being built
on the mainland, caves were used as dwellings and burial places in
Neolithic Crete. However, at Knossos an early Neolithic rectan-
gular house existed of sun-dried brick on a stone base. Houses
with rectangular rooms also existed in sub-Neolithic times. They
had inner partitions which formed a honeycomb-like complex,
unenclosed by external walls. This openness was fairly common in
the Near East and it was a theme of Minoan palaces. But in Greece,
as well as in Crete, settlements had, as yet, no particular plan and
should not be mistaken for urban developments simply because of
their size and the density of their populations: Neolithic and sub-
Neolithic settlements were nothing more than agglomerations of
houses and huts placed together for convenience, but without
design. In some cases, however, settlements on the islands did have
the air of a town about them because they were surrounded by a
wall, the proportion of which was in scale with the settlement; but
turrets and gateways suggest that the function of walls as a means
of defence transcended the importance of houses as a means for
living. Examples are Thermi on Lesbos, H. Andreas on Siphnos and

Colonna Cape on Aegina. These were places, however, where the status of a town was achieved. On several islands there is evidence of paved streets, squares, fountains and cisterns for water, all of which suggest the active community life of a town. Many settlements or towns were located on the coast, and this suggests that the livelihood of the people came from the sea as well as from the land, from trade as well as from fishing.

So 'cities' with a long history existed between the cave and the rise of the great palaces: examples are Gournia, Palaikastro and Phylakopi. Here houses were mostly small and crowded together with little space between them, streets were narrow and rough, and the variation in their levels would have made wheeled traffic impossible. The methods of constructing houses and the details of their plans were fairly advanced from an early stage. They had several storeys and were divided into separate rooms. The lower part of the walls were of rubble or stone, and the upper part of sun-baked bricks. Floors were sometimes merely beaten earth, sometimes plastered over or formed of flagstones. A mixture of types of houses occurs, like the arrangement of spaces in palaces

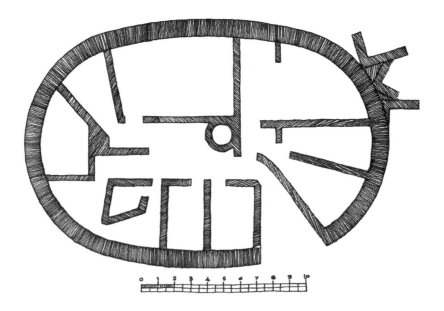

House of Middle Minoan civilization at Chamaezi, Crete, 2000 BC.

later; the earlier Aegean system of communicating rooms existing side by side with the isolated living room was adopted, with the hearth as the central point of the house. This planning goes back as far as the second city of Troy. Small, independent towns like Gournia and Kato Zakro had flourished but fell when the power transferred to the palaces. Both the density of settlement and the types of dwelling unit that were built in the next phase (Early Bronze Age) were derived from the preceding period. On the mainland several examples of the megaron were found which were the same as before: stone base, walls of burnt clay reinforced with a frame of beams and with a flat earth roof, occasionally gabled and thatched. There was evidence of contact – just as vigorous as ever – from east to west across the Aegean; there were regular cultural injections from the Orient during its early dynastic period,

Restored drawings of Faïence house fronts from Knossos, Crete.
Left: dark grey ground with crimson stripes and window frames.
Upper windows open right through lower windows, sunk with scarlet filling. *Right*: all grey and white windows sunk with scarlet filling.

Left: diagram of Greek plan of architecture. *Right*: diagram of Minoan plan of architecture.

and this is manifest in wall construction where the stones are set in herringbone patterns – as can be seen at Troy and in early Helladic building on the mainland. The rectangle was becoming more precise and, in some cases, one of the shorter walls, probably the wall opposite the entrance, was semicircular, forming an apsidal end to the building. This recalls the combination of the two basic shapes – round and rectangular – of the Tell Halaf culture on the Mediterranean coast, now merging into a single form; and it seems to forecast the shape of churches to come. It may be assumed from this that the roofs of these houses were hipped at one end and gabled at the other. Both of these types of megara – the true megaron and the apsidal-ended form – existed in urban dwelling houses of the so-called Early Helladic culture on the mainland of Greece. In the culture of western Asia Minor the megaron is without an apse, and no apsidal megara appear in Crete. But just as rectangular buildings had become more precise, so circular dwellings progressed three-dimensionally and were taken to their logical conclusion: dome-shaped, built of clay over a stone base. The most important Early Bronze Age innovation is that megara and circular dwellings now appear in monumental form for palaces and religious buildings.

So we go on to the palace of Knossos, which represented the climax of grand Minoan domestic building. The character of this remarkable work of architecture is defined by its openness: it was open to the sky as it was open to the Mediterranean; it was multi-storeyed, random and lacked symmetry. It had no fortifications whatever, and this proves Crete's supremacy at sea during a great period of trade. The design of the palace has a curious confidence that seems to reflect this supremacy. It presented no single façade of the accepted classical kind but instead was assembled from a number of pieces which suggest façades. There was no special sense of direction operating through the interior, no special sense of a particular entrance or axis – there was nothing, that is, to impede people's natural movements among the spaces. Although there are superficial equivalents in this use of a central space which were forerunners of the Minoan palaces (and these are, of course, found in the Orient and Egypt) no effort was made to force its existence as a focus through symmetry or emphasis on entrances as one finds,

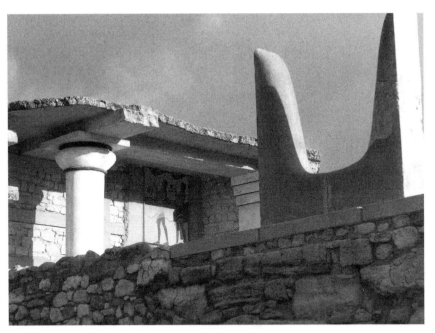

Horns at Palace of Knossos, Crete, 1500 BC. Le Corbusier revived the theme of Oxen's horns at Chandigarh, India.

for instance, in the Roman plan and atrium. And so it seems that everywhere – in the Minoans' view of decoration, their perception of architecture in its widest application, their consciousness of the outside and the relationship of this to the inside – there must have been a unique freedom of thought. It would appear that they had broken through several barriers at once and realized their position – on the borderline of history and prehistory, between the ancient East and the young West – and attempted a complete fusion of the two which had not taken shape. The court, which in Mesopotamia and the Orient had been contained as the centre of inward-looking buildings, at Knossos looked outward as well as inward: openings leading to the outside world are one and the same as those leading to the interior of the palace. But symptomatic, too, of the precarious situation of the Minoan world in time are the combination of primitive features with this most remarkable concept of unity.

There exist structural affinities with Cretan decorative art of the pre-palatial era in the connection between interior and exterior

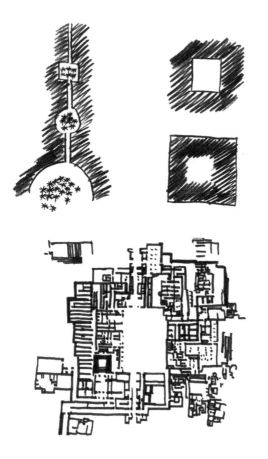

Left: plan of Bath grows out of a formalized green thread of square, circus, crescent.
Top right: Minoan plan grows from a rigid centre.
Bottom right: Sumerian plan grows inward from a rigid outline.

The Great Palace at Knossos, Crete, c.15th century BC. Plan of principal level, illustrating a freedom of design from the centre outwards.

spaces. Where before two-dimensional art exploited spirals and whorls, now these appeared as winding passageways, and this can be seen at Knossos and other Minoan palaces. At Knossos, in the stepped portico and the staircase, these decorative, flat designs are turned into three-dimensional forms and spaces: light, dark and shape. In this way the decorative and architectural dimensions take on the air of a double image: decoration, so to speak, melts into architecture, and vice versa. The two mediums create a unity – and this is consistent with a theme that ran through the feeling of the building as a whole – that was accepted by a spontaneous order which sprang from the jumble of its parts. The view from the Caravanserai makes a composite impression from the merger of separate elements: it is like a collage of the building; this same impression appears upon entering the central court. In creating a

Column at Knossos, Crete, c.1600 BC. Reconstruction in painted concrete to represent the original tree trunks used upside down with roots spreading the load – as in modern structural systems.

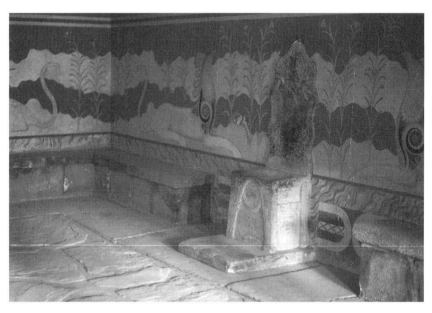

The Throne Room. Throne and wall frieze together display a unique unity of design.

unity by this method the Minoans anticipated the artists of the classical age, but without proceeding from the same starting point (symmetry) as the latter were to do. In their palaces there was lack of logical consistency – order was shaken into place and seemed completely subordinate to natural laws – and this continues around the court where various arrangements of rooms were separated from one another by passageways that were open to the sky, giving the impression of islands between which were corridors of air flowing from the centre space and circulating through to the outside. But a random collection of walls and spaces of this kind must have important centres of interest if an architectural anarchy is to be prevented from taking possession. And at Knossos these centres lay largely in the structure; most particularly, perhaps, with the columns that framed the main court, but also with those that climbed up alongside the staircases, created façades and supported entrances. The interest lay in the structural directness of these columns' unique, tapered shape, in their obvious strength and in their powerful colours: the earthy red and the matte black. As with the great cathedrals of the Middle Ages, it is to the structure at Knossos that one looks for reassurance: the regularity of the columns, their size, diameter, vigorously expressed purposefulness – all these things combine to resist the anarchy that can, at any time, break out in architecture. How well we know this today from the shambles that collect like scum round the edges of most industrial cities, and that destroy their skylines and attack their centres. We know all about anarchy, and our inability – through carelessness, arrogance, ignorance and greed – to relate the simplest sequence of buildings. What is missing, every time, is a sense of both the importance of compositional structure and certain centres of interest around which concentrations of imaginative and intelligent detail can collect: what has gone, in short, is the architectural focus and order that make the starting points from which all good design may naturally flow. Yet they exist in the traditional Japanese house with its scattered courts, and in the precise symmetry of the Chinese or Roman house, and in the irregular Greek plan that was fitted around a central space. And at Knossos they are found in the colour and definition of the frankly exhibited structure.

But it should be remembered that Knossos represented an experimental period, the transition from ancient to modern, and the plan of the palace betrays a comprehension that buildings consist of parts that have a variety of uses, and that these not only exist, but must exist together. It would not be strictly true to say that the Cretans realized that certain spaces, or groupings of spaces, belonged to each other – this realization came later – but it would be true to say that they recognized that the spaces had differences, and that, since these differences existed, the spaces had to be separated. The fact, however, that the spaces were separated with walkways – rather than with the walls of traditional plans – shows a clear need to relate the rooms to the outside by the limited means of an internal courtyard and, at the same time, all parts of the building, including the central space itself, to the outside world. But at the same time, too, the separation of parts meant the possibility of a new evaluation of the functions of each, thus leaving these people free to follow their nature, rather than accepting a preconceived form imposed by the past. In the Orient and Egypt the most important aspect of the house is its cube form, and this meant that it appeared as a definite object, finalized and complete. There the need to make objects of this kind was understandable because of anxieties about mortality. But at Knossos and other Minoan palaces this traditional form was taken and turned inside out. In diagrammatic terms, the starting point was the rectangular courtyard, set out in advance of the building around it. This building was then free to choose its own shape and size; it was also, in the process, freed from the courtyard, as the parts of which it was composed were freed from each other by walkways, and, symbolically, this shows an important break with tradition: before it was the perimeter that had been marked out first and the building of individual rooms had taken place within this until the space left over formed the courtyard. The traditional plan was, therefore, restricting; at Knossos, on the other hand, the limitations were dispensed with, and the possibilities of the world around were appreciated.

At Knossos at least a dozen elegant dwelling houses were grouped around the palace; some were close enough to it to be influenced in their orientation. The loveliest, the so-called 'little palace', is approached along a paved path about 200 metres (656 feet) long

which leads due west from the north propylon (the entrance to a large architectural composition of buildings). Its foundations were laid in the Late Palace Period, as were most of these houses. It opens up to the east; and the rear, where the domestic quarters are situated, rests on a sloping hillside. Most of the other private houses are built along similar lines. There are no central courts but there are traces of the palace theme of building growing outwards from the central nucleus which was sometimes, but not always, the main hall. Here is a pattern which recurs throughout history. First there is the prototype, which is large, lavish and designed to suit the great occasion, and this tends to set the fashion. Then, in order to apply its principles to more universal needs, it is evaporated and, like a substance in solution, only the crystals remain. Thus the essentials of the style are extracted and can be used in a variety of situations – at Knossos, these were the mansions which surrounded the palace. The grand plan disappears and a tendency to arrange the living and ceremonial rooms (most of which are pillar halls) nearer the outside walls emerges, and this shows the freedom and openness near the perimeter, a characteristic of the palace; the rooms project or recede in a haphazard manner. This, and the rambling plans, are features as typical of the houses as they are of the palaces from which the motifs are derived: pillar halls and columns tapering at the base, stairways, pillar crypts, bathrooms and lightwells.

At Mallia conditions were much the same. Adjacent to the rear of the palace was an open square, with houses situated along paved streets which ran eastwards from the palace. These were built over fortifications at least as late as the sixteenth century BC. They are larger than those at Knossos since there was more trade and farming going on by this time. There were some smaller inner courts as well and these buildings, like the palace itself, were less pretentious than those built before. Stately villas were found scattered over the whole country; one of the oldest known is situated not far from Amnisos, a coastal site about four kilometres (2.4 miles) from Knossos. This dates back to the seventeenth century BC, at the beginning of the Late Palace Period. A group of such villas existed near Tylissos, west of Knossos, and they also occur individually; for example, near Achladia, Apodulu, Sklavokampos, Vathypetros and Zou. Most of these villas were built during the sixteenth century

when the Minoan civilization had declined with the destruction of the palaces (circa 1400 BC), and the houses around them had been deserted. These villas continued because they were the country seats of the landed aristocracy. But, all the same, their form moved away from the free and open plan of before. They had inner court-yards, but these were much more enclosed by the building, showing a partial return to an inward-looking house devised for defence. The grouping of rooms around a central nucleus also occurs here, retaining much of its early agglutinative character. Still, the style was in a decline.

But the destruction of the Minoan palaces was not the end of an epoch; instead, it was as though fragments of them had been showered across the sea, as far as the Greek mainland, and that, scattered, they had lost their potency, growing up again in a weaker

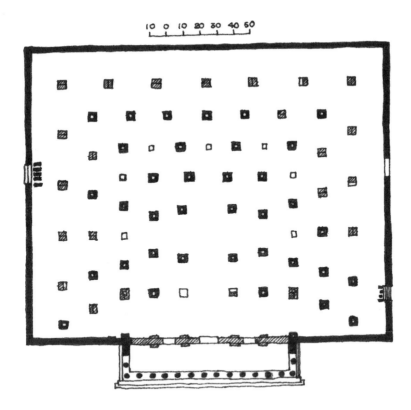

Plan of Thersilion Temple, Megalopolis, c.1600 BC, with a forest of columns.

form. The Minoan style still persisted in art forms too, but the centre of developments had shifted and production fanned out over the entire Aegean. Before, it had been concentrated on Crete.

The strong personality of the Minoan form appears to have been replaced by a less committed outlook which could easily be mistaken for a decadent interpretation of the earlier culture. In Mycenae, on the Greek mainland, and other places round about which came within its sphere of influence, it was non-Minoan characteristics that determined the future Greek style. However, it was not the shift in area that accounted for the change, but the people who had taken over, a different race with a different character and background, and the architecture that they had been used to on the mainland was still very much a part of them. The architectural story is, in fact, like the story of a family: new members enter it at regular intervals, and although they are absorbed into its system and they help it to continue and develop, it is never quite the same again. And although the Mycenaeans had their own life to lead, so to speak, this did not stop them being open to ideas from elsewhere. So, really, there were two main sources of inspiration: their heritage, and the Minoan civilization, with which they had a natural affinity (Crete was a close relative). Thus the indigenous forms were still found: the megaron house was very popular, but so too was the oval-shaped dwelling, sometimes elevated to a stately appearance, and apsidal types. At the same time, the few residences known – Malthi in Messenia, Asine in Argolis, and fortifications such as Aegina, Brauron in Attica, and Malthi – are less pretentious than before.

At Malthi, the fortification walls, oval in form, and about 135 metres (444 feet) in diameter, have no bastions and the five gateways are simply passages in the walls. The main house was in the centre, and a number of smaller rooms of approximately the same size are arranged radially around the inside of the wall. The whole thing has a more primitive and rustic air than any work of equivalent status done in Crete. But the climax of Mycenaean culture came in the thirteenth century BC and it was devoted to large architectural conceptions rather than the detail studies of decoration found in Minoan houses; it was concerned with structural ideas that were on a monumental plane. The Mycenaeans were on

to bigger things, greater and – as it turned out – much more profound discoveries, and the pottery which had occupied such an important role in their past (as a creative method of expression within narrow limits of knowledge and imaginative comprehension, and as a part of a booming trade) had been left behind; it drifted into insignificance, at least for the time being. The sights of invention and inspiration had been trained on other, more ambitious targets. These were citadels, palaces and tholos tombs. The conception for, say, the citadel at Mycenae was a large one: there was this hill, which suggested a fortress, and there was this wall which surrounded it, following the undulating slopes of the land, and even the shape of this wall itself (seen in section), terraced down towards the interior ground level, seemed to have become an organic part of the landscape. But although this wall, like the total conception of the fortress on the hill, was large, rugged and impressive in the Cyclopean manner, the outlines of certain important elements in it – gateways, bastions, lookout towers – were sharpened up like pencil points with precisely sawn ashlar blockwork. This is revealing: ashlar was introduced for visual emphasis, for aesthetic reasons, not for strength: the stone wall was strong enough as it was. And these touches, these refinements, incidental and minor though they may seem, suggest that new architectural awareness about the properties of materials had crept on to the scene.

A closer look should be taken at this citadel. Starting from the entrance is a ramp, and this leads directly up to the palace on the hill top. The final approach is, however, made along a winding path – the ramp ends when it meets this. In the west and east sectors, within the defensive wall, were residential and domestic quarters. There were also a number of remarkably fine houses, of which the most impressive was the House of Columns. Little of the palace remains, but the form of the plan is plain. The chief thing about it was that it had, at its centre, a climax, as the palace itself was a climax to the citadel on top of the hill. This centre is commonly called the 'megaron', and this is derived from the megaron house; the palace had simply absorbed the megaron within its walls. What was this version of the megaron like, and how was it incorporated? In the first place, it faced west; secondly, it was a portico with two columns and antae; it had a transversally placed antechamber and

a rectangular principal chamber, which had a low circular hearth in the middle, and four columns around it supported the roof. The back of the megaron, and its south wall, once towered high above the precipitous rock face, supported by part of the perimeter wall. The stuccoed court in front of the façade formed an approximate square, twelve (39 feet) by twelve metres, and was enclosed by two-storey buildings. The entrance to the palace was in the north-west corner. But as far as the relationship between a palace and its fortifications is concerned, it is in fact easier to see how it happened at Tiryns than at Mycenae where the most important element was this 'megaron' centre and the form of the palace plan arranged around it: here were the components – roughly enough presented, still in the process of change and capable of the many different arrangements that had still to be tried – of the future Greek and Roman house plan. The appearance of the hearth is interesting, although it has far more to do with the past than with the future when, in time, it disappeared. In fact, its central position in the middle of the columns in the principal room in the palace was more an acceptance of tradition than a respect for needs. And traditions are difficult to relinquish. The hearth became fixed in people's minds from way back when it had been the central focus of every northern hut. But when the parts of the domestic house were reshuffled it was the peristyle of the Greek plan that eventually superseded the hearth and took first place.

The hearth is only one of the things from the past that the Mycenaean citadel carried on: the citadel itself was not a new type. The perimeter wall succeeded the citadel walls of the Early Bronze Age in the Cyclades, and traditional motifs on the mainland were also carried on. Door jambs were still constructed with a few blocks with a large slab on top (a good example is the tholos tombs). The gateways at Mycenae (the Lion Gate) and Tiryns were built in the same way. All of these examples are directed the same way: there was great attention given to structural expression and great emphasis was laid on it. This could not have come from the colossal monuments of Egypt or the Orient, built prior to the Bronze Age, since the interest of these was centred on the whole geometric object, not on the parts of which they were constructed. This is just the difference: the Mycenaeans *were* interested in the parts of which

the buildings were constructed. Unlike the Egyptians, who borrowed the ziggurat form without perceiving the functions which shaped it, the Mycenaeans went back to first principles, and it was this analysis that led to their own monuments – the Parthenon, for example. The pyramid form created nothing but the pyramid form, nothing which could be given a universal application, nothing which could be used in another way that would benefit society. And what about the Mesopotamians? They were the originators of the structural forms used by the Mycenaeans, and they knew about the arch as well (not adopted by either the Mycenaeans or the Greeks), but they failed to develop any of them because they were held back by the limitations of their materials – the mud brick. The structural discoveries of the Mycenaeans, on the other hand, went on to many things we use today: posts, lintels, beams, even the frame. The Greek temple was, in perfect terms, a finite demonstration of these discoveries.

But how did the Mycenaeans see these developments architecturally? Well, first there was this stressing of the outline of certain elements of particular importance in the perimeter wall; this has been mentioned. For instance, they may have emphasized an

The Lion Gate to the palace at Mycenae, c.13th century BC.

63

opening, the gateway perhaps. The main wall was of rough stone but this stopped, say, a couple of metres from the entrance where, around the opening, the finish was smooth. The actual structure of the gateway, however, was different again because the parts of which it was made were separated. At the Lion Gate two stone posts supported a lintel, and above the lintel was a triangular piece of stone which had two lions in relief. This decoration increased the status of the entrance – it was the main gateway – but the fact that the lions were sitting indicated the job the lintel was doing: carrying the piece of wall above it. At the same time, this deco-rated stone was the expression of an unnecessary load in the construction. And at the Treasury of Atreus this triangular piece of wall above the lintel, being unnecessary, was left out altogether. This indicates a great advance in the Mycenaeans' structural aware-ness. But it is possible, too, that this discovery follows from the roof over the megaron which produced a gable end – the typical form of the porch which reached Greece from the Tell Halaf culture of the Mediterranean coast much earlier. Incidentally, however, it reached forward into the far distant and misty future to the Pantheon in Rome, and, centuries later, to the Villa Capra at Vicenza in AD 1550. The tholos tombs put the position clearly. The form of these extracted the essence of what was different about the features in Mycenaean architecture which were to become those of the clas-sical Greek style and those of the architecture as a whole, as well as differentiating between these and the zenith of the Egyptian and ancient Oriental styles. They also exhibit the same naturalism – they slipped into the shape of the landscape, under mounds. The walls also fitted in, but as an extension, even an exaggeration, of nature. Here is the difference between burrowing and building: in burrowing adjustments are made to nature, but there are no super-imposed changes. But while the tombs described structure, at the palace forecourt at Mycenae structure was given an architectural expression on a much wider scale. This demonstrates the same kind of points made by the gateway: the parts of the construction are separated – the Mycenaeans were aware, and enjoyed this aware-ness of what supported what, of essentials and nonessentials. Windows and doors were slotted in between strong, dark, hori-zontal bands of faience and terracotta, and separated from one

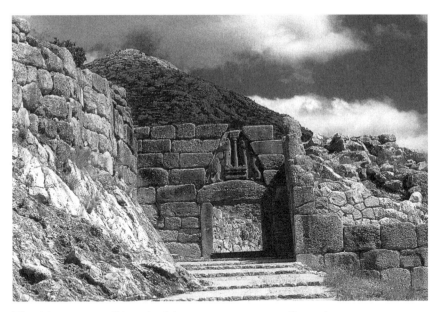

The Heraeum at Olympia, 6th century BC, nature framed.

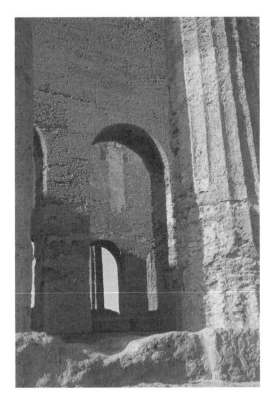

Taormina, remains of a
Greek and later Roman
theatre on the east side
of Sicily. c.400 BC.
Photographer H.T.
Cadbury-Brown.

another by ashlar masonry. In some cases a rectangular column occurred in an opening to allow a larger span, and this means they could have had larger lengths of window if they had wanted. Having discovered the possibilities of post-and-beam construction there was now a choice: the absence of big windows shows the strong influence of climate – small windows allowed a view and a flow of air, and they kept the interior cool. But it should be noted that the dark bands which helped separate solid and void and differentiated between supports and beams took the structural appearances of the façades out of the sphere of engineering and into architecture; for architecture takes liberties with function and it is these bands which provide exaggeration here. The extent of these peoples' awareness was amazing: if these façades are reduced to a simple diagram of lines, the ashlar over the windows is forgotten, and the spaces between the windows are also forgotten; what we see is nothing more nor less than a frame. One thinks of the aesthetic frame as a twentieth-century innovation; its roots go much further back.

The megaron was the only symmetrical form in the Mycenaean conception of the citadel. In the Aegean there was a deeply entrenched feeling for space, and the possibility of movement in space (hardly surprising with all that empty sea and all those horizons among the islands). A form that seemed to suit them was the spiral, perhaps because it was full of movement. An approach on a curve, continuing for some distance, contains a vast sequence of views which are revealed, one after the other, each different, as the corner continues around, leading you up to the climax – withheld until the last moment – at the centre. The suspense is incredible. A symmetrical approach has no such variations since the end is in view from the beginning. But the spiral at Tiryns is more forcefully and architecturally expressed than at Mycenae: the fortification wall and the wall of the palace combined to make a passage that led to a forecourt which directed you through a colonnade and propylaeum into a large open courtyard surrounded by rooms which, in turn, emphasized the position of the entrance through a smaller propylaeum into another courtyard which was a regular rectangle surrounded by porticoes. Although the total assembly of parts is Mycenaean, there are clues, nevertheless, to foreign

influences everywhere: in the megaron, for instance, as the centre-line of the courtyard, in the entrance to its antechamber where two rectangular pillars in the Cretan manner replaced the earlier Mycenaean door and wall, in the tapered columns of Knossos belonging to the colonnades and the propyla – and these went back to the palace forecourt at Troy. And this is not all: the stair-well at Mycenae copies the free forms of Minoan designs. And then, of course, there was the influence of the Hittites who pushed the palace and surrounding buildings to the highest end of the walled enclosure, as on the rocky summit of Buyukkale on the eastern outskirts of Hattusas.

The idea behind the Mycenaean scheme is the build-up to a great climax which is dominated by the megaron, the largest room in area and height, and on the highest point of the citadel. The megaron was most imposing at Mycenae and, although it was placed below the summit, it dominates everything from its position over-hanging the sheer rock face, its south-east corner resting on the citadel wall. At Pylos, Gha and Phylakopi on Melos, the megaron was surrounded by lower corridors and ancillary rooms to produce a similar effect of dominance. This arrangement indicates a contin-uation of a stage already reached in Minoan palaces where the parts had been separated in such a way that they could be rearranged in a new form with a different emphasis. A similar system of plan-ning was used in Aegean citadels at the time of Neolithic Troy which did not survive to take part in the great booming period of architectural activity that began in Greece shortly after 1300 BC. But Troy's citadel in 1200 BC shows the beginnings of a breaking up of surfaces into more visually comprehensible areas. Flat projec-tions on the citadel wall, their shadows dividing the face at regular intervals, are repeated on the inside: this characteristic was derived from Anatolian architecture where walls were built in sections. At Troy and Gha their only function is aesthetic; the horizontal mortar joints run through uninterrupted. The importance of concentric and radial motifs in this design indicates the increasing process of differentiation between Anatolian and the Aegean styles. But Anatolia was an influence too, and this is certainly true of sepul-chral architecture: there is no doubt that this had its source in Anatolian prototypes.

So the megaron emerged as the dominant element in the Mycenaean conception as it had in the Minoan house. In the Minoan palace it was the courtyard that was important, since the conception centred on it. But in the Mycenaean palace the courtyard was reduced to the status of an entrance hall in a house, although expressed – since it was a palace – on a far larger scale. This courtyard became a preparation for the megaron, and the megaron gained in status because of the courtyard's function. Therefore it was Crete that brought the courtyard to the Mycenaean palace, and in Crete, quite early on, there are plans which show open spaces (possibly for animals) in front of one-roomed houses; and later this space was surrounded by a number of rooms with various uses, forming a courtyard. But the large courtyards in Cretan palaces assumed an importance of their own. They were not a means of communication between surrounding rooms, as they were in the small house, because the chief spaces did not necessarily open on to them; so many had been added progressively outwards from the centre that passages were required for access. But in the Mycenaean palace the disposition of the courtyard – or courtyards – seemed to have a prearranged plan which linked together the main departments of the building. Therefore, although the megaron was the focus at the point of entry, the courtyard, and its design, was treated with importance too, and as an integral part of the working arrangements that went on inside the building. The whole plan had the semblance of an architectural order which would assist the life that went on inside. Tiryns was a considerable advance on Knossos: something of the primitive remained at Tiryns, but it had been directed towards a definite aim and had thus been given an intellectual standing; the concepts of inside and outside were made clear.

Planning is one way of assisting people to organize themselves, and good planning makes things easier, producing spaces which work together. But the arrangement of structure has an important effect on the interior, and Mycenaean architects went much further than anyone before in solving internal arrangements. This is evident in the tholos tombs as well as in the magnificent megarons of Mycenae, Tiryns and Pylos. The success of the interior lay in the combination of the four columns, the lantern above them, the hearth at their feet, and in the placing of this structure

within the space. But an attempt to arrange the interior structure was not without precedent: it had been tried before in Troy and even before that, in prehistoric times, in the border region between the Orient and Europe. And in the Minoan palaces, which were so open, there was no break in the continuity between the outside and inside and a total harmony was assured. But what was also assured – and this was passed on to the Mycenaeans – was an awareness that the outside made the inside. One sees this in the design of the megaron. The entrance at Tiryns is a good example because the lantern, seen from the outside, suggests the invisible structure within. From the outside, part of the inside can be seen at the same time; it was open and the interior space was released more rapidly than elsewhere: the physical separation between the interior and the court had been reduced to a double line of columns. This means, in aesthetic terms, that it was impossible for attention to be divided between the outside and inside, and that equal attention had to be given to both if an aesthetic continuity was to be maintained. This meant, too, that an awareness of the whole of architecture grew and transcended an awareness of a building as an object. And, finally, this meant that love and affection were lavished on structures which were for the living, not, like the pyramids, for the dead: houses, rather than tombs, were given priority, and were cultivated.

It could be said that the house only progressed in consequence of the break with the Egyptian pyramid and the formality of the Oriental, inward-looking, courtyard house – both of which were self-conscious, confined by the rigidity of their outline, and incapable of development. A different approach was required, and it is hardly surprising that, in going back to first principles, the Minoans started again, took the house form apart and reassembled it in a different, if rather crude, manner. But crudeness is to be expected in a transitional stage, which this was; look at other periods of history – the Middle Ages, for example, and what is happening today. But these transitional phases (including our own) are extremely gradual, and it took a long time for the Minoan kit of parts to be evaluated, for the Mycenaeans to shuffle the pack, and for an aesthetically comprehensible diagram to come out of it all: the end product was the Greek style and the Acropolis at Athens.

Atrium of the House of Menander, c. 2nd century BC. The frame of sky, peristylar garden and pool.

Take the megaron – part of the process. The pieces of which it was composed were originally scattered all over the place. There was the hearth; its important status was inherited from the north. There were the columns which can be traced back to the support of the superstructure of Anatolian houses. There was the portico that goes back to the elongated gable-roofed anterooms of the Tell Halaf dwelling. All these scattered traditions which were known and tried were called in and fused together in the megaron. Roughly speaking, this shows where the megaron came from, but it was also an important step on the way to the temple. As Andrea Palladio pointed out, the classical portico of the house came from the temple, which had originally got it from the house. But it was left to the Greeks to extract the embryonic idea from Mycenaean architecture and, by a continuing process of elimination, to arrive at the dynamic compactness of the classical style. It was not a question of how the Minoan or Mycenaean styles had been changed or whether they had declined; it was, instead, that their forms had been given a different emphasis. Symbolically, therefore, the Parthenon was raised above all else at the Acropolis – as the megaron had been before, at the palace at Tiryns.

The Homeric period exhibited no spectacular changes in the Minoan and Mycenaean house or palace style. These early Greeks were a warlike people and were too busy to have ever designed and built a new type of dwelling. More often than not, they probably inhabited old Mycenaean palaces and houses. They held on to the megaron as the central form which, as far as can be gathered, they copied from the earlier period, but in certain cases the megaron was enlarged to become the palace itself, absorbing within its outline all the ancillary rooms. Generally, planning was less complicated, wars undermined interest in the future, and the mainland megaron had been complicated by the Cretan mazelike system of rooms. The Mycenaean palace at Gha was probably similar to the Homeric palace, a linear form where one room led to another. But the essential parts were the same in Homeric and Mycenaean palaces: the courtyard with its propylaeum, and the megaron with its entrance hall abutting on to the courtyard. However, there does seem to have been one significant development in the megaron

type of Homeric palace. The problem of separating the women from the men was a matter of great importance, and this seems to have been solved in some cases by the addition of a women's megaron at the back of the main one. To make the women's section more private it seems that a second courtyard was introduced between the two. There were variations on this plan, and usually the women's rooms were placed on the first floor. However, these were palaces: the average Homeric house was a workmanlike 'baby' megaron and often very disordered in plan. This was the most common kind of house, but the occasional building was elegant: the Palace of Alcinous, for example.

It is possible that the single-storey house, containing a central courtyard for the purpose of achieving a separation of the sexes, marked the beginning of the peristyle of the later Greek plan: a number of forces were no doubt at work to produce this and, in any case, the courtyard is an element used all over the Near East. Yet it would seem likely that the peristyle was the natural follow-up of the adjusted and more open megaron palace plan. The cards have been given another quick shuffle; it could be that the four columns round the hearth of the Mycenaean megaron and the sudden development of the Homeric courtyard had between them merged to form the peristyle: the hearth disappears but sometimes reappears in the same sort of position – in the centre of the colon-naded court – but as an altar. This is to be expected, too, because the hearth, at least in grand houses, always had a significant, some-what religious air, standing there in the middle of such a solemn space, with a lantern placed over it.

In the time just following the Homeric period, the classical period of the fifth and fourth centuries BC, no houses of the megaron type were found until those at Priene in the second century. It is possible that the megaron may have been abandoned as a form for the dwelling house and retained only for the temple, religious beliefs making a break with tradition inconceivable – the fear of the gods would have been too great. The wars had caused a good deal of poverty, and lowered standards which led to simpli-fied private houses, although the megaron type may have continued to exist alongside them. But, in either case, dwellings were very far from the spacious Homeric palace: social and political conditions

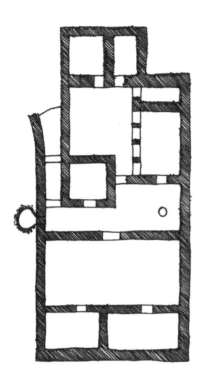

Plan of house at Dystus,
Euboea c.2nd century BC.

had changed vastly. There was what amounted to a typical postwar slump – the adventures, courage and expeditions of the great heroic age were done with; people had to get back to the relatively dull business of reality and go on with the humdrum routine of life. But the after-effects of war are interesting in another way: they tend to bring together people who have been scattered. After the violence and damage, there is naturally a strong, communal desire to reconstruct life, and this covers culture, relationships, family patterns, and so on. People are driven, perhaps, into towns, for it is in such centres that vitality and vigour are concentrated. This certainly seems to have happened after the Homeric wars: space appears to have been very short in the city, the sizes of houses rationed and the large palace was ruled out, although it is impossible to say whether or not it survived in the country where houses were, in any case, more beautiful and spacious; they normally are – a slower life gives more time for thought and creates (in the long run) more memorable and often more influential architecture. But in the cities the architects thought in limited terms: this again is

not far removed from contemporary experiences. Common party walls, for instance, had to be used to economize on space, and the megaron – that expansive conception, that relic of better days – appears to have vanished entirely from the domestic scene.

In cities like Athens, poor houses lined narrow and tortuous streets in spite of luxurious public buildings. Some effort was made to improve the layout of streets by Hippodamus of Miletus (fifth century BC), the champion of parallel streets and rectangular intersections, and he left his mark on Piraeus, Thira and Rhodes. In an age of piracy important towns were often sited a couple of miles from the sea, with a high rock for the citadel. When wars ended, this type of fortress was often dismantled and used for sacred purposes – as at Athens – and the agora (marketplace), the prominent feature in every important Greek town, became the civic centre. Various sacred precincts provided open spaces throughout the city which, to some extent, alleviated the monotony of long rows of mean houses. Athens was a typical city, and here the private houses were mostly of only one storey, the majority consisting of a single cell, or sometimes two or three around a courtyard. But there may have been many blocks of dwellings of three or four storeys to house the slaves. In these conditions the agora took the place of the megaron (or centre of life) in the city. It was a public meeting place, it made up for the meanness of the little houses, and it substituted for the feasts and revelries which had characterized the Homeric age. Women still stayed at home while men met their friends at the agora, only returning home to eat and sleep. Tiny houses would have been impossibly claustrophobic if a man brought his friends home. But for those who could afford it houses were made so that entertaining could go on at home. And the desire for space and open air – a legacy from the Homeric age – brought private gardens into the plan. (It is known that the rich would even buy the house next door, knock it down, and turn it into a garden.)

As far as the rest of the plan went, only the Homeric court for women recurs, with another for men. Ischomachus pointed out, talking to Socrates, that the women's apartments were 'cut off by a door with a bolt from the men's apartments, so that nothing could be carried out which ought not to be'. But these houses

were for the rich, developed from plans for the poor with the addition of a second peristyle: this is what the courtyard became (a space completely surrounded by a colonnade) in luxurious houses. The normal type of house from Homeric times had two courts, one entered directly off the street, and the second (to separate the women's quarters) by a door at the far end of the main room (or megaron). But the excitement of the architecture lay in the spatial arrangement, with suspense maintained by the blank outer wall, the solid, heavy outer door and, within, the glimpses through passages like tunnels from court to court: it is possible to get an idea of what it was like in various ways – the university quadrangle is near the mark since the larger Greek houses had gardens; and in the Spanish town of Seville there are similar types of houses today with courts revealed through the open ironwork of the door. Everything about the interior of the fifth- and fourth-century BC house was simple: the furniture, vases and plates, and day-to-day tools. This simplicity continued in their heating and lighting arrangements: heating by charcoal braziers, natural light from the open courtyards. The light is so strong in Greece that all decorative details, tiles and colours shone out even when the windows under the peristyle were small, as they usually were. There was no break with tradition: it was through these courtyards that the light entered, filtering through to the back of rooms.

In the third and second centuries BC the development of houses and palaces continued along the same lines. There was the usual entrance hall to the inner room set at the back of the courtyard which faced the door from the street; and there was a consistent movement towards compactness: rooms were planned within a square. And this compactness grew out of the influence exerted by the Homeric palace. Thus the megaron had enlarged from the dominant element in a much larger plan to include the remaining rooms within its outline. It is logical that this should have happened in the Homeric period because it was an easier shape to defend than the old rambling type. It is also logical that it should have been continued when space in cities became short after the wars; it was economical and provided a fixed frame, the limitations of which forced a plan out. Although a similar courtyard form had existed before – in Mesopotamia, for instance – there had been a

fundamental change of attitude: the Sumerians had a largely utilitarian interest in the house and their courtyard meant little more than a method of communication between various rooms. In the Greek plan, on the other hand, there was an attempt to use space in a sophisticated way.

The Greek experience of history extended back to the Minoan civilization and further, and the Greeks were in a position to select what they wanted and to preserve it. For this reason certain characteristics are continuously developed and form part of an unbroken theme throughout centuries of Greek architecture: the megaron in particular recurs like the central figure in a drama who, as he grows older, changes his outlook with an increasing experience of life. First he is born and, although he is insignificant compared with the more mature, grown-up scene which surrounds him, he is, all the same, an individual. The first trace of the megaron appears in Crete as an incidental reference at the palace at Knossos. But at Tiryns it has assumed a more dominant role in life, commanding the main courtyard facing the entrance. Learning and civilization bring confidence and the megaron form takes over the palace itself, as one sees in Homeric times. But the final outcome of learning is wisdom, and this means a greater knowledge of reality, and so, at Nippur, the megaron returns to a position of less dominance, seeming to understand the extent of its limitations within the larger context of existence. At this point, having contributed everything of which it is capable to the structure of the house, it recognizes that the time has come for change and for its retirement from the scene, and it hands over most of its responsibilities to another form: the peristyle.

The palace at Palatitza has no megaron, only a courtyard surrounded by a colonnade, and this is reached by a long entrance hall leading in from the street; but it is in the houses of the period that continuity is most clearly seen. Priene, a town of the second century BC, had long straight streets of windowless houses which were lit entirely from within, and unobtrusive entrances opened on to a side street. In appearance it must have looked like Pompeii. This was the normal house plan of almost all the houses in Priene; an approach by a long narrow passage, presumably covered – it was like a porch, with one door set back a little from the street. At the

end of this passage, around a corner, was a courtyard: the sugges-
tion of a spiral approach recalls memories of the sequences of corners
and courts at Tiryns, again showing traces of continuity. At the palace
at Palatitza the essence of this tradition is recorded in the entrance
and approach to the peristyle, where the passage is divided into
three distinct stages. On the north side of the court in the houses
there is still the largest and most important room of the house, still
entered through an antechamber with two columns standing
between antae: the megaron has not yet made its exit and, although
reduced in status, retains the essentials of its traditional form. On
the other side there were storerooms and, facing south, a recess for
sitting in, like a loggia. This recess shows an appreciation of the
possibilities of a space off a space, which is a development of the
megaron conception of spaces leading out of each other. The interest
of this relationship, however, lies in the linking of a covered space
with an open one, and here again it is possible to see a connection
with the megaron, for this also consisted of a relationship between
two different spaces where one was closed and the other open –
but laterally, not vertically; the outer space was screened with a row
of columns, while the inner space was closed off with a door in a
wall. But the outer space was a recess which extended from the
main room into the courtyard. In this way, within a limited frame-
work, a sequence of spaces continued diagonally across the whole
house plan, unifying it by a variation of simple spatial devices: a
roof to the recess (but no wall), an open courtyard, a colonnaded
passage which made a visual connection with the porch of the
megaron, then again a recess (but now screened with columns),
finally the climax of the inner closed room. This climax was
extremely important: it was another fragment embedded in past
experience which the Greeks seemed determined to preserve in
their own setting; its ancestry, in particular, is Tiryns. This spiral
approach had a further dimension which must not be missed. There
was the feeling of suspense created by corners, but there was also
the means by which the different stages in the approach path was
prepared and established. At Priene all the spaces were carefully
anticipated. To begin with, there was the street – this must not be
forgotten. Then there was the recessed porch off the street before
the entrance door. Then, behind the door, there was the short length

of passage that was a preparation for the colonnade: the continuation of the passage in columns which in turn was a preparation for the open court. The architectural (or visual) experience was like a graph of light: light was decreased or increased by stages that were partially closed (the open-ended passage), partially open (the colonnaded passage), and open (the court, like a room without a roof). The light graph then began to reduce again, the enclosure of structure re-exerted its influence: the entrance to the main room (the megaron) was partially open (a screen of columns), and this was a preparation for the complete enclosure of the inner room. All these experiences are to be found on a much more elaborate scale – but less concisely presented – at the palace at Tiryns. There, again, was the narrow entrance passage formed by the fortifications and the palace wall, there was the propylaeum (the door) which was a preparation for the grand scale of the first large courtyard, the smaller propylaeum which anticipated the smaller interior scale of the building, and so on. Put one way, all these experiences were natural events that arose from a desire to make the transition between exterior and interior as easy as possible, and to take the abruptness out of fortification walls that had to be built for security. Put another way, the design and construction of such architectural devices as

The Propylaea at Athens, 437–432 BC. The frame.

gateways and courts reflect the equally human wish to establish a relationship between outside and inside, and to show that the huge walls behind which man shut himself away – or the central court plans of the Sumerian houses which enclosed him – were not made from choice but from some kind of fear: obviously people do not really enjoy a self-imposed prison life with bars on the windows to keep out danger – this is not their idea of life at all. In Minoan palaces there were no walls because the Cretans were free from fear, and were confident of their freedom; the pleasure they got out of life is reflected in the clear, bright colours they used and in the openness of their architecture.

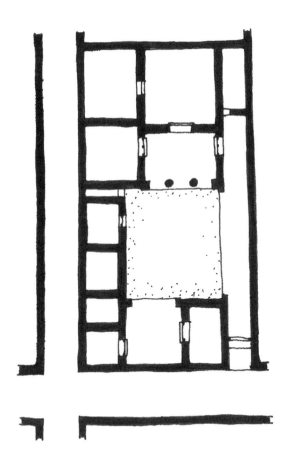

Plan of the house XXXIII at Priene, c.2nd century BC. The megaron is the focus of the courtyard.

So the Greeks, inspired in the first place by the secure, firm outline of the Homeric megaron, selected the traditional forms that suited their own special problems, such as shortage of space. But they saw a solution to this problem in compact planning methods that had evolved for entirely different reasons. Once adopted in general terms, the plan had then to be rearranged, and its parts shuffled, so that full and imaginative use could be made of the confined space within; this was now seen from an architectural point of view, and every spatial opportunity was exploited, yet with the utmost simplicity and naturalness. Thus the influences of the past were presented in a way that accepted the social conditions of the present: hence a strong similarity with forms that had gone before, but also a great individuality. There was also considerable variation in the types of plans, as houses at Priene, Delos and Pompeii show. Although Priene and Delos were contemporary, there were distinct differences between their stages of development. The normal type of house at Priene retained the megaron, and, although it was scaled down to suit the size of the whole, it continued to dominate the courtyard. At the palace at Tiryns, the megaron – although palatial in size – is noticeably proportionally smaller to the courtyard than it is at the house at Priene, where its significance was recognized as the focal element in the plan. But in some of the other plans modified versions of the megaron appear which suggest that the form was beginning to fade out of the picture.

FOUR | # The Garden

In two houses a pair of tiny megarons appear in each; neither leads into the other, both open on to the courtyard through the usual anteroom. One was for men, one for women. Once again we see that the same features appear in these small houses that were present in palaces of the Mycenaean epoch and in Troy, over 2,000 years before. In fact, this type of house was continuously in use from prehistoric times through the Homeric and classical periods up to the Hellenistic age.

But the megaron was becoming less important, and in the house at Gingenti, in Sicily, it slips into obscurity as a recess opening off the courtyard and with a hearth in the middle of it. This house was otherwise very simply planned as a double row of rooms sandwiched between two peristyles so that no passages were necessary. But at Delos, a prosperous town in the second century BC, houses were rich and luxurious. Their design was fairly uniform: all have a central court surrounded by Doric or, in one case, Ionic columns like the palaces at Nippur and Palatitza, and they were probably fluted and elliptical as before. In most of these houses the peristyle was complete. There is no megaron, just a recess (as at Gingenti) without the hearth, like the house near the sacred lake. In these wealthier houses there were separate kitchens, and heat must have been supplied when needed by portable braziers. Still, the recess occupied the usual position of the megaron: facing south and

frequently opposite the entrance to the court. A house at Delos, at the summit of the hill, had two recesses of this kind, symmetrically placed opposite each other; and this pair appeared in the atrium of the Roman plan and were known as *alae*. The courts of these houses, like those at Priene, were surrounded by various rooms and entered through a narrow passage with a door opening on to the street. The bedrooms and the kitchen all opened directly on to the courtyard and are small; but there is always one magnificent room, with a mosaic floor and elaborate decoration, opening on to the peristyle through three large doors, or by one door between two large windows. This was probably inhabited exclusively in the winter when it was too cold to sit out in the courtyard, and also in summer when guests were entertained. A characteristic of houses in all of these towns was that the courtyard was never in the middle of the informal and seemingly casual plan. Once again an experience of the past – the Minoan and Mycenaean freedom of movement – has been incorporated in a restricted space. But in some houses there was also a trace of an upper storey, although the staircases, probably made of wood, have disappeared. While it is true that the Delos house leads on from Priene, it has only one courtyard where two could be expected. These houses were rather grand and, if they had been copies of those at Priene and before, this type of elaboration would be expected. In fact they were an independent development, like the palaces at Nippur and Palatitza; they created the complete peristyle and were responsible for an important development which led to the houses at Pompeii, where the Greek and Roman plans met and the peristyle joined the atrium.

The simultaneous influence of Greece and Rome was central to the design of the Pompeii house. The mainstream classical theme is as plain as ever: the wall around the perimeter, the compact plan, the peristyle and, apparently, on the face of it, no megaron, only a large living space facing south on to the main courtyard. But, in fact, where the importance of the megaron was fading in the house at Priene, and where there was only a big room to show for it at Delos, the Pompeii house of, say, Pansa, was true megaron from start to finish. In effect, its form had gone straight back to the Homeric conception where the outline was enlarged to incorporate

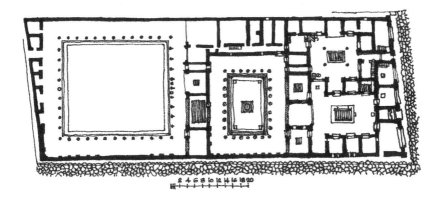

Plan of the House of the Faun, Pompeii, c.1st century BC. The combination of the Greek peristyle and Roman atrium, together with a complex plan of rooms around two ancillary courtyards created an exceptionally grand one-storey house.

the whole of the palace. Here, at Pompeii, was the long formal rectangular shape and disciplined plan, the central courtyard dividing the accommodation at the back from the accommodation at the front. The plan of the Homeric palace had been revised to suit new circumstances: a line of rooms across the middle overlooking the atrium had replaced the megaron overlooking the front courtyard. So, in this sense, the atrium could be seen as a substitute for this entrance courtyard, and the *tablinum* (the main living room), in the centre, could represent all that was left of the megaron at Priene. But the analysis does not end here; the roots of the Pompeii plan are more deeply embedded in the past than this. What we see there is not one variation on the megaron theme – this strange, economical form which so possessed the Greeks and, later, the Romans – but a number of variations: we see megarons within megarons. The truth seems to be that both Greeks and Romans had observed the architectural possibilities of the megaron while no longer being limited by its traditional context. Instead it could be used in different contexts and with different scales and plans. Its influence remained in more general terms: as a frame, an outline and a guide. Once the traditional characteristics were done away with, the way was clear to give the form other uses. So, on the one hand, the atrium was faced by the tablinum but, on the other,

83

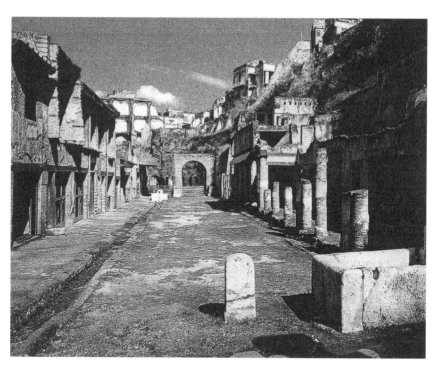

Main street, Herculaneum, c.500 BC: destroyed by Vesuvius AD 79, not so completely as Pompeii, street terrace walls remaining clearly defined.

the atrium itself was another interpretation of the megaron plan as it was first conceived in the Palace at Tiryns. There are striking resemblances between the Roman and Mycenaean forms. In the middle of the space at Pansa there was a tank for collecting water for drinking; immediately above it there was an opening in the roof with the same dimensions as those of the tank; sometimes four columns supported this opening at the corners; finally, the atrium faced on to a porch which led to the street. So there it is: the tank stood in for the traditional hearth of the megaron, the opening in the roof replaced the lantern, we know all about the origin of the four columns, and the porch was reduced from an antechamber protected by the antae; even the recess which had deposed the megaron at Delos and Gingenti was included, facing another recess on the opposite side of the atrium. And what does 'atrium' mean anyway?: the black smoke of the hearth. In other words, the hipped roof with a hole in the top, which appears on

Etruscan house urns and which suggests the extraction of smoke, had been turned inside out. The Romans did not use the hearth for cooking (the cooks had been banished to the kitchen), and heating could be supplied by portable braziers; ventilation was most important, however, and so was drinking water – water is more necessary for survival than food. Ventilation, air and sunlight produced the Greek peristyle; water, the Roman atrium. And this is the picture we see at Pompeii. It all fits: the simultaneous Greek and Roman influence – the hearth, the columns and the lantern, the peristyle and the atrium – and in the background the shadowy but huge presence of the megaron.

From the moment the Romans entered the domestic scene the house took on a more organized appearance. Symmetry was religiously enforced; the Greek irregularity went. At the house at Pansa one side of the atrium is faked to produce symmetrical effects, and, similarly, symmetry is achieved in the peristyle by a screen wall that has no functional purpose other than to make a profile identical to the one opposite. At the House of the Surgeon a direct view was maintained from front to back, and the whole plan – porch, atrium, tablinum – was arranged symmetrically to this end. This axis was always preserved while the plan was varied around it: the pattern of rooms could be changed, courtyards and terraces could be added. As long as this fundamental order was maintained any variation of plan could be attempted; order, moreover, enabled the Romans to remember where everything was: porches, courts, tablinums, garden. Their houses were like well-organized desks: all the rooms were filed away in their appropriate places, and the north–south, east–west axes which scaled down the arrangement of these rooms to quarters of the whole, reflected the *cardo* and *decumanus* of the Roman town. Immediately the house appears as an integral part of a much larger grid: everything relates.

This is illustrated at the House of the Surgeon at Pompeii. The tablinum is, as it always was, open so its full width faced the atrium, and this, like the megaron, was framed on either side with pilasters, resembling the antae. The entablature rested on the antae. This tablinum was, therefore, a flexible space because it was open: once walls are put on all sides of a space it becomes incapable of change. In a conception as free as the Roman house it was imperative that

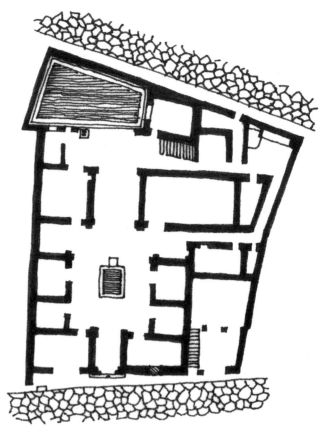

Plan of the House of the Surgeon, Pompeii, where a direct view is maintained from front to back. 4th–3rd century BC.

openness prevailed throughout. For example, the open ends of the tablinum could, on the atrium side, be curtained off on occasion while, on the garden side, it could be screened with a window, doors or shutters – there was quite a choice. The alae extended to the outer walls, and were open on to the court, emphasizing the cross-axis; but, in the matter of windows, it was the view the Romans were after. They were interested in the outside. But their house plan also had religious connotations since it was related to the master's living quarters on north–south and east–west axes in the same way that the temple plan was related to the sanctuary where the god reigned. A good example of this can be seen in the Temple of Mars at the Forum of Augustus. The same relationship

of spaces is apparent at the Surgeon's House, showing how the master felt about his position in his own home and outside it. Obviously this does not apply to the depersonalized multistorey tenement, but only to the one-family house such as the single-storey town house of Pompeii and the isolated country villa. This concept included the plan of the upper storey as well: it was possible to look out over the atrium from a continuous open colonnade, or a loggia with two columns between antae. So the openness of the ground floor was carried upstairs, often accompanied by bright colours and decorative reliefs, creating an airy framework inside the house.

One gets a vivid glimpse of the Roman house (and building operations) in a letter Cicero wrote to his brother, Quintus, who was in Britain later on, in 54 BC. Diphilus is the architect. Cicero has been inspecting the water system at one of his brother's finished houses at Arce. He says: 'At your Manilian place I found Diphilus going slow even for Diphilus. Still, he had finished everything except the baths, the cloister and the aviary. I liked the house enormously for the dignity of its paved colonnade which I only realized when I saw the whole length open and the columns polished. It will all depend on the stucco harmonizing and I will see to that. The pavement seems to be getting well laid. I did not care for some of the ceilings, and ordered them to be changed. They showed me the colonnade where you had written you wanted a porch made, but I liked it better as it is. I didn't think there was room for a porch, and it is not usual to find one in houses where there is a larger hall, nor would it be big enough to have bedrooms and suchlike apartments opening off it. As it is, with its fine vaulted ceiling, it will make an admirable summer room. If you still don't agree, write at once. In the baths I have moved the hot chamber to the other corner of the dressing room, because it was so placed that the steam pipe would be under the bedrooms. The fair-sized bedroom and the high winter room I liked greatly, since they were both spacious and in the right position, on one side of the cloister, that next to the baths. Diphilus had got the columns neither perpendicular nor opposite each other. He'll have to take them down, of course. Perhaps some day he'll learn how to use a plumb line and a measuring tape . . .'

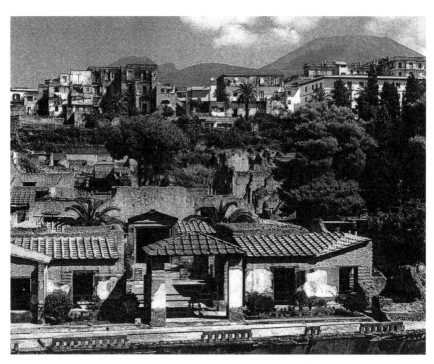

Casa dei Cervi, Herculaneum, destroyed AD 79. Gatehouse.

One feels quite sorry for Diphilus. A paragraph about a private road follows, and then the letter ends: 'I am all in favour of you carrying out the proposed additions; though as it stands the house is like a demure moralist reproving the frivolities of its neighbours. You'll enjoy having the extension. I admired the topiary work: the ivy has so mantled everything, both the foundation wall and the spaces in the colonnade, that now those Greek statues look as though they were topiary artists pointing it out for your approval. Again, the bathing place is as cool and mossy as can be . . .' One never fails to be astonished by descriptions of this kind which seem to make time past as difficult to comprehend as the idea of eternity.

In the case of the double-storey house, the tablinum was the key to the design, interlocking the two levels inside. The roof sloped towards the centre of the house in most cases, and rainwater was collected in the tank below. This roof shape meant that no water ran down the sides of the house damaging outer walls and causing inconvenience in crowded conditions. It did tend to make the

interior dark, however, especially in the upper storey where the penetration of light from the atrium was so slight that windows were introduced in the outside walls and glazed with gypsum. The Roman house must have contained some beautiful spatial effects, looking up towards the gallery and the opening in the roof with the blue sky beyond, or downwards through the colonnade to the mosaic floor around the rectangular pool of water. The sequence of different spaces on the horizontal plane must have been equally exciting. Pliny, the philosopher who did so much to save the slaves, talks about one of his villas by the sea not far from Rome: it was built circa AD 100, and, like Cicero, he puts the picture extremely well: 'If you approach the house from the east, you come first into a simple but not too modest atrium. Adjoining this are colonnades, which surround, like a big Latin 'D', a charming little courtyard. Next to the colonnades, on their centreline, comes a pleasant big room, and next to this a space for three couches, which juts out of the main body of the villa towards the shore . . . This room has double doors, or windows as big as doors, in every wall, so that you can look out, as it were, on to three different seas. Looking back at the house you see, one after the other, the big room, a colonnade, the little room, then another colonnade, the atrium, and finally the woods and distant mountains.' How superb the architectural effects sound, how clearly conceived – how one would have loved to have lived there. But many other houses were as good as the Villa Pliny; and they all seemed to possess this marvellous view through the house and out the other side.

When the Greek peristyle and the Roman atrium met at the house at Pansa, it was a beautiful combination (although never used outside Italy). The large hall of the atrium with its pool of water and somewhat dim lighting was a perfect architectural counterpart for the bright sunlight and vivid colour of the peristyle beyond: shade and heat, cool water and a hot garden alive with plants – it was the rich man's paradise. The House of the Faun was another later and even grander example at Pompeii. Here there were two atriums (and thus four alae) and two peristyles, and the symmetry of the plan was suggested by the arrangement and size of spaces, not by an actual centreline. In consequence a complex interior was created, and a gradual increasing size of spaces from the first atrium

to the large peristylar garden at the end. The shops that completed the side of the house with the entrance makes the block seem a self-contained entity, although physically unconnected with it. However, shops were often attached to larger Roman houses – and sensibly, too. It is, as we know today, important to mix up shops and houses. Shops are like meeting places scattered about among housing, and the colour of it all (the bright spots of natural colour like tomato red, banana yellow and grape green) must be remembered, too. Shops, together with windows open, shutters back, washing hung across narrow streets, corner traders, and people milling about give towns their life: miles of well-meaning rules and regulations deprive us of this life today, and the intense and vigorous detail which accompanies it. In Ostia and Rome, for example, streets were sometimes flanked with pillars with open balconies above: these were mostly of the third century AD, but some were older. As at Pompeii, houses often had balconies high up: the desire for a view of the world was a peculiarly Roman characteristic.

But, while development of this kind had been going on around the first half of the first century AD, shortage of space forced a new building form on the Romans: the multistorey block. Although this meant duller streets, the variety – an important element in the Roman scene – was maintained. The ground floor of the flats consisted, at least partly, of shops and warehouses: trading was high up on the list of Roman priorities. A maze of markets made pockets of light and air among the dense blocks of houses and flats as they wound through long, narrow courts, small inner piazzas dotted (sometimes) with fountains, behind streets and down lanes: the Romans used any gap they could find for buying and selling, or would cut off a corner to slot in an alley and fill it with shops. The street plans were equally complex; for instance, houses might be contained in two blocks, divided by a slim courtyard, which would run parallel to the road and be connected on the first floor with an arched bridge: arches added as much life to Roman architecture as anything one can think of – atriums, gardens, shops. But, like the arch, many of their ideas were taken from other people. From the Etruscans (that mysterious race that seems to have turned up from Asia in the ninth century BC) they discovered culture.

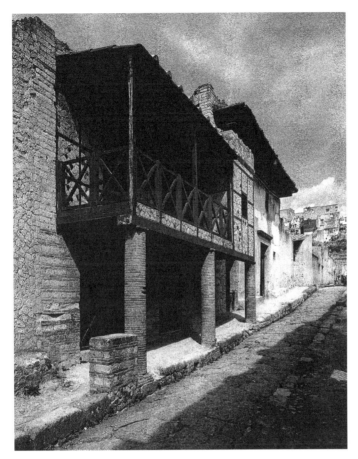

House with a balcony, Herculaneum, early 1st century AD.

They learned a vast amount from the Greeks, and their interest in gardens, which was certainly considerable, may well have come from Egypt when they took over that country from the Ptolemaic rulers. Capitals may also have been inspired by Egypt, although the Aeolic capital, which bears a strong resemblance to the papyrus bundles used in the early days, may well have provided the inspiration for Italian Etruscan architecture: the sources of such things are various, and often vague. But the Romans certainly seem to have seen the possibilities of the arch from their conquests around the Euphrates and the Tigris. The Sumerians never got much further than the vault and a patterned imprint of the arch on their decorated façades. When the Romans, however, discovered the arch, all

Roman aqueduct at Montpellier, France; early 1st century AD.

was arches. And it was here that their great contribution to architecture was really made. For the Greeks had never used the arch; nor had the Etruscans.

The Romans introduced the arch wherever a suitable structural problem suggested it. Hence the wonderful aqueducts and bridges. And in the house the semicircular, segmental or flat arch was used not only for windows and doors but also for supporting staircases. The ground floors of their multistorey apartment blocks often had vaulted ceilings. Arches were needed to hold up their high buildings. These apartments were sometimes as many as five storeys of flats (Augustus imposed the highest limit of 20 metres (65 feet) for Rome, which was later reduced to 17.5 (57) by Trajan), the plans of which were repetitive throughout. The Romans used every housing form known today, and they have a remarkably modern look. Again, like flats today, terraces of houses gained a certain anonymity from identical façades following identical floor plans and heights. Special rooms with traditional origins – the tablinum, for example – had to be omitted on account of shortage of space (again a source of trouble nowadays). While the blankness of the repetitive façades was alleviated somewhat by the large windows

(gypsum glazing), by ground-floor tunnels through blocks of building at frequent intervals, this blankness reflected the cut-price standards of the planning – all but essentials were eliminated: there were no bathrooms, no separate kitchens, no chimneys, no lavatories. Thus one can say that the Romans were not generally interested in the architecture of their buildings and put their creative energy – which was vast – into structures which had status attached to them. Large size gave them the incentive to expand imaginatively, allowed them the opportunity to spread themselves in a lavish world of decoration, materials and craftsmanship. Where the Greeks seemed content to play with variations on a limited theme, the Romans sacrificed the finer delicacies of design and precision finish for more grandiose effects. Materialism, in fact, transcended the pure art of the Greek work, always seeming to insist that they make larger conquests, in whatever area they worked. Therefore, in their houses – compare the house at Pansa with the House of the Faun – they were constantly striving to increase their territory, and the house, of course, represented the boundaries of man's kingdom. If, in the town, shortage of space forced a compact plan and a strict outline upon this kingdom, in the country one observes, perhaps, where his real desires lay – in a longing for space – and the houses there spread with a freedom and irregularity of plan that was never found in a town.

It is significant, perhaps, that the Romans made no effort to send their house product abroad: the atrium seldom turned up in Africa or the eastern provinces where the Greek peristyle plan continued to be popular, and the Babylonians carried on with their traditional methods (as indeed they still do), almost as though the Romans had never happened. Of course, they built their amphitheatres, aqueducts and roads but these were more in the causes of pleasure, progress and communication than from some ambition to impose the Roman way of life on their Empire. Instead, sensibly, they tended to accept the traditional practices of other countries, and the Roman house thus remained almost exclusively the proud property of the Romans. This, again, reflects a general attitude, like their country house. And, so far as this was concerned, there were two types, the country villa and the farmhouse – not very different, but distinguishable. In the case of the villa, this belonged to the

rich man who lived in the town. It had an urban form, but in the centre of the house was one large peristyle: the atrium was either dispensed with, or retained in a modified form; as a space of size and status, it had been relegated to a minor position in the plan. Now it was the peristyle that was the most important element, and the generally casual, straggling arrangement of rooms around it emphasized its importance. Often, too, there was a large peristylar garden, another dominant element. This is exactly what one would expect from the beginnings of a new tradition where the rich city worker sought weekend peace in the country – a highly civilized pursuit which only reappeared after the disasters of the Middle Ages, and has continued ever since. Ideas sparked off in the town – ideas about life, how best to organize it and enjoy it – were acted out at leisure in the country. Just as shortage of space meant that the multistorey apartment block must force out the individual town house, so the overcrowding caused by the rapid and dense building of apartment blocks meant that the individual was forced out too, and into the country to seek peace, quiet and space. The same thing is going on today and, then as now, only the rich had the means to achieve this much more perfect and balanced life. So it follows that the confined plan of the town house, with its squashed internal arrangements, opened out to the country air. Hence the straggling plan, hence the huge peristyle: it would be difficult to think of a better illustration of the differences between town and country life, and the significance of the two, than the plans of town and country houses.

Bound up with these, another element was introduced: the portico. There had been a tendency to emphasize the exterior with elaborate entrances of this type, as with palaces and temples of the past; for example, in the villas of Diomedes and Fannius Sinistor, near Pompeii. Then there was the continuous external colonnade which, even more than the portico, blurred the hard-edged barriers between building and landscape, making the two melt into each other by means of a gradually increasing sense of enclosure; and with both the portico and the colonnade one may discern a link with the ideas of Palladio of fifteen hundred years later, who was the first architect to consciously give building a relationship with the surrounding landscape. This might suggest that the Roman

peristyled villa had copied the Hellenistic Greek style. But this sounds unlikely since no Greek building was copied by the Romans; even Hadrian, a great admirer of Greece who filled his villa with Greek statues and vases, and named parts of it after places he had visited in Greece, did not attempt to reproduce them: like most Romans, he was a collector, not an imitator.

The consequences of the concentration of emphasis on the outside exemplified by the portico and the colonnade, and the growing consciousness of the freedom possible in the country, eventually forced the peristyle out into the open; the inner peristyle was a rare occurrence after the first century AD. The gigantic peristyle, the Piazza d'Oro, in Hadrian's villa, was really a peristylar garden: important buildings were concentrated at one end, instead of around the space. The court had gone; what replaced it was a garden that had, so to speak, been roped off from the landscape by a colonnade. The forces that had driven people inwards to

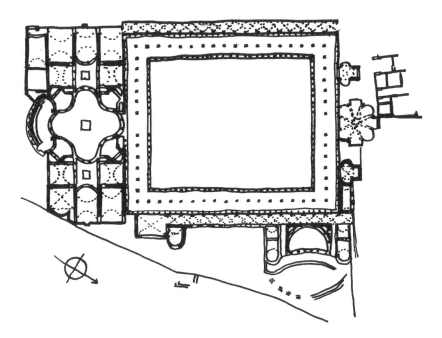

Plan of Hadrian's villa, Tivoli, 134 AD. The 'Piazza d'Oro' – the self-contained structure in the southern part of the Great Palace is a notable innovation; the peristylar garden is enormous.

hibernate in their houses did not exist in the country, and the plan of the villa was, in consequence, turned inside out. So the precious bits of light, air and sometimes garden that the peristyle rescued for people in the town was enjoyed on a very much larger scale in the country, and this made the peristyle as it was known in the town obsolete. And the recognition of the need to enjoy the outside is recorded by the changes in the plan of the house: first the atrium goes, then the internal courtyard. The farmhouse also illustrates the movement from the inside to the outside, with the peristyle court-yard pushed to the perimeter. In the first century AD some country houses had completely abandoned the idea of an inner court: a single rectangular block had a closed corridor on one side, or an open portico, either on one side or running all around the block – the 'corridor villa' forecast in Thera in Hellenistic times. Both corridor and portico types are found in Campania (destroyed by an eruption in AD 29). Both occur in Syria and are characteristic of Gaul and Britain. In Silchester, founded in the second half of the first century AD, the square insulae produced by the Roman street plan were treated as blocks of land for villas of corridor, court and portico types. What the Romans had developed to suit the country was here applied to the town. Again one is made aware of the human struggle to continue, improve and perfect; all through the history of architecture we find this pattern. A type of building evolves, is developed, and pieces are added; finally, outside circum-stances overtake it and render it obsolete, and then follows a period of renewal. This pattern shows itself in the early settlements, in the ziggurat, the pyramid, the Minoan palace and at Tiryns in Mycenae, the development of the megaron form, the tradition of the hearth, and the growing consciousness of the outside expressed by the evolution of the peristyle and the rejection of enclosure. A plan reaches a conclusion but life changes, experience increases, and greater knowledge requires different patterns to satisfy it. So the formula of the atrium and the peristyle, rejected by the increasing size of cities, goes to the country and there it is taken apart and the essentials that still apply to a new situation are extracted and put together again in a different way: peristyles merge into gardens, the columns that defined the court became, by some mysterious piece of sleight-of-hand, colonnades, and rooms re-form in another

position. And then the new article returns to the town, but in another place, another country, where there is the space to build it. In England, at Silchester, what the Romans made, based on the *cardo* and *decumanus* principle, was a bit like the garden suburb. And, somehow or other, this form held out, and recurred, centuries later. The pattern of New Haven, Connecticut, was inspired by it, taken to America by the English; and, even later, in our own century, it is difficult to completely dissociate the arrangement of a development such as Welwyn Garden City from the Roman scheme, poor though it may seem by comparison.

FIVE | The Still Centre

At this point we look east where a parallel civilization was gradually evolving in China. Knowledge about Chinese culture begins at about 1500 BC; a good deal more was known by 1300 BC.

Neolithic settlements in China probably date from the third millennium BC. The largest settlement that has been discovered was Pan-po, about eight kilometres (5 miles) to the east of Hsien-fu in the Wei valley. It was a town on the site of the famous ancient capital of Ch'ang-an and is older than Ao and Cheng-chou. It covers two hectares (5 acres), and huts were either round or oblong, built of beaten earth. Internally, wooden pillars helped support the roof, and the variations in size reveal a distinction, even then, between rich and poor. Similar houses were found at Ao which were average in size and either round, oval or a large irregular shape and probably roofed over. There were some oblong houses on raised foundations of pressed clay, and wooden pillars supported thatched roofs. Houses of the same type as these also appeared a hundred years later at Anyang. There were halls, too, at Ao (possible meeting places, shrines or temples?), with pillars along the length of their walls taking over the support of the roof from the solid structure. Raised houses were general and laid out in rectangular towns protected by ramparts, and there must have been, judging by ideograms, towers of two or more storeys, with hipped roofs. An example of this kind of town is at Cheng-tz'u-yai, in Shantung,

which measured 457 by 393 metres (1500 × 1290 feet), and belonged to the Lung-shan culture, but it may or may not be older than Ao or Anyang. But what we have to keep in mind, for the time being, is the point that the house is rectangular. This is interesting, and is directly related to the Chinese comprehension of life.

The Chinese never questioned the creation of the world or the origin of man in ancient times: they took both for granted because, from the beginning, there was no lack of either; that is to say, there was plenty of land as there were plenty of people. In fact, their civilization came into being in conditions that were opposite to the other springboards of civilization further west around the Euphrates, the Nile and the Indus; these rivers run through deserts, and habitable land on either bank was often only a narrow strip a few kilometres wide; in these situations this land was under constant threat from flooding and invasion or, on the other hand, it had to be irrigated in time of drought. Life in these places was, therefore, a perpetual struggle for the people who lived there. In China there was no threat from deserts and, except for the forests, land was limitless and without obstacles. So the numerous little agricultural communities of Chinese never suffered land hunger. But the forests were a problem: the climate in northern China up until the latter half of the second millennium BC was much warmer than it is now, probably similar to the subtropical climate of central and southern China today. And it was here, in the north, that the Chinese civilization originated, it was here that the first traces of dwellings are found. The south would have been too hot and was covered in impassable forest and undergrowth. And if the Chinese were afraid of anything, it was the forests. While they were a protection against attack, they were also a menace because they grew so fast, and the Chinese were constantly cutting them down and using them for building. It is scarcely surprising, therefore, that their houses were made of wood and that, consequently, nothing remains of them but the pottery ridge tiles. So all the knowledge about these times comes from literature and, while it is likely that the magnificence of their capital cities and palaces was exaggerated, it is clear that they were fairly remarkable. But just such a city was Hsien-yang, somewhere in the vicinity of modern Hsien-fu, which was big even by contemporary standards, its population reaching

nearly a million, and Ch'i (an important state in Shantung) had a capital city measuring 1.5 by 3 kilometres (0.9 × 1.8 miles). Finally, it is interesting to note that the first signs of culture were exhibited by painters and calligraphers, not through architecture and sculpture. And this calligraphy was in itself a parallel art to painting. It was beautifully done: each character was, in fact, a painting and was on a par with all that truly remarkable pottery that was coming out of such places as Iran and Tello in the third millennium. The likeness between the formation of their letters and the brackets that supported their roofs is most fascinating. But this is only one example: there is a list of national characteristics that are so similar and interrelated as to be inseparable.

It was in the Han dynasty (from 207 BC to AD 220) that the real step forward in the Chinese civilization took place: their culture began to radiate out as never before, following, perhaps, Alexander's conquests which had opened trade routes between East and West. Silk was the major commodity; in fact, as far as Mediterranean countries went, the desire for it resulted in a situation comparable to a gold rush. And only by Han times is it possible to get a good idea about what Chinese architecture was really like. There are no great buildings still standing above ground; but in the tombs, especially at Lo-lang, there are brick-built chambers as well as wooden ones. And the moment the Chinese learned about brick they learned to construct vaults and domes; Sham was built of overlapping bricks. But wood continued to be used far more than brick because it was capable of much greater elaboration – which the Chinese were most interested in – and so many of the possibilities of brick as a building material were neglected. Great intricacy in carving wood was possible. And so interested were the Chinese in the decorative idea that later brick buildings were squeezed into the mould of a form appropriate to timber construction, with balconies and elaborately carved capitals. Stone architecture leaned towards this kind of imitation to an even greater extent. And if this is difficult to imagine, look at Japanese modern architecture today. Reinforced concrete is the popular material now, but the constructional methods are elaborated in a way quite foreign to this medium, often a copy of forms that are natural to timber work. Thus a plastic material takes on an aesthetic of a different method

of construction and ends up with attachments that are no more than applied decoration. This fashion reached the West, whereas the Chinese fashion of the Han dynasty remained in China. But both show the same thing: a passion for timber that was on a scale as great, perhaps, as that shown for some national art like painting or calligraphy. This passion is immediately comprehensible in the case of the Japanese since, according to Shintoism, nature was as important to their way of life as, say, ancestry. In the case of the Chinese there is an equally simple explanation: they were unable to relinquish the decorative forms which were available in timber because they suited their two-dimensional view of architecture.

But from paintings it can be seen that much Han architecture has remained unaltered down to the present day; it is even more vividly portrayed by the numerous pottery models of houses and towers found in the tombs. These gifts to the dead also include stables and pleasure domes, and everything that was part of the house. Some of the house models are glazed or painted where details of construction, and even the paintings on the walls, are

Ornamental windows Lo-shon T'ang, I-ho Yhan. T'ang Dynasty AD 618–906. Shapes reflect those of nature. Photographer Peter Gresswell.

often true to life. One such model represents a tower with a court-yard and gateway. It was very grand and has four floors and a mezzanine, and lovely 'cloud roofs' overhanging all the upper storeys. Descriptions of these houses appear in their books and it is clear that the Chinese delighted in towers piled up on top from Han times onwards. In the height of summer this meant that people could enjoy a nice fresh cool breeze up there, or go there to be alone: the Chinese liked their peace and quiet and sometimes pulled up the ladder, like the fifteenth-century painter Ko Chun-chih, who used to disappear into his tower so that he could work un-disturbed by his wife and child. The paintings are very interesting on the model: near the gateway, trees are indicated by a bold line, with birds sitting about among the branches in the usual decora-tive Chinese manner. The gates themselves (the first doors) were patterned with an intricate network of curving lines, and these may well have a greater significance than might appear – they might represent the Chinese feelings about the forest as an impassable barrier. It is significant, for instance, that the paintings were on the outside of the gates, since this was the face that would confront the stranger: it was part of the Chinese conception of relationships that the residents of a house and city should start from the inside and work out, and that the stranger, from the outside, with greater difficulty, should work his way in.

There were paintings all the way up the walls to the highest roof, decorations with a great variety of diamond patterns; clearly colour and painting was a very important part of architecture in Han times, and probably long before (no examples exist): a Chinese city or a rich man's house probably looked as gay then as it does now, and, what is more, each colour had a meaning. Blue-green was the colour of vegetation and represented the elements of wood and the up-reaching tree: this was also the colour of the Blue Dragon of the east, the direction of the rising sun and, not un-reasonably, the symbol of spring. Red was the sun at its zenith and hottest, and the Red Phoenix was the symbol of the south. The White Tiger of the west represented the metallic autumn and was symbolic of weapons, war, executions and harvest. White, to take the point further, can represent peace of mind or regret at the end of a day; and the new beginning lies in the dark of the night or

the dark of winter – morning or spring, in fact. Its direction is the cold north, its colour is black, and its element is water, since water is a symbol of life held latent (as in winter) in its depths, and the colour of depth is black. The animal symbol, Hsuan-wo, is a snake coiling around a turtle; two hibernating reptiles preserved underground. So white can be death, and white is worn in mourning; black is life; both have meanings opposite to the same symbols used in the West. However, the range of colours, including those with symbolic meaning, were used freely by everyone in the early days; but later on, when populations had increased and the organization of society was more complex, rules were laid down about how colour should be used. Beijing, for instance, had rules regulating the hierarchy of colours. In an expanding society – and rapidly expanding in the case of the Chinese – rules are required to make people cooperate, and this has led to different forms of controls, functional and aesthetic, in all countries. For example, there were the zoning rules concerning the alignment and set-back of buildings in China which existed in some preindustrial towns later, and in Latin America the laws of the Indies, introduced by the Spaniards, prescribed narrow streets for shade and uniformity of façades, and orientation to encourage the circulation of air through streets.

In any understanding of the Chinese house or the planning of their cities in general, a number of themes should be considered simultaneously. With Greek architecture the position is different: it is possible to see the relationships of the parts without having to define them; or to separate the components of a Roman house and show how they came to form the particular arrangement they did, as self-contained spaces placed together. But it is not possible to separate the components of a Chinese house in this way because the existence of each was dependent upon the existence of the others. Bearing this in mind, one may choose to start with one of the more tangible aspects of their domestic design. This may be described broadly as cosmic orientation, or a method of establishing the position of a house or city in relation to the cardinal points of a compass. This is a factor which has to be considered in many different cultures, although it developed to a greater degree of complexity in China where the creation of the world and man was taken for granted; and because life there was not demanding

and time existed to think about things outside it. However, the Chinese were not alone in adopting cosmic principles. The layout of the Indian town, like that of the Chinese city, is based on the 'cosmic cross', the cardinal points representing the points of the universe; but the Indian town and its temple was intended to be symbolic of the celestial city of heaven, and this was not the intention of the Chinese. A similar symbolic form was also applied in Inca Peru, Africa (Ghana and Egypt), and the placing of Pawnee villages in relation to each other always mirrored the different diagrams of the stars. Then the Hottentots followed the circle of round huts arranged around a circular cattle ground; this form, they believed, was favoured by heaven and, since the sun moved in a semicircle, the chieftain's hut is always precisely in the spot of the rising sun, while the other huts are sited in hierarchic order in the direction of the sun's movement. A similar form again is found in European peasant cultures; for example, the Solskifts of solar villages of the Baltic countries also reproduce the daily path of the sun. Here the main street is on the north–south axis, and with houses on both sides arranged in an order beginning on the west side; and on the west side the houses are numbered from south to north, and are continued on the east side from north to south, giving a movement symbolic of the sun's movement. A similar system was applied to the fields and, although it broke down in most places (it was too rigid to be practicable), it is still found in Sweden, Finland, Denmark and Yorkshire.

In China, spatial orientation goes back to the earliest times, and windows of Neolithic pit dwellings from Pan-po in Shensi to Anyang in Honan all face south. This makes good sense in the northern hemisphere: houses faced the sun, and light. Tombs, on the other hand, were orientated in various directions, usually north, and this shows how sensible Neolithic people were to consider the comfort of the living. Yet it also exhibits a perfectly natural human reaction to the elements; with the walls of the house as a shade against the cold, people turn instinctively – like plants and trees – towards a source of warmth. But everywhere orientation is governed by cultural or religious reasons rather than material ones. In China, however, the feng shui system was sometimes related to comfort, yet even so comfort would have to give way if it conflicted with

religious ideas. And these were a powerful influence: cosmic principles lay behind many architectures and inspired their shape, although certainly the architectural possibilities of this application of cosmic principles was most highly developed in China. They accounted for rectangular design; the great variety of house forms within a single village; many layouts of these villages, each different, each related to the natural phenomena believed to occur in nature; and, finally, in cities, a more rationalized version of the same approach.

The rectangular house form evolved as a direct result of its relationship to the cardinal points of the compass, not from the shape of the mud brick of the Near East. Thus there are sides which face north and south, east and west, from the beginning: in the design of the later Han dynasty tiles, the world of man is clearly marked off from the unknown on all four sides by symbols in animal form; these, and the earth on which man stands, are known as the five elements. But the Chinese man has no knowledge of the extent of the universe; all he does know is that he exists in it, and thus places himself in what he imagines to be the middle of it. There were hundreds of tile and brick designs showing this plan for life represented by the house or the city. In India, however, the plan was different: here it was imagined that some kind of invisible magic pillar separated heaven and earth, and the universe of India revolved around this as the cosmic axis. In China the universe is a cube and the tile designs were plans of it; and if there is a central pillar it is more abstract and is associated with the line of memory connected with time and ancestral worship. The rectangular plan was an unnatural form (as far as nature is concerned) and was applied, regardless of topography, to everything – houses, tombs, palaces and classical city plans. Thus, from start to finish, an intellectual order was imposed upon the land.

All the roofs in China were tiled (usually dragon-blue in colour) and all houses were built of the same material. Yet in a single village, where houses enclosed courtyards, the influence of cosmic orientation produced very different forms: E-shaped, D-shaped, oval, round and rectangular, to pick a few types at random. This variety has its basis in superstition and chance: it could be said that every form was a gamble. Success in life (and Cantonese peasants are

supposed to be particularly inclined to this view) is dependent upon no liberties being taken with the rules concerning the relationship and orientation of settlements and houses to the supernatural forces embodied in the environment; these lucky forces have to be tapped for good fortune. The roof forms depend upon the juxtaposition of the building to these forces, and the setting-out process is much more precise than the interpretation of a structural steel diagram, and is the responsibility of experts. This delicate business of divining the forces – which are all around us in the air like mysterious breezes – have to be contacted with human radar, and complex natural traps are set (like the special planting of trees) to enmesh them, and building may very well have to wait until these trees are tall enough to make this operation possible. This careful planning continued inside the house, affecting the arrangement of rooms and even the position of each piece of furniture. But while the Chinese experts were trying by every means to net good luck they were, at the same time, trying to ward off penetration by the evil spirits which were thought to approach in straight lines. Hence the many barriers that were set up: the humped bridge that we know from their paintings, curving paths, asymmetrically placed entrances and inner screens. It was also important that the entrances did not face in directions which were thought to be unlucky, and these precautions are still as carefully followed today in the more prosaic regulations for the protection of health. As late as the 1930s houses planned by diviners used these rules, codified in special diagrams with twenty-four cardinal points which gave good and bad directions, separated by as little as seven or eight degrees. Problems raised by topography were completely overruled in such circumstances. According to Dr J. M. Potter, 'This system is still in use in Hong Kong today, where I have seen it applied to a new office building in 1965.' Like a number of things, this system of relationships of the Chinese was copied and used in Japan. As a result, superb views might be faced by a lavatory, because an entrance, kitchen or lavatory must never be placed on a north-east–south-west axis. The lavatory, in particular, was regarded by both Chinese and Japanese as a sacred place of contemplation. But then, the whole house was regarded as sacred, and the north-west corner in particular.

Thus the Chinese preoccupation with these relationships led to an attitude towards architecture where spatial achievements transcended structural methods. The greatest concern was with man's position: this was defined originally as in the centre, and the enclosed space, demarcated by the cardinal points in the first place, had to be organized around him. The ideas with this end in view could not arise from an engineering source, or from the discovery of new materials, but only from an idealized understanding of the relationships between man and society. The arrangement of spaces in the house, and from house to house, form diagrams of these relationships. And the city is a dramatization of the relationships worked out in principle on a small scale within the house. The Chinese were also concerned with planned movement in the architectural context. In order to achieve this, the house was conceived as a stage and the structure as mere props. This approach to design does not encourage permanence in building. Height, enclosure and the relationship between structures were used to support a climax which could be a particular occasion or ceremony. So when a new need arose palaces and temples were frequently dismantled and the parts put together for some other purpose, sometimes in a faraway place. It is hardly surprising that the temporary structures and perishable materials of wood and earth became a Chinese tradition. But both ancient Chinese and ancient Indian artists had this ability to explore relationships, and, in doing this, both translated volume into two-dimensional design. A sense of time passing linked these flat scenes in all directions and various subtle, new arrangements were revealed. This planned world of man and the unplanned and unknown world became geometrically related, and human beings involved themselves in the spaces formed by rituals or ceremonies. From beginning to end, their architecture reveals a fascination with the spatial experience. Thus the image of the stage falls into place, with movement among the scenes guided by an invisible director.

Every part of this spatial experience which forms the environment of the planned world is explored. The properties of the wall had to be thought about, the height of platforms, placing of individual buildings and the organization of the compound. And while the structure was regarded as of secondary importance to all these arrangements its existence was, of course, crucial to their success.

The Chinese failed to recognize the drawbacks of their timber structures and used them merely for their own ends – and these ends were the realization of planned space around man. This was the beginning of an attitude to architecture concerned with space, and assisted by structure. The Japanese took this comprehension further: in copying the Chinese principle they recognized that structure could have a more active part in the regulation and ordering of space – and in consequence introduced a strict structural module. It was because the Japanese gave structure proper recognition in the architectural network that their buildings had a far greater flexibility than had the Chinese, but then they put structure to work, and attached the legs to the brackets; in effect, they made the legs walk. The Chinese simply were not interested in structure; they were constantly in an experimental stage, and their subject was space; any really serious consideration of more solid forms would have proved to be an obstacle to their refinement of this area of architecture. For instance, their earliest knowledge of the construction of the arch never led to a masonry tradition; such a slow process would have conflicted with the nature of their spatial conceptions. In contrast, the underground construction of tombs used sophisticated arches to form a system of subterranean chambers. This technique was also used for bridges, but never for houses, or even palaces or halls: it remained outside the *t'u-mu* (temporary) system of superstructure. On the other hand, such solid and immovable building methods suited the position of the dead: the Han imperial tombs are monumental stepped pyramids of stone and, although their form is reminiscent of the hill terraces of which the Chinese are so fond, it also recalls, unmistakably, the shape of the ziggurat and the tomb in Mesopotamia. The pagoda resembles the ziggurat as well, and the traditional Norwegian church form of circa AD 1000 was not unlike the pagoda, and many of its decorations had a distinctly Chinese character. This suggests that the sources which inspired various forms were diverse; but also that the forms reflected similarities of a race, for Laplanders have certain physical likenesses to Orientals. Both India and China were open geographically to the nomadic lands of their north-west frontiers (if frontiers existed) and the mobile tribesmen of these regions were for centuries the carriers of inventions, institutions and ideas.

Nor should it be forgotten, in this context, that the north-west corner of the Chinese house was the most sacred, and this could be by association with the direction of new knowledge from far away in the 'Unknown'; it was, perhaps, for this reason that the corner came to be thought of as 'lucky'.

In the wooden construction of buildings there was, however, a fundamental difference between the East and the West. In the West, the top of the wall meets the underside of the roof, which it supports. In the East there is a gap between the top of the wall and the underside of the roof; the wall does not act as a support. Instead, it acts as a screen, and the Chinese were able to use it as they wished, and consequently the wall could take part in the manipulation of space, and no practical obstacles prevented it from doing this. But because these delicately constructed houses have collapsed over time the only records of the evolution of this structural form (*tou-kung*) exists in Buddhist monuments – preserved because of their religious meaning, better upkeep and safer situations. But this manipulation of space and the freeing of the wall to assist the various forms of enclosure and the needs of movement was made possible by the post-and-bracket construction, of which the graceful overhanging of the eaves was an important outcome. The repetition of similar-shaped parts, balanced on one another, also created rhythms and these became an innocuous presence in the elaborate, intricate and pervasive needlework of the building fabric. Slowly refined over time, the development of later construction consisted almost solely of the evolution of the tou-kung, which was at first primitive and functional. It goes right back at least to the Neolithic settlement at Ao in the halls in the third millennium, and possibly to India where the tradition in similar bracketing can be traced to the early civilizations of the Indus and Persia. But this method starts out as large and powerful in the ninth-century-BC hall of Fo Kuang Ssu at Wu-t'ai in Shansi, and becomes complicated and delicate at the eleventh-century pagoda of Fo-Kung Ssu at Yinghsien. In the early period of its life this bracketing system was exactly tailored to the catenary curve formed between the uplifted corner eaves over the length and width of the building. This meant that the bracketing over each bay was different, if only slightly. The structural posts varied too: their

Chinese eaves detail, traditionally adopted. These were, together with the roof, painted to prevent deterioration from weather and insects, and this led to decorative effects – yellow roofs, bright colours for windows, cool under eaves, which were tilted to throw off evil spirits.
Photographer Peter Gresswell.

diameter increased towards the centre, and the lighter corner posts sloped inwards to meet the swept-up eaves. This meant a firm and stable structure but of a temporary kind, at least when compared to stone or brick. That they could put such effort into making something which was visually stable from materials which possessed an inherent instability reflects enormous feelings of self-confidence and security. This was the great period in bracketing; it was reached in the classical T'ang dynasty – the culmination of its development. A long process – covering centuries – had gone into the refinement of this structural method, and it was not until the fifteenth century AD that it began to decline, becoming used merely as decoration. But at this time the entire character of the framework and its outline altered and became duller. The wonderful soaring curve of the eaves was exchanged for a straight edge, and the variations

that had occurred from bay to bay – each with its minute indi-
vidual differences, each with its distinct character – were ironed
out: the brackets followed suit, and the usual justifications in the
name of simplicity took from the form the original invention of
the craftsmanship and burned out the inspiration which had created
it. So the same bracketing was found repeated in each bay, each of
which was identical. The sloping posts at the end had gone – they
were upright, there were many of them, and there was no longer
any balance of forces to which they could be related. It is a story
that has a familiar ring, particularly as far as we are concerned,
bang at the start of twenty-first century materialism: once more
the demands of convenience had transcended the needs of art.

But right through the story of the house, in certain cultures,
particularly those which are both crowded and hierarchic, is the
theme of the courtyard. It goes back to Jericho and can be traced
through Mesopotamia, Egypt, the Indus, Greece, Rome, Islam, India
and Latin America. And in the very complex 'Jen' house of China
there were numerous courts. Some ways of arranging the 'house-
yard' have survived and are still found in modern buildings. Two
of the most common demonstrate the significance of the court-
yard. One type has only a few rooms connected by walls to form
a yard, and the back wall is the same as the perimeter wall. Another
type, which is also well developed and seen frequently in T'ang
dynasty murals, was freestanding buildings set within the yard with
a continuous wall around them. What seems clear is that the court-
yard theme is characteristic of places with a highly involved social
strata, and this could not have been maintained had there not been
an element of separation from the society of which it was part.
But there must be a strong link with climate as well: in hot places
we require shade and cross-ventilation as well as privacy, and it
would appear likely that climatic needs suggested a form with a
hole in the middle which was suitable for shade and ventilation,
and which could also suit privacy. Conversely, of course, a plan
which evolved for reasons of privacy would have been found to
be acceptable on the climatic plane, and therefore the evolution of
the courtyard may have been inspired from either direction, or
both, simultaneously. The Chinese house-yard complex is an illus-
tration of the two influences at work. In this case, parts of the

house took on a kind of free-form arrangement, sometimes in separate blocks according to the principles of cosmic orientation and the ordered movement of man in space. The space around the building was as important as the building itself. What we have is a succession of spaces, and preparations for these spaces, which were used to give order to man's immediate surroundings. The entrance courtyard – and this may be the only courtyard (depending upon the circumstances of the owner) – lies between the wall to the street and the eaves of the house. This wall was only a visual barrier and beyond it all the usual street sounds could be heard, wafting over with the scent of flowering trees and the buzz of voices. But when the wall is considered in conjunction with the special gateway with its pitched tiled roof, with the huge spreading eaves supported by the complex shadowy, branching network of brackets and with the darkened interior, the space between had tremendous presence as a preparation for entering the building. This courtyard form mirrored the teaching of the five elements in which the world was seen as a five-sided box open to the sky. And it would clearly be in the Chinese way of thinking that the will of heaven could only be gradually and respectfully excluded, and then just for the moment. The space under the eaves shaded the eyes and was partially enclosed. In the same way, the central room, known as the *ming* (meaning 'bright'), connects the porch and the inner *an* (or 'dark') rooms, and this is another intermediate space before the total privacy of the inner rooms, which are found to the left or right of it. The stage was therefore set for a drama in Chinese etiquette. A distinction is at once made between respect and intimacy, the guest and the owner, the longitudinal division of the house between east and west, and in the idealized plan between front and rear – in fact, as the cosmic-cross principle. The guest is persuaded to enter by the owner. The two then separate: the host takes the eastern steps on the right, while the guest turns left and takes the western steps. In climbing the steps, the guest follows the host's moves; observing the longitudinal symmetry, as the host lifts his right foot the guest lifts his left. Movement in space was planned to this precise degree and raised terraces dictate the path, and the invitation of their staircases – and the taboo of forbidden corners – are stated rigidly and finally. In cases of houses with a number of courts, however, these

rules of etiquette were waived, and the ritual began when the inner court was reached. It was questionable whether this time-consuming ritual should have been followed at every gateway since the passing of each represented a further penetration of the privacy of the owner. So the Chinese doorway was more than just an opening and its position in the wall is accentuated by its roof. The Chinese man is thus positioned on stage by his script. In ancient times he would have been educated from childhood to be in the right place at the right time, and to follow the right path – through life.

There was no façade facing your approach. Instead, the succession of courtyards and rooms through which you travelled presented a composite picture seen in the duration of your walk; the effect was not unlike the drop-scenes of a theatre stage or peep show. Thus it follows that the Chinese man organizes the space around him, piece by piece, in order to progressively organize his country and universe. It was only from an inner calm that man was able to discover and shape calm surroundings. The immediate surroundings of the house, for instance, is the block of houses with its own network of streets known as the *fang*, and the position of man's house in this fang was determined by status, as was the number of courts he could have within the house; it was a hierarchical society in the truest sense. In contrast to the seclusion that was sought in his house, it was prominence that was sought in the context of the fang. Houses with one – or only a few – courtyards opened on to side streets, while the more magnificent opened on to larger streets or straight on to main thoroughfares. The city was made up of groups of fang in which houses of all sizes were organized and, in turn, these groups were related to the street planning and the rectangular city wall which were again directly related to the cardinal points of the universe: cosmic principles, therefore, created a simple guide for a town plan. In the centre of the capital city was the largest house-yard complex, and this was occupied by the emperor, who thus dominated the walled city as he symbolically dominated the nation. The plan of the city begins in the centre. In Beijing, in the central group of ceremonial halls, known as the *San-tien*, roof shapes indicate the crossing of the axes. From this point, working outwards to the city wall, was the succession of rectangular courtyards, each working outwards to its own perimeter

wall. The Palace City is twice enclosed by city walls: first there is the wall to the Forbidden City, with its corner towers; secondly the city proper is surrounded by a high and protective wall, but the emperor dominated the entire nation and this was defined far beyond the city walls of Beijing by the Great Wall of China, outside which were the barbarians – just as the man outside your gate was a stranger. Therefore, from top to bottom, there is a complex but articulate range of house types and these developed such an organic pattern of relationships in city life that a perfect balance was created between privacy and community where neither encroached upon the other. Architecture reflects the social order: just as the city can be broken down into the basic units of the house-yard complexes, the homogeneity of Chinese society is composed of the individual families which they house. However, the regularity of the city layout in the Sui-T'ang capital of Ch'ang-an, or in Beijing, which reached the highest peak in this tradition, was by no means the rule, and had not always occurred. The development of the classical plan was a long process and gradually found its shape from material drawn from many different sources, encompassing a whole history of experiment.

The way in which the city plan has developed shows the difference between the Chinese attitude to life and that of the Indian. On the surface they appear similar because of cosmic preoccupations in the first place, and the Buddhist influence on the Chinese later. On further examination, however, the two attitudes are found to differ in almost every aspect. The Chinese were not concerned with that eternal pilgrimage from the periphery to the centre of the universe which concerns only the seeker of enlightenment; they relied on themselves as the originators of knowledge and looked to the ground rather than to heaven. In an idealized fashion, the Chinese man sees himself not fixed in the centre of this world but looking longingly beyond his walls: he starts from himself as the centre, and works out towards a clearer understanding of reality. Thus, to this end, he organizes his basic cell in order to organize the world around it. Inside his own house the Chinese regulates human relationships to achieve internal harmony – which is seen as the highest goal to be achieved on earth. As society became more complex the relationship between people had to be more

refined; the architecture accepted these changes and assisted in their further clarification by extending the vocabulary of correct human positions and their movements in space. The conclusion reached by the Chinese man in his house culminated in such a city form as the new capital Ta-hsing laid out in the Sui dynasty at the end of the sixth century AD to the south-east of the old Han capital. This shows a total superimposition of man's order on the natural

The circular garden gate leads from the rectangular house of man to the meandering life of nature, representing the circle of heaven on earth. Ts'ong Lang. Traditional T'ang. Photographer Peter Gresswell.

terrain, a scheme which was already apparent in Han palaces where a prominent feature was the high and steep terrace, often made by shaping the top of a natural hill. Later, in T'ang times, Ta-hsing grew into a great cosmopolitan city famous in many parts of the world, and it inspired Japanese copies; for instance, at Nara in AD 710, and Kyoto in AD 794.

But this is still the square world: the Chinese term for the house or the city. There was the circle, which was heaven. The square or rectangular design represents man's order and knowledge. Nature's chaos and truth are represented by circular forms. Where the square is placed inside the circle, illustrated by the plan of Ming T'ang Piyung, Sian, of the early first century AD, the space outside the square, but inside the larger circle, is called *t'ien-jen-chih-chi*, 'between heaven and man'. This was the garden. It was here that man assumed an idealized role in order to think philosophically on matters of eternity, like the poets. Often the garden was entered symbolically through a circular gate and the way led on to the irregular forms and winding paths which were deliberately planned as obstacles to slow down movement, as the grille across a circular opening in a garden wall slowed down the appreciation of a view. So, while man was trying to organize his world of straight lines and right angles, in the garden he could get a glimpse of the larger and extremely complicated order of nature which man could only understand as chaos. Its secret would only be imparted to him finally after death, but to be receptive to it when it came required a large period of study and preparation. In the garden, rules of etiquette and those concerning status could be relaxed and the organized and worldly man could unwind. The conditions laid down for garden architecture were completely different from those of the palace. While the best timber was used for the palace, the garden was constructed from bits and pieces that were left over and ingeniously used. Free of the rules in the square world, man could improvise and experiment with the design of his own garden. Again, unlike the palace, a garden was never considered finished but remained open-ended and continually in an experimental stage. As a chapel of flowers it was part way to heaven and a preparation for the eternal life; but, for the time being, it was peace on earth.

SIX | Life is One Animal

The Japanese house continued the Chinese tradition; it was not just that the architecture had obvious affinities with the structural and spatial experiments carried out on the continent – even their garden design came under the same kind of religious influence. But this is the later picture: the Japanese had their own tradition, and they started from different roots. In the Stone Age, Japan was inhabited by the Jomon people who probably came from the north and central Asian mainland via Korea. These may not have been the first people who came to the islands, but they were certainly the first to have an organized culture, and they achieved one of the highest artistic levels of any Neolithic people. By 1000 BC their dwellings at least were arranged in large groups, probably for protection, and this indicates that the existence of fairly stable communities was reached at that time. The dwellings themselves were huts constructed over shallow rectangular pits of about 0.6 to 0.9 metres (1.9 to 2.9 feet) in depth. It is not all that surprising that these people started building in a rectangular form since they were immigrants from a land where building had already developed from circular beginnings: China was a case in point. The structure over the pits showed an extraordinarily practical use of Stone Age materials insofar as it was able to withstand the high winds and earthquakes prevalent in these islands; Japan has suffered climatic instability throughout its history. From the floor of the pit, a box-frame of

posts and lintels was constructed, made of logs. Resting against the sides were supports which formed a tent-shaped structure over the frame. The whole thing was lashed together and covered with bark and grass. The ridge was thatched separately over the main body of the tent and the ends were left open to allow smoke to escape. This form was very important indeed since it established a tradition which persisted, to some degree at least, throughout the whole history of Japanese architecture. The roof shape of the Engakuji Shariden (Reliquary Hall), for example, 2,000 years later, has scarcely changed at all: the only real change in appearance is the introduction of the ground-floor structure beneath it.

A second wave of immigrants to settle in Japan were the Yayoi people, and they came via Korea too, and seem to have arrived from south-east Asian or Oceanic sources. This is probable because of the houses they built, which were high-floor, pile-supported dwellings. This form of house building recalls an interesting development in Central Europe on raised platforms which may also have existed in the Cyclades where a similar form is depicted in their house urns. This was known as the Lacustrine type of dwelling; it began to make its appearance in the Stone Age – a much earlier Stone Age than Japan's, of course – and continued throughout the Bronze and Iron Ages. From their origins in lakes on both sides of the Alps, where they flourished, they spread all over Central Europe and as far west as Ireland. A relic of this village form can be seen today at the north end of Lake Garda at Riva in Italy. Indeed, many of these settlements existed along shores of lakes, and some platforms were constructed as artificial islands. The inhabitants probably lived in tents or huts on these platforms as well as in isolated pile-dwellings. Such pile structures occurred in other places besides Italy, like Hungary, Holland and Germany, and it is possible that both round and rectangular forms for the huts were used, though naturally the rectangular was preferred since the material was wood. Herodotus describes a little village of this type on Lake Prasius, and the post and lintel construction of the platform may have been an influence on Greece on its way to Japan. Herodotus, in his description of the place, says, 'Each has his own hut, wherein he dwells, upon one of the platforms and each has also a trapdoor giving access to the lake beneath. . . . They feed

their horses and their other beasts upon fish, which abound in the lake to such a degree that a man has only to open his trapdoor and to let down a basket by rope into the water, and then wait a very short time when he draws it up quite full of them.' It was in the Yayoi high-floor dwelling of the first to fifth centuries AD that the external balcony is first seen in Japan encircling the building. It derived from the village platform circulation and became the veranda in later Japanese houses. At the same time the Yayoi people had a superior culture to that of the Jomon, which was duly absorbed, and under their influence the siting of buildings became much more closely related to the needs of farming: where groups of pit-houses had often been located on hillside ridges and other defensive positions, Yayoi settlements occurred in the lower midlands which were far more suitable for the irrigation of crops and the growing of rice.

But it is not impossible that Greece, indirectly, may have influenced Japan, since it was from China that some Greek influences (amazing as it may seem) reached Japan. In the Horyuji Temple, near Nara, decorative motifs on roofs suggest this. This is not all: in the Horyuji Chumon (middle gate to the temple) typical columns have an entasis very like that of the Greek columns of the Doric order. This could be due to the influence of architecture at Gandhara, the site of a Greek colony in Hellenic times on the north-west corner of India. But then the Romans also had their trading station for silk on the south-west edge of China and it is likely that their ideas were passed down the line. Eventually, though, entases in columns faded out. Nevertheless, the Japanese inherited proportion from the Chinese and also the straightforward use of the structural system of columns and lintel beams which may have come from Greece as well. From China certainly came the corbelling out of brackets (which had been developed on the Ganges from Indo-Persian ideas) and low roof slopes. But the outside influence which really changed the direction of Japanese architecture was, of course, Buddhism, the religious doctrine that followed hard upon the heels of the Yayoi immigrants from China and first began to exert itself in the fifth century AD. Earlier, people had held on to the simpler beliefs of the native Shintoism which maintained that gods and people, animals and everything found in nature had

the same father, and, therefore, looked after each other's interests. It was not a religion of fear of the gods but of friendship with them. In pre-Buddhist Japan there were already highly organized agricultural communities, coastal fishing villages, and district centres with clan headquarters standing out through their emphasis on defence and prestige. Settlements and shrines were situated in places with natural and remarkable qualities of atmosphere: a sense of grandeur, mystery and excitement was produced by such phenomena as waterfalls, caves, rock formations, mountain peaks or clearings in forests. Shinto was not an analytical or philosophical religion: it was a practical guide, a way of life. Its respect for nature led to a sympathy with materials which still exists. The old Shinto centres are not vast permanent monuments (as they were in the Near East) but similar in construction to the original Yayoi high-floor dwellings, and part of a life in which nothing lives and then dies, but is renewed and reborn. Similarly with the structures; they were regularly rebuilt about every twenty years, in the same form.

The development of the first domestic style in Japan was known

Dyoanji Temple garden near Kyoto, c. AD 1500. Sand raked into ripples around rocks.

Le Corbusier Centre, Zurich, Switzerland, 1967: architect Le Corbusier. The frame of steel with glass and coloured steel panels.

as Shinden-Zukuri, and occurred during the tenth to twelfth centuries AD. It was in the Late Heian period (AD 898–1185) when there was a reaction against imported culture. When the T'ang dynasty in China – much admired by the Japanese – fell, cultural missions from the islands ceased, although contact continued between merchants and priests. Cut off from events abroad, the Japanese were able to select and digest what they had learned thus far from China, and Shinden-Zukuri was the style developed by the aristocracy in their mansions. Built on an elaborate scale they consisted of a number of rectangular structures joined by long corridors, with a landscaped garden on the south side, and with a pond (or small lake) with an island in it (like the traditional pictures on their cups and saucers). The main hall, called the *shinden*, was surrounded by an open veranda (a feature never seen in China), which was a development of the balcony around the Yayoi high-floor dwelling. Various kinds of movable partitions were used to divide up the internal space, suggesting the beginnings of future

subdivisions of sliding paper screens. As yet, however, there was no built-in furniture. On the other hand, the poor people were still living in simple houses with thatched roofs. Gradually symmetry, one of the main influences from China, was less rigidly enforced and the various buildings were no longer connected by corridors but joined immediately to one another; the subdivision of rooms became more pronounced, and the style more simple and practical. And the final form of the Japanese house evolved towards the end of the fifteenth century, and many of the elements which it incorporated were discovered in the Kamakura period. Then, in the sixteenth century AD, there was a widespread increase in the practice of the tea cult. The design of tea rooms changed the face of the Shinden-Zukuri which had reached an extreme of elaboration, and under its influence the style became once more restful and spiritual. Former massive ornamental walls gave way to simple walls spread with clay or sand, natural colours imparting a feeling of peace and stillness: all contradictions had at last been reconciled. The origins of the tea cult led naturally to the space being embellished by the built-in features seen in priests' houses of the

Half-timber thatched farm building, Dorset, England, c.16th century. The frame in wood with brick infill panels.

Roof terrace, Unité d'habitation, Firminy, France, 1967: architect Le Corbusier. Random windows to the nursery school.

fourteenth century. Following the Muromachi, the Momoyama period (1568–1615) is characterized by the forceful Emperor Hideyoshi, under whose rule the opportunities of secular building were fully exploited in a new world of size and runaway magnificence, and towards the opposite extreme of reticence. The ebullience of the Momoyama was quietened down at the beginning of the Edo period (1615–1867) and achievements so far were reconciled to make a new and integrated form. After this, the evolutionary process slowed down almost to a standstill, and the movement which continued was different: forms and standards filtered down from the top social levels through the greater part of the hierarchy. Thus it became a national trait in the Japanese to conceal wealth and prestige behind a humble house front. Poverty, to their way of thinking, often comes close to a state of grace. This attitude has its origins in the Buddhist faith, which preaches the transience of life. The Japanese doesn't regard his house as an important necessity of life: it is merely a temporary home, and he thinks it superficial, or even sinful, to live a materialistic life in a splendid house. He derives inner happiness from an ethical and contented life in a simple, natural house.

Mature feeling for intimate, picturesque arrangements is revealed in some later buildings. This type of design at a relatively high stage of elaboration in the later Kuro-shoin style is described by Japanese historians as *sukiya*, meaning 'artless' buildings. Construction in the sukiya taste must *seem* simple, though its simplicity and apparent casualness may well conceal an intense creative effort – in fact, it is deceptively simple. This is demonstrated best in the tea houses, or *chasitsu*. Something of the sukiya idealism is discernible in almost every Japanese house today. Its historical foundation lies in the preferences traced from the beginnings of Japanese houses: delight in natural materials and colours; pleasure in spareness and simplicity; and an insistence on proximity to nature. What distinguishes a sukiya building from its Yamato farmhouse ancestor, or from the Shinden-Zukuri, is its extreme artfulness in creating the illusion of natural simplicity. In a sophisticated way it is a means, peculiar to the Japanese, of escape from social problems and responsibilities, revealing this other side to their violent and warlike nature (seen particularly in the character of the Samurai warrior). This is manifest in the tea house: a miniature world, isolated from everything else except its own patch of garden, often entered by a kind of symbolic renunciation on hands and knees through an uncomfortably tiny door. Inside, all is clean, compact and orderly. In the development of the tea house the psychological contradictions of the Japanese personality are brought to the surface. They had this love of power and rough magnificence; and they knew the political value of public display, turning for relief to the opposite set of experiences embodied in the tea cult and valued them the more as they were made more drastically astringent and purgative.

The Edo period was a time when buildings were standardized in general characteristics and infinitely varied in details. Except under special circumstances, all building was from the same narrow repertory of materials and equipped in the same general fashion. Continuity had been maintained in the national preference for light construction and sliding partitions that permit maximum openness. All have, in varying degrees, the contrived artlessness of the sukiya and exploit as freely as possible the potential of picturesque irregularity. The difference between the house of an aristocrat and that of an ordinary person is incomparably less than it would be, for

The tea pavilion in its garden. Plan of 'Shokintoi' at the Imperial Katsura Palace, c. AD 1500. Random landscape.

example, in eighteenth-century England. Usually it is only a better quality of standard house materials and superior workmanship which characterizes the houses of the well-to-do. Height varies least of all in Japanese housing but it is considered the most luxurious when houses are closest to the ground. A second storey is the result of necessity rather than choice.

Japanese domestic architecture has not lost its integrity in fifteen centuries and, like Chinese, gradually refined with time. There is a notable difference here between the East and the West. In Japan, the same system has been employed throughout, resulting in a national style; yet each building retains its individuality. Points of study in historical periods and cultural influences are of secondary importance in the understanding of such an architecture.

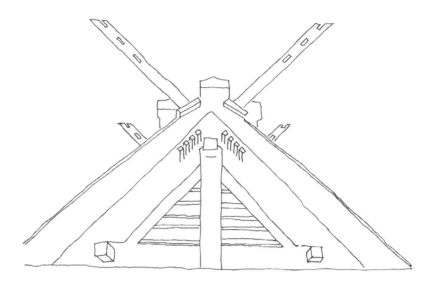

Traditional roof construction in Japan.

Examination of its principles shows how the changes that occurred in the history of the Japanese have been absorbed into the system without causing the basic changes of style that were brought about in other countries. The underlying principle which gives the house a national as well as an individual character is a pervasive sense of order; and this order is flexible, joining together the inherent patterns of form and space into an organic whole. Order implies a unifying concept which relates the complex elements of architecture. This has its beginnings in the geometrical symmetry of the early Japanese religious and official buildings, but the unique contribution of Japanese architecture is the development of an asymmetrical order. Asymmetry is a more vital order requiring human participation in the experience. It asks the mind to complete the incomplete – it leaves a gap which imagination must fill – and provides a constant source of relationships that are continually changing. Extension within the asymmetrical order gives the feeling of something that is infinitely extendable. Asymmetry is not a finality but recognizes that life is not static or capable of perfection, and that its essence is growth and change, and that it is composed of relationships. This larger order (the order that the Chinese were searching for in their gardens) requires a free structural network

that can enclose various functional requirements which make asymmetrical patterns and allow them to extend, while still relating back to the structure down to the smallest detail. Materials are valued for their natural shapes, patterns and textures. Effects are achieved by simple contrasts and relationships between these inherent qualities. This overall unity is expanded by the use of harmonies of colours and textures which originated in the generic compatibility of natural materials. Insistence on natural finish, colour and texture established the continuity of the pattern-making process from nature to architecture. A long history of primitive contact with nature developed in the Japanese a profound respect for natural forms, and it was in nature that the larger asymmetrical order was discovered. A simple, direct structure, in the first instance, was the basis for evolving forms. Here the fundamental forces involved were related to common experience, and therefore understood, and this resulted in the very close connection between construction and architectural treatment. Uprights are visible inside and outside, and play a dominant part in the decorative treatment. As skill increased – in, for example, the Ise shrine building – these multiple forces were resolved into their horizontal and vertical components, thus creating the basic rectangular geometry of post-and-beam construction. This constructional system was not arbitrarily imposed on design but structurally derived in conjunction with it. Similarly, nonstructural components were resolved into repetitive patterns.

The conjunction of contrasting materials is a vital source of expression, where one pattern-making process comes up against another. These relationships have affinities to life. Each element and material has its own clearly stated identity, yet with a sense of value greater than itself, continuing in the repetitive patterns it makes: the universal reflected in the particular. Overall order is given the added depth of expressive relationships. The strong dark column and thin white wall convey the true meaning of support and nonsupport. In later dwelling houses this expression went beyond the logical repetition of parts similar in function, beyond the mere statement of structural fact. In the creation of the whole, structure is not always honest, evident and logical. Apparently structural members are freely added for their rhythmic and decorative effect, and others, such as diagonal bracing, carefully hidden. In this way

the final intent is not laid down but is able to absorb new relationships which may be resolved structurally in the future. Time and place are only relative states in space; natural colour, texture and the firm structural module unify the various rhythms, textures and shapes into a single composition. Intricate patterns are contained between the two powerful horizontals of roof and earth, and it is to the earth that the roof is related, allowing freedom of movement beneath it. The limits of the architectural shelter are strongly emphasized by it, and its hovering dominance is the least flexible element in the whole scheme. And it is right that this should be since its position is directly related to people – and these people wanted to remain on the ground. After all, the attitude of the Japanese to space is also the outcome of a close contact with nature. And Chinese Zen Buddhism, whose doctrine held that religion could be practised anywhere, any time, independent of static places of worship, found a sympathetic form in the flexibility of Japanese architecture. This is why Zen's influence was so pronounced in their art and life; it appealed to warriors on the move, another explanation why a sophisticated religion came to be accepted by a people who had held naive beliefs of Shintoism. In Japanese art, space assumed a dominant role and its position was strengthened by two important Zen concepts. Zen affirmed the reality of immediate experience, such as a pattern made by foam on a river, which exists only for an instant, and declared that it was indivisible from

Arbour of the floating Wine-cup in Japan.

the present – which is infinite. Space was felt to be the only true essential, for only in space was movement possible; place and time were only relative states. Change could not be arrested, only guided. It is a movement through space which cannot be confined, only directed. Such vast underlying concepts as these might have been expected to produce a love of the grand, the monumental in architecture, as in European baroque. Instead it developed in the Japanese a concern for the small events of a human scale in design and a realization of the need to progressively relate these to the greater whole. The stress is on a continuity of relationships, the ordered progression of man's movement through time and space. The architecture clarifies the individual's relationship by its rhythmic extension from the near and definite to the distant and indefinable. House building in Japan has been a process of discovering how the diverse forms, colours and textures in nature have succeeded in achieving visual harmony.

Complex associations are the chief characteristics of the Japanese man's love of nature: he likes it best when it follows art. He learned

Le Corbusier Centre, Zurich, Switzerland, 1967. Architect Le Corbusier. The architect's Modulor system of proportion leads to flexibility.

from nature and, understanding it, abstracted ideas from it which he applied to his architecture, so that symbolism was the common language between himself and nature. The extent of his curiosity can be judged by his ritualistic contemplation of flowering trees, snowfall and the moon. This taste, on the whole, cost no money, and it was a collective practice rather than the exclusive preoccupation of individuals. But closely connected with Zen Buddhism and nature – indeed, the physical expression of them – was the Japanese use of space. Their way of sitting and reclining has influenced house design more than any other custom. It facilitates the economical use of space, which is the basis of its flexibility. A Japanese sits on knees and heels, directly on the matted floor: rooms may therefore be small, since no space for furniture is required, and ceilings may be low. The same room may be used for different purposes, and hospitality presents no problem since the provision of bedding had been made a simple operation. A mattress, or *futon*, which is a thickly wadded quilt, serves as a bed and is kept in a wall cupboard during the day. Mats of rushes woven over a wooden frame with further mats sewn on top, each 1.8 by 0.9 metres (5.9 by 2.9 feet) and at least 5 centimetres (2 inches) thick, form a continuous pavement throughout the house which yields slightly underfoot. A single mat represents the minimum sleeping surface for one person, but in practice the allotment is far more generous. The matting floor is kept very clean. Shoes are taken off on entering the house and the mats trodden barefoot or in special socks, while sandals are worn on the wooden floors of verandas and in other parts of the house. A Japanese does not distinguish between the aesthetically beautiful and the hygienically clean: they are considered one and the same. Out of respect he seeks to adapt himself to nature, rather than to subjugate it. As a token of this respect wood is left clean and unpainted, or painted in a delicate way which does not mar the appearance of the natural grain. Such decorative features, the picture in the *tokonoma*, and the glimpses of garden through the wooden slats and the gaps left by sliding screens, are adapted to the low-level viewpoint of the squat position. Buddhism maintains that the mind is considerably influenced by posture, and quiet mild colouring of the rooms is employed to amplify the peaceful state induced by squatting.

The layout of Japanese houses consists of three areas: a raised area spread with *tatami*, which is devoted to the living rooms; another raised area of boarded floor which includes the verandas, corridors, lavatory and usually the kitchen; and a comparatively small lower part with an unboarded floor which forms the hall, bathroom and a section of the kitchen. In general, the living space, that is, the area covered with mats, takes up half the total area of the house. The plan is based on the size of the mat; this unit of measurement applies not only to the matted area, but also to the areas with boarded and unboarded floors. The size and shape of rooms are determined by the number and arrangement of mats. Certain kinds of arrangement are customary: the size of a house or room is measured by units of surface area rather than by column spacing, since ceiling heights are standardized. Dimensions are taken from centre to centre of wooden uprights because the thickness of walls is also standardized and very thin. The flexibility of the layout lies in the many possibilities in which the various rooms can be used. None of the matted rooms has any particular exclusive purpose, and each room can at any time, and without effort, be turned over to another use. Fixed walls are reduced to a minimum, and sliding, or even completely removable, doors separate rooms so that a whole house can virtually be transformed into one big room, opening directly on to the garden.

Arrangements of rooms vary according to the size of the house. The corridor is hardly ever found in small houses, apart from the veranda, which also serves as a corridor, but is a necessity in larger houses. Living rooms normally face south or south-east since a western orientation is unbearable because of the strong afternoon sun in summer. On account of this the plan of a small house is usually rectangular, rather than square, the long sides running as far as possible in an east–west direction: a certain amount of depth is needed so that one can withdraw from the summer heat. In larger houses the preference is to arrange the rooms, connected by sliding doors, back-to-back in a north–south direction so that the principal room faces south and the anteroom north – one or the other is favoured according to the season. In the design of very large houses these rectangular groups of rooms are irregularly staggered in plan and joined at the corners; the light and ventilation of the

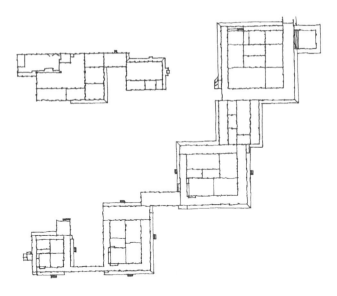

Plan of the Ninomaru Palace, Nijo Castle, Kyoto, c. AD 1500. The modular system of the tatami mat leads to flexibility.

rooms is improved in this way, and there is a closer connection between the house and the garden. The Japanese house is usually one storey which increases the contact with nature, and this form of plan has been popular for centuries. Big houses often have interior courtyards or isolated rooms linked with corridors and, in this way, it is possible to have quiet rooms in a house which is, by reason of its construction, not soundproof. The layout of a Japanese house is free and flexible: rooms are connected in a natural fashion according to function, without following any rigid pattern. It must be remembered that symmetry was customary in Japan only until about the twelfth century, whereas in Europe it has remained important for far longer, even until the present day, with neoclassical buildings.

It could be said that individual expression has been sacrificed to the thorough integration of a national style. On the surface this may appear to be true but it has had the valuable effect of directing this expression inwards to the core of the problem and has resulted in establishing the sound fundamentals of the system. Beauty has been codified – no disputes in the area of taste are permitted. This

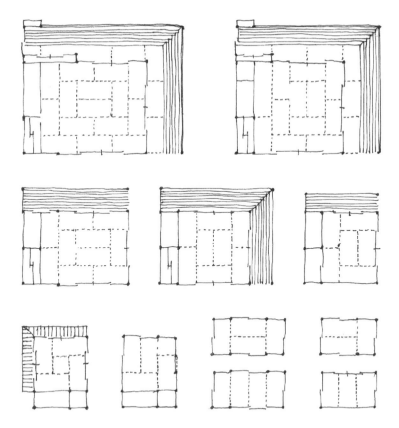

Some plan possibilities for the 6'×3' tatami mats in
the design of Japanese houses.

is not peculiar to the Japanese. Sumptuary laws regarding the standard and style of living, often down to tiny details, were a part of every old civilization. One has only to think of the Spartans – who were famous for their scantiness of dress and brevity of speech – and, more recently, of the strictness of the English Puritans. The Japanese are extraordinary, though, for having enacted sumptuary laws of a variety and a minuteness unparalleled in history. For the little man the benefits of legislated taste far outweighed its restrictions. It meant that there was no need to keep up with the Joneses. Instead, great skill and ingenuity would be employed in making the best of things within the range of commodities allowed to each caste by law. A farmer whose nutrition had to come mainly from soup became an expert at making soup. If a Japanese woman of a

certain caste was allowed to wear only a particular type of shoe she would insist on it being good. This is one of the lessons of Japanese design which we would all do well to study today, and we should also study their overall system of architecture in which everything was logically thought out and little scope is allowed for superficialities. The size and shape of all rooms in the Japanese house is standardized by the unit size of the mat. The plan is designed from a purely practical point of view, freed from all pre-conceived ideas of what its shape should be. Standardization goes down to the smaller units of all the parts used in the construction of a house. If the plan has been determined – a three- or four-mat house – the exterior and interior follow automatically. It is quickly built and therefore suitable for mass production. However, unlike the systems of mass production being used today, its stan-dardization is far from mechanical and plenty of scope is provided for individuality through the choice of timbers and dimensions, as well as paintings, flower arrangements and other things. This stan-dardization ensures that the general as well as the individual character of a Japanese house is achieved.

Rag Rug illustration of a traditional English cottage in snow, c.17th century. Artist Louisa Creed.

With such a strong tradition it would not have been over-optimistic to prophecy that modern Japanese architecture would show an exciting and authentic line of development. Again they surprise us: instead of encouraging their great heritage to persist and grow gradually they appear to have extracted its decorative effects and to have expressed them in an alien form using modern materials such as reinforced concrete and that consequently their cities, as elsewhere, are now littered with skyscrapers. But, for the rest, one thing is certain: the Japanese (and Chinese) house building bridged the gap between the time when spiritual and public building was far and away the most important architecture, and the time when secular building – in particular the places where people lived – took the lead. And the contribution of the Japanese was to demonstrate how space can be used economically with a sparing demand and cheap, natural construction. Of all the historical lessons which may be learned, the most relevant to architecture today – and housing forms the greatest part of it – is Japanese flexibility. It seems certain that only a really flexible system (but accompanied by a flexible outlook) can meet the problems of an increasingly fast-moving world.

SEVEN | Jigsaw

The next great domestic theme with a universal influence was the Georgian style. This was the style which put the Greek and Palladian principles of design to work on a huge scale. It penetrated more parts of the world than any before it and seemed to suit the conditions of every country where, like the pioneers it accompanied, it settled. It reached Ireland, Norway, America and the English colonies. It was derived from innumerable sources but the characteristic that finally transcends them all is its Englishness: from first to last it was a matter of compromise, creating what seems to have been the perfect balance between the practicalities of living and the needs of aesthetics, between the interior and exterior world.

Possibly the best way to trace the origins of Georgian architecture is by means of a triangular-force diagram: afterwards, each of the significant lines that make the diagram can be pursued in greater detail. The first is Greece: Rome takes its classical ideas from here and may be considered as central to this English style. The Romans went to England in the first century AD and built terraces of houses there. However, their influence ended when they left and their ideas were dropped, not to be picked up until much later, and their conceptions of urban planning were not completely understood until the eighteenth century. The second main influence on Georgian again emanates from Rome, and this, often referred to as the Mediterranean influence, also includes Greece. But we are

now talking about the Italian Renaissance, and the revival of Greek and Roman classicism, when principles were clarified and used by such architects as Serlio and Palladio, and it was their influence that was transferred to England and became responsible for the general outlines and proportions of Georgian architecture; in particular, of the terrace style – back to the Romans again. Between the two influences, in fact, between Roman Britain and Georgian Britain, a broken line of development then persists, if spasmodically and somewhat half-heartedly, producing the third force in the triangular diagram. This line is largely concerned with the evolution of an architecture which combined the growth of timber construction, the influence of the Norman keep and the traditional hall house. But woven into this line was another thread: the thread of memory which carried with it snatches of the Roman past, centuries away.

So the Roman influence was, in its time, fleeting, and its presence was rediscovered only through the Italian Renaissance. It was as though the Romans had come to England, set out their basic ideas for living and had then departed, leaving the English apparently none the wiser. They were unaffected by the experience because they were too backward to grasp it. Nonetheless, the Roman method had been introduced and the digestion of it took centuries; but when it was reintroduced by the Italian Renaissance, the English were far enough developed to receive it and use it, though in a much changed form because of the tradition that had grown up in the meantime. This was largely concerned with the development of frame construction, and the Italian version of the Roman style was also expressed as a frame, the concept that had absorbed it. Thus the final outcome of this metamorphosis was English in character, in the same way that the outcome of the sixteenth-century château was French. In the first place the Romans had brought over the town house and the country villa. But the important difference was between the two types of town house, as evident in Rome and Ostia, for example. The true town house was treated as a part of the street façade and not as an independent unit – like the town house which stood in its own garden. So the Roman urban scene was composed of the house in the terrace and the house in the garden, and it was the second type which spilled

into the country as ribbon development along arterial roads creating just the sort of sprawl that we see today. Both these features of the Roman architectural occupation were to reappear later in a different form: as the Georgian street façade on the one hand, and as the Georgian house in its garden on the other. This is not an unlikely explanation: the eighteenth-century form came from the Renaissance and its foundations in the Roman remains had been there all along. The memory of this civilization was kept alive in the first place by Romans, Celts and Britons intermarrying; and, in the second, by empty abandoned towns which were intact for several centuries – for example, Roman Bath and London; and they only gradually deteriorated because they were very strongly built – everything by the Romans was strongly built, including their timber-framed houses. One of the great values of architec-ture lies with the knowledge it leaves behind and the way it inspires the imagination. There is no doubt that the early Britons must have learned a great deal from having this permanent record available. It was not only the layout of the town and the house type that was to re-merge but details: the baths, for instance, the underfloor heating systems, and, perhaps most curious of all, there may be a connection between the common design in Roman mosaics and the fanlights over eighteenth-century doors which they exactly resemble. There were other clues to the trail of Roman building practices: the use of Roman brick (intermixed with flint) by the Saxons who had taken them out of leftover supplies manufactured in vast quantities during the occupation or from ruins; the cylinder-blown glass introduced by the Romans, and this may never have died out in the way that bricks did. The Saxons never made bricks themselves and the Roman brick had no direct connection with the Tudor brick, which came from Flemish and French influences – from Flemish immigrants and from English soldiers returning from wars in France. In fact, there are no records of bricks being made between the Romans' departure and the beginning of the thirteenth century. The brick was then a most important discovery and another link with the eighteenth century; it was the first step towards a form of standardization that made the frame of Georgian architecture possible. But the total absence of the brick during the Dark Ages is very curious; after all, it was widely used abroad and

goes back thousands of years. Moreover, the word 'brick' did not become common usage until the fifteenth century, before which it was referred to as a tile – another link with the Romans.

However, the Roman civilization was superimposed like an overlay on a line of development that was continuing more or less independently. This overlay, in one sense, was a bit like tracing paper: the line carried on through it, and for some time afterwards nothing changed. And before the Romans came, hundreds of years before, say in 1800 BC, Britain had already entered the Bronze Age. At least this was true in the south, although in the far north the Neolithic people were still working in stone. In Skara Brae, in the Orkneys, for instance, the little stone houses with their single large room and central hearth had an extraordinary range of built-in furniture – shelves, shelved dresser, cupboards, beds – all of stone and very like the furniture in seventeenth-century-AD farmhouses in the Lake District. But one most extraordinary find in this settle-ment – and it only occurred in one house – was a truly architec-tural attempt at constructing pillars with wide capitals which supported an architrave and framed doorways and recesses. One

Internal structure of a neolithic house at Skara Brae on the mainland of Orkney recalls the classical column and capital, together with the essence of the classical frame.

presumes that the strong likeness of these columns, capitals and lintels (in the sense that the architrave spanned a distance) to the structural forms of the Minoans was purely coincidental, but the similarities make the likeness quite remarkable. At least this shows that the Stone Age farmer required something more of a house than just a functional shelter, and this is interesting enough without comparisons with a highly organized civilization about the same date and 2,000 miles away. This type of house seemed to have had no immediate successor; it led nowhere but suggests this sleepy consciousness, this human struggle to create which persists from the beginning, from the cave, and, in particular, from the moment man left the cave. The next development, in the Iron Age, was what is called the 'long house'. This evolved in the period just prior to the Roman occupation and was found again during it, and still exists in some districts today. It had a very simple plan: a division into two rooms, a living room and a byre for cattle. It was really the crofter's cottage we know today and these are, of course, sprinkled about all over the place – in Cornwall, Wales, the Highlands, and so on. At that time the family and their animals were sheltered under one roof. Nothing is known of the long house in the Dark Ages except that it survived and was widely known in medieval Britain. In parts of Cornwall and Devon, in the north, in Wales and Ireland, this tradition outlived the changes which in southern and eastern England led to the separation of the byre and the dwelling. These primitive long houses seemed to relate to the rectangular house which emerged towards the end of the Middle Ages where the crosswalk dividing the animals' shelter from the family apartments is similar to the screened passage in the hall house. The characteristic Irish homestead also comes very close to this in its arrangement. And, before chimneys were introduced, the hearth was in the centre of the main room, completing a picture that was very similar to that of even older hall houses. However, this type did not lead to the English rectangular house which seems to have come from a mixture of forms – the medieval hall house, for instance, and the cruck-built house, with influences from the Normans who brought over the two-storey stone house.

The medieval hall house was very primitive when it became the characteristic form of dwelling of the landowner of the early Middle

Ages. It was used by the Romans during the occupation, but it was not begun by them. On Romano-British estates it became a barnlike structure which housed animals and labourers. Poor landowners lived in it with them, and their part was separated from the rest, which was a significant development. This was the plan which, elaborated, followed right through to the Tudor house. The interior of the Roman labourer's dwelling was divided into a nave and aisles by lines of timber columns, and occasionally a partition, similar to the screen of a medieval hall, ran across one end. The aisles occurred because the span was too large to manage without intermediate columns, and a large space was necessary for the different activities which went on in the one-roomed house. So its structure and form was rather like a church and probably came, via the Romans, from the basilica. Again its plan was like a memory of the Nordic house of the Vikings with its central hearth. There were doors opposite one another at the end of the hall and, in the Irish tradition, they were left open to provide a draught for the fire. At first the fire was protected from gusts of wind by short screens just inside these doors, but later on these became a continuous screen with two doors. This recalls the long house passage and, interestingly, the Greek megaron: there was the rectangular plan, the hearth, and, more particularly, there was the development of the porch which, because of the draughty screen's passage, became architecturally elaborated – they were not simply doors, they were expressed as important entrances.

So the plan of this house, as a general theme, went to Tudor. There is then the question of the advanced form of timber construction of the late fourteenth and succeeding centuries in which the frame took the main stresses and was infilled with wattling and clay daub and rendered with a coating of lime wash or plaster. Where did this come from? A similar form existed in Roman Britain but was not followed up after the Romans left. Nothing remains of it, of course. During the Dark Ages the round hut was the commonest form of dwelling and made of wood when it was available, or of stacked stones. Some of the Irish *clochans*, as these beehive huts were called, are more oval than round, a few almost rectangular, but the development from round to rectangular had nothing to do with the Romans, who never reached Ireland. The

overall shape of these stone structures was like an upturned boat, similar to its timber counterpart, the cruck-built house, and the cruck may have been used as its formwork. The construction of the cruck-built house was a frame made of two pairs of bent trees and poles or branches and this was covered with thatch. The ends were filled in with wattle and daub, with an opening left for the door. This was the form that led to the frame structure of the fourteenth century – the form which was so primitive by Roman standards that Vitruvius had already described it as obsolete before the conquest of Britain. But cruck houses were still being built in the Middle Ages, and much later, and can still occasionally be seen. It was an elementary stage in the development of the timber frame and such houses have never been found in the south-east where much more rapid progress was made, possibly because of closer contact with France and the Low Countries where the timber frame was in popular use. This probably followed the Norman Conquest, after which slowly maturing traditional methods incorporated foreign elements in their design. The entire period, however, was entirely overshadowed by ecclesiastical building, and although stone largely replaced timber in churches, the medieval house continued to be constructed of traditional mud or wood. Stone houses were extremely rare. The transition from cruck-building to box-frame or post-and-truss methods was probably first achieved by church builders who discovered that if a tie-beam, placed about halfway up the cruck, was extended outwards, vertical walls were possible. This was the first step in the evolution of the timber-built houses and timber roofs of the later Middle Ages, and was used in a number of pre-Saxon aisled halls as well as timber-framed houses. Church builders probably pushed the development of the hall house along at the same time; for instance, in churches they introduced the rood loft above the chancel screen, and later a similar loft was added above the screen's passage, becoming the minstrels' gallery, fashionable in fifteenth-century halls.

The main differences which had occurred in the interval in the life of the timber-framed house between the Norman Conquest and Henry VII was that the walls and roof of the cruck house were indivisible, while the timbers of wall and roof in the post-and-truss type of house are separated, providing for variations in

The cruck-built house – a cottage at Didbrook in Gloucestershire, England.
Far rougher than the Japanese roof construction it superficially suggests,
the form recalls farm implements used by inhabitants.

height and width as well as in length. Running parallel now with
the cruck house was the Norman keep and this represents an ambi-
tious and practical architectural advance on the vulnerable and
traditional timber-framed hall of the Saxon community. The keep
was, of course, designed for violent times, as a base for attack as
well as defence and, in comparison with it, the Saxon hall – unfor-
tified and built of relatively fragile materials – seems obsolete and
inappropriate. The Normans, on the other hand, built in masonry,
and they built high so that a watch could be kept on the country
for miles around. But, as far as the evolution of the domestic house
goes, they carried design much further than the limits of the impen-
etrable huge stone walls of, say, Castle Hedingham in Essex. Behind
the austere, still and bleak façades, with their scattered slits and tiny

holes for windows (out of which the lord and his knights peered for a whisper of danger) lay a spacious and often magnificent interior. From the confusion of animals, servants and owner squashed together in the hall and long houses, rooms were suddenly lifted on to a completely different, and much higher, plane of living. In the centre of the plan was the great hall, and this went through two storeys. At Castle Hedingham the combination of openings at the upper level and the powerful Norman arch produced tremendous spatial effects. Moreover, there were bedrooms, a grand fireplace, lavatories (of a primitive variety) and, like all Norman work, remarkably careful attention to detail was applied to the carving (in a chevron motif) and the ribs around openings. The Normans, in fact, achieved a great deal: their keeps resembled their religious buildings: they were huge objects with a sense of purpose, like their name. But it was the permanence of these places which inspired architectural advances: inside the protective walls the family were safe, and safety meant that greater attention could be given to the home (and the Normans' two-storey house was also strong), as one sees from later domestic developments when internal wars ended. But where this sense of permanence does not exist – in the temporary construction of the cruck house, for instance – people do not feel free to attend to the house, and fear instead leads to a struggle for mere survival, with everything focused towards that end. In the case of the Norman keep and house the situation was quite different. For once the limits of people's personal territory are firmly established, even when violence exists outside, they are free to live their lives more normally and peacefully. Perhaps this is why, after the wars were over, the Norman tower became fashionable as a house form for the rich: it assumed a new personality – no longer a means of defence, it was a symbol of authority and security.

At this point domestic architecture stood on the edge of the familiar Tudor house period. The timber frame structure was revived; it was a peacetime theme. The tower (popular) combined with the hall (traditional) produced an L-shaped plan over several storeys, still nostalgically in stone (an example is thirteenth-century Little Wenham Hall in Suffolk). But it was the hall and the two-storeyed Norman house which combined to produce the Tudor manor house. This was a more experimental conception than the tower

Framed timber construction. Farmhouse, Normandy, France c.16th century.

with its permanent associations and the frame rationalized it. So experimental was this conception that it started off with two separate structures – the hall and the two-storey dwelling – linked by a passage. Pushed together, they formed a T-shaped plan. And the subsequent H-shaped plan was formed by the addition of another cross-wing at the other end of the hall. Thus a direct arrangement in three parts was set down. The lord and his family occupied one two-storey wing, servants occupied the other, and the two were separated by the communal hall. Then there was the French influence which came over during the Hundred Years War. The French castle, or château, was quadrangular and usually had a moat, and this brought together the Norman keep (planned around the hall) and the manor house. This produced the H-shaped plan with the quadrangle in the middle and a moat around the whole. Oxburgh Hall in Norfolk is an example of the moated house, and Hampton Court not only had a moat but was H-shaped. And with Hampton Court the story of the Tudor style really opens. In parts it is typical Tudor, in parts not. It shows traces of Church Gothic and of the medieval hall. And it had, without doubt, a considerable influence on the style of building that followed it.

This is not at all surprising. Cardinal Wolsey, who began it in 1514, was the most powerful man in the country and one of the richest. He was in a key position to create a fashion or control the direction of taste. In the year before he became Cardinal and Lord Chancellor of England he bought the site. He began by pulling down an old manor house and then set to work. Wolsey divided his gardens into two parks with walls and fences, and then constructed a huge moat around the whole of his grounds. This moat was strange; it was, of course, the medieval castle device for protection against attack, and as a method of defence it had died out after the end of the Wars of the Roses. Wolsey's moat was, therefore, one of the last − as it was also one of the largest − to be made. The architect is unknown. Some of the detail was Italian but most of it stems from the surveyor, who was also a priest. It seems clear, however, that the plan, style and scope of the building were Wolsey's work, and the strong church influence reinforces this supposition. He was a churchman and the original lavish sprinkling of Gothic windows and detail, brick crosses in the walls (much of which no longer exists) would clearly have been designed and built on his instructions. In fact, the style of Hampton Court and other buildings connected with the Cardinal are so distinctly ecclesiastical Gothic that they have been called 'Wolsey's architecture'. But it has to be remembered that the technique of English masons was less advanced than on the Continent so that Hampton Court, like other buildings of the period, was a modified version of Renaissance that retained many features of the old English styles. The beautiful exteriors were achieved by the choice of materials selected, the red brick of a kind unknown today and only five centimetres thick (modern bricks are seven and a half centimetres thick); by the stone for the windows, doors, copings to parapets, and so on, and by the subtle harmony of style and material with nature. The fantastic plant forms of Gothic, for instance, were tamed and ordered in Tudor as they are in nature; the peach-red brick of low quadrangles framed green lawns and, in winter, the ornamental chimney stacks and octagonal turrets with their lead cupolas dissolve into the natural background like leafless trees in a wood. In Tudor architecture there was no imposition of an alien grandeur on the countryside. The style's balance was an expression of the sensitive

taste of craftsmen and of the composition of English society. Great extremes of status – financial or otherwise – did not exist: the feudal nobility were reduced and the peasantry had not yet sunk to the poverty which overtook them later in Henry VIII's reign. As far as Hampton Court was concerned, of course, there was no shortage of money. Wolsey was in charge of finance and no expense was spared in the design. And when Wolsey fell out of favour, and the king took it over, numerous wings were added in a style indistinguishable from the original.

It was constructed in a series of courts which, approached from the gatehouse, ended in a great gallery 55 metres (180 feet) long. This gallery was in fact similar to the old medieval hall and one has to go back to this form in order to understand the Hampton Court plan, and that of the Tudor house in general. The reason for the shape of the plan was plain and the H-form was typical as long as the hall was the focus of the arrangement. At each end of the long, narrow hall there was the subsidiary accommodation – such as bedrooms, service area, and so on – and this was treated in a relatively unimportant manner. The hall, therefore, dominated the composition inside as well as outside where the gables held the roof-line taut, high above the rest. So the general layout was direct and simple. On the one side there was the kitchen, buttery and servants' quarters; on the other were the private family bedrooms and sun parlour. The hall was the social centre and was used for meals and other communal activities by everyone. Then there was the gallery for minstrels at the service end and a raised platform with an oriel window in a recess opposite. Each wing had its own staircase because there was no possibility of upstairs access from one end to the other, the hall occupying the whole of the central space. Thus it was possible for the occupants to make a hasty getaway from any part of the building: every space was directly accessible to the outside. This was crucial in such dangerous times.

Up until the Wars of the Roses there had been continuous conflict in England and these people, who lived in such houses, were the first to enjoy a lull. Now that it was relatively safe it was possible to have lots of windows, and glass was available. And the window, no longer representing a weak point in the defences of a house, made a psychological contact with the outside, unlike the

purely physical one that had existed before. From now on they were designed for pleasure, were made larger and there were more of them, until Hardwick Hall was described as 'more glass than wall'. The width of the doubly-transomed lights increased very little after Henry VIII because the mullion was an integral part of the structure. Its spacing was crucial to the size of the window since it shortened the span of the lintel, and this made opening up the wall surface a possibility. A similar expression of this structural system can be seen in half-timbering; there, glass fitted in between the vertical studs and the change between window and plaster panel was so easy to manage that the architectural unity of the façade was in no way disturbed. It was a remarkable innovation, but this individuality was the special property of the timber frame, emerging more and more as time went on. It is hardly surprising that this form of structure represented a contemporary international style. Besides northern France, Holland and Belgium, where identical methods were used, very similar constructions can be found in different parts of Europe and in both the Near and Far East (in, for instance, Norway, Iran, Iraq and Japan).

As far as the hall was concerned, the Tudor architect sought to diminish its importance by increasing the size of the subsidiary accommodation at its expense; the hall became smaller. This process began in the fifteenth century and took another hundred years to complete. Since the greater area of the hall was no longer needed as a no-man's-land against attack (from brigands and others), the reduction in size, and therefore in importance, became inevitable. But the break with Rome was also a critical factor in the development of the design of the house. This created a spirit of renewal which was in sympathy with the Italian Renaissance, already a century old, and it was not unreasonable that this was a strong influence. The Vitruvian principle on which Italian architecture of the time was based was symmetrical order: this was adopted as the most obvious characteristic of the composition. As long as the great hall was retained, its huge windows had to be counterbalanced even though these did not express the interior. Here was a conflict, and the elevation became an architectural trick. Different levels, for instance, were suppressed behind one large window which suggested a single large room of a single height, and this recalls similar tricks

with glazing today when a wall of glass will, for the sake of elevational simplicity, cover over a number of different floors. The main entrance had to be in the centre for the same reason: before it had been placed at one end of the hall, and this meant that the hall could not be in the middle of the group, it could only occupy one side of the elevation. So the subsidiary rooms at one side of the hall and occupying the other half of the elevation were, in spite of their difference in size, height and character, given the same extent of window. Thus the symmetry was accomplished.

The medieval plan was rambling; pieces had been added, irrespective of the total form, as and when required. When one compares this kind of plan with those of the Tudor period it seems as though the later architects had taken a long look at what their predecessors had done, and at what they had inherited, seen what was wrong, juggled with the parts, and had put them all together again as a simple object. For instance, there is the treatment of the gables. Originally, this device was borrowed from the gable end, then repeated around the sides to bring light into the attic, like a dormer on a large scale that was continued up from the wall instead of being set into the pitch of the roof. The visual possibilities of this are plain, and it is no wonder that it caught on: architecturally, it is neat and strong and makes a continuous top. It was an early form of standardization of the kind that one finds in Japanese architecture of a similar period in time, and recalls the repetition which the Japanese used and which is to be seen in nature – that is to say, leaves on a tree and blades of grass: the gables were like a range of hills. The process of selection and grouping goes on down to the last detail in both the Far East and Tudor England. This is a human instinct: vast numbers of variables are broken down to produce a fewer number of elements and greater visual economy, which make for easier comprehension. This is the secret of good architecture, and, as Palladio would say, 'as with all the other arts'. In the same way that medieval architects added on to their houses so the Tudor architects, having simplified the composition, added embellishments to be simplified in turn by later architects (see Inigo Jones). And, so far as the gable was concerned, its details were imported from the Continent. Eventually, therefore, because it was a major architectural element, the gable was seized upon by

decorative designers, its simple outline was broken by curves, angles and scrolls and additional finishes after the fashion of the Low Countries (where all this was common practice), and so transformed into a fussy, facile and unreal association of ideas rather than a functional composition.

So what is the general picture of living that the Tudor period conveys? There was Hampton Court, but there was also a new, rich style. There was the framework borrowed from the church and the mullions substituted for the arch to support the stonework above – see Hardwick Hall, Tom Quad at Christ Church in Oxford, Horsham Hall, Great Cressingham Manor – in fact, anywhere where building material was heavy. There is a suggestion of Flemish pattern-making applied to the beautiful thin red bricks of upper storeys and the expression of each flue of the chimney that became the signature of Tudor architecture. The cluster of chimneys, for instance, at Thornbury Castle and the delicate tracery that decorates the individual flues leads up to brick copings that have been shaped to suggest a crown. Everywhere there is evidence of simple architectural forms being reinforced by exacting detail and strong colour: black and white paint, orangy brickwork and dark-red roofs. But possibly the outstanding characteristic which consistently reappears throughout the period is the strong vertical element reminiscent of perpendicular architecture, with its soaring aspirations to heaven. The constant emphasis on towers, chimneys and turrets was exploited to a powerful architectural end. It was a remarkable and highly original period of English architecture; but, with the enlarging scale of civilization and, in particular, the increasingly urban character of towns, a more permanent, efficient and less complex style was required to meet the new problems of life in cities. Tudor was a country house, rural and rather leisurely kind of architecture, which played about with the more elementary aspects of construction and living. It would not, for example, have stood up to the test of any fire regulation – however primitive – in high-density situations. So a replacement obviously had to be found and this, in the end, was Palladianism, followed by the Georgian style.

While all this was going on, the medieval H-plan was becoming more compact and rectangular in shape, and the space occupied

Village group huddled in the shadow of Vézelay's cathedral, France
c.11th century.

Cottages at Bryant's Puddle, Dorset, England, buried under a hillside of
thatch. c.17th century.

by the double-height hall of the old days assisted in this. But again,
while all this was going on – wood construction was reaching a
perfection of detail in ceilings and windows and doors of cabinet-
making (houses were as immaculate as furniture) – events were
moving fast in France. It is a fact that England has a way of being

The *Ark Royal*: Lord Howard of Effingham's flagship against the Spanish Armada, 1588, in which stern detail is an adaptation of the Tudor house with classical echoes in columns and capitals.

Lavenham Guildhall, Suffolk, England, corner detail.

held up by the Channel, but this has not always proved to be a bad thing because it has meant that the country has had the opportunity to select ideas that are well advanced elsewhere, and is not tempted to pounce on half-baked ideas in early stages of development; and there is also a greater range of possibilities to choose from. This happened in the case of the Italian Renaissance; and Japan, also an island on the edge of a huge continent, took its time about following China as well. The Italian influence only reached England in force at least 200 years after the Renaissance had begun, but the date often mentioned as a starting point, 1402 – the date of Ghiberti's winning competition design for some doors – is a little arbitrary.

The real beginning of the Renaissance lay in a growing consciousness of the classical past and it was Petrarch who really stirred interest in Italy's Roman background. He was recognized as a great poet when he was young, and in the 1330s he began writing in Latin. That he did so is not surprising: he loathed his own time, which he regarded as narrow, bigoted, cruel and full of political and religious cynicism. He was particularly critical of the

Lighthouse keeper's lodge at Cromarty at Ross and Cromarty, Scotland, 1846. Recalls the ancient Greek house and colonnade.

popes and was determined to discover the truth through first-hand experience, and thus to know himself. This meant a rejection of contemporary dogmas and starting from the beginning, from first principles. So he went back to the Bible, the Roman classics, Plato, Latin and to the countryside and nature for his source of knowledge and inspiration; he loved the flowers, the clouds and the mountains. Medieval architecture, which he disliked and ignored, represented for him a hideous and warlike present, oppression by the Church, and the humanist movement that he founded was as central to his faith in freedom and man as it was opposed to authority. This movement grew in influence; its following grew – it is extraordinary how often in history the desperate human needs of a civilization can manifest themselves in the genius of one man, and how one man's insight can change a world: Le Corbusier is a twentieth-century parallel to Petrarch. In the fifteenth century, the Western world was focused on Italy; it was never the same after Petrarch. For instance, Latin had to be learned for his poetry to be read. Then the humanist movement spread: a group of scholars brought back Greek manuscripts from Constantinople in 1393, Ghiberti won his competition, and Brunelleschi designed the dome of the Cathedral of Santa Maria del Fiore – the Renaissance had arrived. But if it took 200 years for word to reach England, it still took a century before the wonderful things happening across the Alps really penetrated into France – the Alps were a barrier almost as powerful as the Channel. True, Petrarch had lived for a time in the Provençal mountains near Avignon, the humanists were already established in Paris, and artists and writers had their contacts in Italy, but, all the same, communications were appallingly bad (the Romans would have got the message through in a tenth of the time, probably in much less). And, as so often, the most immediate and sweeping discoveries were made as a result of war. But if it was treasure Charles VIII was after in his campaign of 1495 (more specifically, it was Naples), he got it: an invasion by armies (it was Charles, *not* the barbarians, who destroyed ancient Rome) was returned with an invasion of taste – not new styles of architecture and painting – no, at first it was Italian *taste* that the French found so seductive. They were particularly enchanted with the northern taste of Milan because it was flamboyant, like their own Gothic

work, and the underlying classical principles which heroes like Brunelleschi and Michelangelo had slaved for, and upon which the Renaissance was so firmly based, completely escaped them. Like the Syrians thousands of years before who had copied wooden structures in their frescoes, it was the outward appearances that the French settled for, the style. They wanted to imitate the Italian way of life: their gardens, dress, society, manners. And the Italians themselves were lured over: craftsmen, architects, painters, sculptors – even Leonardo came for a vast bribe of gold and the gift of a palace from Francis I. And these rewards were significant. The truth was that the campaign of Charles VIII, and those of Louis XII and Francis that followed it, created such havoc and poverty over the decades that the art movement central to the Renaissance shifted from Italy to France and the West – to the Low Countries and eventually to England – anywhere, in fact, that offered peace and financially better conditions. No Italian artist could resist the temptation, and few, with the notable exception of Michelangelo, did: and not unreasonably – France had the money, and the rewards for the immigrants were considerable. Some settled in Tours – the new capital of the recently centralized nation – and their influence spread rapidly to all parts of the country. The châteaux, and the rich, were the first to benefit, of course. Blois, for example, which had been begun by Louis XII in the native flamboyant Gothic manner, had had a dose of Italian pilasters by the time Francis I finished with it. He was by far the most artistic of these three kings. An energetic sponsor of Italian culture, he went so far as to form a court of an intelligentsia that would rival the Italians. He built the château at Chambord and commissioned the Italian architect, Bernabei Domenico da Cortona, to design it, and the full effect of Renaissance mannerism hit Fontainebleau between 1530 and 1540, while Francis was still in charge. So what had begun with a few foreign affectations – an Italianate door in a medieval tower, a relief over a window, frescoes, and a Genoese fountain and gardens at the château in Gaillon – began to take a deeper, stronger hold on French architecture. A double-height loggia from the Vatican was introduced at Blois, and the châteaux at Bury, Chenonceau and Azay-le-Rideau adopted a new regularity of plan. Chenonceau was absolutely symmetrical, and like Azay (which had

symmetrical façades), dropped the corner tower in favour of the turret. All three used pilasters (purely as decoration) and horizontal string courses. Finally, the battle of taste was won at Ancy-le-Franc, the château designed by the great Italian and humanist architectural thinker Sebastiano Serlio, who built little but had a considerable influence on Palladio in the early days.

Indeed, it was really Serlio and Palladio, between them, who had the most permanent effect on the French way of thinking, and it was Serlio's books, and Palladio's books and buildings, that were chiefly responsible. Serlio's writings on architecture were best-sellers in most European languages, and Palladio's *I Quattro libri dell'architettura* formed the basis of French theory and style in the seventeenth century.

EIGHT | Positive Negative

Palladio's work formed the basis of English theory and style in the eighteenth century as well. Thus his influence was enormous; it eventually reached America and Russia. For this reason alone a close look must be taken at Andrea Palladio. There are his well-known houses and palaces; the villas Pisani, Capra, Foscani and Poina, and the Palazzo Chiericati, and these should be examined in some detail; there is his book which explains his method; and there are the numerous much smaller villas and farmhouses (many of which are now crumbling away because of neglect) that he designed around the Brenta – all inspired productions but scarcely known at all.

What special quality did this architect possess that his influence reached England and was then carried across the Atlantic? One feels that there should be a clue in his face, in the dynamic head, beautiful features and passionate stare. But the answer to the question is given quite simply in his buildings and writings. Like Petrarch, he went back to the Romans and thus to Greek principles. Petrarch learned the language, Palladio studied the buildings, and his research was done with great care over a long period. This was no easy matter in those days – Montaigne, for example, says in his *Journals* that it was 'dangerous to walk abroad [in Rome] at night' – and Palladio did not give up until he died. It was on this research that Palladio based his architecture. He fully understood

the principles which governed the planning, proportion and scale of the classical tradition, and he then put these principles to work in the context of newly discovered knowledge and prevailing social conditions. In other words, he extracted the material from the past which still applied to the present and rejected material that no longer applied: he took the essence but not the bulk. For instance, the military disciplines which counted for so much in Roman times were obsolete, but the architectural disciplines remained the same, as people remain the same. And once the military influence was subtracted the scale of building immediately contracted. So Palladio's genius lay in his ability to observe the line of continuity which linked him to the past and future. And thus, from the beginning, he reduced the grandeur of Roman conceptions to a human scale; and thus, again from the beginning, these conceptions were given a range of a universal kind, or at least one that could be seen to be capable of adaptation to universal domestic needs. In this way it is possible to see the link between Palladio and what followed after.

Then again Palladio saw buildings as a whole and not as pieces

Palazzo Chiericati, Vicenza, Italy: architect Andrea Palladio, 1550. The portico from the inside.

of a Roman vocabulary; not, in fact, as a portico, a single façade and a pediment where each was separate. What Palladio saw – and so, for that matter, did many of his contemporaries and followers – was more than a sum of parts; he saw what could be made out of the parts. And this was a step towards seeing buildings not as isolated objects but in relation to one another and as parts of cities. He saw how one interior space affected another interior space, and how, outside, a building affected an exterior space. So in this new consciousness of the meaning of architecture we see a microcosm of the Renaissance when life and culture were seen as a whole; when a knowledge of one subject or area of experience led to a greater knowledge of others; where painting affected, or could be seen to be a part of, the evolution of architectural thought; and when, through the exchange of ideas, it seemed a natural progression of events for Leonardo, for instance, to have worked as a painter and scientist and to have practised architecture, and for a sculptor and mathematician like Michelangelo to have done likewise. The discovery of perspective was central to this new visual consciousness (it became possible to order objects in three dimensions), and indeed the idea of perspective could be seen to have had the most extraordinary number of ramifications affecting even historical theories: Vico's, who anticipated the Hegelian movement of a century later. According to their philosophies, no walls should be allowed to form between different areas of life: to progress meant the exploitation of one for the benefit of others; as Aristotle said, 'You should play a flute but not too well'. According to the architects, the same truths held good: Wren was an engineer, a physicist, a scientist and a professor of astronomy before he designed the Sheldonian in Oxford; Inigo Jones was a stage designer as well as an architect – experience in one area assisted fulfilment in another. And in much the same way, Locke cannot be separated from Newton, and Newton from Bach, and Bach from the eighteenth-century English architectural rationale if a true mental picture of this age is to be gained; there are links between them all. And the development of this consciousness of relationships, which began with the Renaissance, can be traced right through to the present when, in architecture, all the doors were finally flung open by Frank Lloyd Wright and Le Corbusier.

Following from this, however, Palladio also perceived the relationship between nature and architecture. As Petrarch linked human freedom with an understanding of nature so Palladio linked buildings with the countryside. And this, in turn, was a step towards the architectural realization of the relationships that exist between interior and exterior spaces. Looked at in detail, Palladio's buildings are consistent in reaffirming his concern that internal and external links should be made architecturally evident: the connection between the two had to be expressed, and differences involving questions to do with scale resolved. For these purposes he used the portico. The Villa Capra is probably the best example, although porticoes of some form or another appear throughout his work; as Palladio said, they 'add very much to the Grandeur and Magnificence of the work'. But the Villa Capra was sited at the top of a hill, with beautiful views in all directions. Thus the house was designed to take advantage of this view from four main positions, and, this done, a relationship between outside and inside was firmly established. The plan then expressed the relationship: it was a cross, the traditional Western church form and a favourite of Palladio's. Each façade of the cross was given a portico; because of the unique setting, and because each view was equally important, each façade was given equal status. Each portico had steps leading straight up to it and the spirit of the conception was carried inside: four staircases pegged out the extent of the large central space, which was then crowned with a flat dome. So the porticoes did a number of jobs. They drew attention to the four entrances: 'In all the Villas and also in some of the City houses,' Palladio says in his book, 'I have put a Frontspiece on the forward Façade where the principal Doors are because such Frontspieces show the Entrance to the house.' Then the terraces gave an all-round view, thus firmly establishing the position of the onlooker in relation to his setting. Thirdly, the porticoes, when approached from the outside, made a preparation for the smaller space within (and, conversely, approached from the opposite direction, they performed the function of releasing the interior space slowly, by stages, into the outside). And, once in the centre of the house, the large main room recalled, and made an architectural balance with, a mental picture of the spaciousness of the countryside.

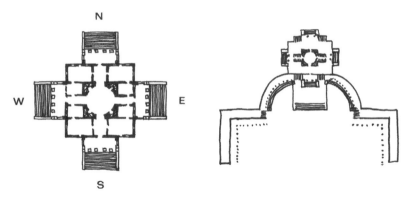

Left: plan of the Villa Capra, Vicenza, Italy: architect Andrea Palladio, 1560. The perfect architectural conception: crowning its hilltop, itself appearing part of the hill, the four porticoes facing the cardinal points of the compass. *Right:* Villa Trissino, Vincenza, is a development of the Villa Capra, attributed to Palladio, but not supervised by him. c. 1560. Where Capra crowns the hill, Trissino embraces the countryside.

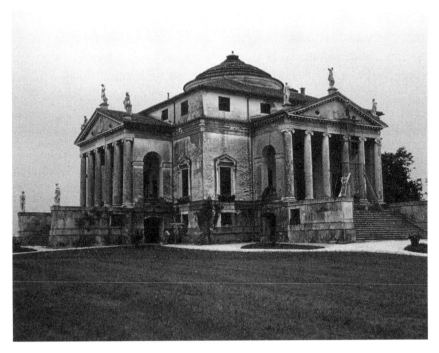

The Villa Capra: like a dense copse, the porticoes of columns reach upwards and outwards.

Thus the outside entered the interior: the relationship was established finally on all planes, and all parts of the building were closely related architecturally to achieve this end. This is what Palladio saw could be made out of the parts and why the Villa Capra is more than a sum of these parts. Look at the outside for final confirmation. Assembled on the top of the hill are the four flights of steps, the four terraces, the four porticoes and pediments, the four entrances, and the four façades of the cross; together they crown the summit of the hill and are themselves crowned with a dome. Seen from down the slope the building slides back in planes, like playing cards, so that it appears to be part of the hill: the structure and nature finish in an unbreakable grip with each other. Again, one observes the importance of the porticoes: their great dominating frames partially open up the façade and allow something of the spaciousness of the country to enter the building. 'Wherefore you ought to have regard to the greatness of places, which ought to receive light,' Palladio said. But here, in this architectural form, we see a link with the Greek covered space at the front of the megaron and, simultaneously, a step forward towards the openness of the twentieth century. But Palladio's struggle to resolve these architectural relationships, and to find ways in which some balance with nature could be accomplished, is illustrated elsewhere.

For a start, he chose a simple shape. He says himself: 'The handsomeness will arise from a fair form, and the correspondence between the Whole and its Parts, of the Parts among themselves, and of them to the Whole: because of that a Building ought to appear an entire and perfect Body, wherein each Member agrees with the others, and all the Members be necessary to what you design.' Here again, in this design process, we see the link with Greeks who chose the firm form of the megaron within which to work; and with the future – Le Corbusier, who chose the cube. The Villa Capra was a cross, the plan of which was constructed of, in all, ten squares; this made an immediately comprehensible diagram or frame which could then be exploited to human ends: its influence remained in the general terms of an outline and a guide, as the megaron had before and the cube did after. The plan of the Palazzo Chiericati was, however, rectangular and here Palladio

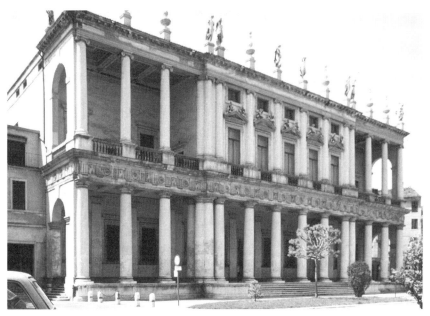

Palazzo Chiericati, Vincenza, Italy: architect Andrea Palladio, 1550. The colonnade as the architectural frame.

so enlarged the extent of the portico that it became the frame for the whole façade.

This frame meant that he could stress the parts of the palace as he liked; it allowed great freedom of expression. The columns running through the design and shooting up above the roof as statues at once established the scale and presence of a palace. From that point Palladio could continue. The ground plane outside carried on inside and the link between exterior and interior that was managed at the Villa Capra with the four porticoes became a colonnade at Chiericati; and the positions of the columns which set out the shape of this colonnade exactly mirrored the positions of the walls which defined the shape of the huge hall inside. Thus he accomplished, with a graduation of scales, the transitional phase. Then, on the first floor, the frame accepted balconies. Between these balconies, and as a centrepiece, the palace suddenly appears with the domestic look of a house: one seems to hear Palladio saying, 'You see, a palace is just a house, after all – it has the same functions and all people are equal'. And it is around this centrepiece that the other parts of the composition fly off with the vitality

of a tremendous catherine wheel. But this upsurge of imaginative energy was, again, made architecturally possible by the classical frame, and the more vigorously this was stressed the greater was the extent of the variations. He experimented with it even more freely at the Villa Sarego. This building is so open and the structural elements so powerfully expressed that one thinks of Frank Lloyd Wright's early houses. Sarego, and the Villa Thiene, seem to have been constructed on rock which has been pulled out of the ground to support – with columns at Sarego, a podium at Thiene – the vast weight of the superstructure. The flat stones with which Palladio made the columns at Sarego (and the podium at Thiene) suggest the great weight they are carrying – crushed by it and withstanding it, simultaneously. At Sarego the roof is huge, very thick – it has to be as a defence against extreme heat and storms. (Palladio writes about the function of the roof in this way.) Again the design of this house stresses the importance of the ground plane; it is upon the ground that this heavy structure stands. (There is a likeness here to the indigenous Japanese domestic architecture

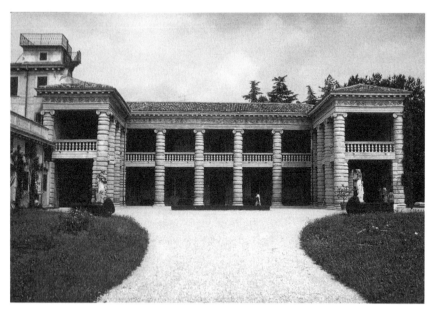

The Villa Sarego, Verona, Italy: architect for half-completed court Andrea Palladio, 1569. Probably his last villa, the structure powerfully expressed in the search for openness.

of about the same period.) So horizontals and verticals, to the exclusion of all else, make the frame at Sarego – the Greek portico in essence but immensely abstracted and simplified. Now we see columns for what they are, and what precisely they are doing: as props displayed in compression carrying a shelter into which, and out of which, people may wander as they please. And like columns in a cathedral, these props act as a measure (we know what happens up there at the roof because we can put our arms round them down here), thus contributing to feelings of security and well-being. Palladio pursues the possibilities of the frame to the end: the balance he achieves between strong horizontals and verticals, and between columns and delicate balustrades is analogous to, and expressive of, the balance he achieves between people and structure and nature.

The emphasis placed on the frame, and the increasing simplicity with which its presence was conveyed, is the dominating characteristic in all of Palladio's designs. In one of his earliest buildings, the Villa Pisani, for instance, the portico is seen as the centrepiece of the scheme, giving importance to the entrance on the one hand and holding the plain side walls together at the same time. The elevation is integrated both in horizontal and vertical directions, and makes a cross which recalls the cross-axes of the Roman plan: all delicately achieved with thin plaster lines, steps, patterned reliefs and paper-thin eaves which lift to a point in the middle of the façade. At the Villa Poina, as at Thiene, the portico is again simplified so that it emerges as little more than a guide; the pediment is done away with and the roof suggests a two-way pitch of an ordinary rural kind. The Villa Foscani is also simple: no balustrades or handrails, just a gradual flight of steps up to the terraces. At Thiene all embellishments are stripped off, the podium (as elsewhere) was left rustic (to save time and money), the pediment becomes a pitched roof, and the horizontal line that completes the triangle is a precise stone projection to throw the rain off. The portico is no more than a memory: it is a brick relief. And, in consequence, the frame gains in clarity. Palladio loathed confusion. He says of design: 'So we must order and dispose an Edifice in such a Manner as that the most noble and beautiful Parts of it be the most exposed to all Spectators, and the less agreeable thrown into By-places and

removed as much as possible from public View.' And of the Mannerists of his day: 'It seems to me not unfit here to acquaint the Reader of many abuses, which are being brought in by the barbarous, and yet observed; to the end that the studious in this art may avoid them in their own Works, and understand them in others.' He saw the problems presented by the country house equally clearly: he put this into two categories – one for the family, one for the farmer. The family had to be protected and he liked the piazza form for this reason: it provided shelter from rain and snow and shade from the sun. 'Besides,' he says, 'such piazzas will make the house look much more spacious and magnificent.' He extends the argument to street architecure and colonnades: 'But if one wants to separate the Place where people walk from that which serves for the passage of carts and beasts, I should like to see the Streets so divided that on either side Porticoes be built along which the Citizens might pass under cover to do their shopping without being bothered by sun, rain or snow. Almost all the Streets of Padua . . . are of this sort.'

A down-to-earth character: from all the classical rules he broke were created others – human ones. People like terra firma, for instance, and so they must be allowed to walk where they wish; obstacles such as walls must be removed where possible. People need protection from the weather; hence colonnades. People want clear directions, the entrance pointed out; hence porticoes. If a farm is being planned, cattle sheds and house must be separated – people do not like animal smells. And so on. He respected the spirit of Man. 'Let all doors be placed in such a manner, that one may see from one end of the House to the other, which is very graceful: And, besides, it is cool in summer, and hath many other conveniences.' It was not merely that the buildings he designed were human in scale because the classical proportions he used were domesticated: the buildings he designed were also in scale with the spirit of man. Portico steps were uncluttered with handrails and balustrades, doors were large and high, staircases flowing, spaces empty of detail (which was again 'cool in summer'); as in Georgian architecture, which followed his principles, the shapes chosen and the sizes adopted recalled those of the human figure – of the Greek insistence on the idea of the supreme importance of the individual

– but they were a generous representation of it. Thus, what we see reflected in his work is indeed the supreme importance of the individual, and we feel important, and spiritually better, for having been in contact with it; or, as Palladio would doubtless have said, more 'magnificent'. What he portrayed in his buildings, and passed on to others, was a lovely vision of human dignity.

He was, however, equally conscious of the spirit of nature: 'I say, then, that Architecture (as all other arts are) being imitative of Nature, accounts nothing tolerable which is estranged, and differs from that which is natural: Wherefore we see that those Ancient Architects who built with timber, when they began to build with stone, directed that the columns might be less at the top, than at the foot, taking examples from trees which are less at the top than in the Trunk, and near the Root.' One thinks of the pagoda. He discusses climate in great detail, showing how the architectural character of different countries is governed to some extent by roof shapes. In Germany, for instance, the pitches are very steep, to throw off snow; in Italy, on the other hand, which is a warmer country, roofs have shallow slopes; flat roofs, he said, were a mistake (he rejected Vitruvius on this one) – they leaked (something which modern architects are discovering for themselves today). And as far as planning goes, he says: 'It is also a requisite that the *Summer* Rooms be spacious and open to the North; and the *Winter* ones small and exposed to the South and West, because in *Summer* the *Air* and *Shade* is very agreeable, and in *Winter* the *Sun*; besides little rooms are easier warmed than large ones.' Some of his clients annoyed him: 'It very often happens that the Architect is under an obligation to follow the Fancy of the Person who employs him and not the Dictates of his own Genius or Inclination.'

But what people want, above all, is order: they must be able readily to comprehend their surroundings. At the same time people like to contribute to their surroundings – it is a human instinct to create – and therefore these surroundings should have the reticence to encourage the contribution of people. For example, if very young children are given a large cardboard box to play with they will turn it into, say, a boat; but if you give them a ready-made boat with oars and so on they will not know what to do because there is no contribution left for them to make – the adult has intervened

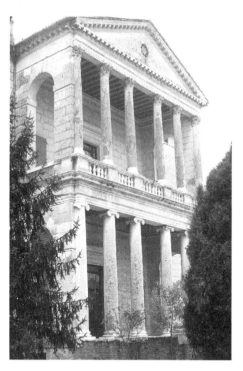

The Villa Cornaro, Piombino Dese: architect Andrea Palladio, 1553. The importance of his client, a Venetian nobleman, is emphasised by the double frontal portico.

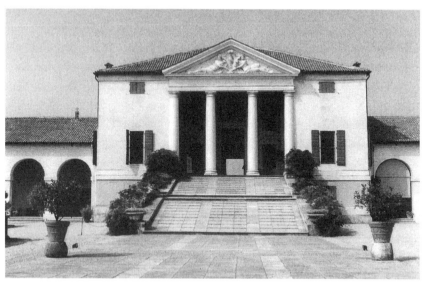

The Villa Emo, Fanzolo, Italy: Andrea Palladio, 1564. Simplicity of detail retains the echo of the Greek megaron, and, like villas Badoer and Trissino, curving arcades, accommodating service quarters, link house to country-side. Photographer Peter Gresswell.

and deprived them of their initiative. But children and adults can't be separated; they are people at different stages of development. And so it follows that adults will react in the same way when surroundings are substituted for the cardboard box: some surroundings encourage contributions from people; others, perhaps because they are too insistent, discourage them. Amsterdam is a good example. This city gives great encouragement: the simple frame of architecture, trees and water, and the rich individuality of the town façades with their Italian and French cornices and scrolled gables both accept and suggest the spread of people with their houseboats, flower markets, greenhouses, chickens and goats. In Rome one sees another effect of the classical background: a rural cottage life, forced upwards by climate, clambers over the old rooftops like creepers; but the disorder is accepted by the plain Renaissance frame – there is no hint of anarchy. And as one draws away from Palladio's books and buildings what one sees above all is an architectural theory with a background order of the kind that will encourage the human contribution and accept its muddle.

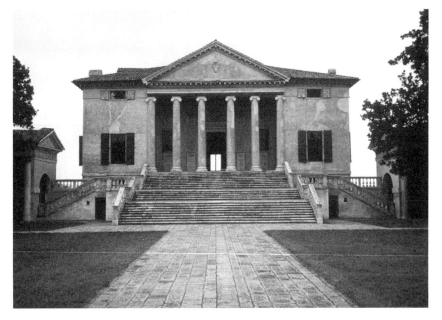

The Villa Badoer, Fratta, Pilesine, Italy: Andrea Palladio, 1556. The grand conception of house at the focal point of service quarters/farm buildings.

By deleting ornament and stressing structural systems based on the classical tradition's five Orders, and by expressing through architecture, space and nature a new consciousness of things, Palladio left behind a theory of design that was immediately comprehensible, rooted in common sense, and capable of suiting human requirements of a far wider kind. In other words, the scaling down of his work follows the normal patterns in the life of any style. It starts out, as only it can, in the form of large buildings for wealthy people and these structures determine certain basic principles of design. It then contracts and finds a more universal domestic range where these principles apply to everyday things. And it so happens that, following from the Renaissance, a search was going on in the seventeenth and eighteenth centuries for a totally appealing, uniform standard of taste for all the arts. And while Newton, for instance, attempted to comprehend the diversities of the universe with a single system of mathematical laws, the objectivity, sobriety and logic of Palladian architecture presented an aesthetic formula which, while accepting variations and adjustments according to climate and other needs, could be applied universally. What is more, in returning to the Romans and Greeks, Palladio had rediscovered the idea of the human being existing at the centre of life and the universe, and thus of architecture. Such a conception had, after all, disappeared during the religious tyranny which abhorred the body, regarding it as bad, sinful and obscene, in the Dark Ages following the collapse of Rome.

And so Palladio reintroduced mathematical methods of relating the human size to a building's dimensions, as Le Corbusier was to do later with the Modulor. There is a clear parallel between the two periods: an aesthetic formula was as necessary to expanding countries and increasing populations in the seventeenth and eighteenth centuries as it is now. Something had to be found – some articulate and disciplined method – which would create a mathematical and firm framework within which to live; again, it is a human instinct to simplify. John Locke, for instance, in his essay, *Concerning Human Understanding*, held that there are no innate ideas, that all ideas are based on sense experience; in other words, on things like sight and touch. In one way, therefore, it follows that a person's character can be cast by the design of his house and the

composition of the district in which the house is situated and of which it forms an integral part. It follows that strongly stated architectural elements are an essential part of a person's background. Seventeenth- and eighteenth-century architects and aestheticians started from this conception. If ideas, personalities, character and, in general, people's happiness are to a great extent dependent upon experience and sensation, then architecture must be clearly organized in order that strong and sharply defined sensations are produced, and ones which can be related by proportion to the scale of a human being. And, of course, this Lockean stress on sense impressions coincided with Palladio's admiration for the firm and ordered architecture of Rome.

The Palladian system, therefore, that spread across Europe did so chiefly because its mathematical and naked plainness was found to meet a universal psychological and aesthetic need. Thus the Georgian town and the American interpretations of post-Renaissance classicism – like Mount Airy, Virginia, and other superb examples of East Coast architecture – were not designed with any particular intention of recalling the past but instead attempted to apply to modern needs the general principles of design derived from ancient architecture. Bearing this in mind, it does not seem surprising that the sharply defined Palladian order of plan and façade should have developed on both sides of the Atlantic. The Vitruvian rules of symmetry, proportion, scale, and so on that this architecture reflected was, moreover, in complete accord with a kind of taste shaped by the psychology of Locke and Newton's world scheme based on his *Principia Mathematica*. Indeed, Palladio's insistence, both in his writings and his buildings, on an orderly relation of parts answers the Lockean demand for simple aesthetic images; and the rational sobriety of his architecture, at the same time, harmonized with the ideals of new and rapid developments in science.

NINE | The Community Frame

The Palladian influence was not as strong in France as it was in England. In fact, it was only in the nineteenth century, around the 1830s, that the intellectual disciplines which so firmly regulated Georgian architecture began to fade away into a more truly indigenous style that was then lost in the neoclassical phase which followed. But the plain Englishness of the 1830s has a likeness to the outcome of the Italian influence on French architecture. Architects and builders in France took advantage of certain principles to do with proportion and scale laid down by classical theory, and they applied them to large houses and town design. At the same time, however, they never relinquished national characteristics. It is in the south, of course, that the classical influence is shown at its simplest: in heat, people need only the bare essentials of life. Viviers, an old Romanesque town, is a good example, and the villages round about are interesting. Viviers is near Avignon where Leonardo lived for a time, and his presence, together with nearby Roman buildings, may have accelerated the Italian influence; one would expect this. But besides an unusually dedicated Renaissance elevation in a back street, the largest and most influential houses chiefly demonstrate the aloofness of the French approach: a perfect Palladian façade, for instance, capped with a rural roof of rough pink tiles – just what Palladio would have liked to see. In the streets of Orange, again, principles of proportion and scale are carefully

followed, but greatly simplified to suit the traditions and materials of the locality. In villages, gable ends form pediments and shuttered windows are classical in shape, but the stone of which the houses are built is as much a part of the place as nougat: pink roofs contain a totally rural picture. In Paris the classical strain is very strong, but intermixed with the grandeur of châteaux architecture that offers a prototype for a city scheme in the Place des Vosges, and this is reminiscent, in some ways, of Inigo Jones's design for Covent Garden – and with similar long-term effects. So, in Paris, the purity of the Palladian method is transformed into the conservatory style of the Parisian boulevard, a manifestation of French values and gaiety. In Dieppe, Palladianism continues with a ghostly imprint of a memorable theme first seen at the Villa Thiene: the irregular street façades are ordered throughout by brick pilasters, and continuity assured. Thus the classical invasion which centred on Tours and Avignon took a hold, but never in such a way that it was allowed to reject the style of the locality, or to deny the expression of local customs and building traditions. Certain basic principles of design were determined at places like Ancy, Azay and Versailles, but these, when transferred to the more universal range of domestic architecture, remained a transparent overlay that was used to introduce a community order to the traditions of plastered surfaces, round towers and high roofs. Beneath this overlay, the individuality of local methods inherited from long before carried on, rather as cruck-building had persisted through Roman and Norman influences, finally emerging at the end with a style of their own. Thus the essence of classical theory was extracted, as Palladio had extracted it in his time, but not with any loss of human identity. The unity of the whole was a major consideration; but so, too, was the contribution of the individual. French architecture, therefore, always manages to combine the most magnificent underlying themes of architecture: like Roman design, it looked up to the community; and, like the cruck house, it looked up to the individual.

Georgian architecture tells a similar story, for it, too, respected the scale of both the individual and the community. The classical outline which described its principles of proportion and detail was, however, more evident and exact than in comparable French work.

A decisive influence was, again, climate. The English light is so very subtle, so often soft and misty, that the architecture responded with great delicacy of detail, and this led on naturally (as it should still) to precise general appearances and hard forms; for instance, eighteenth-century bricks were as excellently made as they were laid, mouldings were perfectly carved, cornices were as sharp as pencil points: in colder climates people need more than the bare essentials of life. But how did the Renaissance influence get to England? For this was the third force in the diagram of influences that was central to the evolution of this outstanding style. It did not come over from the Netherlands: it was already entrenched before Cromwell's regime precipitated that source of research. In England in 1610, let us say, when classical theories of design had been fashionable in France for about a century, not a single truly classical building existed. Yet fifteen years later, at the outside, a powerful classical movement was forming in England. Who was behind it? It came from the top, as the Tudor influence had come from the top (in that case from Wolsey); the answer to the question is beyond doubt – one man, Inigo Jones.

Who was Inigo Jones? A study of him reveals the way that ideas travel, are passed on, influences spread, and how the discoveries in one country overlap with developments in, and requirements of, another. Who was he? That he was a famous architect is not, in the circumstances, much of an answer. What was he? This would be a more leading question. Extraordinarily little is known about him, despite all that has been written. His first twenty-five years are particularly mysterious, and certain mysteries even hang around the authenticity of buildings and drawings originally attributed to him – and, to make matters more difficult still, only a handful of the buildings remain. Some people claim that he was the son of a carpenter, others say that his father was a tailor; in either craft it might be possible to perceive links with what became of Inigo Jones. One theory, however, is that he was a servant of the Earl of Pembroke. Did he – the fourth earl – discover Jones? If so, how? Probably because Jones's extraordinary insight into painting, theatre and architecture was clearly evident. Someone discovered him, for he was sent, all expenses paid, to Italy; it is fairly well established

that it was the earl. And what a discovery! Within fifteen years or so of his visits to Italy at the beginning of the seventeenth century his influence had become enormous. He controlled the shape of London; he advised Charles I on buying pictures and, had it not been for Cromwell, the English collection would now be the most remarkable in existence. But, above all, Inigo Jones, concentrating on Palladian principles of design, brought the spirit of the Renaissance to England. Through Jones, and those who followed him, these principles were spread throughout the world. His clarity of vision cut through the confusions of his time like a laser beam.

One thing *is* certain: Inigo Jones was in Italy, perhaps for the second or third time, in 1613, when he was forty. On this occasion, in one year, he travelled all over the place: to Paris, Nîmes, Germany; he was several times in Rome and on the Brenta. And it was on this occasion, too, that he got hold of Palladio's book; the date is in the flyleaf. So he discovered Palladio when he was forty; that is established. But it was in the flyleaf, also, that he copied out Palladio's signature, very carefully, over and over again. Equally carefully written was his own signature, in appearance an exact copy of Palladio's, and his signature was again repeated all over the page. The copying of the signature – like a child copying an adult's – suggests that the discovery of the book, and of Palladio's ideas, was like an incredible flash of illumination: like a vision. Yet the realization that he was forty when he found Palladio discloses another mystery. What had he been doing in the years before? How had he spent two critical decades? Well, one or two things are known: he was designing stage scenery in 1605 and it is thought that he was consulted on the planning of Hatfield House in 1610. It seems that he had also been travelling a good deal; there is the first visit to Italy that Pembroke is supposed to have financed when he was in his early twenties. 'Mr Jones, a great traveller,' runs a pamphlet by an unknown writer in 1605. So what was he doing on those travels? Making notes, applying himself to research, studying the past in the minutest detail?

The momentousness of his discovery of Palladio is recorded by thumb marks on every page of the book (particularly in the bottom right-hand corners); disciples examine the books of Le Corbusier in much the same way today, and Le Corbusier travelled great

distances to study classical buildings as Jones did. Then the notes and comments by Jones fill the margins of every page; and they sometimes take a bit of deciphering; his normal handwriting was not in the least like the studied, level signature. The book became his bible, his picture of the Truth. Even his own words are like a copy of Palladio's, but perhaps, since he translated the book into English, it is not unreasonable that he became enmeshed in his master's prose. In his preface to *Quattro libri dell'architettura*, Palladio says: 'My natural Inclination leading me to the Study of *Architecture*, I resolved to apply myself to it: And because I ever was of the opinion that the ancient *Romans* did far exceed all that have come after them, as in many other things so particularly in Building, I proposed to myself *Vitruvius* both as my Master and my Guide, he being the only ancient *Author* that remains extant on this subject. Then, I betook myself to the Search and Examination of such

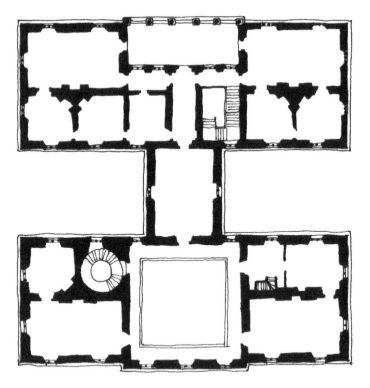

Inigo Jones's original plan for the Queen's House at Greenwich, London, England, for which his designs began in 1616.

Ruins of Ancient structures as, in spite of Time and the rude Hands of the *Barbarians*, are still remaining; and finding that they deserved a much more diligent Observation than I thought at first sight, I began with the utmost Accuracy to measure the minutest part by itself . . .'

Then we have Inigo Jones saying: 'Being naturally inclined in my younger Years to study the Arts of Design I passed into Foreign Parts [here is further proof that he was in Italy around, say, 1600] to converse with the great Masters thereof in Italy; where I applied myself to search out the Ruins of those Ancient Buildings, which in Despite of Time itself, and Violence of Barbarians, are yet remaining. Having satisfied myself in these, and returning to my native country, I applied my Mind more particularly to the study of Architecture.' He certainly did. And so what Vitruvius had done for Palladio, Palladio had done for Inigo Jones, who set about the enormous task of passing on his knowledge to others, and to succeeding generations.

A year after Jones returned in 1614 he became Surveyor to James I. This was an appointment of great importance, the key position from which he could direct his strategy. Then, in 1616, he began the designs for the Queen's House at Greenwich. It was built later. But it was *designed* in the context of the shaky lines of London's timber-framed buildings and within twenty years of that amazing Elizabethan mansion, Hardwick Hall. It was a gem – perfect in all respects. Now we begin to see how Jones had spent his 'younger years'. His research, study and patience had meant that he was ready to commit himself. A test of greatness is the extent to which the work of a genius can be absorbed by the disciple without ill-effects and with only good effects, these enabling the disciple to continue the work of the genius, and to interpret him objectively. The Queen's House illustrates this form of greatness, which was Jones's. The architectural result was faultless, and it was startling: the sight of this spare Palladian work in traditional English surroundings must have been quite as alarming as seeing a building like the Villa Savoye by Le Corbusier on the edge of a Paris suburb in 1930. The form of the Queen's House – its plan, volumes, façades, windows, doors – was derived from the cube, and a natural relationship of the parts. Jones never deviated from these rules: all his

work was ordered by the cube. But the importance of the work, which has endured, and will continue to endure, into the far distant and precarious future, lies not so much in the magnificence of the objects he made, but with what perhaps lies beyond them. Where Palladio had the vision to see buildings as greater than the sum of their parts, and in relation to other buildings, Inigo Jones had the vision to see how Palladian ideas could be domesticated to make an aesthetic order for city design itself. This was a big step forward, and the plainness of the Queen's House reveals the extent and quality of this vision. It is present again in the quiet, controlled façades of the Banqueting House which he began designing in 1619: the strong classical frame of columns and pilasters suddenly looks up to the scale of a city, and a city's centre at that.

Inigo Jones says himself: 'One must first design the ground, as it is for Use, and then vary and adorn it. Compose it with decorum, according to its Use and the order of the Architecture to which it belongs . . .' Simple words, simple as his buildings. 'Then vary and adorn it . . .' The Queen's House is outward-looking, an ornament set down in a park. The variations and adornments lie in the south-facing terrace, the columns of the terrace, the steps to the

Plan of the Banqueting House, Whitehall, London, England: architect Inigo Jones, 1619–1622. The ceiling panels (broken lines) were painted by Rubens.

north, slight changes of plane, delicate carved edges to roof and windows. The Banqueting House is inward-looking, set down in a city. The magnificence of the design is focused on a single interior space, a double cube. On the outside the emphatic repetition of columns and pilasters (as at Palladio's Chiericati) transcends the detail of the variations and raises the scale to urban dimensions. At Greenwich, the complex order of nature required a simple response from the architecture; in Whitehall, in London's centre, the architecture had to display strength as well as reticence. We begin to see the direction that Inigo Jones was taking: he conceived buildings as parts of places, as surroundings.

Jones, like Palladio, boiled buildings down to the bare bones. All applied decoration went. The detail which varied and adorned his St Paul's Church in Covent Garden relies, much like Palladio's Villa Thiene, on modulations of surface, on the modelling created by the enormous barnlike eaves, by the columns. Now these modulations of surface seen in the church (which acted as a focus for the classical cross-axis of the square) were then followed through in the terrace façades which unroll like wallpaper around the total space of the piazza. Here we see the vision of Inigo Jones in full flood. Here we see a prototype – perhaps *the* prototype – of the eighteenth-century urban scheme that followed. The pilasters frame the façades as they frame the individual, and the sides of the square thus look up to the scale of a person as they also look up to the scale of the community. Jones seems to have analysed and put together a number of ideas simultaneously. To start with, there was stage scenery – he had been designing stage scenery of a classical kind back in 1605 – one can see signs that he had been making drawings from Michelangelo and others. A particular theme runs through these designs: the illusion of depth created by symmetry. In other words, he used the sides as the background to focus attention on the distance. Considerable economy of idea was exercised in the designs, a good deal more than by his Italian influences: trees focus on distant trees, buildings on distant buildings. Thus this composition focused attention on the actors within the limited frame of the proscenium opening. Now, in bringing Palladian disciplines to England, and in seeing the significance of the architectural frame, Jones also made the discovery that

buildings could be regarded as background urban scenery: he had seen the Shakespearian connection between the stage and life, between background and architecture. The analogy with the urban picture is pretty clear: scenery has to make a background that is simple and direct; it must not detract from the action of the play and the performance of the actors – it must assist, not intrude. Jones understood this, and the Queen's House and Covent Garden demonstrate the theatre approach in architectural terms. The Queen's House firmly established the background in plain Palladian lines, and this background established the visual limits of the foreground which people could then enjoy. If this conception is enlarged and simultaneously scaled down to embrace the town plan we can see how it reaches the more ordinary urban situation that applies to everyday things. Covent Garden is like the Place des Vosges in Paris – also a prototype for an urban aesthetic. Jones had indeed carried Palladian methods a great deal further, further domesticating them, and we begin to see the evolution of an idea that has been handed down and handed down, through the work of Palladio, Jones, Wren, Le Corbusier and others; and one which consistently respects people through both the community and family frames.

Whitehall Palace for Charles I was a development of conclusions reached in Covent Garden. But here his vision of the urban background was given a much greater variety and range: here is a monumental scale mixed with a domestic one, the circus form as well as the square. Monumentality arose from use and situation, the diversity of scale and form from the size and complexities of the problem; but it was still, after all, a place where people lived, and so here was a kind of town and its centre, a microcosm of a city. The conception follows all Jones's golden rules. The outline is derived from the square, which makes the frame, and then within this frame there are the variations, much like Bach: the beat and the improvisations. The square is 'the ground' and this must be varied and adorned, after which the whole composition is glued together in three dimensions with a repetition of columns and pilasters – as at the Palazzo Chiericati, the Banqueting House and Covent Garden. When this is accomplished and the external form set down, variations and adornments enter the picture; hence the

Plan of Whitehall Palace, London, England: architect Inigo Jones, 1638.

towers and domes. Nevertheless, one wonders whether these domes and towers would have survived had Whitehall Palace ever got off the ground. Lying just below the surface of this classical man, and showing every now and again in a ludicrously tall tower of a design of the imagination, was a romantic Celt trying to get out: there was an Inigo and a Jones. But when it came to the point, to the reality of a building, the Celt was again put away in the cupboard; personal expression was suppressed; it was the public whom he had to serve, not private ambitions. When it came down to it, his sights were trained on the spread of a coherent style, and this strategy did not accept outbreaks of self-indulgence.

And this brings one to Wilton House, the last piece of the jigsaw with which Jones was directly connected; and another mystery – the authenticity of his designs. In a number of cases, this is questioned by historians. Coleshill, they say, was not by him; it was by

Pratt. Many drawings, originally attributed to him, are by Webb – so they say. And Wilton, it is now claimed, was not by Jones. In a sense, however, it is precisely these mysteries which disclose the real Inigo Jones. On one level, a big question mark stands in front of Wilton. Whose hand was it that decided the perfect form and faultless proportion of this remarkable building? Was it Isaac de Caux's, the architect Jones recommended to his lifelong friend, the fourth Earl of Pembroke? Or was it really Jones's, operating the pulleys in the wings; was it Jones working through de Caux who, it is now established, did the drawings for the south front completed in 1640? De Caux signed the drawings: but what does a signature mean in architecture, and how much does it matter? It was Jones who was back haunting the scene after a bad fire there, some years later. It was he who redesigned the State Rooms, rebuilt in 1649. On this occasion, however, Jones was accompanied by the devoted Webb; on this occasion it was through Webb that he was working.

A picture of Jones, a more precise portrait of this elusive man, sharpens into focus. He stood for continuity; a dedicated Royalist, he preferred to remain in the background, controlling operations; a maker of backgrounds, he became himself a background against which others tested their abilities; a consultant to whom, perhaps, his disciples went for advice on architectural principles, and for criticism; a man who, with a minimum of effort, directed his energy with maximum effect; a man who became a frame that accepted the variations of others. This makes him a genius. The man and his work suddenly merge; the work is the portrait of the man. Did not Covent Garden achieve the maximum effect with the minimum of effort? Is not this the real message of his buildings, of the Banqueting House, Whitehall Palace and the Queen's House? And surely, then, the mysteries that surround the authenticity of so many of his designs have a simple explanation? Jones worked tremendously hard as the King's Surveyor. He, himself, controlled the shape and taste of London: he was a kind of on-the-spot Minister of the Environment, a job that needed a great deal of energy and time. But this was a small part of his work for the king. While de Caux was putting the finishing touches to his drawings for the south front at Wilton, Inigo Jones had completed his vast design for the King's Palace in Whitehall – with drawings by John Webb. Yet this

18th-century savings bank, Cork, Ireland, originally a private house designed in the true Palladian manner. Photographer H.T. Cadbury-Brown.

was still only a part of the Jones jigsaw puzzle; his real mission, central to all his work (and his dedicated research, writings and buildings are proof of this), was to direct a coherent aesthetic that would exert an order of a far-reaching kind. The pattern for this lay in Covent Garden and Whitehall Palace. But as King's Surveyor, he was in the key position to take the range of his ideas much further, and make his mission a reality; more than a dream.

Surely this is it? Jones worked through others. Nobody questions that he was the architect for the Covent Garden piazza. Yet the man who actually did the drawings was none other than Isaac de Caux. The assistant on the Banqueting House and St Paul's Cathedral was Nicholas Stone, and Webb did the drawings for Whitehall Palace. De Caux worked on Wilton, but so did Webb. And so was Sir Roger Pratt really responsible for Coleshill or was he merely a tool of Jones's? And isn't it probable that Stoke Bruerne

Terrace architecture, Leamington Spa, England: 18th-century stucco purity. Photographer H.T. Cadbury-Brown.

Early 19th-century Federal terrace architecture, Georgetown, Washington DC, USA.

18th-century Federal terrace architecture, Georgetown, Washington DC, USA.

Early 19th-century terrace architecture, Chelsea, New York City, USA.

and Kirby Hall are, after all, indisputably by Jones as well? The truth seems to be that he used his position as top man in the network to extend his area of control beyond his own as Surveyor, and did this by picking his man for important and influential projects; there was practically no limit then to his power and influence. He was like the head of a firm, but his assistants were all architects who practised independently. Webb was a good example. Being Jones's nephew, Webb was probably closest to him of any of the architects, and the relationship of these two may explain Jones's organization in general – at Wilton, for instance. Webb was so closely associated with his uncle that – rather like Palladio and Jones, and their signatures – he became a projection of him and his work. So much so that confusion arose over the authenticity of the drawings in William Kent's book *Inigo Jones* in 1727: were they by Jones or by Webb? If Kent was mistaken it is likely that he also mistook Webb's handwriting for Jones's. On one level it is an academic point; on another, it is an exceedingly important point; what matters is that Webb's work had become indistinguishable from his uncle's.

Wilton House seems to present the story of Inigo Jones's career,

186

all he struggled to achieve; like a poem, it caught the essence of a heroic idea, an epic. It is a study of order, perfection and continuity: architecturally, its history covers 300 years. Inigo Jones's Wilton is founded on the cube; but also on the remains of a Holbein house burned down by fire; also on Palladio. Jones took his siting from Holbein (thus maintaining the continuity of the original's life in the landscape), designed a house with a square plan and a quadrangle in the middle, and as a square it mirrored the all-around magnificence of the park. He also took Holbein's turrets, but as Italian cottage architecture – one cottage at each corner. He kept the only relic from the fire: a centrepiece by Holbein. The cottage turrets introduced human scale and a feeling of the country. The hard form of the building – strong and plain – remained as reticent as the Queen's House; it was a background for people and a grand way of living: an ornament for a park. But it was strong enough, and simple enough, to accept the contribution of others. Continuity at Wilton shows in its respect for the past, and the endeavours of the past; it shows in Webb, who carried on his uncle's

18th-century Bettiscombe manor house, Dorset, England.

18th-century ironwork, Georgetown, Washington DC, USA.

work; and it shows in the designs of those who followed Jones and Webb. Roger Morris added the bridge (he was the architect who designed Marble Hill on the outskirts of London). William Chambers added the gates. James Wyatt added, in around 1800, the internal Gothic cloisters and the cottages on either side of the gates. All accomplished without any disruption to the whole. Inigo Jones's plan for the house, and for the future, had held good. He had created a situation where other architects could work together to maintain the architectural order.

But that is not quite right, either; there is more to it than this. Jones respected Palladio as Palladio respected Vitruvius. Jones also respected Holbein. And his own struggle for order, space, discipline, magnificence, continuity – in particular, continuity – was, in turn, respected by those who followed him. And so you make another discovery. Palladio, Jones, Webb, Kent and the rest are really part of a much larger force – the force of evolution, the struggle to progress. The frame for these classical architects and their architectures was the cube. The frame for the whole, however, is the continuum.

The rediscovery of Inigo Jones and the Palladian revival came

at the right time, even in the nick of time, perhaps. They did not happen at once. The work of a genius may be appreciated and highly valued by those closely associated with it, but the real meaning and force of the work can, for outsiders, take years to digest – barriers have to be broken down – barriers constructed by prejudice and tradition which may have been cemented into position over centuries. It is only when the work has been fully digested and understood that it will receive a following powerful enough to bring its underlying principles within the reach and scale of everyday things. For there is a point where the work of the genius and tradition must meet; neither can survive in isolation. In the same way that Jones was enriched by his discovery of Palladio, and his view of architecture enlarged, so tradition, when it meets enlightenment, is also enriched, and it is in this way that it progresses. If the meeting is not accomplished, tradition will die and genius remains in a cul-de-sac. We are experiencing the terrible dangers and disasters of defying enlightenment now.

So enlightenment and tradition must, at some point, merge. But for a time they will remain apart, at least until tradition is ready to accept enlightenment, when it will absorb it in the ancient system. When this point was reached at the beginning of the eighteenth century the three-force diagram of the English style was, after nearly 2,000 years, finally resolved. Prior to that, tradition and enlightenment continued on separate routes; Inigo Jones, his vision and genius, scarcely touched the ordinary man. The craftsman's style carried on regardless of him, embedded in the past, incorporating influences from elsewhere on the way (particularly from the Netherlands), and continuing the close relationship between the design and its execution of the Tudor period. This style followed Jacobean – in spirit as well as in time – and, deriving from the best in London joiners, masons, bricklayers, and so on, lasted until the end of the seventeenth century, a long time after Jones died. It was made by craftsmen: superb on detail, they were blinded by detail; it was impossible for them to comprehend the whole. The style was Mannerist rather than classical; more sympathetic to French and Netherlands taste, it had little to do with the Palladian thought central to the theory of classical architecture. The Netherlands had their chance early on, but they missed it. Italian

architects worked in Holland, there was no monarchy to push the fashions of the day, artists passed around the word from translations of Italian books, and Serlio's treatise had been published. The records on the Renaissance must have been put straight, architectural principles clarified, classical and Mannerist forms separated – in particular, Palladio from the later work of Michelangelo. But, in the end, countries choose the clothes most near to their nature. The French chose Mannerism; and Flemish styles, traditional bourgeois Gothic taste firmly entrenched in the background, followed suit.

In simple terms, Michelangelo, not Palladio, was their man. And Mannerism showed itself in flowery, fussy detail: stone bands, arches, obelisks, all the jazz, and all aimed at bringing walls to life. Applied decoration approaches the finished product from the outside, making no headway beyond the wall; a long way from Palladio and Jones who approached the fundamentals of the architectural problem from both the inside and the outside simultaneously. Mannerism showed itself, too, in the use of the giant order (derived from Michelangelo's part in St Peter's in Rome) with a consequent loss of human scale. However, later on in the seventeenth century, the shortage of money did away with these affectations, the pilastered order was dropped and the ordinary man took over in flat and sober façades. Architects had to tighten their aesthetic belts to conform with their patrons' resources: design reflects cost limits as it reflects social change; seventeenth-century Holland was no exception to the rule. This new economy of appearance coincided with the search for a uniform aesthetic that was going on in England; there were a number of connections between the two countries and these multiplied after the Cromwellian phase when influential people fled to Holland. And as this simple Flemish style developed the flatness was emphasized. The window changed: gone were the heavy mullions, transoms and leaded panes; in came the sash window with divisions as thin as lines on graph paper. Gone was the projecting window frame: it was set back, stressing the flatness of the brick. This produced a sculptural effect; architecture was now exploiting economy, and as the window became more important in the elevation – bigger, to let in more light – its detail had to be simplified; hence the sash. Matters concerning aesthetics and more efficient techniques are indivisible, both lead to a single end.

Other constraints were at work too. Amsterdam, for instance, presents façades that were limited in width by the defence network of canals; land was short; houses were forced upwards; stairs were extremely steep, and this meant that windows had to be wide as well as tall – to get the furniture in. Again, this led to the same end, a need for simplicity, the scaling down of monumentality to a middle-class budget. Shortage of land and simplicity also meant that the picture of the street formed by individual houses was a thing of the past, and that all that was left of the giant order was the narrow widths of brick between strikingly broad windows: the solids made the frame which glued the composition of the street façade together. Set side by side, houses found a uniformity that went some way towards creating the illusion of a single building, which would act out the Renaissance conception of the unity of the whole, of Petrarch's humanism and philosophy of liberalism: a house was neither superior nor inferior to others, all men are equal; and details such as windows and doors became subordinate to the

Amsterdam, Holland. 17th-century houses convey the presence of families.

design of the house, the street, the community. This was the kind of lesson that the English learned from Holland.

Inigo Jones had, of course, provided a true architectural solution to the aesthetic problem presented by the house, the street and the community in his first designs for Covent Garden in the 1630s. Short-cutting the craftsman's slow process of trial and error, and the long route through a jungle of influences and missed directions, Jones had already arrived at his destination by the time others had begun moving the same way. For the English style, guided by the Dutch, was also heading for a simpler and more compact architectural method. Windows lost their stone mullions; cornices diminished the importance of the roof, anticipating the Georgian parapet; brickwork superseded stone; pilasters introduced a sub-Palladian theme. It was a story similar to the Netherlands'. The English were making the same points but with greater conviction. A terrace was built, for instance, in Lincoln's Inn Fields that was seen as a single composition where the centre house had greater height and was given more importance than those on either side of it. Town planning was simplified at a stroke; a district could be comprehended in very large chunks and not confused and complicated by a haphazard collection of individual houses. It is this sense of unity that is fundamental to the Georgian style. And this particular terrace standardized a house front and street façade that spread all over London. They would have gone to the country if it had not been for the civil war.

Shortage of money and land, coupled with strengthening classical influences of one sort or another, produced the Amsterdam style. Expanding populations, the increasing importance of the town, and corresponding cost limitations coupled with similar influences, produced the Georgian style. The architectural guardians were people like Webb, Hugh May and Wren, but perhaps it was the Great Fire of 1666 which, on the scale of a modern incendiary war, really pushed the style out into the open; such disasters have a way of dragging the best people to the front, and the best out of those people. It could be said that a huge conflagration, an acute housing crisis, and the need for speed in rebuilding forced out the standardized component-built architecture we treasure so much today – but standardized in every direction, not merely the aesthetics, but

heights, according to the importance of streets. New regulations – introduced to stop flame spread – accelerated the process of simplification: windows were set back, the parapet replaced wooden eaves, and the sash took over from the casement. That was that: the Georgian style had arrived; diminishing evidence of the craftsman was superseded by the increasing influence of architectural disciplines. And, while the importance of such things as fire regulations can be overemphasized, it would be right to stress that, once imposed, they were exploited architecturally. Good design evolves in such ways: human requirements, however these may be interpreted, are the inspiration for art. Good buildings come from people: and all problems are solved by good design.

Fortunately, it was through Inigo Jones, his contemporaries and followers, that a great architecture was indeed created; fortunately, too, it was not possible then for schemes to fall into the bleak hands of pure materialists of the kind who are in key positions to control the direction of building today. There was, perhaps, a moment when, at the end of the seventeenth century, this could have occurred: there were speculators around who would have

Royal Crescent, Bath, England: architect John Wood (the younger) from plans by his father. Photographer H.T. Cadbury-Brown.

seized on the repetition and economy of the style to make easy money, so robbing it of its dignity. The Palladian revival put a stop to this; perhaps above all other things, it gave space back to architecture. What happened was this. Inigo Jones's death in 1652 did not mean that he had disappeared from the scene; his disciples saw to that. Eight years later there was Dugdale's book about Jones's designs for St Paul's Cathedral. Then Hugh May got the job as Comptroller of Works and John Denham (a close associate of Webb) became the King's Surveyor. A few years later Wren was made Surveyor General. The grip of the architectural network had tightened its hold on design and taste, and it was not going to let go. Webb died and left his precious collection of his and his uncle's drawings to his son who, in turn, left them to his wife. She promptly sold them to Dr Clarke who, with Hawksmoor, designed Worcester College, All Souls, and The Queen's College at Oxford. A set of five drawings by Jones was then published by Colen Campbell, designer of Mereworth Castle (a homage to the Villa Capra); and Clarke's collection of Jones's drawings was used, together with some acquired by Lord Burlington (designer of Chiswick House – another homage to the Villa Capra), by William Kent in his book on Inigo Jones which appeared in 1727. Inigo Jones was back, and as a much more influential figure than he had ever been in his lifetime. Wilton was, therefore, a microcosm of the whole story. It was his perseverance, toughness, vision and total dedication to his subject which gave him immortality. Working through others when he was Surveyor, his spiritual influence continued to do so after he was dead: through the Woods at Bath, Adam at Edinburgh, the Bastard brothers at Blandford, and Nash in London and Brighton.

It was – as it had been before, from the ancient beginnings of the classical story – books that spread the gospel, from Palladian principles to the carpenter's most ordinary detail. Once more, as in France and as in Italy, Vitruvius was published, and also Palladio's great work. But there were also the craftsmen's books, written specifically for craftsmen; they gave detailed information, and they were followed like textbooks. Where Palladio laid down principles of design, the craftsmen's writings formed the basis for a universal standardization of methods and products. Thus any joiner could

make a range of fanlights of the same design and as well as any other in any part of the country; and in this way a high quality in appearance could be maintained that was comparable to that of the Japanese (whose taste was regulated in even greater detail by sumptuary laws). Ultimately, the Georgian diagram was simple enough to accept all kinds of different situations that might happen inside and outside; the system that had evolved was extremely flexible. It put up a well-designed front to the world behind which people could do what they liked. Although individual houses were economically planned with narrow frontages, a sense of great spaciousness was gained by tall windows and tall rooms; there is no feeling of constriction when plenty of space exists above the head (a fact forgotten today when regulations fix minimum heights and lack of money establishes these minimums as maximums). But then these Georgian architects, influenced by Palladian ideals, were very conscious of space, and here again one thinks of the Japanese, who are so conscious of its importance that their language has special words to describe particular spatial situations: the space over the head, for instance, and the space surrounding objects. In the Georgian house it was the difference in room height from floor to floor that was the chief source of variation within, and it would be true to say that it was this consciousness of the need for variation in size of spaces that makes the range of lovely conversions carried out on Georgian houses a possibility today.

Again, the exterior was deceptively simple: while the façade presented a reticent and somewhat blank appearance to the world it contained a number of important incidents. The basement was one of these, and this was deliberately created by juggling with the ground levels. From an economic point of view, the basement was an ingenious method of getting around height limits, imposed when rebuilding was going on after the Great Fire. From an aesthetic point of view, however, it was discovered that an excavated area introduced in front of the house brought light and a pleasant outlook to basement rooms, and a visual break, not unlike a moat, between the vertical plane of the building and the horizontal plane of the street. This was all part of the innate flexibility of Georgian architecture which could be directly related to changing contours, and to the landscape beyond. The overall frame was so clearly stated,

and with such conviction, that slopes were no problem; this can be seen, for instance, at Shrewsbury or in the dramatic use of levels at the Adelphi by the Adam brothers: instead, a balance with nature was achieved – the primary objective of Georgian town planning. The introduction of squares, and the streets which connected those squares, brought a suggestion of the country estate – so imaginatively designed by people like Capability Brown and Humphrey Repton – to the town; they brought, moreover, colour and movement: the movement of leaves, for instance, can be crucial to the visual comfort of the urban scene (buildings are, after all, static elements). In this context, the Georgian square seems the ideal form. Here, the trees were planted around the perimeter; thus, in summer, the green centre of the square became a secluded breathing space in the middle of a dense city. From this, the surrounding terraces can hardly be seen for foliage; the terraces, on the other hand, have the advantage of looking at the trees, which also help to shade the rooms from heat and glare. In the winter, when the leaves drop off, the terraces have a different view: a view of space, and this is convenient because the light is poorer then, shade is not required, and the square is not often used. But, in a more general way, the organization of this relationship of architecture to nature was based on the same kind of factors which regulated the heights of buildings in an area. A square, say, has four storeys, an important street has three, a lane (now the fashionable mews) has two. So a town has a park, a district has a square or two, a street has its trees, and a house has a garden: simple rules which prompt a green thread connecting various parts of a city, and the city to the country. The balance is accomplished: a magnificent example, which uses, in addition to the square, the crescent and the circus, is Bath. And the curved form clearly goes further than the square towards a complete relationship with nature. It is no surprise that this universal style spread. In England it travelled from London to York, Norwich, Bristol, Derby, Nottingham and many other places. And it went abroad: to America, Norway (where it was copied in vertical boarding), and to the British colonies. It is no surprise that a perfect Georgian port exists in Tasmania, backed up by white-painted bow-fronted Regency terraces that are as good as any seen in Brighton.

★

So the story of the house begins with a hut in Mesopotamia, a country which is, curiously enough, equidistant from New York and Japan, from the modern centres, in effect, of West and East. It was from this point that man began his extraordinary journeys to the west and east. And towards the end of these journeys we see two traditional domestic architectures reach a state of near-perfection: in the West there are the classical ideals represented by the Regency work of the late Georgian period, in the East there is the continuing development of a style rooted in Zen Buddhism. Outwardly, both are quite different in appearance, and the ways of life of West and East are manifest in these differences: on the whole, both are created – and are seen to be – by diametrically opposed philosophies. In the West it is believed that there is, on earth, only one life; in the East it is believed that there are several. Outwardly, too, Georgian architecture made a thoroughly realistic assessment of modern problems – it was a practical tool which could be used to solve them – beside which Japanese forms seem to exist in a fantasy world of streams and the scent of flowers. Again, the structural methods of the two architectures express fundamental differences of attitudes that are not unconnected with climate: methods which are permanent imply finality of death, methods which are temporary imply confidence in the continual renewal of life. But inwardly, however different these styles appear on the surface, there are strange similarities. Both, for instance, achieved a balance with nature, and both had an architectural frame. The Georgians achieved their balance with nature in the urban scene through a more complex set of associations. Squares, circuses and crescents linked large compositions of houses and landscape; the terraces enclosed the trees, and the trees screened the buildings from different views; and so nature and architecture work together in a formal layout and cooperate in making contrasts which benefit each. The Japanese, on the other hand, put their houses in among the trees and allowed nature to gain the ascendancy in any composition. By selecting materials from their surroundings the connection with nature was difficult to avoid. There is a parallel, too, in the way that both architectures betrayed their inner feelings, as it were, to the company of their surroundings. The Japanese house, ringed by trees and grass, could be completely open; the Georgian terrace, in close proximity

to other terraces, presented a noncommittal and almost anonymous façade to the outside world. So both accepted the situations in which they found themselves, and the forms were suggested by them. And both, again, accepted these situations through the frame; this, in the case of the Japanese, was a structural order; in the case of the Georgians, it was a visual order. The Georgians looked up to the scale of the community: the squares, the crescents, and the avenues which linked them made the frame, and the houses may be regarded as the frame within this frame. The Japanese, however, looked only as far as the scale of the house: the mats, from which they organized the plan and then the three-dimensional form, made the frame within the structural frame. Finally, both had an aesthetic uniform where there were variations in quality of materials and size, but where the fundamental arrangements of shape and form were essentially the same; and both these uniforms were controlled by laws governing taste. It is hardly surprising that the Georgian domestic style emerges as the most remarkable in the world.

Stowupland House, Stowmarket, near Ipswich, England. A typical 18th-century design. Photographer H.T. Cadbury-Brown.

TEN | The Machine

As we know, the English style went to the American continent. The settlers required an architectural method with a repetition and brevity that would meet the practical needs of speed and efficiency. The English method satisfied these and the settlers copied it straight. This move shows no departure from the normal pattern of things. In this century, for instance, Le Corbusier started the Indians off with Chandigarh, warning them at the same time that they should seek more from local customs, materials and life, less from Western ideas. This advice had its historic precedents. In the sixth century BC, for instance, the Etruscans meticulously copied Greek art in their pottery before going on to find an indigenous style which depicted the gaiety of their life; and the Greeks did likewise, copying Egyptian art, until they too found an indigenous style. What the Greeks did for the Etruscans, the Egyptians did for the Greeks: started them off. And the English did this for the settlers.

The seventeenth- and eighteenth-century style was indeed the obvious choice. It was an example of the old maxim that form follows function – it was common-sensical and adaptable. The Dutch style, from which the English had itself evolved, was, by comparison, far too complicated for application on a universal scale; the different sized windows and gables which characterized the Amsterdam method were irrelevant to the needs of the settler. And as soon as the English gained financial ascendancy over the Dutch

– buying out their trading posts and so on – the Amsterdam influence ended and the plainness of the English took root. The fascination of this highly developed, post-Palladian urban style must, of course, be accepted. The classical elevation had a simplicity and coherence which quickly established man's presence on the scene, a factor which was most important in the case of the settler. But this English style had other attractions, none of which can be separated from the human instinct for security. In the first place, it presents a house, and although this house is joined to other houses, so making a terrace, the door and window arrangement establishes the presence of each house: and this house provides a frame for the family, where the terrace provides a frame for the community.

Then again this frame encourages the participation of the human being along Palladian lines, recalling my theory of the cardboard box. The style produced a framework which preserved privacy and, in so doing, also produced an outward reticence which did not deprive the human being of his initiative; it encouraged him to pursue it. Architecturally, the spirit of his contribution is reflected in subtle variations of façade which, in turn, respect the individual. Thus all aspects of the style are intent upon working with human nature, not in conflict with it, and on producing an order which is in harmony with it; privacy is protected and feelings connected with identity are stressed, simultaneously. Again in its favour, and again particularly important in the context of insecurity, the style had associations with aristocratic 'class', and therefore supplied a suitable accompaniment for the Americans' growth in status which ran parallel with the country's increased confidence and affluence. For some reason, personal achievement – and the rituals which go with it – must be defined in terms of possessions, particularly in the West.

The form of the English style represented the first Western breakthrough in industrial building techniques, and it may be quite properly regarded as an embryonic kind of system building. This idea appealed to a fast-developing industrial consciousness in the United States (prefabrication was the tool needed in the circumstances) and the style supplied the beginnings of this method of building. The components of the English system were standard. At the same time, the Americans had to make adjustments to suit requirements

created by different circumstances. But these modifications formed part of a pursuit of simplification which was forced on the façade by the urgent pressures of standardization. The English, for instance, set their windows back from the face of the brickwork; they had to do this to comply with the fire regulations. The Americans, on the whole, set them forward so that they followed the surface of the outside wall, and here they adopted the technical thinking which perfected the detailing of the weatherboarded house, thus protecting the junction between window frame and wall from the weather. Timber construction naturally suggests this method as the simplest solution to a perennial problem; the Norwegians also adopted it in their vertically boarded version of the English style. Thus the American decision was a technological one, and more important than it at first sounds. Their method meant the creation of a smooth façade where every possible projection and indentation was done away with. This adjustment to the design made a single surface that could be considered in pattern form: part glass, part brick or boarding, as the case might be. Thus the precise point at which one material departed from another appeared as a line: a more or less direct reproduction of the drawn line one sees on structural diagrams; no shadows, no modulations. With a single and almost imperceptible variation in design the English model had been taken a few steps forward in the direction of the modern industrial aesthetic, towards the continuous skin and the glass envelope. From the labour point of view the adjustment meant a quicker operation; it reflected a search for simplicity that was consistent with the American method and based on the necessity to get things done with a minimum of fuss. At the aesthetic level, an element of abstraction had crept into the picture, and this meant, possibly, that something of the spirit of the original had left the scene. A slight differentiation between materials is desirable; in this light, the American method seems fractionally less subtle than its English counterpart, the emphasis on human scale a shade less strong.

The American domestic style matured in the eighteenth century and so ran parallel with the development of Georgian. But from copying the English in the beginning, the American settler had gone on to find an indigenous style – the Colonial style. Most commonly represented by white-painted boarded houses, it suggests

a cross between the log cabin (brought to Delaware by the Swedes in the sixteenth century) and the classical frame introduced later. The frame absorbed the native architecture, gave it order and assisted it to progress: a process which can be compared to the effect of the classical influence on Tudor and the rural architecture of the French. But, like Georgian, the Colonial style accepted numerous variations within the general framework. Scale differed: some houses were three-storey, some single-storey and with deep overshooting eaves, some hid the roof behind a parapet. Some terraces were brick, some windows had shutters, some had verandas. But the style always remained distinct and firm. And it spread, rapidly, in all directions: to Old Deerfield in Northampton and Hadley in Massachusetts, to Rhode Island, to Stonington in Windsor, Litchfield and Farmington in Connecticut, to Washington in North Carolina. A comprehensive architectural picture was, moreover, completed in a century, and patches of it in half that time. In 1650, say, the formula was nonexistent – the English settlers were groping about in medieval forms with oak and thatch. However, with the first sawmill in operation in 1649, the weatherboarded style developed from cottage to house architecture by the latter part of the seventeenth century. And so there is this extraordinary picture where one domestic image is superimposed on another – caves, tents, log cabins, timber-framed construction, the Colonial style – and where the lengthy processes of evolution are missed out in a sequence of technological jumps which cover great distances, like slides at a lecture depicting the story of man from the Stone Age to the eighteenth century, all in the space of a hundred years or so. But where the Colonial style remained tied to the scale of the street, and thus to the individual, the Georgian style had, in the meantime, continued to a point where its scale embraced the city. And then, in the United States at the end of the eighteenth century a reversal of the normal pattern of events took place and the cards were shuffled: rich people began building large Palladian villas.

Throughout the story of domestic architecture, certain patterns emerge. Medieval buildings, for instance, with their slit windows, moats, and solid entrance doors suggest an oppressed society – oppressed by fear and violence. But as internal wars decreased, and the social structure became more stable and ordered, windows

enlarged, and moats and other defences disappeared. Similarly, as civilization progressed, and enlightenment became more general, education gradually seeped through to a greater number of people; equally, wealth was distributed more fairly, and so the number of slaves, serfs and servants correspondingly decreased. Correspondingly, too, the form of the house follows suit, becoming more domestic and varied, more workable for increasingly modest requirements, less extravagant in appearance, and planned with greater economy; the plain neutrality of the speculatively built Georgian terrace was a reflection of this trend. In the ordinary way, every style has its prototypes: the Palladian mansion, for instance, was eventually succeeded by the eighteenth-century street. But in the United States the reverse process occurred; a start was made with the street formula, and then, as Americans grew richer and life was more settled, social needs correspondingly increased. Wealthy Virginians had bigger ambitions. Yet the picture they wished to project of themselves was not so much financial as cultural: something of lasting value had to be shown for their wealth. It was as though these people had, like the historian Francis Parkman, quite suddenly fallen in love with the past they had lost or destroyed along with the Appalachian forests and the Indians. But because the West was still regarded as a safe-deposit box of knowledge from which ideas could be taken and, so to speak, processed in American laboratories, it was from the West that guidance was again sought. And so these extremely beautiful, enormously grand houses began to appear up and down the East Coast. The influence of Palladio was most evident. But the man who brought this Palladianism to America was, unquestionably, the remarkable Thomas Jefferson.

Scores of them were built: Arlington in Virginia, Andalusia in Pennsylvania, Berry Hill, the Wilson and Dexter houses, and the Woodlands are among the best. Most had porticoes, and mostly they were set pieces central to some vast landscape composition of the English kind. Stucco was the finish generally common to all, and certainly all were designed and made perfectly, down to the last door handle and brass lock. These houses were not, as they have been said to be, examples of Greek Revivalism, the movement which was fashionable on the English nineteenth-century

scene. They were the genuine articles, as genuine as the work of Inigo Jones, Gibbs or Adam.

Jefferson's buildings set the example and acted as the prototype. Again, we see the pattern in the life of a style developing as before. But again, true to the American story, the time taken over its evolution seems telescoped; everything happened very fast because what was done had been done before: the period of trial and error was left out. The Palladian method was applied – as the English town house style had been earlier – to suit the local materials, status and scale. Palladian porticoes from the Villa Pisani were recalled at Belmont in Tennessee, and yet again (although it is the ghost of the Villa Sarego that floats through the composition) in the really original arrangement of avenue and colonnade – tree trunks and columns – at Oak Alley in Vacherie, Louisiana. Such works, and the many others like them, seemed to have been the last, flashing glances of the Renaissance; a brief vision of the pioneers whose work had, in the first place, inspired the town architecture which preceded Belmont and the rest. It is a curious reversal of the normal historical order; and now, looking back, these houses appear as a portent, like the energy and vitality sometimes gathered together in a moment of recovery just before death.

There is something to this analogy. These beautiful and stylish buildings arrived too late, and at the wrong time, to effect what happened afterwards. Produced out of context and in isolation, they could lead nowhere of significance: an architecture with a universal range could not follow in the way, for instance, that Colonial house design had followed seventeenth-century English classicism. The Industrial Revolution, waiting around the corner to demolish the high ideals and values they reflected, meant that any continuation from such a point of departure would indeed have been, in Lewis Mumford's words, 'a rootless affectation'. Instead, Palladianism declined into the worst kind of Greek Revivalism. Once corrupted, architecture quickly goes to seed – our situation today is witness to this. And the commercial view that art is merely an ornament with which to decorate life (and not an absolutely integral part of it) accelerates the downhill process. The view that art and life are separate beings, and that culture can be bought like a painting or an old castle, may be a reason why building there went so rapidly

to the bad – as indeed it is in Europe now: nothing, for instance, could surely seem so separate as the shoddiness of English structures to house the poor and the vast amounts of money paid out by the rich for art works as investments.

In the United States, architecture degenerated at an amazing speed during the nineteenth century. Street forms ran through a hundred years of European styles in a decade. The purity of Georgian was overlaid with Victorian decoration; houses and terraces became suddenly much heavier in appearance, bigger and taller: they were copies of copies and thus architectural evolution stopped. Delacroix puts the Western position clearly in his *Journal* of 1850: 'Ordinary architects are able only to make literal copies, with the result that they add to this humiliating evidence of their own lack of ability, a failure to imitate successfully. For although they may copy their model exactly down to the smallest detail, it can never be under precisely the same conditions as the one they have imitated. They are not only incapable of inventing a beautiful thing, but they also spoil for us the fine original, which we are astonished to find appearing flat and insignificant because of their treatment.'

What would he write now? But in the United States only the traditional Colonial style – in country districts near the land, where agriculture and craftsmanship were strongly entrenched – held out in the face of the vast, speculative and commercial architecture that was sweeping west from Europe with the wind.

It is significant, possibly, that Delacroix wrote with great passion not once, but three times, about architectural imitation. While he himself relentlessly pursued the true nature of romantic painting within the framework of the classical tradition, his generation exactly preceded the coming of the French Impressionists; perhaps he sensed a weakness in his own position which was revealed in what he says about building – he was the first painter, for instance, to write about colour. But his view that the real meaning of architecture 'lies in the absolutely essential harmony between common sense and great inspiration' expresses the line of continuity which links past and future: the eighteenth- and twentieth-century rationales – this cannot be stressed too strongly. But Delacroix's

point also links up with Locke's belief that a person's character is formed by his experience and that strongly stated architectural forms are an essential part of his background; and this suggests, in itself, a reason why ornament, decoration and the over-elaboration of façades are extraneous to purpose, if not bad. We are often told this is true, but not explicitly. Wittgenstein once made a remark which could be interpreted in much the same way, and he started out as an engineer. He said of a friend, who had a lovely house filled with pictures and other things of great value, that his possessions would corrupt him, indicating that they might take over his life. For 'possessions' one could read 'ornament'; and ornament can take over a building, becoming with time a form of disguise which, initially selective, degenerates into pure imitation. At this juncture the architectural elements which define the structure, proportion and form of a building can become so suffocated with an overlay of unnecessary bits and pieces that they can no longer be seen. When the dramatic crash of architectural values occurred in the nineteenth century it was, in particular, the classical sense of scale that went: the scale and proportion of a window, door or room in relation to the size of a human being. But it is at this juncture, too, that a style may go through a period of renewal, eventually being replaced with something else; modern architecture, for instance, followed the nineteenth century, and Le Corbusier re-introduced human scale (a factor ignored by those who have copied him). The human instinct to simplify is constantly active; after a time, the eye cannot accept more than a certain amount of visual confusion: we must, in fact, be able to comprehend what we see, and relate it to the size of a human being – which was Locke's point.

The urge to simplify is reflected in a strand which runs right through American architecture. First it shows itself in the adoption of the Georgian style, and then in the standardization of its parts. But it shows also in the cities that were planned and grew around the time architectural coherence began to break up. While the craftsman is important to the quality of a terrace, the street plan affects both the individual and the community as a whole. In some cases the American town evolved in a rambling and, by English standards, normal way out of river valleys and harbours. This was

the early form of Boston: the houses followed footpaths like an English village. But more common was the application of the grid, relics of which still exist in England – at Winchelsea in Kent, for example – but otherwise scarcely used there: the Roman system did not really suit England, the country is too domestic in scale, too up and down. English planning needs plenty of on-the-spot improvisation and constant adjustment to the irregularities of the contours. Still, the English took the grid to Ireland – an isolated spot with a much flatter geography – where it was widely used at the time of the colonization of America which was, of course, the perfect site for this method of planning. The country was so vast that a system of this kind was required if only to define the problem and to establish the human presence in a seemingly infinite space: this takes us back to the people of the Indus again, and their reasons for using the grid. The system also meant that the number of people to the acre living round a central square was known and that a town or city could be reduced to communities of a comprehensible human size: these assisted people to establish where they were and their position in a metropolis. Thus what the proportion, say, of a classical window was to the individual, the square in a grid was to the community. In the early examples, such as New Haven of 1824 in Connecticut, the square was usually occupied by a church and a meeting house, and, since terraces were not popular at that time (with so much space and a thin population they had no function), the architectural spaces were linked with trees. The avenue was, therefore, exceedingly important to the coherence of the New Haven scheme – so important, in fact, that its visual association with the cathedral structural form it resembles was remembered in the naming of streets. So, on a small scale the grid made the perfect community form, as the Greeks had discovered at Smyrna in the seventh century BC and at Metapontum in the sixth century. Expanded on a large scale it could, however, be a different matter, the streets very easily losing the respect for individual identity displayed at New Haven.

The enlargement of the grid town into a city is possible provided the total area is broken down with, say, the green squares that appear in the original plan for Philadelphia. And at Savannah, Georgia, one sees a diagram which suggests how the idea could be exploited

to a real architectural and imaginative end, with houses arranged in more informal ways within the strict framework of the grid and with considerable variations of spaces. This arrangement recalls the Georgian frame where, working within the classical discipline, asymmetry often appeared out of symmetry, again demonstrating the flexibility of the method. But as far as the grid plan goes – and the Georgian, for that matter – the element of scale, and not merely the street pattern, was important. The inherent scale of the place – the building related to the size of a human being – had to remain intact. When tall structures replaced houses and gardens, traffic congestion replaced quiet streets and such things as express-ways took over, all the quality and possibilities of the plan disap-peared, and the form was destroyed. Another limitation of the grid, when conceived on a city scale, is its rigidity. No doubt there were shortcuts by footpaths through the squares in the less ambitious, earlier days but solid blocks of buildings quickly excluded possi-bilities of this kind. Eventually, the footpath became the diagonal route imposed on the grid which, while improving transport, finally destroyed the format of most American cities of the mid-nine-teenth century. Until then only a few cities used the radial scheme – Detroit, for example – while some used radial avenues imposed on the grid. And so another idea, remarkable in itself, came to nothing. It was defeated by the machine which had helped to make it – as the craftsman had been defeated. Like craftsmanship, it had solved a problem, after which it became obsolete. As Mumford said, 'It was another false start, another unfulfilled ambition.' The commercial values which had put 'paid' to the classical influence over the proportion and scale of the terrace had caught up with the city plan and eroded it.

After this it was the end – Los Angeles, for example. All the small things that ordinary people care about – some individuality, pieces of privacy, a slice of nature – became impossible, outlawed by the progress of materialism. The house with a lawn and some trees became little more than a memory that had been concreted over, some time in the past, and people have no recollection of things so completely and suddenly buried. But even now one wonders whether the Roman heritage has gone forever. After all, what Hadrian brought to England was reproduced nearly 2,000

years later in Ireland and the United States. It was only because of outside pressures – populations, traffic, vast commercial developments – that a strong and purposeful idea failed; and because, when complications set in, people did not know how to use it. The old Chinese saying holds good: 'If the wrong man uses the right means, the right means work in the wrong way.' Beijing, for example, is planned on a grid, and the pattern of its evolution has not altered over twenty centuries or so because, very simply, the pattern of Chinese life has not altered, or at least very little. Beijing works as a city because, again very simply, the architectural frame respects the identity of the individual, allowing freedom of expression. Nature is included in this: the automobile is excluded. What perhaps Beijing reveals is that simplification accepts the things people care about and encourages them to pursue their interests, and that it thus possesses a precisely similar human quality to that possessed by Palladian and Georgian architecture: the quality of providing a background and an underlying order for living. Oversimplification, on the other hand, suggests the abstracted acceptance of human physical dimensions to the exclusion of emotional considerations, and in these nature plays an important part.

White boarded early 19th-century house, Bennington, Vermont, USA. Photographer H.T. Cadbury-Brown.

19th-century terrace architecture, 16th Street
N-W Washington DC, USA. Decorative overlay.

19th-century red brick terrace architecture, Richmond, Virginia, USA.
Standardization. Photographer H.T. Cadbury-Brown.

Now the grid accepted nature in its form in much the same way that the module of the Japanese house had done. In both cases, the simplified order of the man-made plan had an affinity with the more complex order of nature: these orders are complementary because they recognize the need for each other. Again we see the sense of the old saying: it is not the grid that is wrong but man's misuse of it. Nature has its own order but obviously no choice in how it is used. Man, on the other hand, has this choice over the use or misuse – as the case may be – of both his own simplified order and nature's more complex one. So, in the beginning – at New Haven or Salt Lake City – we see a balanced order where both nature and man enjoys the company of the other: the avenues lead nature by the hand down the roads at New Haven, and the mountains at Salt Lake City are so powerful that they diminish the city grid to a latticework of routes out of which the mountains appear to grow. The acceptance of nature is apparent in William Penn's early plan for Philadelphia in 1682; here it shows in terms of the square contained within the Roman grid which acts as a breathing space in a built-up city. But in the later nineteenth- and twentieth-century versions this clarity declines and nature begins to be exhibited in a somewhat self-conscious manner. It is when the grid is found to accept nature no longer that the two conflict, and both suffer. For instance, one finds nature displayed by man in sentimentalized ways: as 'landscaping' (and not pursued, as Capability Brown pursued it, for its naturalness), tulips set out in ranks like some absurd miniature military formation, flowers made into words and all the rest of the suburban paraphernalia. Architecture loses from this lack of respect: it works both ways. Nature is only respected when it is allowed to retain its own order and is not simplified to coincide with man's. Conversely, architecture can only be respected when it, too, is allowed to retain its own order and is not reduced to the same level of man's misuse of nature. If, for instance, we watch people in a park running about among trees – those huge, calm and noble presences – the underlying meaning of the different orders becomes clearer. The grid of trunks accepts people as the mountains accepted Salt Lake City and the cross-axes of routes at New Haven accepted nature. We know more of Palladio's intentions when he talked about the spirit of nature being transferred

to the making of architecture, and more about the significance of the repetitive posts in the Japanese module.

It is the absence of respect – for the individual, for nature and for the materials which emanate from nature – that is the most noticeable characteristic of twentieth-century architecture.

The American order reveals a method that was largely the outcome of material necessity, as exemplified by the Colonial style and the grid. Another pattern emerges. First there is the simplification of classical ideas to meet specific situations; but then, and leading from a more material attitude to things, the logical conclusion of this seems to have been oversimplification. An illustration of the process is Victorian architecture in the United States which was, again, copied straight from England. The irregularities of the Georgian style were ironed out in favour of more complete standardization. The human presence, so vividly conveyed by eighteenth-century buildings, was given the 'drawing board' treatment, and largely suppressed; but, to avoid the thing becoming boring and to disguise dullness, the façade to a terrace might be camouflaged with a mean-ingless overlay of decoration. This led to a stronger division between inside and outside, and between people and a style, that was more crudely expressed than by anything that had come before. And this method of building, which first indicated the exclusion of the human being for purely materialistic ends, was a foretaste of what we are experiencing today when one of the great human prob-lems is loss of contact. Massive technical developments are propor-tional to a massive neglect of people. For instance, it could be held that respect for people is inversely proportional to technical progress and a formula devised to show how this decreasing respect runs parallel to the increase in progress, people paying less attention to emotional and psychological factors as the machine does more for them. This is the danger now – an artificial situation is being created – and at some speed. Hanns Sachs, writing in the *Psychoanalytic Quarterly*, called attention to it as long ago as 1933. Loss of respect for the human being was central to his argument. Conversely, he showed how the Greek and Roman regard for the human being could be seen to suggest why they resisted economic pressures to pursue the machine in a practical way when it was within their

power to do so, and instead used it only for play. To illustrate his point he recalled a visit to England made by Heinrich Heine in the 1830s when this country was ahead of Europe and on the brink of the machine age itself. Sachs explains that in his play, *Florentine Nights*, Heine makes the Figure voice his own thoughts and impressions: 'The perfection of machinery, which is applied to everything there, and has superseded so many human functions, has for me something dismal; this artificial life on wheels, bars, cylinders, and a thousand little hooks, pins and teeth which move almost passionately, fills me with horror. I was annoyed no less by the definiteness, the precision, the strictness, in the life of the English; for just as the machines in England seem to have the perfection of men, so men seemed like machines. Yes, wood, iron and brass seem to have usurped the human mind there, and to have gone almost mad from fullness of mind, while the mindless man, like a hollow ghost, exercises his ordinary duties in a machine-like fashion.'

This makes extraordinary reading now, more so even than the later comments of Delacroix, which were about another aspect of the same thing. And what would Heine say today with the automobile becoming indistinguishable from the driver, buildings from graph paper? But this is precisely what he is talking about. Sachs goes on to suggest that the development of the machine at the expense of the individual intensifies loss of identity because feelings of unreality about the human body are magnified, and he examines fantasies and hallucinations of schizophrenics which demonstrate how the machine and the body become confused, the body dematerializing as the machine becomes more influential and dominant. For the Greeks and the Romans, totally committed to the supreme importance of the individual, the confusion this implies would have been repulsive, and rightly so. Transferred to architecture it becomes, if anything, more repugnant since it is then a very large, visible, indisputable fact. Yet this is where the unquestioning acceptance of the machine has led. And as the machine does more for people, and the number of inventions increase, the less easy it becomes to appreciate the need, growing all the time, for adjustment. A corollary of discovering how to adjust ourselves to vast technological advances is the discovery of what we need to make life rich and enjoyable. In architecture as in life we have first to

discover what is needed, then to achieve it. And then we can build on what we have discovered and continue to develop. One of the ways to do this is to look right back into the past as Palladio, Inigo Jones and Le Corbusier did, to explore it, and then extract what is important: once related to modern conditions, the essentials which still apply will be seen, and one of these will be the understanding of how to use industrial ideas. For instance, when the caveman needed a tool it was perfected. Today the equivalent tool is machinery – the wastemaster, say, or the refuse disposal unit – and with internal machinery of this kind the last vestiges of human contact can be sucked away. But, and again this must be stressed, it is not the machinery that is wrong: what is wrong is that machinery has taken precedence over architecture, lessening the apparent need for an aesthetic order and thus limiting contact between people of a kind known and remembered in the past. For in the end people need what they have always needed: other people, and places which stimulate contact and creativity, and provide privacy. But they also need assistance and guidance. In particular, perhaps, it would seem clear that what people have to acquire is some psychological adjustment to overwhelming pressures that attack from every side. A tool was needed to counter these pressures and it was found: the psychiatrist. His advice – crucial in times of stress – is required in every field of environmental research now. Another tool – crucial at all times – has failed us: building.

So oversimplification works against human nature, blocking its development, and this seems to be because contact with reality becomes, in consequence, remote, and solutions to problems about living increasingly abstract: rules are imposed which exclude the human being and deny him the freedom of expression which the true simplicity and reticence of eighteenth-century architecture, for instance, encouraged. But now it is the machine that has intervened to deprive people of their initiative. Surrounding us in one form or another – as mass production, mass media or straightforward technological gadgets – it is the machine which, on an international level, now represents those cultures of the past that were first copied and then so absorbed in different systems that indigenous styles evolved from them. Again, it is the appearance of the machine and its methods which have been copied, not the

underlying principles. And the unpleasant truth is that machines, while productive, never create; they work under orders and continue to copy. Thus copying this culture, we learn to copy, to be productive, not to create. The first evidence of this sort of imitation appears in the nineteenth century when classical detail was machine-made: human irregularities had begun to be straightened out. But today, the model is functionalism and this is worse than the former kind because it is duller and more repetitive. So the identical blocks of flats which sprout up everywhere have as their justification the theory that, if conditions are the same, it is irrational to be different. Louis Sullivan, the American architect whom Lloyd Wright followed, made this point for intellectual reasons which were, unfortunately, totally misunderstood by others: and Dan Burnham, a Chicago architect practising in the nineteenth century and married to the daughter of his richest client, took Sullivan at his word and re-created 129 acres of the city with identical blocks that had identical standard steel windows. This scheme, horrible in every way, can be seen as a portent. But perhaps another American architect puts it best. William F. Lamb, who designed the Empire State Building, said: 'The programme was short enough – a fixed budget, no space more than twenty-eight feet from window to corridor, as many storeys of such space as possible, an exterior of limestone, and completion by May 1st, 1931, which meant a year and six months from the beginning of sketches. The first of these requirements produced the mass of the building and the latter two the characteristics of its design.'

Here are quick lessons in how to become a millionaire at the expense of people: William F. Lamb had travelled a long way since Palladio.

It was out of the darkness and soot of the Industrial Revolution, the factories, tall faceless structures, skyscrapers and the rest, and from the inventions of that time – the new machines, cast-iron and bridge spans – that the modern architectural style came, innocent and sparkling, arriving with a bang quite suddenly, so it seemed, at the beginning of the twentieth century.

The Industrial Revolution made some progress for man: it was another of those extraordinary jumps forward in the story of

civilization, like the changeover from hunter to farmer; but at what a cost in terms of human suffering. The material gains presented by the machine and the amazing, dazzling view of wealth opened up by the speed of mass production overwhelmed all human considerations, and were, to the industrialist, irresistible. But for millions of poor people, including women and children as young as five, the discoveries meant nothing except enslavement and life imprisonment in the iron foundries, wool trade, cotton mills and coal mines: in fact, sheer misery and poverty, the side-effects of which are being felt in the social revolutions of industrialized Western countries today. On the production side there was also a complete change: hand-made articles became machine-made, and the control of craftsmanship passed from man to the factory. But the design and style of such articles were often most surprising, not at all the sort of thing one would have expected, suggesting a crazy ornamentality − not, say, the sharp simple aesthetic of contemporary machine-made objects. It was an absurd mix-up of ideas and threads. What had happened was that traditional conceptions about art and craft became tied to the new methods of production: events in the technical field had moved so fast that people did not have time to adjust themselves to changes of a radical nature and were thus unable to put the methods to their proper use. The right means were made to work in the wrong way; that is to say, only the superficial possibilities of these means registered. And so, of course, for the time being, no aesthetic true to the nature of the machine emerged; people were so baffled by the scale of the advances that they could not see how to apply them to day-to-day needs. In fact, we are in much the same difficulties today as we were in the nineteenth century: events are still moving so fast that we cannot adjust ourselves to them and are thus unable to control the means that are at our disposal. And, in the same way, it seems impossible to make these means work in the right way, and constructively, and instead we allow them to dominate us and bring chaos to our society. Variations on this theme, we notice, have occurred before; in a way, it is an old story. The Sumerian discovery of the arch had to wait 2,000 years for the arrival of the Romans before it could be given a structural outlet, and the Egyptians did not understand the meaning of the ziggurat and therefore used it in the wrong

way. But 3,000 years later we find Le Corbusier recalling the form in his Palace of the Governor at Chandigarh – and most appropriately, since this new city is not far from the Indus where, again thousands of years ago, the ziggurat was tried in a pyramidal shape. But, of course, events pass us by partly because we become too bogged down by tradition to make a break and try applying new ideas. Human beings – and the human emotional mechanism complicates all situations – find the whole business of accepting change and adjusting their outlook to meet the needs of change, one of the biggest obstacles to progress, and the more entrenched tradition is – and in Europe its foundations have been cemented into position by centuries – the stiffer is the resistance to change. In nineteenth-century America, for instance, tradition was far less well established than it was in Europe, and, therefore, although the Industrial Revolution arrived on the scene slightly later, its effects were felt much more rapidly. It swept across the continent invading every corner and crevice: modern methods were not resisted; they were welcomed. In England, on the other hand, the opposite was the case and resistance to change was stiff. It still is, and, as an example, a sort of social syllogism can be made out of the presence of the computer: man invents the computer, the computer puts man out of a job; therefore society rejects the computer. And so the computer fails to be properly used. We may indeed have to wait, like the Sumerians, for another civilization to come along and see everything freshly before the fantastic discoveries of the twentieth century are properly used for the benefit of man.

So it was that at the Great Exhibition of 1851 the maddest and most improbable collection of products were shown inside Joseph Paxton's beautiful and immense glass chrysalis – the Crystal Palace. For here the complete absurdity of the situation was truly exposed. Paxton's iron structure was of the most modern kind, like his conservatory at Chatsworth or Brunel's bridges. The objects inside – Persian carpets, vases, silverware and patterned materials – were only made by machines because more of them could be made more quickly; otherwise, there was no deviation from tradition. Doubtless all these things, most of them hideous, were thought to be marvellous. However, at the same time, even die-hard Victorians admired Paxton's structure; one architect commented, '. . . a new

style of architecture, as remarkable as any of its predecessors, may be considered to have been inaugurated.' As a matter of fact, it had not been: Europe had to wait another sixty years for that style. Both Paxton's glass houses and Brunel's bridges were structural ideas but, amazing though they were in themselves, they went no further than this: they were portents, no more, as Abraham Darby's iron bridge (the first of its kind anywhere) of 1781 across the River Severn had been. And when Brunel was commissioned to design the 1851 exhibition building all he could manage was a stodgy neoclassical edifice in stone – a scheme rejected in favour of Paxton's idea for a temporary structure. No; these pioneers were engineers who were testing the properties of certain materials still in the experimental stage. E. R. Robson, the great English school architect of the 1870s, remarked: 'Our difficulty lies in the fact that, considered as a vernacular or universally-practised art, architecture has not had a being for many years and there is, consequently, no prevalent architecture of good type from which to develop.' Yet there was, generally, a feeling of disgust for nineteenth-century materialism; the spirit of art, high ideals and so on could not be crushed without a fight.

This attempt to put the art back in architecture and the craft back in building was, of course, led by William Morris and Philip Webb in England and by Henry Richardson and Stanford White in the United States – the two most advanced centres of the Industrial Revolution in the world. But, unfortunately, the work of Morris and Webb and, more particularly, that of their Pre-Raphaelite friends (Edward Burne-Jones, Charles Voysey and Gabriel Rossetti) was directly responsible for the emergence of Art Nouveau, a style which totally rejected the machine and went back to nature as a source of inspiration. In fact, the style was further from the meaning of nature than machine art, seizing on its superficial appearance of muddle and bypassing its underlying order and repetition (blades of grass, leaves of trees, for instance) that were so perfectly understood by the Japanese. Art Nouveau became, therefore, a fashionable offshoot of the Arts and Crafts Movement (Morris and Webb, not unnaturally, disowned it) and, like so many other shallow decorative styles, it spread rapidly to Belgium, Germany and France; in the United States the fashion was taken

up by Louis Sullivan who passed it on to Frank Lloyd Wright. And although Wright was sympathetic to the style (brought up in the country on his uncle's farm, he was immersed in nature and loathed the industrialized advance of cities) he does not seem to have seen in it any qualities outside those of decoration. Wright did not reject the machine; what he criticized was its misuse. And, therefore, while hints of Art Nouveau haunted his buildings throughout his life, it was to an architectural balance with nature that he looked for his inspiration, and the nearest copy available for this was the Eastern house. A style as suspect as Art Nouveau could not last, any more than its products − whether in the sphere of painting or architecture − could survive the searching, questioning gaze of analytical eyes. If we reject all that is central to our times we must expect

Huitträsk, Kirkkonummi, Finland: architect Eliel Saarinen, 1902. Private house and design centre, log construction.

to be rejected, too. Art derives its vigour from change: only in this way can it truthfully reflect the human struggle to continue, to survive. And it was Le Corbusier who, from the beginning of his life's work, rejected Art Nouveau.

This is the kind of background against which the modern architecture of the twentieth century has to be seen: the decline and eclipse of the Palladian influence, a shouting match of revivalist styles, industrialism, invention, fashion and controversy out of which no coherent argument could be heard above the din; chaos perhaps, a shambles certainly – both understandable – man simply had not had time to digest his new knowledge. And what modern architecture did, as much as anything else, was to sweep away the debris of half a century and restore an element of sanity to the scene: it returned the design of a building to a consideration of first principles. And so European architects went back to the beginning again: not to the Renaissance, and not only as the Renaissance did, to Greek principles, but to the principles that lay behind them. In housing this means, in effect, that they went back to the shelter, to its bare contents, to the real meaning of the house and man's

Agrigentum. Ruined temple on the south side of Sicily, among a number of Greek colonies. c.400 BC Photographer H.T. Cadbury-Brown.

needs without the props of ornamentation and preconceived ideas. Le Corbusier, for instance, found his inspiration in the primitive village architecture of the Greek islands which he visited when he was eighteen. It was in the simplicity of its whitewashed sculptural forms that he saw a recognition of the essentials of life, but in the context of the classical frame – the post-and-beam structure expressed in the Orders – and the feeling of space in and around them. Similarly, in the United States, Wright went back to the principles that lay behind Japanese architecture and, again, this meant seeing the house as a shelter, but one which was linked particularly with nature, and not so much as an object isolated in space – the Western view. Thus Wright emphasized elements, the parts of a house: roof, podium, fireplace, stone walls. And Le Corbusier emphasized the frame: the space where everything happened. And it is with the frame that, architecturally, the evolution of the house begins and ends. The function of the house as part of the community has not advanced from the Georgian frame and, in isolation, nothing has been done which improves upon the spectacular Le Corbusier Centre in Zurich, designed as a house and built in 1967, after the architect's death.

ELEVEN | The Mandala

So far, this account of the evolution of the house has been straight-forward: it presents a picture of man's struggle to survive and continue, beginning with the cave and ending at a time when quite complicated structures are made to meet the general complexities of modern life. But behind this story is another more emotional and elusive force which manifests itself in a search for balance and harmony. And the underlying theme which emerges throughout this book – a theme reflected in the relationships and differences between East and West building conceptions and methods – seems to insist that this other human force is seen and recognized.

People are never perfect: and the knowledge that they are not drives them on to try to create things which are perfect, and this struggle for perfection helps them to progress. An attempt to indi-cate what lies behind this struggle could be made by following Dr Carl Jung's example and calling on a symbol. As he pointed out, people turn to symbols of various kinds when they try to give meaning to things which are beyond the limitations of reason and the intellect. In this case the point that has to be made is that there is more to a building than pure function; it is more than a sequence of rooms, more than the sum of its parts. And what has to be somehow conveyed is that a balance exists between practical matters and matters of the spirit. Words and numbers are symbols, but a more complicated symbol is required to explain more complicated

problems, and the symbol which provided Jung with the most profound insight into those aspects of life and psychology that seem to be incapable of explanation in ordinary language was the mandala. This is the symbol which is also, perhaps, most suitable in relation to architecture. In itself, however, it is possibly not quite enough. Leading from it, some specific illustration can help to show how an interpretation of such a symbol works out in practice: and for this the houses and development of those two great modern architects, Frank Lloyd Wright and Le Corbusier, seem to serve best.

Jung held that the sources of human inspiration had remarkable similarities, and Dr Glyn Daniels's claim, for example, that civilization today has its roots in the independent evolution of seven civilizations occurring at different times in various parts of the world merely adds authenticity to this view. However, in his commentary on Richard Wilhelm's study of the Chinese mind in *The Secret of the Golden Flower*, the only pictorial evidence that Jung offers in support of his argument is the symbol of the mandala. At first sight this may sound rather meagre. But when the mandala's meaning becomes clearer all its ramifications seem to apply in a bewildering number of ways, not simply to human problems but to every part of life, to the complete theme and rhythm of living, art, science and architecture. Thus the mandala was sufficient for Jung's purposes. In the first place, as he explained, examples of mandalas have been discovered all over the world: the most beautiful originate from the East but the earliest known mandala, dating back to Paleolithic times and resembling a 'sun wheel', was found in Zimbabwe in the early 1930s. Mandalas of the 'wheel' and 'flower' sort have also been discovered in sand paintings by Pueblo and Navaho Indians. The mandala, however, is not just an ancient symbol which, buried in history's unconscious, has been dug up by archaeologists; possibly the strangest observation Jung makes is that it is, as a universal symbol, as living now as it was far back in the distant recesses of the ancient Chinese mind. Jung says that before he ever became concerned with Eastern philosophy, his patients (who had, of course, no prior knowledge of, and no connection with, remote Chinese and Tibetan cultures) used mandalas in their paintings; and, if they did not draw them, they danced them. 'My patients,'

Vault at Masjid e Jamen at Isfahan, Iran: a recall of the mandala.

he comments, 'can say very little about the meaning of the symbols but are fascinated by them and find them in some way or other expressive and effective with respect to their psychic condition.'

The mandala describes balance. This is so whatever the pictorial form. But in the East we see the picture at its most direct and superb because it is a circle – the magic circle, the Circle of Heaven – and the terms of the mandala's message rely solely on this circle and in the way the parts are resolved within it, and not on outside assistance from cardinal points, the 'centre' of the 'flower' and other devices. The circle is divided into two parts, the top being male (the Yang), the bottom female (the Yin). This is beautiful and signif-icant enough in itself and, regarded as a diagram, the form at once suggests the meaning which lies behind the abstractions of the symbol. It looks like a tennis ball where the join is seen to curve in a horizontal direction, and the lovely, waving dividing line press-ing down into the left-hand corner of the lower half, pushing up into the right-hand corner of the upper half of the mandala is as crucial to the integration of the parts as it is to the structure of the tennis ball: the ball gains strength from the curve of the join. The parts are then distinguished by colour: the top, with its

aspirations to the world and life outside, is light, while the bottom half, rooted in the earth and nature, is dark. The symbol clearly has numerous interpretations – the mandala works hard on various levels simultaneously – yet, in principle, all seem to return to one point of departure. There are the two halves, and Dr Jung refers to the top as representing the conscious and human nature, while the bottom suggests the unconscious and the instinct. These two images are then contained within the circle, thus establishing 'the union of opposites', a spiritual concept which, on another plane, relates to Jung's proposition that the male carries a female within him, and a female carries a male. It does seem quite amazing that such an ancient symbol observed fundamentals of life and human nature which are only being understood now, and then largely through the work of Jung and his disciples. It would appear that the symbol's source of inspiration is, like all man-made things, natural phenomena: night and day, sun setting and sun rising, heat and cold, land and sea – contrasts of light, warmth and movement. Of course, countries with different religions, geography and philosophies adopt different forms. In the West the mandala has a plan which is similar to its counterpart in the East but it is usually more emphatic, with cardinal points expressed with Christian evangelists or animals: Gislebertus's twelfth-century sculpture at the entrance to Autun Cathedral is a good example. Egyptian mandalas have patterns of similar kinds. 'Wheels' and 'flower' forms are common and the Jewish mandala is made up of two identical equilateral triangles placed over each other, one point up, one point down. Here there is a link between East and West, the multiple triangles of the Tibetan mandalas (forming a circular movement) and the cross of the West (suggesting a compass). In all cases the image of the circular mandala is recalled: the male triangle turns towards the world, the female towards the earth, and together they represent the wholeness of life.

As is to be expected, mandala symbolism shows itself in art. In a sense, an understanding of the mandala explains art, and what the artist is striving for. The primary theme of Tantric art expresses itself through mandala forms. The chief concern of the French Impressionists was the discovery of balance between light and dark. But there are more specific illustrations. Picasso's *Nude Woman in*

a Red Armchair is constructed from a succession of mandalas: see the face, torso, thighs, the arms of the figure, and the arms of the chair. Epstein's *Madonna and Child* uses the Jewish mandala as a frame: the two figures, when simplified, make two identical, over-lapping, equilateral triangles. Now it is surely most unlikely that Picasso and Epstein were aware that they were working in mandalas; being an archetype, the form probably came into the artists' minds as the forms of nature do, from the unconscious. One finds the mandala in Le Corbusier's work too – not only in large building shapes and paintings but in details: creating a semicircle out of a wall to contain, say, a stair, he would continue the curve to repro-duce an identical space on the opposite side to contain a basin perhaps, thus making one thing do other things. Similarly with universal architectural forms. The Western church is normally a cross, like the Western mandala. The Villa Capra follows precisely this plan, and this house has been copied in Europe and America. The ceiling of the Pantheon is a circular mandala where the struc-tural ribs focus on a central lantern light.

In town planning there are the curious examples of, for instance, Palmanova in Italy and L'Etoile in Paris. The towns of the ancient Indus civilization, laid out according to the cardinal points, had a similar source of inspiration to that of the mandala, reflecting man's need to establish his position in a vast unknown space by the posi-tion of the sun, by light and dark. Beijing is interesting in much the same way, particularly when seen in the context of a mandala painting of an imaginary fortified city by one of Jung's mentally ill patients. This picture shows a plan that has similarities to the plan of Beijing: a walled city set out on cardinal points (each pegged out with a turret) and a circular moat at the centre which protects and surrounds a golden temple. At Beijing the moat, of course, becomes a wall, and the temple becomes the palace. But the likeness imme-diately suggests a link between town and mandala-making; it suggests, as Jung would say, that man's sources of inspiration *were* the same. Beijing, however, leads on to bigger things. This walled city, with the Forbidden City at its centre, is the spiritual heart of China. And around China is the Great Wall; thus, like the mandala, the spiritual forces of the country work from the outside inward to an architecturally unified centre which is fortified. This plan

symbolizes the family, the patient, reflective and dreamy mind of the East, and suggests the lower half of the mandala which is rooted to the earth and the instinct. The West, on the other hand, outward looking, and with great upsurges of technological and scientific energy, fits the upper half of the mandala. Neither can do without the other. Each represents that half of mankind, and its potential, which the opposite half wants. Both are contained within a circle, the circle of the world.

An analogy with buildings and, in particular, houses, is plainly made. In architecture, as in life, the symbol becomes one-sided if a part is missing: both parts – that of function, that of the spirit – are required for balance and harmony. This can be illustrated in other ways: the conscious is meaningless without the unconscious, inexperience of life limits the intellect, architecture cannot manage without the inspiration of nature. If 'the union of opposites' sought by Jung is to be achieved in architecture a building has to be treated rather like the mind: the part concerned with the external world and the part concerned with the instinct must be encouraged to develop at the same pace, not one at the expense of the other, but in such a way that one supplies energy to, and derives inspiration from, the other. The two parts must be integrated and a bridge formed. The need for integration, and methods for accomplishing it, are as amply conveyed in architecture as they are in human lives, which buildings, after all, mirror. The interior of a house, for example, personifies the private world; the exterior of it is part of the outside world. Both are opposites – as opposite as land and sea. Land is like the secure ground of home, the sea is like life, the outside, the unknown. The interior is, therefore, tremendously important because it provides seclusion, a retreat, a place which is secure against strangers and the intruding bustle and noise of the world. Yet, for all this, the interior is a part of the exterior and cannot be separated from it: the outside is the source of light, space, air, views, and therefore windows, doors and so on are needed for a sight of the changing seasons, distant hills, and a glimpse of the plants outside which bring the bees inside. However, these windows and doors do not mean that privacy is to be denied: the require-ments of the interior have to be balanced out. Similarly, the exte-rior cannot do without the interior since it is from this, as from

life, that it derives much of its inspiration and character. But only partly: at the same time inspiration is drawn from the outside world, from openness, climate, geography, nature. And so, together, interior and exterior make a mandala.

These mysterious forces have always lain just below the surface structure of accepted and familiar housing forms. They can be perceived whatever the period or place: pre-Greek, Greek, Roman, Chinese, American Colonial – the clues are in the cave, the primitive hut, the native settlement. At this point then you could say, speaking very generally, that the character of domestic housing has evolved from certain principles which, central to man's needs, have remained constant throughout, and that the pursuit of privacy is a thread which has helped sew the whole fabric of its evolution together; that, to a considerable extent, architectural continuity depends upon the existence of this thread, and a reason why continuity has broken down today is that this thread has been cut. So at this point too we can see that an architectural description of place and an architectural description of people draw together: the threads join, and it is at this moment, the transitional moment when the exterior world enters the interior world, and a bridge is created between the two, that some form of articulation is required. The need for this, again passed over or forgotten nowadays, has always been recognized in the past and some answer supplied. But a consciousness of the need for articulation that would mark this relationship between outside and inside, and which was, for instance, fully recognized by Palladio, his disciples and followers, must in the first place have been instinctive.

Originally, of course, the point singled out for articulation centred on the entrance: one sees this going back to the ashlar round doorways in the ramparts of Mycenaean architecture; and it was only the Romans who first seem to have conceived of a relationship being accomplished with windows, views and movement, and the Chinese who achieved it through the openness of structure. But as far as the entrance goes there is evidence of architectural description from far back: there is the example of Khirokitia where the covered path led down from the central road to the communal space around which the huts were grouped, and there were the stone steps to the entrance of each hut. The space, roughly enclosed,

made a move in the direction of a preparation – like a porch or courtyard – for the smaller space inside, and the steps accentuated this on an individual scale. At Tell Halaf there is an attempt at something which resembles the porch, or at least a preparatory covered space or pause before the main circular room was reached. In the more fully developed Sumerian house it is the thickness of rooms between the openness of the outside and the all-important inner courtyard which, acting as a barricade, may be seen to manage the transitional phase; while at Knossos, where the inner courts are established with vigour and firmness, the irregular and flexible nature of plan and structure allow interior and exterior to intermingle freely. The Palace at Tiryns is planned like a shell, the onlooker drawn in by the curving entrance and a succession of spaces that reduce in size as the heart of the scheme is approached. In the typical Greek house the entrance is again singled out, and its narrowness, and that of the space succeeding it, draws attention to the space of the peristyle to come. In the Palladian conception the physical relationship between external and internal worlds was accomplished by grander methods, and the discovery of perspective gave men the power to relate ideas in depth and to order objects coherently according to distance. Thus, from this point on, these relationships could be given a new dimension, and the landmarks which created them – the avenues, reflecting pools, fountains, steps and porticoes (the Michelangelo Capitol in Rome is an excellent example) – and which focused again on the entrance heightened the suspense and projected internal spaces outwards, while at the same time drawing the approaching person inwards.

The schematic design, in which the emphasis is placed on symmetry, does, of course, express the Western mind – very much so. Man is actively controlling nature from the wings; and eighteenth-century English street architecture used Palladian methods that were scaled down – porches, a few steps, a bit of ironwork – to get similar effects within an urban range. In modern architecture, however, the treatment of these traditional relationships underwent enormous changes, their importance being considerably sharpened in the process. While Frank Lloyd Wright, for instance, was concerned with a connection between the outside and the entire interior space, Le Corbusier demonstrated how *piloti*

could finally break down all the barriers, but not, it should be stressed, at the expense of privacy and architectural discipline.

Now this need for some form of articulation at the entrance, and its importance in linking interior and external spaces, seems to overlap with another equally profound psychological or emotional consideration. This occurs outside. And we begin to see then how the principle of the mandala applies throughout, to everything. The interior carries the exterior within it, and the exterior carries the interior within it. The garden, on the other hand, is concerned with both the interior and the land beyond the garden. So the situation is as before: there are the two halves of the mandala and these must be integrated, they must connect,

Masjid e Jamen, Isfahan, Iran: the interior carries the exterior within it, as with the mandala.

and in architecture the connection occurs in the garden or setting of the building. Landmarks – trees, paths, steps, walls – assist in establishing this connection, as they assisted in the marking out of the cardinal points of the Indus towns, and native villages as well, when the plan was positioned on cosmic principles. What is more, the gap felt by the notable absence of landmarks in much banal housing done today reaffirms their importance. Indeed, if landmarks were not important – as a link, as part of the setting – why should ancient planners have gone to such trouble to provide them? They may have lacked our sophisticated knowledge but they were, in consequence, as visually aware and as intuitively sharp as children. Clearly – by establishing the position of a building, or by coordinating a set of buildings – landmarks help in relating the position of a person to the building: we can use the landmarks, for instance, to measure distances. And so landmarks can be linked with a need for reassurance and security; and the making of a fountain, pool or gateway may then be regarded – aesthetic pleasures aside – partly as an architectural expression of a simple, human need. And as the number of buildings increases, and their arrangement grows in complexity, so the landmarks become more numerous, the connections multiply.

This perhaps gives a picture of the infinite extent to which the principle of the mandala applies in architecture. What we know, too, in the way of landmarks in the East and West may be seen as indications of different minds, cultures and mythologies, but not, basically, of different needs. The methods used as links or for the making of relationships do, of course, vary considerably. In the West, for instance, the direct approach to a building is normally adopted; in the East, an indirect approach is more usual. And, in general, the different architectural means employed to assert common aims can be similarly regarded – as an indication of different minds at work – whether these aims are concerned with privacy and planning, relationships between interior and exterior, or the status of buildings in the context of the outside world. We have noticed that the Western view of life seems to have its architectural manifestation in a movement which is primarily outgoing and extrovert, betraying a certain worldly one-sidedness that has its image in the upper half of the mandala. And we have noticed too that the

Chinese view shows itself in a somewhat more balanced fashion, yet one in which the ambition and initiative of the West is largely absent: and so the upturned eaves that hint at the Circle of Heaven and continuity, and the enclosure of the more introverted court-yard plan based on the Square of Man, combine to offer a harmony that is closer to the whole being of the mandala. In the West, a building has status because it is a man-made object, it is a symbol of man's achievement and should be expressed as such; and in the solution, for instance, of internal and external relationships, and those which exist between, this expression of achievement must not be denied.

A comparable concern with human status does not show itself in the East: where symmetry as an overt expression of balance is central to Western architecture, the Chinese house, although often symmetrically planned for reasons of balance, is not given any special symmetrical expression. There, as we know, it is nature that is regarded as the dominant influence: it is symbolic of life and the afterlives, and, in consequence, no hard-and-fast architectural conventions of the Western kind can obtain. In Japanese houses the interior melts into the gardens of the outside world and the symmet-rically ordered landmarks in the Western path of approach are substituted by a winding path of experience – winding past flowers and hillocks, through trees and over streams. The West, on the other hand, using such forms as the boulevard, the piazza, the circus and other classically orientated devices, orders nature to suit man's purpose: on an urban scale, trees not only linked terraces together, but streets; they became the green thread that was, like the avenues of New Haven, a unifying element of great loveliness. But in the East, man adjusts himself and his buildings to suit nature as he finds it. And so, from examining the ways in which relationships are formed between buildings and nature, and the ways in which the East and the West have struggled to accomplish a 'union of oppo-sites' within their own terms, one perceives a further analogy with the mandala, and how much balance and harmony matter, and have always done so.

If we were considering the early settlements in Norway, Sweden, Germany or England of, say, the fifth century BC – those simple, timber-framed houses with a hearth in the middle of the space –

it would be clear that building was everybody's problem, that the struggle to survive involved each person, and that the contribution of each person could be listed. The man next door had put on your thatched roof just as, not so long ago, the fellow in the village knew the shape of your feet because he made the shoes you wore. The issues were plain, life was primitive, and structures could be described in terms that were the same for all. But as the issues become more complex, and human contact becomes correspondingly less evident, simpler terms have to be found by way of explanation. And where styles may serve to describe Japanese and English work, for instance, up to the end of the eighteenth century, today's issues are so vast that it is to personalities that one returns for suitable representatives of the human struggle with life in relation to architecture.

Three characters dominate the twentieth-century story: Frank Lloyd Wright, Le Corbusier and Mies van der Rohe. They are all dead now; but in the way that the brothers Karamazov may be seen to present different facets of their father's character, so these architects seem to present the chief characteristics of the architectural heritage. All three were remarkable, all grasped immediately, in the magic way that geniuses do, the meaning of their time. Of the three, Wright and Le Corbusier attracted most notice and publicity, seizing the centre of the stage while Mies, like his buildings, remained somewhat shadowy, in the wings: what the Georgian method was to the classical style, Mies was to Wright and Le Corbusier — the common denominator, the neutral axis, the cool line of continuity. Wright was the romantic, Le Corbusier the innovator and classicist, Mies the picture of sanity in a century of hectic technological advances. But how often all three presences return to haunt the present. How many people realize, for instance, when they are chatting about boarded houses and 'split levels', that the use of natural materials, open plans, and slopes in the ground are inherited from Frank Lloyd Wright? Or that it was Mies van der Rohe who delegated to others the work of building the glass towers that are scattered across the skylines of our cities? And that the so-called 'brutal' style — board-marked concrete, balconies and all — was made in southern France and India by Le Corbusier and imported at great expense to industrial countries, where it was

most inappropriate? When we sweep aside today's appalling mess we find that the real story of modern architecture – the story that will survive and endure – largely lies in the relationship among these three architects; and, as far as domestic housing goes, between Wright and Le Corbusier (not through friendship – they never met – but through their work).

One must start with Wright, since he was first on the scene. He was a third-generation American, born at a time in the nineteenth century when the country was becoming, at great speed, a modern industrial centre, but with first-hand experience of its agricultural traditions, the clear memory of which followed him throughout his life. He was Welsh, and the umbilical cord which tied him to Wales was never severed: he longed to go there, kept photographs of his ancestors, and obviously had a nostalgia for this little country that was like the nostalgia he had for those preindustrial roots which manifested themselves in his early memories of his uncle's farm. Thus, from the beginning, there were emotional problems to resolve, and they left him divided. He recognized his age for what it was, and its architectural possibilities in technological terms. At the same time, however, he seems to have rejected it, or at least was unable entirely to accept it – his early life in the Wisconsin hills and the influence of a dominant mother were too deeply em-bedded in his childhood to make complete acceptance possible. In consequence, a faith in primitive traditions and methods, a horror of expanding industrialism in cities, and a corresponding fascina-tion for nature and its space always influenced his architecture.

His grandfather arrived in the United States early in the nine-teenth century: a severe, vigorous and much admired Unitarian preacher. His mother was, at a guess, the picture of womanly motherhood, and intent that the ambitions she had for her son were fulfilled. In 1876, at the Philadelphia Centennial Exposition, in a Japanese pavilion and among examples of Georgian archi-tecture, the family came across Froebel's kindergarten building blocks. These seem to have taken over their lives: Mrs Wright started the first Froebel school in the country and her son became absorbed in the creative possibilities of the blocks. Teaching through play was an entirely new educational conception then. Today it is accepted with systems like Lego. Then, particularly in the hands

of an extremely imaginative child, the impact of the system was enormous, and the effect of the building blocks on Wright's structures in the early and middle periods (the Robie and Kaufmann houses, for instance) was, quite literally, remarkable. His mother had discovered more than Froebel.

The farm she sent him to is another piece of the Wright jigsaw. He hated it to start with, tried to run away from it all – up at four, milking cows, breaking in horses – but the experience brought him into contact with nature. He came to love the country. He says of the woods: 'And the trees stood . . . like various, beautiful buildings, of more different kinds than all the architectures of the world.' Wright had become a farmer and thus understood the earth, the mood of the weather, the feel of natural materials and the sharpness of stones, the colour and variations of light. The country was a complete part of him, as inseparable as paint from a painter, clay from a sculptor. He knew nature, and its space – the huge space of the United States. Just as the idea of Wales left some sort of picture in his mind – mountains dwarfing people and thus houses – so this knowledge of space was later imparted to his architecture. But then, suddenly, his father disappeared and the divorce which followed pushed Wright into architecture. The records suggest that this family break-up was all for the best, but life, unfortunately (or fortunately), is not as simple as that. People may, like the animals, suffer silently, but relatives, particularly close ones, cannot vanish – however disliked, feared or blamed – without serious repercussions. Frank Lloyd Wright's attitudes to things were being fixed, and these early experiences, together with the dominance of his mother, may have had far more to do with the form of his architecture than the influence of someone like Louis Sullivan, for instance, whom he admired and from whom he learned about 'the functions of function'.

It was not surprising that he was drawn towards architecture as a method of making another kind of enclosure. Put in a different way, in attempting to establish roots, he found himself acquiring some symbol of security outside himself. Nor is it surprising, in the context of his upbringing and of his time – Art Nouveau, Froebel, the spread of the Japanese fashion – that he should be drawn towards Eastern architectural forms. Where the Japanese,

however, accepted nature as a part of the continuity of life, Wright depended upon it as a symbol of continuity. Perhaps, at first, Wright subconsciously saw architecture and nature as something that was synonymous with his conception of his mother, but after she was gone and his work transcended her in importance, it could be argued that nature assumed, to a degree, the role of a substitute, his mother becoming fixed in his mind as Mother Nature herself. In this case the Wright house, at least in the early and middle periods, may indeed be seen as the womb at the centre of Wright's universe, of the earth, of nature. This might account for the elaborate preparations for the structure rooted there in the landscape, the foundations exposed, so to speak, to suggest strength, and followed by the equally elaborate, at times mysterious, preparations for entry and exit; for the narrow doors and halls; for the obstacles, deliberately devised, which obscure entrances and exits; and for the general desire, that seems implicit in his architecture, to escape to the outside before the variations possible within have been entirely discovered and exploited. All these factors have, I believe, a considerable bearing on any evaluation of his work.

His early houses always merge with the landscape. In this sense they are as modest as people would appear small at the bottom of a Welsh mountain. At all times he attempted to honour nature, and, to point to his understanding of its true meaning in his work, used methods that could be associated with primitive man and the simple tools which were available in the Bronze Age or pre-Columbian times. He denied that he was influenced by either the Roman or Japanese conceptions of space (before, that is, he was commissioned to do the Imperial Hotel in Tokyo), perhaps because a conscious recognition of outside influences would have weakened his confidence in himself. Yet they existed; and it is clear that he brought the shape, openness and materials of the Japanese form to the United States, and thus to the modern architectural movements of the West. Again, this openness was entirely sympathetic to the nature of American life – this kind of plan personifies a tradition which manifests itself in the log cabin and the idea of mobility and freedom of choice. The European notion of privacy, for instance, which goes with doors, has little meaning there. And the characteristics which made Wright's buildings legendary – the

protective roof hovering over the earth, the emphasis on the ground plane, the light fabric between these horizontals melting into the shadows, the immense openness within – belonged to the spirit of this tradition. The philosopher, Henry Thoreau, describes it in his book *Walden* when he is talking about a 'dream' house: 'I sometimes dream of a larger and more populous house . . . which shall consist only of one room, a vast, rude, substantial primitive hall, without ceiling or plastering, with bare rafters and purlins . . . a cavernous house, wherein you must reach up a torch upon a pole to see the roof; where some may live in the fireplace, some in the recess of a window, and some on settles, some at the end of the hall, some at another, and some aloft on rafters with the spiders, if they choose; a house which you have got into when you have opened the outside door, and the ceremony is over . . .' And Henry Thoreau, who believed in the freedom of nature, was put in prison for refusing to cut his lawn.

It is difficult, sometimes, to see where the past ends and the present begins. Then centuries are stages in development where there are no ends and no beginnings. Wright was as much a part of the ancestry as the ancestry was of his future. The space which suddenly came to the Heurtley, Martin and Coonley house in the early 1900s was no invention of his, but part of a story that was much vaster and more intricate than even Wright realized or would have cared to admit. Taliesin I, for instance, built in the Arizona desert in 1911, was a comprehension of the seemingly infinite space of the United States within the frame of a house; yet in spirit it was essentially Eastern.

When Wright was building Taliesin, a creative upheaval was happening in Europe. The teaching methods of Froebel and Montessori, and the work of Freud, were gaining international importance. Art Nouveau was fashionable. Advances were being made in medicine, and the first aeroplane had taken off. And, on the art side, the last wave of the nineteenth-century breakthrough in light and colour had brought ashore Cézanne, Braque and Picasso. It is with these artists that the architect, painter and writer, Le Corbusier, is inseparably linked.

While an evaluation of Wright's work depends to some extent

upon his background and childhood, no such investigation appears relevant in the case of Le Corbusier. Here we seem to witness the evolution of a great mind unrelated to family matters. As time goes on, the enlargement of this mind shows itself in buildings, painting and writings. There are, however, a few biographical facts worth noting: he was brought up in a narrow Swiss town, his family were watchmakers, he left school at thirteen and a half, was apprenticed to an engraver, and built his first house at eighteen in 1905. Then he began to travel: Munich, Paris, Vienna, Berlin (the centres of the modern art movement), Florence, Istanbul, Rome, Athens. He became glued to museums and their extraordinary possessions, studied folklore and drew the whole time – marvellous drawings. His knowledge came largely from acute observation; his eyes missed nothing. As Inigo Jones had (at roughly the same age and three centuries earlier) seen the Roman remains for himself, so Le Corbusier examined Greek remains. He spent six weeks in the Parthenon, scrutinizing it. For him it represented the 'perfect solution', the object, the idea on which he based his own earlier work. 'The Greeks built temples on the Acropolis,' he said, 'which answer to a single conception, and which have gathered around them the desolate landscape and subjected it to the composition. So from all sides it is unique. This is why no other works of architecture exist which have this grandeur.' And the Parthenon was, he said, a 'pure creation of the mind'. He had, so to speak, rediscovered it as the Italian Renaissance had 500 years before: it is amazing that he could see it so freshly. Then his interest in the colour white, which never diminished, came from his study of 'folk art' on the Greek islands. He was bowled over by this discovery from the beginning. 'Whitewash is absolute,' he said. 'Whitewash has been connected with the home of men since the birth of mankind.' He seems to have absorbed, with a wonder that only belongs to children and great artists, everything that was happening around him. There was Art Nouveau which he rejected as irrelevant because it was decorative. He grasped the obsolescence of manual craftsmanship. There was the work of the painters around him: Mondrian, Laurens, Arp, Klee, Gris. There was Auguste Perret, who introduced him to reinforced concrete, Adolf Loos, Gropius and Mies van der Rohe. Le Corbusier tells part of the story in the introduction to the first

collection of his works, which was published in 1930. But even when he is writing he is in a hurry – the details he gives about his teachers are mere handshakes, a formal courtesy – he wants to get on and show his ideas, his buildings: there is no time to waste on stories in a philistine and reactionary world. What he says is all the more to the point because of this necessity for speed. 'Though I have reached the age of forty-two,' he explains in 1929, 'I have never ceased to be a student. As I believe profoundly in our age, I continue to analyse the elements which are determining its character, and do not confine myself to trying to make its outward manifestations comprehensible. What I seek to fathom is its deeper, constructive sense . . . Differences of style, the trivialities of passing fashion, which are only illusions or masquerades, do not concern me. No, what appeals to me is the magnificent phenomenon of architecture . . .'

For those who have latched on to his comment that a 'house is a machine for living in' as a base from which to criticize his work, he hands out a straight right: 'Architecture demands a clear formulation of the problems to be faced . . . Are we to limit those problems simply and solely to the satisfaction of utility? If so, we must start by defining utility. Do poetry, beauty and harmony enter into the life of modern men and women; or must we consider their scope as being confined to the mechanical functions postulated by "the machine for living in"?' He adds: 'To me the quest for harmony seems the noblest of human passions.' This is a different kind of person from Frank Lloyd Wright talking. But where Wright's family consisted of his mother and father, and his background was his ancestry, Le Corbusier's 'relatives' were people like Picasso, Braque and Léger, his background was Europe, and the head of the family was represented by the classical frame.

Le Corbusier had an independence and authority which were strikingly European. He was aloof, normally appeared withdrawn, but among close friends gave out warmth like a radiator, could be exceedingly funny, even carefree. But the difference in outlook between him and Wright is as fundamental as their characters were different. Wright, with his enormous respect for the past, developed the Eastern influences with the intention of turning them into something of his own; Le Corbusier, on the other hand, who

saw the past as part of himself, set out to replace the old with something new; he was able to grasp (as T.S. Eliot said) that 'time past and time future . . . point to one end, which is always present'. His art was derived from the cubist movement of the period; from the outset he was concerned with the classical conception of the cube as an object in space, and what could be extracted from the object given the limitations of the cube. His immediate associations lay with the amazing work of Cézanne, and his ideas were in accord with the leaders of the art movement, Braque and Picasso. As early as 1910, when Wright built Taliesin I, Le Corbusier made an astonishing discovery in a scheme called the *Ateliers d' Artistes*. It was a project, but what the solution to the problem revealed about the nature of the cube formed the principal basis for the first thirty years of work done before the Second World War. *Ateliers d' Artistes* showed a central pyramid symmetrically surrounded by a number of small cubes, which were the studios; these cubes were separated by spaces, which were yards where the artists could work outside. The composition was in the form of a square, an arrangement of objects around a more important geometric object. But the limitations of the composition were defined by the square; this, together with the cubes and the pyramid arranged within it, proclaims what may be left behind after the architect has lifted off the top part of a larger cube; of this, only an outline remained – the square.

At the age of twenty-six, therefore, Le Corbusier was already seeing complex architectural problems on a huge, three-dimensional scale. He wasted less time in attacking essentials than Wright, and this is because there was no resistance from tradition in his case – he belonged exclusively to the twentieth century, he was a European with a long line of continuous architectural development behind him, and he was now at the head of the line. Thus he was in no way inhibited about rejecting the past, or reclaiming architectural principles embedded there which still held good for the present and applying them with the technical means which still belonged to the future. He was free to work at the inner structure of the cube, treating it as a sculptor might treat a block of white Portland stone, chiselling away until the required spaces were fully revealed. And it was at the *Ateliers d' Artistes* that Le Corbusier seems to have seen, in a dazzling flash of illumination, a new interpretation

of the cube. His vision was not dissimilar to that of Cézanne, who was also working inside a square or rectangle – the canvas – to try, as he explained, '. . . to render perspective through colour alone'. Le Corbusier was doing much the same thing with walls. But this great French painter went on to say that '. . . technique grows in contact with nature. It develops through circumstances. It consists in seeking to express what one feels, in organizing sensations into personal aesthetics.' Le Corbusier might well have used these words to explain his later work at La Tourette and in India, when his perception of nature had overtaken his explorations into the nature of the cube. But Cézanne also said: 'It took me forty years to find out that painting is not sculpture.' A significant remark in the light of his cubist interpretation of the *Pigeon Tower of Bellvue* (1889), in which he appears to have forecast the spirit of modern architecture and the forms of Le Corbusier himself: look at the light shafts at the chapel at Ronchamp.

But of course, Braque and Picasso were up to their necks in cubism by the time *Ateliers d' Artistes* was conceived. Braque's beautiful *Houses at L'Estaque* (1908) reveals precisely the same concern with cubes and pyramids – and the spaces between them – that Le Corbusier showed in his studios. It would seem that these artists were working towards something which could be called the fourth dimension in art. In other words, the object in the painting was presented in such a way that it might be seen from the sides, the back and the front simultaneously; Picasso, in particular, developed this theme in his later paintings, and in his sculpture. But Le Corbusier was working in straight sculptural forms from first to last. In order to understand what he was up to, and how his work influenced the domestic architecture of this century, it is important to look more closely at his cube.

It was, of course, the simplest and most direct architectural shape at hand, and, in a world full of muddled thinking and vast social problems, the form was an obvious choice. In Le Corbusier's understanding of the cube, so far as one can judge from his buildings, the shapes, spaces, staircases and walls already existed inside it, and his aesthetic depended upon his ability to reveal such things. In the same way that he insisted in his writings that the happiness he had found in design existed for others who were as determined as

he to search for it, so he would have claimed perhaps that all the shapes that he had found in the cube were universally available. And so they are – to those with the eye, logic and passion of Le Corbusier. But his point was right. One could assume for the sake of argument, for instance, that a cube consists of millions of diagonal lines. If some triangle of these lines of a certain depth is then removed a space is left which has a right-angle corner and one side which makes a diagonal across the cube. Alternatively, one could say that the cube is made up of hundreds of small blocks and that if an area of these was removed a square hollow inside the cube would be left. Again, one might say that any kind of circle or curve exists in a solid, and that when the adjoining part is removed these circles or curves are then revealed. At the same time it could be said that, by this means, he was also emphasizing the outline of the cube which contained all these things.

At the Dom-ino house (1914), a project to rebuild, quickly and cheaply, towns that had been devastated in the war, he was thinking along the same lines. What he invented was a structural system (the first example of industrialized system building to be designed) that was independent of the functions of the plan of the house. It was to be made of standard elements which could be fitted together, thus, as he said, '. . . permitting a great diversity in the grouping of the houses . . . it then remained to fit up a home inside the frames.' But the aesthetic of the cube remained: the top and bottom floors reveal its outline in plan; the columns, its outline in section. At Pont Butim sur le Rhône he is looking for curves within the cube, and at Maison Citrohan (1920), when he was also painting with machine forms, he became interested in interlocking spaces over two floors. The point made at Dom-ino – that all that remained was the fitting up of a home inside the frames – is taken further as well. Having subtracted the quantity of material necessary to create organic spaces – staircases, boiler flues, columns – another process begins: the addition of new parts. And it was at this point, too, that another persistent, and more complex, theme entered his houses: the possibility of being able to sense – if not entirely to see – a building from every point, whether inside it or outside; and it was this theme that brought the contents of the cube into the fourth-dimensional sphere. At the Maison La Roche, one of

his earliest buildings, the glazed screen in the curved white façade, together with the undercroft beneath it, shows the shape and depth of the entire object at a glance. The cube, more and more, took on the appearance of a skeleton: at the roof terraces on the houses at Pessac, for instance, and at the house he did for Madame Meyer in Paris in 1925. Of this design, he said in a letter to his client that it was '. . . *une maison qui fut lisse et unie comme un coffre de belle proportion*'; and his image of the chest of drawers describes the cubes within a cube which he was, once more, demonstrating years later in the Unité d'Habitation at Marseilles after the war. Cézanne makes much the same point when he said that '. . . it is in modelling that one draws, that is to say, one detaches things from their environment – the daylight alone gives the body its appearance!' And this, after all, is what Le Corbusier saw: he had brought sunshine and air into the darkness of the cube: it was light which defined the parts.

But for Le Corbusier it was horizontal and vertical lines that were important. He had to establish – and they did it – the outline of the cube: this formed his limits. In fact, Le Corbusier made his cube work hard, as Palladio before him had made columns and pediments work hard. And in his acceptance of classical principles, Le Corbusier realized that a comprehensible diagram was central to the continuity of architectural evolution, a frame that allowed and encouraged contributions and variations of others. Le Corbusier had acknowledged the need for this frame from the beginning: it presented the aesthetic limits within which the architect must work if the imagination could be put to work, limits which Le Corbusier described as the 'rules which order'. Like Wright with his open plan, he did not, then, discover the frame: he rediscovered it. As we know, this frame can be traced back to the Sumerian civilization; in particular, it can be traced to the Greek megaron, the rectangular discipline which ordered the form of ancient houses and palaces. Again, it is evident in the portico, which, derived from the megaron, was used with great effect by Palladio at the Villa Capra and the Palazzo Chiericati – a particularly good example, since here the frame gave dignity and presence to a scaled-down version of the grandiose country palace. And the importance of the frame – noticed by the Greeks, upheld by Palladio, recognized

by Locke, Newton and others, and obscured by the mess made by the Industrial Revolution – is as fundamental to the day-to-day business of living as symmetry and harmony are to nature and the behaviour of the elements. Le Corbusier, in going back to the Greeks and accepting their discipline, clarified the meaning of the frame and applied it to modern problems using modern methods. No wonder he said that '. . . the quest for harmony seems the noblest of human passions'.

And so he re-established the frame. He said that '. . . in periods of a new beginning, in epochs of the birth of new civilizations, ideas must be human before being rational'. Once more he is calling attention, as the Greeks did, to the importance of the individual, while stressing, at the same time, that human muddle was diminished when given an external order. He recognized that a similar order is required by art, the abstract principles of which may be traced from nature. When Cézanne talked about horizontal and perpendicular lines and planes he was suggesting a way in which this natural order could be transferred to a canvas in terms of structure. Le Corbusier was doing precisely the same thing – but transferring the structure of materials to man. He showed us this structure; stated and restated it. And inside the frame he could carry on with his experiments. He made, for instance, great advances in planning: at Garches, the house plan was much more ambitious than anything he had attempted before. Curved walls to corridors, circular stairs and rounded corners became the modelling that stood inside the familiar shell: no reference concerning the cube and its contents is forgotten. All, as usual, is white: nothing else can convey so clearly the meaning of the idea; the significance of the framework is marked out at every point; the freedom of the internal spaces is made plain by shape – shape detaches them, as Cézanne said, 'from their environment'. A great work – yet still only a beginning. At a house at Carthage he turned from the plan to the section. After this he moved on again, this time to the Villa Savoye at Poissy.

Le Corbusier was never satisfied with the Maison La Roche: the spread-out form was, he maintained, 'very easy'. This was no 'perfect solution'. That could only be achieved by taking the forms and reassembling them within the framework of a single cube. And at the Villa Savoye, in a bare field, all that he had been striving for

Maison La Roche, Paris, France: architect Le Corbusier, 1923. Now the Foundation Le Corbusier, the architect regarded this as his first achieved work of modern architecture.

came together within the square, in both planes, vertical and horizontal: he had isolated the middle floor by putting it on *piloti* and dropping the usual continuation of the frame at the top. It was more relaxed than anything attempted before, suggesting that he was now escaping from the disciplines he had deliberately forced on himself. Nothing had been lost on the way – all the characteristic elements were present: the sun deck off the living room, the roof terraces, and not a piece of the house was unavailable to the hand or eyes; one could stand under it, or on top of it, see through it. It was a fourth-dimensional object again; a classical object in landscape that had been opened like a watch, and a view of all its parts – in some cases minute – had been revealed in a single impressionistic sweep. A closer investigation of the inside shows how involved those parts are. In fact, the unity of the internal conception rests on a series of strong diagonal members – the ramps – which link the enclosed spaces with the sun deck and the roof. The interlocking wheels of the watch – the garage, the staff

flat, the heating system – are on the ground floor, and so ingeniously arranged that one feels that the architect was methodically and consciously laying the foundations for an idea of genius. As the house rises out of the semicircular entrance it opens like a flower, and like a flower, too, one finds at the heart of it those extraordinary colours that are seen only when petals are carefully examined. One thinks of Ozenfant, a friend of Le Corbusier's: 'Architecture is light, because it is through light we see it. And light is colour.' Cézanne said much the same thing. So did George Schmidt: 'Space, form, colour, light are one.' And so did Le Corbusier. At the Villa Savoye, the real point of architecture had been made, and of the architect's faith: logic had produced a work of art without which there would have been no justification for the logic.

The European architecture of the twenties and thirties is particularly remembered for those white, sharp, open houses which threaded through France, Germany, Holland and England – bright and fresh and sparkling as a sunny morning. Le Corbusier was at the source, and therefore at the forefront, of the movement. But

Cup and saucer by Frank Lloyd Wright on the window sill of Taliesin East, Wisconsin, USA, 1910.

things were very different for Frank Lloyd Wright in the United States. He was alone, separated from European developments by the Atlantic. He was working more or less in isolation, surrounded by provincialism and the odious side-effects of industrialization. It is hardly surprising that he should have turned to the land for inspiration. His love of it went very deep: it was as natural that he should be drawn to the Eastern way of thinking as Le Corbusier should be drawn to the architecture of the Greeks. Our past is inescapable; no art is made in a vacuum and we are all victims, to some degree, of our heritage.

'Home is where one starts from,' T. S. Eliot said. For Le Corbusier 'home' was centuries of Western civilization based on Athens; for Wright it was the country and agriculture – the true American tradition. But of course he was influenced: in the Frederick C. Robie house of 1909, for instance, the tall-backed chairs, the ceilings striped with timber battens, and the lights have a startling resemblance to his contemporary, the Scottish architect, Charles Rennie Mackintosh. It was, however, the Japanese influence which dominated and persisted. The West, he claimed, and not without reason, was far too impatient to understand the movements and courtesies of the tea ceremony, but it was the dignity of the Chinese house, and the love of nature rooted in Shintoism, that led him to say that he '. . . looked forward to Japan as a refuge and a rescue'. He added that Japanese '. . . art was nearer to the earth and a more indigenous product of native conditions of life and work, therefore more nearly modern . . . than any European civilization alive or dead'. This remark corresponds with his outlook in general – he disliked Greek architecture: it was, he said, at odds with nature. 'The best native architectures of the world,' Wright said, 'have been, and still are, great architectures which arose from within the lifetime of civilizations they actually serve to express.'

Wright put his philosophy to work with all the drive and efficiency of the early pioneering spirit. The results of this energy are in the early houses. He saw a wall as a form of protection against the weather and not as the side of a box; he saw the room as a space that was part of a larger space and which flowed outside, not as a box within a larger box. The wall, therefore, could be the connector between the outside and the inside. He was attempting

to rid the house of unnecessary obstacles, reduce its number of parts to a minimum and 'make all come together as a free space'. So, in the Wright house, the wall was no longer structural but functioned simply as a screen, associating 'the building as a whole with its site by extension and emphasis of planes parallel the ground'. So in spite of their different statements, it can be seen that, even in the early days, the polarities of Wright and Le Corbusier were not so far distant. Wright's starting point was always the achievement of a harmony with nature, and the shapes and slopes of landscape were echoed in his roof forms. 'At this time,' he said (the time when the Robie House and Taliesin I were built), 'I saw a house primarily as a liveable interior space under an ample shelter. I like the sense of "shelter" in the look of the building. I still like it.' He aimed to get '. . . the unwholesome basement,' as he called it, 'up out of the ground . . . making the foundation itself visible as a low masonry platform . . . on which the building should stand.' Again the concern that the building should be rooted to the ground: a structure must be seen to be the symbol of security which, by definition, it is; but when walls, in the traditional sense of their meaning, were done away with, other elements had to replace these familiar conventions, and Wright's instinct was to exaggerate the importance of the roof, the extent of the eaves, and to transform the normal terrace into a podium. By insisting upon a strong relationship between outside and inside, Wright had suggested a human desire that had not, in the West, been given a new architectural expression since Palladio's days. And Wright, like Palladio at the Villa Sarego, set about defining the limits of his 'shelter' by exchanging the usual importance given to walls for a new importance given to the roof and the ground plane. In this way, the visual and psychological balance of the house form were retrieved.

His work was, however, uneven. Architecture, like all other arts, extracts its value, in some way, from the resistance put up by the problem: it is the confrontation between this resistance and the architectural solution that gives the building its tensions; and the stronger the resistance and the more direct the confrontations, the greater the tensions, and the deeper the architectural penetration. In addition, buildings (unlike paintings, for instance) are large affairs, complex and in no way disposable – they are permanent – and their design

places a vast responsibility on the architect, whoever he is. As Le Corbusier said, 'Architecture is a tough, exacting job . . .' In such situations, with buildings growing in size, knowledge bringing increased possibilities, and social needs becoming more complicated, the demands of self-criticism are vast, and these put the architect under considerable intellectual and emotional stress, at any time. In the first place, one wonders whether Wright was always aware of the real resistance inherent in the problem; in the second, one remembers that he was working (at least until the end of the First World War) in comparative isolation, that there was no American tradition to secure his position from behind, and that, unaided, he had to break through a provincialism, suspicion and ignorance of a kind unknown today.

I suppose Wright did see himself in some sort of heroic role, as part of an epic: isolation can create delusions and fantasies of this kind. So perhaps when he was given the Imperial Hotel to do in Tokyo, the importance of the occasion was too much for him. He was influenced by the Japanese at Taliesin I insomuch as he had transferred the spirit of their forms to his massive roofs and open, spacious plans. Certainly at the Imperial Hotel in Tokyo, and in the work of the next decade or so, he became a descriptive architect as never before – his buildings were curiously pretentious. He flung himself into the Eastern way of life, was taken over by everything Japanese – Shinto, tea ceremonies, social rituals – and had gone native. Then there were Mexican influences. What he needed was help, a fresh start. As it happened, these were not so far away, across the Atlantic. Under Wright's nose, the European art movement, together with the name of Le Corbusier, had become internationally famous. Could it be that its message struck home? For Wright's decorated period ended as suddenly as it had begun. He built his winter headquarters – the Ocatillo Desert Camp, in Arizona.

The space down there – the rocky outline of the mountains and the peculiar shapes of the cactuses – released an architectural energy that was his own: it did not belong to someone else or to another country. He talks about the landscape in his autobiography: 'Arizona's long, low, sweeping lines, uptilting planes . . .' At Ocatillo the triangular windows, the wood and canvas walls, the nearness

Fallingwater (for Edgar Kaufmann), Bear Run, Pennsylvannia, USA; architect Frank Lloyd Wright, 1938. The dramatic cantilevers linking house, waterfall and garden, the stability of which engineers questioned at the time of building, are now under threat.

Fallingwater. Stepped canopy leading from Kaufmann's house up to the guest house, added 1939 by Frank Lloyd Wright.

of nature, the loose arrangement of studios and bedrooms round a camp fire on the top of a hill belong to the authentic Wright world – the world of the early settlement (Perleberg, East Germany, first millennium BC, for example) encircling the central oven, of the handmade structure and the Bronze Age tool. Wright had first discovered this new freedom at Taliesin III, two years earlier; Ocatillo, however, was like a douche of cold water – it was refreshingly simple. And it recalls too – in a flash, absolutely clearly – the cubist purity of the European movement. Surely this is it: some of that Western clarity of vision had rubbed off on Wright and had pointed out the way.

After all, Le Corbusier and the rest had gained a good deal from Wright's open plans around Chicago. Nor had the Luxfer Prism skyscraper project of 1895 gone unnoticed. This is how life works: an exchange of ideas is inevitable; isolation, in the end, is quite impossible. Art thrives on mixtures of blood, it continues to develop in this way, and Wright's work was no exception to the rule. There is little doubt that his St Mark's Tower in 1929 derived a good deal from van der Rohe's conception for a skyscraper of nine years earlier, and a series of lucid images flowed out of Wright from this point on. He became preoccupied with wood. Picasso once said that sometimes he seemed to get full of green and had to paint and paint green until he got the green out of his system. Wright must have felt the same about wood: he seemed insatiated by it. After this (and after an exhibition in which his work was hung next to buildings by Le Corbusier, Mies van der Rohe and Gropius) he went over to concrete in the famous Kaufmann House. Simplicity was the theme, light had become the natural source of variations (the light filtering through the canvas roof at Taliesin West), soft glows from polished woods, and the extravaganza was replaced with a normal, warm and human understanding. These are the sorts of things in Wright's work which have endured, and which return to haunt the scene today. Even the roots with nature were pulled out of the ground: the Kaufmann House positively separated its occupants from the forest and the waterfall outside. True, the form, the steps and the stone slopes at his lovely Taliesin West appear to have been raised from the Arizona rock, but the need for strictly self-imposed rules and regulations had been

John Pew House, Shorewood Hills, Wisconsin, USA: architect Frank Lloyd Wright, 1940.

Sturges House, Brentwood, California, USA: architect Frank Lloyd Wright, 1940. Carport of lapped redwood. 'It leaked more deplorably than most Wright houses' (Brendan Gill's *Many Masks, A Life of Frank Lloyd Wright*). It is still a beauty.

discarded. The long wooden bungalow floor at the Johnson House rides over a shallow valley like a bridge, and with a serenity that recalls the frieze of monks' cells at Le Corbusier's La Tourette; and the side of the hill sweeps past and beneath the Sturges House with the greatest possible nonchalance. The planes of his houses had drifted clear of all conflict and confusion, and had taken to the air; the flat, floating roofs seemed to be supported by air, the hand that shaped the forms gaining a gentleness of touch infinitely more expressive than the overt aggressiveness it replaced. It was just as though, at last, the inner anxieties which had pursued Wright through his life had, like great, menacing, flapping birds, suddenly wheeled away and left him, vanishing to black dots, to nothing, over the horizon and into the flawless blue sky.

Two houses in particular, for Lloyd Lewis and John Pew, found a real peace among the trees. These houses were built in 1940. Four years earlier Le Corbusier had made a significant statement in a letter to a group of young South African architects, saying, 'How are we to enrich our creative powers? Not by subscribing to architectural reviews, but by undertaking voyages of discovery into the inexhaustible domain of nature! . . . I wish that sometimes architects would take up their pencils to draw a plant or a leaf – or to express the significance of the clouds, the ever-changing ebb and flow of waves at play upon the sands . . .' Like Cézanne, Le Corbusier had begun to 'perceive nature rather late': the classical tradition had held them up, unlike Wright, who had behind him no such tradition. The new phase in his work had begun which was to carry on until the end of his life. As Wright's work became less ruled by nature, so Le Corbusier's self-imposed disciplines, already noticeably diminished at the Villa Savoye, relaxed as well. It was almost as though someone was working the pulleys in the wings, to get the balance just right.

As he grew older, Le Corbusier often talked about his 'green houses' and 'green cities': beautiful words which made beautiful pictures. But writing in the *Architectural Review*, also in 1936, about his Vertical Garden City that was designed in the middle twenties he made some really down-to-earth statements, such as: '(a) Brings the solution of modern speed: the separation of automobile and

pedestrian routes. The whole site is at the disposal of the pedestrian, out of danger from cars. (b) Gives facilities for the organization of communal services: liberation from domestic slavery, of great importance to women. (c) Safeguards the site: creates a real landscape and provides the opportunity of admiring it, by means of eloquent avenues superimposed one upon the other. (d) Restores the land for useful purposes, one of which, at least, is to provide sports facilities at the very feet of houses; another, if necessary, to provide vegetable gardens for intensive cultivation; much more interesting than the traditional small garden system . . .' Le Corbusier never failed to get down to day-to-day details, to the individual. In the Vertical Garden City, people stay on the ground, cars go upstairs: people must be allowed to move in any direction they like, cars follow routes. Such ideas are full of optimism.

Le Corbusier had a peculiar gift for seeing life for what it was. He was able, therefore, to suggest exact, practical and vigorous methods for making it enjoyable for people. He could see 'the sports facilities at the feet of houses' – they were real facilities for real people. The vegetable gardens were also real, intensively cultivated by real people. At the source of his visions were workmanlike details, like the heating plant at the Villa Savoye. His magic was made from plain facts, plain necessities: the plain man – nothing else. His architecture expresses the view that the state must provide rules to progress, and, to bring humanity back, the rules have to be broken – but not in such a way that the principles of the rules are denied. Hence the frame with its variations within – the beat and the improvisations. He seems to have begun on a problem, treating it as unique, from the beginning, from ordinary people – the living spaces, the kitchen, the bedrooms – and then expanded outwards; but, simultaneously, he worked from the total problem, the structure in its space, inwards. His 'green houses' were repetitive units in single structures that together would create the 'green cities' which were isolated happenings in the green country. Thus, on the one hand, he was making, in 1933, his perfect flat in Paris overlooking the Bois, while, on the other, he was suggesting massive new urban orders for Algiers, Paris and Antwerp. The details of these schemes were already worked out, in his head, or on paper: they were variations on the theme of the Vertical Garden City.

Unité d' Habitation, Rezé-les-Nantes, France: architect Le Corbusier, 1954. The balconies blaze with colour, capturing in an indefinable manner the art and imagination of France.

Unité d' Habitation, Avenue Michelet, Marseilles, France: architect Le Corbusier, 1952. Now rising above a superstore on the 50th anniversary of its completion.

On one level, these schemes accepted nature: they were free and open, and the buzz of city activity was concentrated within the housing structures; here, over a number of storeys, every house had its own terrace garden. On both levels, therefore, whether of city planning or individual living, the green lifeline was continuous, as it is in the traditional Georgian town. But the *piloti* of the Villas Savoye and Cook and Maison La Roche were another important factor: Le Corbusier called *piloti*, or stilts, 'another victory of modern technique'. In his book, *Concerning Town Planning* (1946), he says: 'Stilts will be recognized as the indispensable foundation of town-planning . . . the ground, level or undulating, will be furrowed by communications entirely independent of the buildings; neither pedestrians nor vehicles will encounter buildings as obstacles to movement; they will pass beneath buildings, through buildings . . . Beneath the stilts we can find shelter, and through their formal ranks can see the green perspective of the park.' Le Corbusier's imagery could be as clear as a cloudless day at times, and as poetic as the summer loveliness of foliage which he saw as an eiderdown to cushion hard structures, and to stop up the gaps between build-ings. Against this background the meanings of Maison Cook and the Villa Savoye become clearer. Not only was he exploring the cube and the mysteries of his medium: these houses were dress rehearsals for some much larger drama that would one day be staged, sketches for a heroic picture.

Le Corbusier's and Wright's points of departure certainly do not appear to be so far distant as they seemed at first. What separated them was what separated Japanese and Palladian architecture – tradi-tion, geography, religion. Wright felt humbled by nature, Le Corbusier saw man and nature as equals. Wright feared cities and their invasion of the countryside; Le Corbusier was exhilarated by them. Instead of rejecting them, as Wright tended to do, Le Corbusier wanted to organize them, and to bring to people good conditions, sunshine and air. But in Wright's city, Broadacre, the emphasis shifts from architecture to landscape: nature is favoured and the importance of the man-made order is reduced. Houses are spread out: one man, one acre, one cow. Architecture merges with countryside – this is the conventional garden suburb – and Wright claimed that the conception was a logical consequence of the

Le Sexton, Maison de Vacances, Palmyre, France: architect Le Corbusier, 1935. The architect's experiment with the materials of the locality, rough stone and a wood structure; the roof, corrugated iron.

automobile, the mobility of which had put 'paid' to the old notion of the city. 'The town,' he said, 'could very well spread into the country – thus you have the city without the city.' But for Le Corbusier the city was a marvellous organic achievement. He had the deepest respect for man, yet, along with Shinto, saw him and the animals as inseparable from nature – as Samuel Butler put it in his notebooks, '. . . life is one animal'. And he seemed, at least in this respect, to have a more profound sympathy with abstract Eastern thought than even Wright.

Yet mere reflection was never enough for Le Corbusier. Positive action had to be taken: nature had to be explored and more fully accepted in his architecture. In 1935 a move was made at a weekend cottage near Paris – it might be called the original 'green house'. If it was possible to imagine the most beautiful poem made of concrete, rough stone and glass, this cottage would be it. At the back the walls were buried in a mound of grass, and grass grew on the roof. The stilts had gone; the cottage was firmly rooted to the ground. The colour of nature was allowed to enter through

large openings and the dreamy film of glass bricks (then a new invention) which transformed leaves and blue sky and movement into an underwater scene. The flat roof had gone too, replaced by concrete vaults with which Le Corbusier had experimented at a village designed a year before. These vaults, mirroring the undulating ground, suited the plan: they accepted flexibility and gave definition to an irregular shape. The cube had not been completely dispensed with – it was still present in the plan. We still see evidence of the square with which he began at the *Ateliers d'Artistes*, but now a side of it had been removed to allow a closer relationship with nature. Thus a free plan achieved an order and discipline from a new direction: the outline was stressed by the roof.

Le Corbusier could now use the cube without being restricted by it; he was free, and a much wider range of materials accompanied this freedom: rough stone, brick and plywood appeared – materials which have an immediate association with nature. This experiment led to another – *maison de vacances* in the south – and then after the war, when money and steel were short and the

Le Corbusier Centre, Zurich, Switzerland: architect Le Corbusier, 1967 (completed after his death in 1965). One of the architect's most inspired works, the abstraction of the pediment and dazzling colour recalling ancient Greek architecture.

building industry had broken down, to the Jaoul houses in Paris and the first and second Unités at Marseilles and Nantes. So, in spite of the war, Le Corbusier's line of development remained unbroken. He took up where he had left off, with concrete vaults, rough finishes, rough bricks – everything was extremely rough. But the war was, nonetheless, an immensely important period. He went back to painting. It might sometimes appear that this was, as a separate activity, as important to him as architecture, but it is also true that painting had a great deal to do with the inspiration of his buildings; for instance, only a painter could make the breaks which he did with the straight lines of structure. But indivisible from painting and architecture was nature. And this fast-developing preoccupation with 'the inexhaustible domains of nature' simultaneously tied him more closely to human beings; inevitably, the one balanced the other. The war may have been an influence here. In 1914 the horrid, savage destruction of towns brought the rapid response of the Dom-ino houses. The Second World War, once more focusing attention on the human being and his suffering, brought the Modulor.

This was the name given to Le Corbusier's method for redefining human scale and relating the proportion of a building to the proportion of a person – factors neglected or lost in the nineteenth and twentieth centuries. This measure, like the rediscovery of the frame, took him back to the beginning again, to Greece and the Graeco-Roman concept of the human being at the centre of the universe: the Greek form of measure was a literal visual translation of this concept. This arose from the circle described by an outstretched man. The centrepoint was the navel, and the projection of the square inside the circle was determined by the top of the man's head and the bottom of his feet. Le Corbusier's method was similar: the diagram is again determined by height, characterizing the space occupied by a man 1.8 metres (5 feet 10 inches) tall. Again the navel is the centre-line, giving a measurement of 113 centimetres (44 inches) from the ground; and the top of his upstretched hand gives the total vertical measurement – 226 centimetres (89 inches) – and thus the double cube. But further variations gave Le Corbusier's system greater range than the Greeks' – other horizontals were introduced by the top of the man's head, the seat of

It was the ancient Greeks who first noticed that a man with arms and legs extended described a circle, his navel at its centre. The circle, and the square within it, has been the basis of scale and proportion of the finest domestic Western architecture ever since. Le Corbusier made the point when he used a diagram of an ancient Greek arsenal in the Piraeus (*above*) in the book, *Towards an Architecture*, to demonstrate 'regulating lines'.

a chair in a relaxed position (and again in a more conventional one – eating, for instance), or by the average height of the elbow when working, and so on. The diagram could also be divided vertically on the centre-line of the figure, creating further proportions. His system was, therefore, similar to the classical method insofar as it was concerned with the shape and dimensions of the figure; but it also represented the human being in movement. This was the Modulor, and the invention was first announced in 1947 and published as a book a year later. Le Corbusier described it as a guide that was essential in an age of prefabrication and industrialized techniques – and so it was. He recognized the menace of the machine, and the Modulor, tying buildings back to the detailed sizes of the human anatomy, had been called in as a practical method to assist in active resistance to it. In a sense then, it echoed the fears of such people as Heinrich Heine, Sachs, Freud and many others – fears which are becoming universal. From the architect's

point of view, however, another bubble had burst, and the source of the inspiration was the meeting of a number of things at the same moment: the preoccupation with nature, with painting, with natural indigenous forms and building techniques: and in the centre was man, represented by the Modulor, holding the huge, diverse and complex structure together.

And so, with a jump of over 2,000 years, a physical link with Greece had been finally established. This gave Le Corbusier the freedom to do other things – the Unité at Marseilles, for instance. Here was a practical and imaginative solution to prevailing conditions, and the Modulor made it possible in human terms. He recognized the problems of scale in very large buildings, and the cost of them, and he had observed the architectural opportunities of strong sunlight and local Mediterranean craftsmanship; things of this sort suggested new forms and imagery. He called the imagery *béton brut* (not to be confused with the fashionable journalese of English New Brutalism back in the fifties) and the word *brut*, translated, means 'raw'. Thus *béton brut* described the exact impression left on concrete by wooden shuttering – the lines of the planks, the grain and the knots in them – and as such could mean a precise representation of natural materials. Applied wholesale to modern living conditions in sophisticated industrial places, the method made no sense whatever (imitators in England who copied its appearances – not its principles – were among the worst offenders) and quickly degenerated into surface decoration. It made a lot of sense, however, in the context of rustic and somewhat primitive building techniques, a hot climate and postwar shortages: from every point of view there was an acute need for architectural economy. And, again from the human point of view, this method of casting concrete brought the grand scale of a huge Unité within the comprehension of a person: the texture was large enough to see and touch. But behind the scenes was the Modulor, manipulating proportion – at 140 metres (459 feet) long by 70 high (229), the Unité is a friendly structure with a friendly scale.

By this time, the aesthetic Le Corbusier had created was copied all over the world. For his imitators the style represented anything they cared to make it represent: 'social realism' and the 'underprivileged', the return of decoration, a 'worker's art', a new era of

Corbusier returned to the Greek islands, and the primitive forms he saw there inspired his later work. And, in a sense, Wright similarly returned to the American tradition of the log cabin. There can be no question that these two architects – through books, buildings and through other architects who worked with them (Schindler, Neutra, Drake in Wright's case; and Niemeyer, La Costa and others in Le Corbusier's) – spread modern architecture throughout the world. Wright gave us space, openness and a real knowledge of the meaning of materials. Le Corbusier's contribution is more far-reaching: the objects which he left behind do not merely exist in their own right: they show what lies beyond. This means that there must come a time when the principles which he set down in his buildings will be more fully understood, and they will then achieve a more universal application. But if the work of Wright and Le Corbusier together conveys a particular theme it is, I suppose, that, above all, human aspirations – behind religions, words, language, race and climate – are much the same, as they have always been.

But the legacy of Le Corbusier, Wright, their disciples and followers has been, of course, the Universal style which, much disliked, has little to do with the heroic battles for architecture fought and won in the 1920s. Examples of this style in housing, in tower blocks, in system building, are seen all over the world: the style varies in appearance and character hardly at all from place to place, and in most industrial countries there is one dominant theme: cheapness in construction and speed of erection. How did it happen? The answer is, I think, simple. Modern architecture is just as dependent upon generous space as that of any other period – Greek, Chinese, Palladian, Georgian. Those who build – government departments and private developers – liked this style because it was simple and, therefore, cheap. And, because money is central to industrial societies, and since architecture reflects the nature of society, the style was stripped of its space, ending up with the non-architects. And so the once emotive word 'functionalism' came to mean non-building. Again, it was the appearances of a style that had been copied, not the principles which lay behind those appearances. This has happened before, over and over again, from the beginning: in the treatment of the arch by the Sumerians, with the

form of the Egyptian pyramid, the Italian Renaissance decoration imported by the French, and in the debasement of the American skyscraper and the Garden Suburb. And so, for much of the time, all we had left of modern architecture was its outline, not its content.

TWELVE | An Age of Fashion

In 1965, a dark time for architecture, Le Corbusier died, long enough ago for his work – buildings, town plans, paintings, sculpture, drawings, writings – to be assessed objectively, and not confused with that of his imitators. Those who have condemned his architecture are normally unable to distinguish between the genius of the original and the banality of the copy. Most great artists suffer such treatment, whether architects, writers, painters or any kind of creator of whom one can think: after 300 years, Shakespeare, Michelangelo and Palladio have suffered from it, and, as Delacroix said, in his case of architectural plagiarists, 'they are not only incapable of inventing a beautiful thing, but they also spoil for us the fine original . . .' In our time, for example, the work of Le Corbusier has, above that of all others, been denigrated by the blunders of many who might claim to be this master architect's followers, and who misunderstood his understanding of his favourite material: concrete.

Concrete became the first fashion of the postwar period, much of it system-built. Using this method of prefabrication, the tower block, a local authority speciality in rented housing, proliferated all over Europe and eventually throughout the world. To start with it was the product of war devastation, with millions of homeless and cities flattened on a massive scale: here was the technological tool that could prefabricate homes fast, making bricks and mortar seem

as slow and ancient as mud-brick Jordanian settlements of 7000 BC. Such was the effect of what appeared to be a sudden break-through in constructional technique. Certainly, governments saw system-building as the solution to a dire problem compounded by an extreme shortage of building materials and skilled craftsmen, and, in Europe alone, more than 100 different versions of the system were developed, some in England, some in Continental countries such as Holland and Denmark, all inevitably leading to the crudest possible picture of functionalism in the slab block, long block, point block, anonymous, tediously repetitive, and of a kind that had a total disregard for national characteristics, a picture which belonged to a new, faceless, nowhere land: destruction throughout Europe, Russia and the East on an unprecedented scale had been reme-died by a rushed, botched-up job, and for possibly the first time domestic building had become entirely detached from the people it was meant to serve. The late Sir Richard Sheppard, himself a first-rate architect, put one side of the English position accurately when he said in the mid-1970s that he believed a reason for the humanitarian disaster (for some regarded it, wars apart, as the worst of the century) lay with the 'vast bureaucracy which stands between the architect and the user', adding that 'it's nearly always a tenant who uses the building, but with an army of housing managers, building officers, administrators between architect and user, build-ings tend to express administration rather than user'. As he pointed out, however, opposition was on the move in England, and had been before Anthony Crosland, Environment Secretary of the 1974 Labour Government, put an immediate stop to system-built local authority redevelopment schemes: refurbishment of old properties, some large areas of neglected eighteenth-century streets, had to replace them.

Sheppard was right, of course. Yet in England – and England with its worldwide influence on domestic architecture serves as an important starting point – the initial use of prefabrication was exemplary and became for a time internationally famous. It was adopted for primary schools in Hertfordshire by a group of young, enthusiastic architects led by Oliver Cox, and manufactured by Hills of West Bromwich, a delicate assemblage of tubular roof trusses, window walls and partitions, the whole of which combined to

produce a fresh, bright beginning to a child's schooling. Yet a solution for one set of circumstances, in this case the postwar shortages, will be unlikely to suit others, and the excessive government demands for huge numbers of homes at high speed were central to these: they led ministries and local authority departments to find a short-cut solution. So once more the Chinese saying that the right means work in the wrong way when the wrong man uses them echoes across the centuries: suddenly, mass production was seen to equal mass housing, a big idea that served English and political objectives swept along by an upsurge of optimism with a creditable enough aim – to replace the multitude of blitzed neighbourhoods and nineteenth-century back-to-back slums with a gleaming vision of towers, equipped with all mod cons, standing in green parkland. People, deprived or homeless, were to be given a sparkling, modern, healthy, hygienic chance in life, a new start. So what went wrong? Design fell into the wrong hands – that's what went wrong. This led to an almost total takeover of the housing scene by the manufacturers; design was put in the hands of the machine, building parts prefabricated in the factory and placed in position on the site by cranes on rails – structure, services, panels, windows, floors, partitions, doors – the lot. The limited systems that had proved so successful on small jobs like the primary school became out of control when driving vast, ambitious projects like the comprehensive redevelopment schemes. Nevertheless, in the 1950s local authorities were carried away by these (as was believed) revolutionary methods of construction that were also cheaper (so the theory went); likewise the government whose lavish subsidies picked up the bill for extra floors, the cost of lifts, etc. – the fact is that financial encouragement made building high irresistible. Architects, moreover, were regarded as something of an irrelevance; a single floor plan could be repeated over, say, thirty storeys, and the saving in professional fees was not an item to be overlooked either.

These were among the factors that began, in the 1950s, to push the private architect out of the English picture, and to increase the importance of the local authority's architect's department: in the profession, called 'empire-building'. The exclusion of the private practitioner, moreover, led in particular to the abandonment of the

architectural competition as a means of choosing the best designs and discovering new talent. The loss of this, used in the 1940s and 1950s, left the English lagging behind. Naturally, there were plenty of bad mistakes made abroad (with tower blocks, system-building, etc.), yet it remains that in Finland, France, Germany, Denmark, Holland – generally in Europe, in fact – running competitions for most public buildings, such as schools, universities, embassies, town halls and housing, was an established custom for the last half of the twentieth century. There, the drive for quality was regarded as a matter of practical common-sense, the importance of which, it would seem, so often eluded the English. Moreover, the buildings rushed up to meet the housing crisis seldom warranted examination, their effect on the environment and threat to social stability passing unnoticed. It is extraordinary that, until the mid-1960s, there was no serious condemnation of the concrete boxes that hit urban centres and their outskirts. Written off as an expedient, these mammoth intrusions on our lives were rarely commented on in specialist magazines or by media critics, least of all attacked.

On the other hand, however, some architects who witnessed system-built blocks under construction did remark on the flimsiness of their appearance. Hidalgo Moya, the co-designer of the fine Churchill Gardens residential redevelopment scheme in London's Pimlico of the mid-1940s and 1950s, said they really did look like 'houses of cards', and the terrifying collapse of huge structures in the appalling 1999 earthquakes in Turkey and elsewhere gives a picture of what could have happened, for example, in Northern Europe in similar circumstances: any country without a fault-line but the possessor of such shoddy building techniques can consider itself very lucky indeed. For they *were* shoddy: to take one simple case, the general contractor on the site might well have had to prepare a framework to accept the machine-made product. Here were two conflicting skills, one rough by nature, the other exact to a fraction of an inch: here was an immediate likelihood of an in-built failure. And there were such failures – bolts that did not fit, or left off, panels that were loose: if a heavy piece of furniture should be pushed against one violently it might be dislodged, even fall out. There were many of a structural kind, many to do with standardization where economy is clearly a prerequisite of

In England the public blamed the architects for what came to be called the £10 billion ($14.6 billion) mistake, while the architects blamed the planners and politicians. Asked how it happened, an architect would scratch his head and say: 'God knows, but they'll have to be demolished.' Or: 'Wasn't it political? Called the numbers game? Successive governments vowing to build hundreds of thousands more homes a year than the last to win elections.' Three hundred thousand was the favourite figure; no members of government, local or central, stopped to think how people would care to live, whether they would prefer a renovated old street to a concrete box that killed the street and produced a desert; whether they wanted a private garden, a communal one, two storeys or three, a flat or a house – essential research of this kind was never done. No detailed thought or analysis went into the common tower block; had it been, 'pram space' wouldn't have been noted on the plans of the thirtieth floor of south London structures, nor, in point of fact, would an inner ringway have been shown by London County Council highway engineers going through Christopher Wren's Painted Hall at the then Royal Naval College, now the University of Greenwich. Both pram and road planning speak an identical language: design had become an abstraction, a matter of statistics. Homes meant votes, not real people with real likes and dislikes; roads, the emergence of the car lobby's additional threat to acceptable surroundings. All the pieces of the disastrous jigsaw were now in place: the stress creator, drugs, vandalism, crime. This was the picture, never better described than by Glasgow's bleak and hideous Sighthill with its stories of murder and violence, a picture that recurs in the city's other 250 tower blocks, some the highest in Europe, which are now due for demolition.

'We shall be punished for this,' was the observation of Michael Scott, the great Irish innovator who brought modern architecture to his country in the 1930s. 'It's barbaric.' Psychiatrists in France believed that mental breakdowns and the like had their source in the madness of the new building programmes. Commander Peter Marshall, former Commissioner of Police in the City of London, visited Chicago high-rise slums and came back convinced that these frightful structures were largely, if not wholly, responsible for the rapid acceleration in crime. In London, Thamesmead, on the river

Sighthill Estate, Glasgow, Scotland, notorious for violence, drugs and murder, typical of the horrible housing estates, 1950s–1970s inclusive, now among the majority of the 250 tower blocks in and around the city to be demolished. The figures in the picture are asylum seekers. Photographer Murdo Macleod.

beyond Woolwich, made a fair comparison with what was found in Chicago: kids with nowhere to go to kick a ball around; nothing to do except vandalize cars, steal to buy drugs, terrify the elderly – at the Hulme Estate in Manchester (now demolished), some were so frightened they didn't dare go to the shops a mile away. And then there was the development of something serious called concrete cancer. Not all the blocks were system-built: some were constructed of reinforced concrete, too tough ever to have structural problems. Yet there were mites that lived off it, tiny white creatures in their thousands. That was quite apart from others breeding from condensation, moisture, mould: those outsize cockcroaches blackening kitchens in Belfast's Divis Estate . . .

It is strange indeed to think that the capacity of tower blocks, in terms of density, was in no way superior to that of a square. As early as 1959, the LCC showed this to be the case when comparing a group of four twenty-storey blocks with a normal square where the sides were four storeys high. It was a hypothetical exercise, of course. However, if the sides of the square are upended the point

of it is made plain, particularly since this illustrates too the effect of regulations imposed on angles of light: these pushed the blocks back, well away from each other (affecting the widths of streets similarly), so accelerating a sense of isolation, and this, apart from exploding the myth put around about a tower's potential, was another serious disadvantage. That was by no means all. According to an artist interviewed on a TV show of the time, *Late Night Line-Up*, overlooking was extremely disturbing. Perhaps the experience of loneliness had a hand in this singular behaviour, amounting to people watching the movements of others in blocks across the way through binoculars. This wasn't a form of paranoia, he insisted; it was a favourite pastime of neighbours, easier to do up there in a tower than down at street level – no obstructions, no trees, buses passing. Moreover, as a follow-up on height, and very important, there was the impossibility of children, back from school and after tea, running out to play (parents couldn't keep an eye on them), so leaving them to sit in front of the telly. That was bad. And so the criticisms ran on – sound insulation so poor that a full married life was difficult without complaints, lifts vandalized or broken down, stress from fear. The tower block was an entirely alien form of living. Thus, although not doing well on densities either, it is very surprising that the building of them continued relentlessly, thoroughly impractical as they were. As ever, in the end it was left to people to force a change of direction, and this they did by organizing local opposition in attempts to stop redevelopment schemes that meant the sweeping away of old neighbourhoods of quality, and which were capable of restoration. St Ebbe's, a beautiful, early-nineteenth-century quarter in south Oxford, was a perfect case for this, the City Council's blanket demolition of it raising furious protests, unfortunately unsuccessfully. During the same period, the 1960s, the best of Islington survived a similar threat, and a plan to develop Golden Valley, an exquisite stretch from Stroud in the direction of Cirencester, was defeated by a campaign led by the poet Laurie Lee. There were many examples. And so it was that public protests and anger were not far away in 1968 when there was a gas explosion in London's Ronan Point, Hackney, one side of its twenty-four storeys collapsing as though it had indeed been hit by an earth tremor: this was the beginning of the end for the common tower block.

In 1972 a vast housing estate in Saint Louis, Missouri, was completely demolished; only sixteen years old and by Yamasaki, architect to New York's ill-fated World Trade Centre. Although it was the winner of a number of awards, it was hated, the target of violence and crime, the centre for drug dealing, all the usual horrors of these alien schemes. And so disgusted with it were the city authorities that the site remained a desert for years for fear, it was said, of making another gigantic, costly mistake. Demolition began to catch on: Ronan Point was of course blown up, but other towers elsewhere followed suit. In 1979 blocks for 900 people in Birkenhead, south of Liverpool, were demolished, together with an enormous development in Liverpool itself, in each case around only twenty years old; and in 1981 a faulty tower in Rochester, Kent, damp, cracked and vandalized, was also blown up – it had been built in 1966. Demolition as an extreme recognition of failure became established practice in countries as far away as Kuwait. In 1999, at a time when Birmingham City Council was planning the demolition of the notoriously faceless concrete Bull Ring (and now completed) and had commissioned a fine design for a department store on its edge from the highly imaginative firm of architects, Future Systems, structural tests were being carried out on 150 of its 1960s towers following shocking discoveries of serious defects in some large panel system-built structures. The investigating manager of the housing department said they were looking closely at the junctions of wall and floor panels, and were not ruling out the possibility of the demolition of some tower blocks. This was quite an undertaking since they were part of one of the largest municipal estates in Europe, carried a local authority debt of £678 million and a repair backlog of £1 billion (still, that other enormous scheme, the Hulme in Manchester, was taken down in the early 1990s because it was a complete failure). 'It's not a design problem as such,' Birmingham's housing manager said, 'but poor workmanship when these buildings were put together. You've got to remember that at the time these blocks had to go up quickly. You've got a guy standing twenty floors up with a crane hoisting a big panel towards him. If he can't locate the various bars in the floor and wall panels that need to line up, he'll make it fit quickly by flattening a few.'

Now the City Council wants to demolish a total of 300 blocks, ending the 1960s grandiose dream of high-rise living, finally, for good.

The replacement is to be conventional 'low-rise homes': that's the bad news, the predictable swing of the pendulum to today's favourite extreme. In the 1960s there was another: disillusionment with those disgraceful drab concrete crates, devised for the storage of people rather than for their enjoyment, and with strategies determined by maximum numbers for a minimum outlay, undoubtedly led to a series of 'isms', some of which were unpleasantly quirky. While the fashion in high-rise was the preserve of the local authority, of a bureaucratic inflexibility that regarded building policy in terms of blanket solutions, the fashions following were the preserve of private practitioners of architecture and, on occasions, international theorists. The anonymity of the first was replaced by an excessive individuality that was condemned by some as originality for originality's sake. One of the examples was mentioned earlier, New Brutalism, derived, as explained, from Le Corbusier's use of *béton brut*, the discovery he made directly the Second World War ended. It is interesting to compare, moreover, the effect that shortages of materials and skilled labour had on design in the different situations: in England, for instance, they produced wholesale prefabrication and inhumanity, whereas in the other, the imagination of genius observed how they could produce the reverse – humanity and a true sense of scale from the raw effect of board-marked concrete in a huge, seventeen-storey structure above *piloti* level. No wonder that architects, seeking inspiration for new directions in thinking, seized on this extraordinary invention – yet another from Le Corbusier, always a unique source of remarkable ideas which, so long as they were not misused, would illuminate something that was untried, not given a thought to before, from the form of a whole building down to the minutiae of the planning and detail of an apartment, house or roof terrace, and never less than fascinatingly. This particular idea, the special preserve of the English, prompted a sudden swing of the pendulum towards architects' architecture, and, as it turned out, one of the ugliest phases on record.

Le Corbusier's idea had of course been misused. Misunderstood,

it was translated into New Brutalism, and this meant, unfortunately, that buildings were transformed into vast lumps where every element became two or three times life-size, losing all the delicacy of contrast that was an inherent part of Le Corbusier's own work. An example was the South Bank, London, then known primarily for the Hayward Gallery and Queen Elizabeth Hall, and the vast handrails, deep beams and balustrades in a formless muddle made a single stride towards chaos, inspiring the vivid definition of New Brutalism as 'using an RSJ [rolled-steel joist] for a toothbrush'. Backed by an up-and-coming forceful Glaswegian, James Stirling, who saw himself as the architect who would replace Le Corbusier (regarded by some as 'past it'), the fashion reached all areas, from small houses to public buildings. Stirling himself took the characteristics of Le Corbusier's Maisons Jaoul, the pair near the Bois in Paris, to a site in Ham Common where he was designing some flats in three blocks; but they were characteristics in outline only. He used board-marked concrete, yet in dropping the sensual forms and roughness of the brickwork in the original (perhaps fearing a charge of plagiarism had he not done so) all its atmosphere went. Copying had indeed gone some way to spoiling 'for us the fine original', if just fleetingly. However, by the time publicity for Ham and for the South Bank had spread the word, Stirling had moved on to another, more industrial orientated fashion: Romanticism. He was excited by the red-brick warehouse architecture of the north, an influence leading to a particularly harsh, beefy, engineering brick (or tile) which was applied to any situation, irrespective of local conditions, materials, use, and in this way was as bad as local authority schemes, some of which had, incidentally, followed the fashion and had flushed red too.

These swings of fashion remained exclusively English: they never crossed the Channel, and nor, for that matter, did their makers and theorists – they went to the United States to teach and theorize over there. And, as it happened, there was a swing of the pendulum occurring in a number of schools of architecture around that country too, again denoting disillusionment with the cul-de-sac in which design appeared to have found itself. Having become dull, architecture needed reviving, rediscovering: this at least was a fairly reasonable explanation for the emergence of Post-Modernism, the

fashion which eventually spread throughout the world the most astonishing affectations seen in buildings. Before it went wild, resembling gigantic blow-ups of Pop Art, Andy Warhol's *Campbell's Soup Can*, Las Vegas and all that, Post-Modernism had a faintly academic, scholarly air, mainly concerned with architecture's historical heritage. There was Robert Venturi's influential book *Complexity and Contradiction in Architecture*, said to be an important starting point for the definition of Post-Modern architecture; there was Charles Moore, head of Yale University's architectural school, a follower of Venturi's studies of classical detail and scale, and an admirer of Sir John Soane (Soane's Dulwich Picture Gallery in south London was an icon for the American Post-Modernist set); and there was the treatise by Charles Jencks which was responsible for giving the movement a name, so establishing it: Post-Modernism. Venturi's book was published in 1966, Jencks's in 1975. Then, again in the 1970s, Peter Eisenman appeared, the architect who led a group calling itself the New York Five, and this group, together with Stanley Tigerman, a sympathetic recruit from Chicago, went the rounds of universities to lecture students on the philosophy of Post-Modernism. In Eisenman's case, this was derived from the early work of Le Corbusier when, as the great Russian architect Berthold Lubetkin put it, they 'wanted to give a face to their age'; he was referring to the colour white, which Le Corbusier had fastened on in visits to the Greek islands as a teenager.

Post-Modernism had different springboards. One was the academic's: this may have surfaced following some kind of study of Petrarch, who had of course seen a return to ancient Greek culture as a way out of the failures of his time. So the academic Post-Modernist acted in a similar fashion, researching classical architecture: out of this came a symmetry that would have created dualities had it not been for elevational touches that produced asymmetry: Venturi showed an expertise in this area of design, while Eisenman and Michael Graves, another member of the New York Five, in returning to the cube, the common form of the 1920s, usually whitewashed, treated this in such a way that the geometric frame was broken down, a portent of the later fashion of deconstructionism. Their approach was thus contrary to Venturi's, whose faith in a classical order led him to design, to an extent, traditional façades

that were true expressions of the interior spaces. And while his treatment of them could be disturbingly quirky, his ideas remained inventive, a vital feature of classic Post-Modernism, as the New York Five and Tigerman were keen to demonstrate. But they were equally keen to demonstrate the philosophical depths they had plumbed, and it was this, unfortunately, that students attending their lectures found difficult to follow, even incomprehensible. Tigerman was specially concerned with this aspect of the debate (as any discussion was called then), introducing literary analogies to it, as though to serve as another method of illustrating some point of profound significance. For example, on one occasion he explained away patterns of tiles in the floor of a warehouse he had converted as identifying lines of columns he had moved — he had, he said, 'dragged these apart to open up the space': here was the evidence of what he had done. It is clear that the urge to simplify, the continually active human instinct, had been supplanted by an obsession for complexity: the Mannerist, for whom Palladio had such a distaste, was back. Le Corbusier, who missed the surfacing of the fashion by a year or two, would have been horrified.

If Post-Modernism had any scholarly affiliations, these vanished in what was to follow, buildings treated as subjects for exterior styling, often so elaborately done it might have been for an ad in a glossy magazine, and so littered with confusing, extraneous details that the vital connection with human scale was lost. Freed from this discipline, the fashion travelled at phenomenal speed — to all parts of the United States, as to be expected, but also to all parts of Europe: the British Isles, France, Italy, Austria, Belgium, Switzerland — everywhere. And, according to the great Indian architect, Charles Correa, there were such riotous examples of Post-Modernism in South-East Asia and Japan that even a ludicrous pastiche of Versailles, an apartment block near Paris by Ricardo Bofill, was made to look almost dull. Worst of all, perhaps, the movement finally degenerated into a third-rate decorative style: whereas earlier movements of distinction — Palladian, for instance — led on from fine examples of villas built for the wealthy to street and city planning with a true order, Post-Modernism attempted no such practical contributions to day-to-day life. This is not of course because its pioneers wouldn't have wanted such an outcome;

it is simply because the style was inherently incapable of evolving in that way. And so, while it was doubtless fun for those with the money to commission a frivolous piece with built-in 'architectural jokes' (such as a stair arriving at a blank wall), the classic Post-Modernist house led nowhere of lasting value. Nevertheless, due to the immense publicity which accompanied the style, an air of authority surrounded it that was seductive: after the high-rise disaster, the system-built nonentity, the destruction of the social order, it could have appeared as a possible way ahead. And by the time many in England had fallen for it, architects and developers saw the style as a useful device for obtaining planning permissions for difficult commercial schemes in architecturally sensitive areas; besides its authoritative air, it gave an outward impression of professional good taste: a new 'ism' had now entered the vocabulary – façadism. Everywhere, façades of houses (detached, semi-ds, in terraces) and blocks of flats became decorated with a semblance of classical details – arches, pediments, circles – in brick outlines which, repeated across the country in streets, office buildings, shopping centres and elsewhere, had the depressing effect of making places look the same – boring and dead. The style spread like a rash to have, in its way, the makings of an urban picture as anonymous as the tower block era ever was.

This may have been the end of the line for Post-Modernism. Yet that did nothing to halt the astonishing collapse of confidence in architects in the 1980s, which in England dropped still further when the Prince of Wales suddenly made his own damning attack on them at Hampton Court Palace. He was presenting Charles Correa with the Royal Institute of British Architects' annual Gold Medal Award for merit in 1983, an architect who has spent much of his time concentrating on the problems of domestic design, one of the few among the top two dozen or so in the world to treat this side of their work with proper respect. Here it is, accounting for three-quarters of urban surroundings, yet the Prince missed a marvellous opportunity to talk about it; instead, he used the occasion to let fly at modern architecture, his pet hate, picking on two proposals in London and in the news: the extension to the National Gallery for the celebrated Early Renaissance Collection, and Mies van der Rohe's Mansion House Square scheme for Lord Palumbo

in the City. He called the first 'a monstrous carbuncle on the face of a much-loved and elegant friend', while the second was dismissed as a 'glass stump' of the Chicago variety. Being the Prince, his comments hit the headlines, the Hampton Court event immortalized as the 'carbuncle speech': Correa, a dedicated humanist and disciple of Le Corbusier, went practically unnoticed by him, despite the fact that the architect was being handed the most prestigious award for architectural excellence in the world. Hardly surprisingly, this singular experience didn't go unnoticed on Correa's part either; he naturally expected the speech to be about his work. What no one expected was the follow-up – according to a wit at Hampton Court that night, the Gold Medal for 'Charles Correa launched the architectural career of Charles'. Indeed it did, at least insofar as broadside after broadside was fired by him across the profession's bows. In some ways, of course, he had a point – he was rightly horrified by the damage done by the blundering attempts to clear up the mess left by the war and the nineteenth-century slums with the horrendous comprehensive redevelopment schemes. 'Whatever we may think about his theories,' the fine Norfolk architect Herbert Tayler said, 'you've got to admit he does care about architecture.' That is true: his failure, however, was an inability to distinguish between good and bad design, whatever the period. His knowledge of the subject was limited, despite a smattering of tutoring from John Betjeman and Hugh Casson; and first-hand experience collected when flashing past buildings in chauffeur-driven cars leads to seeing architecture as façades, not as the three-dimensional spatial construction it is.

Whether he was aware of his ignorance is unclear: perhaps he was, since he surrounded himself with a number of advisers, some of whom were architects and respected names in the profession, others who were unknown until they were known to be assisting him, at which point they became well known. This circle then itself became influential through its royal connections, yet in what way its members did in fact assist him is also unclear. He continued to attack modern architecture, still apparently mistaking it for the worst category of local authority tower blocks. He continued calling new buildings names – the British Library by Colin St John Wilson was 'like an academy for secret police', Number One Poultry by

Stirling and Wilford in the City 'a 1930s wireless' (a possible compliment, if unintended), and Philip Dowson's scheme for Paternoster Square alongside St Paul's a 'prison camp' – and campaigning via lectures, interviews and a TV film called *Vision of Britain* for a more old-fashioned approach to building: academicism was his 'ism', a proper regard for tradition expressed as physical appendages (brick chimney stacks, cornices, sash windows, pediments), not of the spirit of the place, the *genius loci*. His criticisms damaged the reputations of a number of modern architects (which, it was felt, was very wrong for someone in his position) and had the effect of influencing others to toe his line. This encouraged another 'ism' still – mock-classicism – led by one of the Prince's favourite architects, Quinlan Terry, and a wholly meaningless siding in the developing housing crisis of the 1980s when government cuts in local authority funds were at a height: such a style suited only wealthy dilettantes. But these various 'isms' again helped in obtaining planning permissions, planning committees keen to please the Prince. Here was a parallel with the effects of Post-Modernism, which could have egged him on. The fashions appear to merge – indeed, the truth is that the Prince wasn't really a traditionalist, after all: he was a branch-line Post-Modernist.

With his confidence much increased by the publication of his book of the film *Vision of Britain*, and by considerable media backing, he launched into an even more active role, twice intervening over the Paternoster Square scheme (Dowson's plan was dropped), and influencing the outcome of an important architectural competition, Grand Buildings in Trafalgar Square, facing Admiralty Arch at the end of the Mall. The winning design by Richard Horden, an exceptionally gifted architect, was duly side-lined and a poor replica of the dull, existing structure executed in its place. This gave excellent publicity for a new fashion of a peculiarly depressing sort, façadism at its worst, the replacement of demolished buildings with either facsimiles of original façades or by retaining old ones. Then he started an architectural school to rival others, notably the Architectural Association's and London University's, the Bartlett. His was for the study of traditional skills, and, to assist the success of this cause, he sponsored the design and building (still in progress) of the Poundbury estate on the edge of

the old Roman town of Dorchester, Dorset, commissioning the neo-Post-Modernist, Leon Krier from Luxembourg, to make a master plan. He was a graduate of the AA School in 1971, the brother of the town planner Robert, and he was, apparently, entirely in harmony with the Prince's aim, namely to create somewhere possessing the recall of a much-loved place, the old town centre, the village complete with a market hall, from another time. Of which time it is not easy to say – 200 years ago, 300?

With this completion of his mission, it has to be admitted that no one could have tried harder to change the direction of architecture, especially domestic design, if with disastrous results. Poundbury, separate from the town's west side, amounts to a large neighbourhood of low-rise houses for sale planned along a maze of interconnecting streets that abandon the suburban cul-de-sac. So far so good: in the first place, however, it was conceived as a picture of life before the car – at least, that was the dream picture, one which, not unnaturally, quickly proved wholly impractical. This apart, two fundamental flaws underlie this failed attempt at residential work. First, there is no overall plan, no centre of interest, and thus no order: in a relatively small area, losing the way becomes easy in rambling streets without a clear sense of direction. Secondly, another essential of architectural order is an economy of materials. Here there's no such economy: in fact, quite the reverse – materials constantly change: gravel roads, tarmac roads; bricks here, stone there; different bricks on opposite sides of streets, and the more disconcerting where the difference occurs in a deliberately slight change in colour. Continuity is disrupted: good architecture – take, say, an ordinary eighteenth-century terrace, and then a far-from-ordinary, truly modern building such as Powell and Moya's Wolfson College at Oxford – succeeds when a firmly expressed choice of one or two main materials is followed throughout. From this point of view alone, Poundbury's failures could be regarded as a lesson in what not to do, and that hardly accords with the Prince's intentions. These are primary errors, the apotheosis of architectural muddle, leading on to a somehow inescapable proliferation of mistakes in no way less important. The human touches are missing. For a start, because of the neglect of landscape, surfaces are extremely hard: there are no random intervals of grass where children can

An example of the current threat from the building industry's volume house builder that is spreading throughout England, particularly in the south-east. This group of houses has scarred a once beautiful stretch of the South Downs near Newhaven.

play, meet, let off steam; no creepers to soften the appearance of stone or brickwork, no scents of flowers wafting over walls, few front gardens and only occasional trees – it's as though the architect was so concerned about what to do with the façades of houses, about how to make them look interesting, different, individual or antique, that the existence of landscape, the crucial ingredient which, for example, gives Charles Correa's architecture its profound humanism, was forgotten; and it was, of course, forgotten in the tower block age too.

Continuity in particular is vital in the making of a background for living: this means parts connecting as easily as a flow of incidents in a story, and this is impossible where individual bits are stressed as though tailored to personal tastes, so transcending in

importance the interests of the community frame as a whole: detail has in fact replaced the frame, leaving a void. This again is why Poundbury has an important lesson to pass on: to attempt to re-create an old village, as there, under completely different conditions from those of some hundreds of years ago produces a pastiche, something akin to stage scenery or a film set, or at best a faintly comic picture. Yet that is what Poundbury does attempt to do; it attempts to go back to pre-Industrial Revolution times, to William Morris and the Arts and Crafts Movement, and to start afresh. This, after all, was the Prince's aim in launching the school of architecture, and Poundbury gave a physical expression to the teaching there. Now much is built, it is extraordinary that the theories which determined this outpost of Dorchester on a 'greenfield' site were ever regarded as realistic, and were not, together with those of Post-Modernists who favoured developments as monstrous as Bofill's Les Arcades du Lac at St-Quentin-en-Yvelines (1981), dismissed as an irrelevance; or, to quote Mumford again, 'a rootless affectation'. If any good came of Poundbury (referred to locally as the 'Poundbury Style', since taken up by developers), this was that its influence never crossed the Channel to spread its reactionary message; because of the royal connections, however, a few architectural eccentrics backed it, forgetting that one of its main objectives was to attract the general public for commercial purposes – to sell houses that were not cheap. And if its influence did lead anywhere, again in view of its promoter's importance, this was to a remake of the dying academicism of the 1920s which, bottled up during modern architecture's temporary takeover of fifty years or so, suddenly reappeared in the grip of the volume house builders to once more vandalize edges of towns and villages with the accustomed hideous subtopia. The laissez faire of the 1980s let them loose when planning permission was sufficiently relaxed to allow the majority of applications to be made without a design by an architect. After this, the work of these spec developers took off in a way not even the most exceptional pessimist could have anticipated. Gathering momentum over the last twenty or so years is an invasion of bleak, brick, centreless sprawls which, with their in-built socio-psychological dangers, present a highly disturbing parallel with the tower block era. The picture presented is, however,

St Catherine's College, Oxford, England: architect Arne Jacobsen, 1960.
Nature and architecture fuse to achieve unity and balance.

the architecture as the dominant half, and by nature as the soft, gentler partner: they complete each other, assuming a balance found in the symbol of the mandala: this is the story of architecture in microcosm – an emphatic statement of form reproduced with great economy of materials, glass and brick, yet it is also a portrait of the students who live there while at Oxford, of student life, open, free, fresh, good on scale (another universal theme); and, equally important, a portrait of the place where it's set, a sensitive appreciation of a low, flat riverside situation in its shape, length, sharp outlines and long, shining reflective surfaces. Taken together, the pieces of Jacobsen's calmly composed picture add up to an unusually concise explanation of architecture for those, like Prince Charles, who need or want (or both) to know more about it. His work has everything necessary for that, and, moreover, shows at a glance what is wrong with Poundbury: where that obsessive study in tedious mock-period details – cobbles, wall lamps, outcrops of stone, buttresses and other clichés – supplants the frame, St Catherine's strong background discipline incorporates subtle variations essential for the enrichment of the whole. The fact that these two examples have different functions, one purely residential, the other for undergraduates' sets of rooms, in no way affects the issue: only defining principles count in an understanding of architecture.

Jacobsen was of course protecting nature by observing the limits of architecture on the one hand and those of landscape on the other; here is a means by which the right balance can be accomplished – a collateral of what the renowned student of Indian thought, Sir Mark Tully, has termed 'the middle way' taken between Western materialism and Eastern spiritualism. The use put to the Georgian square is on the same lines, as too was the succession of green spaces planned for Savannah in 1733: the square, courtyard or quadrangle form has been running through planning from the earliest days, constantly reappearing and reasserting itself because it provides an excellent foundation from which the community can grow. Substituting the family for the community brings the form within the domestic frame, where it becomes the garden, private, secure, inward-looking. From Minoan and earlier forms, it was at its most sophisticated in Roman villas such as the House of the Faun in Pompeii and abbeys such as the Cistercian Le Thoronet

Con Felix, house at Mallorca, Spain: architect Jørn Utzon, 1991. Physically sepa-
rated into functions, this describes Utzon's art – love of light, bare simplicity,
space in terms of volume in the making of the shelter.

in France: it never fades from the picture. In 1921, for instance, its
possibilities were being explored in the 'Case Study' houses in Los
Angeles, notably by Rudolph Schindler, and thirty years later Jørn
Utzon had devised an innovative use for courtyards at Elsinore in
Denmark. This was a development of Jacobsen's work on the terrace

form during the Occupation with 'linked houses' which, linked by low walls screening gardens or secondary accommodation, were not so economical as the terrace but a good deal more flexible. This was at Elleoaekvej in 1943, and in 1946, at Søholm, he brought off a masterpiece in terrace design where the linked form was subordinated to a strong frame of sloping roofs and tall chimneys: it was a unique composition. Nevertheless, Utzon gave the idea an entirely original interpretation at Elsinore: after building a one-storey, open-planned house for himself at Hellebaek, he saw how a combination of the linked form and courtyard could make a community from what he called his 'additive method'. Explaining this approach, he said: 'In this way it can grow like a tree. If it grows naturally, the architecture will look after itself.' And it did. The Kingo houses, as those at Elsinore are called, form a group of sixty-two in all, are one-storey, and the success of the scheme is owed to one thing: a simple idea. The houses are identical, square in shape, and out of the square comes an L-shaped structure over-looking the square of the garden left behind: brick and glass, together with a tiled roof tilted inwards to produce a rippling edge to the walls, put the finishing touch to the form. Then the square struc-tures are linked in varying numbers, some in threes, some in as many as ten, their placing determined by views, contours, a lake, orientation, and with the flexibility of his additive method a unique, closely interwoven community form emerges. This, for many the most perfect of all postwar residential creations, was the product of a concentrated imaginative effort where the layout made the decisive contribution.

When Utzon visited Elsinore to inspect the site for his commis-sion, and was struck by the dramatic location of Hamlet's Elsinore Castle, he was, he said, so enthralled that it inspired the idea for his entry in the international Sydney Opera House competition, which he won in 1957 (one of the assessors, Eero Saarinen, fortu-nately picked out his design after it had been discarded by others), handing Australia that marvellous world-beating landmark for the city's distinctive promontory overlooking the harbour. So he was working on two radically different planes at the same time, in the Opera House imagining enormous volumes of space within his magnificent structure, in his community of houses considering the

minutiae of exact effects and connections. Then, while the Opera House was building in 1962, he started on a second group of court-yard houses, this time at Fredensborg, again following the form that worked so well before. Not unnaturally, these schemes had their imitators and thus an excellent influence, as Jacobsen's were to have, especially in England.

There, however, some unusually original postwar developments were already under way, whether tailored to city or country. In 1946 Philip Powell and Hidalgo Moya, in their mid-twenties and recently qualified at the Architectural Association School, won a gigantic national competition for an entire run-down neighbour-

Churchill Gardens, Pimlico, London, England: architects Philip Powell and Hidalgo Moya, 1946–1960. Terrace architecture facing the River Thames. A competition winner, this vast scheme led on to some of the finest modern buildings of the 20th century by these architects. Churchill Gardens is notable for having none of the vandalism which is the usual hallmark of failed housing of the period. Photographer Joan Scotson.

hood in London's Pimlico that was ready for redevelopment. This was Churchill Gardens, one of the first in the work of reconstruction: nothing of its size had been attempted before, and so there were no precedents to follow in the building of around 1,800 flats and houses, an immense task in itself. It is, moreover, difficult to imagine, or even remember, those times immediately after the war when relics of the Blitz were lying everywhere; it is difficult, too, to imagine in such depressing city scenes the sense of optimism generated in architectural circles by this startling, innovative competition winner – like the excitement surrounding the Festival of Britain five years later, it was a really momentous event. Best of all, perhaps, it brought together two outstanding gifts: tough analytic genius with uniquely inventive imagery. So remarkable were their combined accomplishments that Isaiah Berlin, who gave them Oxford's Wolfson College to do, compared their collective brilliance to Christopher Wren's, this convincingly illustrated by their Skylon's shaft of light suspended in the night sky at the Festival.

At Churchill Gardens, this brilliance was displayed in their continuation of the prewar modern architecture of heroes from the 1920s and 1930s. There was a gaiety about the tall terraces along Lupus Street, with its shops, clinics, library, and about primary schools and adventure playgrounds in the heart of the scheme; about the sequence of nine- and ten-storey buildings which, absorbing a density of two hundred to the acre (the highest density of the day), were so delightfully designed and executed. The humanized work of Dutch architects like J. J. P. Oud influenced their appearance most, and then one related to the site, a factor ignored by those of the Bauhaus. It was a fine site, beautifully exploited by the suggestion of the maritime imagery of liners recently launched, perfect for a riverside setting, an example of the *genius loci* Moya discussed in a BBC talk shortly after the competition was won. It was the humanism of their work which, as much as for any other reason, won Powell and Moya such a massive commission.

The three-storey terraces on the embankment, with gardens in front and a line of plane trees (planted when construction began), introduced an immediately friendly, domestic air to the enormity of the work, the more so when houses replaced the flats of the competition entry after Philip Powell visited Rotterdam in 1948.

This was at a time when architects, freed from the imprisonment of war, rushed over the Channel to catch up with what had been done before it, a grand tour which always included, not unnaturally, Le Corbusier's great works. It was then that Powell saw Oud's buildings of the 1920s, finding them far more exciting than they had appeared in photographs; and these were Oud's terraces of houses, a discovery influencing those at Churchill Gardens. Every piece of the scheme was put under intense scrutiny, whether it was these, or the form of an adventure playground, boiler house and library, or panoramic setting. Here, the town planning effect was particularly well seen: the combination of trees and buildings (the trees, fifty years later, huge and flourishing) following through the skyline of Chelsea Embankment, so preserving essentials of continuity in North Bank design: this is in striking contrast to the south side where developments have generally obeyed the accepted muddle of warehouses, power station, railway sidings, gasworks, contemporary architects preferring, apparently, to make laborious statements of personal importance. Continuity is out, its significance ignored, a failing characterizing much in the present-day scene. Yet at Churchill Gardens there is a real sense of the architecture belonging, that it's a piece of a far bigger picture, not a section of it cast adrift. Perhaps it is an awareness of this, as much as an innate appreciation of good design, which accounts for there having been no vandalism (the trademark of the horrible housing estate), and that's as good a recommendation as anyone could want.

It has, however, not gone unrewarded: given a Civic Trust Award in 1961, Churchill Gardens was picked out of 1,025 projects as the winning scheme to celebrate the fortieth anniversary of Trust awards in March 2000, a most appropriate honour to give a work that is, with its garden squares lush with lawns and trees, both a descendant of Georgian London and a dazzling array of modern architectural ideas, precisely the formula required today, forty years later. The architects were also modest, as Powell demonstrated when writing that he found his approach difficult to define, even to himself: 'If I can detect principles, they are too often negative or humdrum – perhaps some are not principles at all; a mistrust of conscious struggling after originality (if originality grows out of the originalities of the problem, well and good); a mistrust, typically

English perhaps, of the monumental approach, of making things big when they need not be; a mistrust of the attitude which treats any job as a "prestige job" . . . finally, a belief that each job – large or small, repetitive and standardized or nigglingly tailor-made – has an identity of its own and should not, in order to save its designer time and trouble, be allowed to become an arbitrary rehash of one of its predecessors.'

Always self-critical, he was not entirely satisfied with the layout, yet was insistent that no part of the design could be seen in isolation, any more than it could be cut off from the surrounding neighbourhood – the road running through it sees to that. Herbert Tayler and David Green, who also met as students at the AA, becoming partners in 1938, held a similar view of architectural design: they too were most concerned with the quality of the place – for them, a stretch of country bounded by Lowestoft, Great Yarmouth and Norwich in Norfolk. 'When we moved out there,' Tayler said, 'I was horrified by the way spec builders had attacked the edges of gems of villages with their hideous estates and decided to set about rectifying the matter. Hard work, but we just got on with it.' He was an outspoken critic of high-rise disasters in cities, and pointed a finger at ill-considered bylaws, road engineers and profiteering builders: 'Minimum houses fringing maximum tarmac enclose nothing but despair and wind,' he wrote in *The Architect & Building News* in 1954. Ian Nairn, writing in the *Architectural Review* in 1958 on Tayler and Green's achievements, commented: 'We have built, since the war, enough houses to have made a complete new set of villages which could have been as famous as the German postwar churches or our own postwar schools. The ordinary traveller about England, as he sees village after village that is a little miracle of vernacular building encumbered by estate after estate that is a little miracle of boneheaded beastliness, has a right to ask why this didn't happen.'

All the works mentioned have a common starting point: surroundings. In the case of Tayler and Green, the exposure of the East Anglian scene draws attention to the form and character of their terraces: they are exposed, out there in the characteristically flat landscape, and simply expressed. Thoughts about the terrace had started early on with their design of the Studio House for

R. G. Pettiward, a painter, in London's Highgate village, a tall, four-storey structure sticking up like a lookout among the muddle of old roofs, the sun terrace at the top capturing a stunning view over the city falling away to the faraway river below. Here was the influence of surroundings. Here too was a landmark: built in 1940, students rushed to see it as they had, a few years before, rushed to see Berthold Lubetkin's great works, Highpoint One and Two, further up the hill. Tayler and Green had, however, interests in another direction: they saw the possibility of a terrace evolving from this daring design – repeat the Studio House several times to make a modern version of a Georgian street frontage. This was not at all far-fetched: drawn out, it confirmed the view that there was an affinity between Georgian and modern architecture – the simplicity, flatness, abstraction of both. Eiler Rasmussen, the Danish architect and author of *London, the Unique City* (1937), had himself pointed this out. For one thing, the eighteenth century always concealed pitched roofs behind the parapet, giving the impression of the flat roof associated with modern architecture; and in Tayler and Green's street elevation this was accentuated by the parapet to the roof garden, a legacy of Le Corbusier's delightful innovation in high-density situations. Although their project never got further than an inspired idea, they went on to resurrect the terrace elsewhere, as Tayler explained in 1953: 'Six or seven years ago, so recently, we succeeded in bringing back the forgotten terrace house once more, great-great-grandchild of the young Georgian beauty, who lived on into Victorian times and became shrunken, ugly and mean and hated. This little architectural revolution could never have been achieved only on the grounds of economy . . . it was achieved by also regarding human dignity and privacy and convenience.' He wrote with great passion, calling private-enterprise houses a joke: 'Again, why is the result of private and public all over the English landscape so very, very often an ugly, or at best an indifferent picture? Because, I suggest, it is a picture, and must have all the fine qualities of a pictorial composition, the judgement, the expert skill, the sensitivity, above all the depth of feeling which must go to the making of any picture and also of our particular picture, housing in landscape.' Not easy, he said. Nevertheless, the terrace they rediscovered was an equivalent of Nairn's 'little miracle

of vernacular building'; it was this they took to Norfolk, their subject for their architectural picture.

Their work ran parallel with the creation of New Towns such as Harlow in Essex, for example, and Powell and Moya's Churchill Gardens. When Philip Powell was visiting Oud's brilliant Kiefhoek estate of standardized two-storey houses with strip windows and front gardens, Tayler and Green were working on one of their excellent Loddon Rural District Council's schemes at Windmill Green, Ditchingham, between 1947 and 1949, a strong statement in terrace forms. These proved how a minimum of elements, boldly used, could take care of details of the design. There were many more as good, as lovingly seen, as disciplined, economical and simple, running right through to the 1970s and further.

Harlow New Town was a case in point. For example, the work there by H. T. Cadbury-Brown in the 1950s was first-rate, considered carefully from every angle – siting, exterior, interior. Cadbury-Brown was one of the most unusual architects of the postwar era; unusual both for his scholarship and range. He could talk to his students at the Architectural Association School about anything they wanted to know of historical significance, whether the work of Palladio or the Arts and Crafts Movement, he taught in the sculpture department of the Royal College of Art, and remains one of the very few who, as a member of the MARS (Modern Architectural Research) Group among such high-fliers as Marcel Breuer, Lubetkin, Christopher Nicholson, Betjeman and Serge Chermayeff, was in at the beginning of the Modern Movement. In fact, Cadbury-Brown was one of those who participated in the design of the MARS Group's fine exhibition of 1938 at the New Burlington Galleries which helped to get, in England, the modern architectural ball rolling. He was twenty-five.

With this and three competitions won behind him, and his magical contribution to the 1951 Festival of Britain highly praised, he was commissioned to design two housing developments at Harlow. These broke with the 1930s white, sculptural aesthetic: Cadbury-Brown adopted brick, pitched roofs and, following the example of Tayler and Green, the terrace (seen by some as a betrayal and old-fashioned), yet made out of such elements a picture of real

by Chamberlin, Powell and Bon: city problems required one of a different kind. Geoffry Powell, who had visited Kiefhoek with Philip Powell (no relation) and won the Golden Lane housing competition (precursor of the Barbican) four years later in January 1952, put the position with his accustomed clarity: speaking of places like Welwyn Garden City, he said, 'We strongly dislike the garden city tradition with its low density, monotony and waste of good country . . . we like a strong contrast between true town and true country.' This view was duly summarized at his Golden Lane, a compact work which returned, in diagrammatic form, to the London square with a collection of interlocking spaces protected from a busy highway by a barrier of apartments. While the form was determined by the site, bang in the centre of the City, Powell had other ideas. 'Today,' he said, interviewed in the 1970s, 'we are too embarrassed to talk about the spirit – unless it can justify its existence by "cost yardsticks" and other statistical jargon. But if you think of any building which has nothing to do with convenience, the money spent on things of the spirit was enormous. In the Victorian era, for instance, everything was very large, shop windows, sign-writing, pubs, theatres; there was great generosity. Once this generosity is eliminated, things of the spirit go too.' Space was what his Golden Lane was about, as indeed was his fine Vanbrugh Park estate at Blackheath: space respected human dignity. 'Architects have to approach their work with care and passion. From the moment I went to the AA School, up to which time I'd shown no interest in buildings, architecture became a passion.'

He never failed to be positive: 'You draw it to understand it, and when you understand it you can build it' – a remark which has an echo of something Le Corbusier said, dismissing the camera as 'a tool for idlers': 'To draw oneself, to trace the lines, handle the volumes . . . it is then that inspiration may come.' Both remarks were about ideas, things so exciting that they can make some very ordinary building, however huge, appear microscopic in impor-tance – a building where architecture equals anything that economics may choose it will equal: the minimum. This was Powell's view: architecture was art, not accountancy. And Utzon's view: just as Tayler and Green were inspired by the sheer flatness of Norfolk's landscape, so Utzon was by the spectacle of Elsinore. He quoted

the American, Louis Kahn, on the subject, an architect who expressed himself with memorable simplicity. 'Kahn,' Utzon said, 'described art like this.' He took out a pad and drew a line. 'On one side of the line is truth – engineering, facts, mathematics, anything like that. On the other side are human aspirations, dreams and feelings. Art is the meeting on the line of truth and human aspirations. In art, moreover, one is meaningless without the other.' At Sydney, he said, bowled over by the setting on the promontory, the inside of the Opera House was inspired by both this and the city's scale: although the interior was ruined by others (he wanted it to be 'beautiful colours of spring, summer and autumn', running into each other as the seasons do themselves), the tremendous flight of steps there nevertheless captured the kind of sudden views common to all great cities – reaching the top, the building opening like a flower, the water and sails of Sydney Harbour are startlingly revealed, the imagery of his enormous billowing forms of the structure catching its magnificence and his optimism. Despite pollution, he said, and the high-rise filling hospitals with sufferers from stress, he remained hopeful about the future: 'Fortunately, people still care very much for art, for things of beauty, for things of the past.' His two marvellous houses in Mallorca, designed for himself and his family, bear witness to the truth of these words if anything could.

Not all tall towers were as shocking as those horribly bleak, windswept, barren slabs found at Sighthill in Glasgow. Some – not many, it's true – were good, and among the very best were the ninepoint blocks overlooking Richmond Park at Roehampton in south-west London. But they were not so tall – 'Oh no,' Oliver Cox said, their architect back in 1955, 'they were only eleven storeys. We profoundly disapproved of these twenty- and twenty-five-storey things. And eleven storeys were tied to the height of Fire Brigade escape ladders.' They were, he said, influenced by Swedish work he and Michael Ventris saw when, while at the AA School, they went to Stockholm in 1947. In many ways too, the Roehampton designs were a continuation of ideas Cox developed when he was in charge of the excellent primary-school programme at Hertfordshire after the war. 'I was also opposed to the other development at Roehampton – the concrete slabs by another group at the LCC. Good architects, but didn't care about people. In our section, each

block was planned to have a heated tiled lobby on each floor so that children would have a play space and could meet. There were two staircases and two lifts, and each staircase had its own wall decoration – a diagonal pattern I worked out. The tiled floors, another idea developed at Hertfordshire, were different colours in all blocks.' The brick was white, a contrast for the red-brick, two-storey houses and low buildings generally: you couldn't, he said laughing, have red point blocks! 'And then, when we ran out of red bricks for the houses, I suggested we painted the cheap flet-tons red instead. That gave us an idea – to paint the houses different colours. And as far as I know, they're still different colours.' The picture which was created was an exceedingly human one, down to having a caretaker for security, almost always absent from council housing. But Cox considers colour specially important: 'It's my passion. When I was at Hertfordshire, I invented what we all know now as the standard range – using stainers, you could make a hundred different colours. ICI took it up first, then Dulux. Now you can make any you like.'

Architects usually have an area they particularly enjoy working on and polishing up as if it were some semi-precious stone – space, structure, detail, materials, colour, landscape, or a combination of them. Cox's was colour, but also landscape: at Roehampton, using existing garden walls from an old estate and by carefully preserving trees as well as planting others, he created something resembling magnificent parkland. For Eric Lyons, the architect who never allowed commercial considerations to affect his ideas, his area was undoubtedly landscape. He loved nature, shunned commercialism, saying on one occasion, 'The British will go to any expense to get something that's cheap', in his view an explanation of much of the postwar redevelopment ending in disaster. With that comment, Lyons was hitting out at system-building, still employed in the 1970s, dismissing it as 'boring, easily controlled by the quantity surveyor and widely disliked', going on to say it was 'put together with large or small windows and without designers [who are "wilful", "anti-social", "extravagant" and "unnecessary"] and can be understood by a computer . . .' In 1956 Lyons built his first work for SPAN, the development company whose managing director was the amazing Leslie Bilsby, uniquely a modern architectural,

innovative builder; the scheme was The Priory in south London's Blackheath, and through it he showed that good design needn't cost money, but can make it – for both developers and owners. The good layout for a neighbourhood, essential to founding a secure community, doesn't cost more than a bad layout; probably less when unencumbered by commercial prejudice ('must be detached houses' or 'semi-ds – they go well') and short-sightedness. Enthusiastically backed by Bilsby, however, Lyons pursued his special interests, good-quality materials, terrace houses and apartments, winding roads (no suburban cul-de-sacs or 'hammer heads') and, mixed in with them all, landscape. Trees, lawns, colour, sculpturally contoured banks make the unforgettable picture carried away from The Priory; again, the planting was done in the early 1950s when construction began. Apart from the work of the few other enlightened architects, no landscape of such a sumptuous kind had been attempted at that time, local authorities regarding developments as

Great Linford, Milton Keynes, England: architects Stephen Gardiner and Joan Scotson, 1978. Terrace architecture influenced by its situation on the Grand Union Canal.

Old Bradwell, Milton Keynes, England: architects Stephen Gardiner and Joan Scotson, 1983. Terrace architecture defined by a recall of Old Bradwell but with bright coloured margins.

the bare minimum in which to put people; Lyons in the meantime was in the process of creating a great atmospheric picture, its maturity there to enjoy today.

He continued as landscape gardener and architect for SPAN until the 1980s, a period during which his example was generally ignored and a landmark – 'Plant a Tree in '73' – came and went. Actually, an exception to the rule was Milton Keynes: by 1973 three million trees had been planted there under the direction of Derek Walker, chief planner and architect to the new city's Development Corporation. Landscape is a passion with him too: 'When I presented a concept for a city greener than the surrounding countryside to the Board, "Forest City" became our image,' he says, 'and after intense debate we allocated twenty per cent of the designated area to a citywide parkland system.' His view of landscape differed from others – used, for example, as a continuation of trees along the embankment at Churchill Gardens, or as a floor of foliage between walls of glass at St Catherine's, or

as parkland at Roehampton, or as the romantic interlude enjoyed at The Priory. Walker saw it, first, in planning terms, 'as a strategy to form the backbone of the city structure' and thus as a frame for Milton Keynes which, once established, would retain its order should the Corporation be shut down and control change hands in the future. This showed considerable foresight on Walker's part, since this is exactly what eventually happened after the change of government in 1979; and in view of the vulnerable nature of its form, open-ended, spread out, the city could easily have become a victim of volume house builders on the rampage. Unfortunately, to a degree it has: Milton Keynes is no fortress like a fantasy city called Civilia, a curious extravaganza thought up by H. de C. Hastings, the eccentric owner of the *Architectural Review*, and Ian Nairn, who ran the *Review* column Outrage at the time and published in book form in 1969, the year, by some singular coincidence, that the master plan for Milton Keynes was itself first announced. This was by John de Monchaux, and in form a complete contrast to Civilia, a high-rise, congested proposal for an imaginary location north of the Midland town of Nuneaton. This could never have trumped de Monchaux's plan, if this was indeed the intention. His Milton Keynes, taken on its way by Derek Walker, was conceived to evolve from existing villages as other English cities have – London, for instance; to evolve from terraced streets, parks and gardens: 'It's absurd,' Walker says, 'as some do, to talk as if the terrace has suddenly been invented – we're surrounded by them, everywhere. Terraces go back to Roman Britain.' Milton Keynes represented, all the same, the first wholesale swing of the pendulum away from the high-rise of the 1960s, the massive planting of trees becoming its guardian.

Landscape, recalled from hibernation, had been promoted from the scale of the garden to shape a vast conception, much after the fashion of eighteenth-century designs by William Kent and Capability Brown – Kent's Rousham Park, Oxfordshire, certainly influenced some of Walker's ideas. Here is an art form, as it was seen to be then, as aesthetically delightful as it was practical, and it was put to work to achieve both ends. Trees led the way, their planning focused on a selection of targets, main among them being Walker's determination to create a country city (as opposed to a

design, this plan could be called additive in conception, a piece of jigsaw being added without any disruption to the unity of the whole, or without human intimacy ever losing its way. Correa has devised a system that suits the scale of community and of the individual – from a distance, white façades, spots of colour and Roman tile roofs poke up over the garden walls; close up, in the courtyard, there is total individuality – canopies over entrances, steps up to balconies, glancing views across to someone else's garden, gates in basket-weave panels, red shutters and railings – excellent detail with the human touch which suggests you could have done it yourself, including personally sowing the grass between the slabs of courtyard paving. The colour suggests this – sometimes it's red tubular supports and rails, sometimes green, sometimes yellow or blue; he shows us how to expand a house within a given framework, single storey becomes double, a porch added, all simple enough to be carried out by local builders and carpenters, under the owner's direction. The colours of women's saris and shadows thrown by big overhangs do the rest.

Correa has found his own solution to this elusive mystery of our time – an urban method equalling the eighteenth-century English concern for order and flexibility: he does indeed mean it when he talks about the fascination of residential design. The picture projected is utterly delightful as he continues developing his ideas for towns, villages or inner-city locations, always holding on to the courtyard for a centre of interest, the meeting place, the focus for the community, experimenting with terrace forms, then returning to single houses, L-shaped, back-to-back or any way to produce garden plans, but never in such a manner that the economy or the order of the whole is blurred or lost. The grip on the idea remains whatever the problems encountered: simplicity rules. Correa is the master of the big idea, of conception as generator: see Ulwe, the New Bombay City Centre, begun in 1991, developed in an enormous stretch of flat land, an undertaking along the ocean shoreline that is expressed as a single emphatic statement of absolute clarity, a plan form determined by a wavy outline of roads around a railway line running straight down the middle. Immense size contracts to the essentials of four main residential neighbourhoods surrounding four loosely arranged parks – apartments, houses, shops,

schools, mosques, hospitals – everything required for living. It is a huge scheme, yet the scale remains human because of the minutiae of the fine work acting as the embroidery sewn ingeniously into an organic masterpiece of design. A glance at his delicately drawn perspectives (the development is still incomplete), taken from above, is all that is needed for a community threaded with the greenery of gardens and trees to spring off the page. You can imagine being there because you are reminded of familiar places known and enjoyed in the past: such is the genius of imagination.

With the future of environmental planning and design remaining the longest running, most exhaustively discussed, unresolved problem, there could be an argument for the immediate introduction of architecture as a subject in the school course, this regarded as important as any other – for an understanding of its aesthetic language, to learn to think visually, to assist with a knowledge of history, for example: to make it vivid. To state the obvious, education could help enormously.

We know what we dislike: extremes – mainly the tower block and the emergence of the new suburbia. The tower block, multiplied by the hundred, destroyed skylines and local scale with devastating effect. Could it make a comeback? Yes, it could; it already has for the very rich, something that has nothing to do with arriving at a decent form for the majority. An example is the recently finished Montevetro on London's river at Battersea. This is by Richard Rogers, who has said on occasions that a return to the familiar street and square would bring people back to cities. Yet he has said of Montevetro that he'd like to see it 'not just as a very special place for a very fortunate minority but as a model for what city housing of the future could be'. Rising to the height of the common tower block, it has of course spacious flats, splendid views westwards, smart technological glass and tiled façades, excellent security, but unfortunately others have to look at it, either from the Chelsea Embankment or in Battersea Church Road, a remnant of one of London's unique village beginnings, across which the enormous structure falls like an axe. But then there is the other extreme, the new suburbia from the volume house builders, spread out and wasteful in roads, drives, paths, land and the rest of the

'prestigious' up-market paraphernalia entirely at odds with an urban situation. The real aim is the 'greenfield' site and what sells, not the character of a region but the taste of the customer, the personality cult, that everything of mine's different from yours next door.

Equally, we know what we like: continuity, clarity, coherence around us, not much to ask for, the converse of the fragmentary picture made by the tower block and, in another way, by the new, chaotic suburban spread of little boxes. We like terraced houses, the garden square, piazza, courtyard found in old villages, towns and cities; the surprise discoveries in, for example, Paris, Rome or Munich, of hidden spaces and activities in passages off busy streets. Munich, beautifully restored after the war, cleverly combines traditional frontages with, concealed behind them, the chic of modern shop design in the courtyard. Similarly in Rome, where one associates the form, not unnaturally, with shade from heat – yet again, as in Munich, it is developed further, exploited for its privacy and quiet away from traffic, and transformed into a space for exclusive apartments, workshops, studios, showrooms, cafés, a backwater full of life, very select, discreet. Paris, however, provides the most complete picture one seeks and admires: besides its ideal consistency, it has squares, parks, boulevards, landmarks, the details in an immensely complex mosaic where each, somehow miraculously, falls into its exact, appointed place. The explanation is of course simple: it lies with the genius of one man, the town planner and architect, Georges-Eugène Haussmann, who carried out, over seventeen years in the 1850s and 1860s, the instructions of his employer, Emperor Napoleon III, to create a magnificent capital for a great imperial power, somewhat after the grand style of John Nash's Regent's Park terraces that Napoleon had seen during his stay in England; to adapt the old city to accelerating industrial progress, and to secure government stability by making insurrections in the streets impossible. So Haussmann, much to the disgust of Émile Zola and others of the time, brought grandeur and direction to Paris in the enormous demolition and rebuilding operations which included 145 kilometres (90 miles) of roads and 1,780 hectares (approximately 4,398 acres) of parks in the radial system that accepts fine ancient and modern landmarks alike – Notre-Dame on its island, Place des Vosges, the Bastille and Eiffel

Tower among the many – to astonish us. Such huge works were matched by Haussmann's vast conception: he had created a frame which in itself required them.

At the same time he brought with it the enviable scale which is a characteristic of his boulevards: a maximum of eight storeys that mirrors the height of the avenues of trees, a rule which included apartments in generous, rounded conservatory-like roof space. This introduced an ideal much sought after in town planning today, namely of achieving high densities with medium-tall buildings, a discipline in Paris manifested as long, orderly frontages. Yet in slicing through the old city with these, he left behind marvellous relics from the past between them: Montpellier gives a picture of Paris before Haussmann – narrow lanes ambling round corners, court-yards again, passages packed with little businesses, historical roads with old restaurants and café street life, pavements opening into small public meeting places: Cheval de Blanc, Cour Damoye, Passage de Chantier, the Rue de Lappe are a handful of the fascinating pieces of backland around Bastille, each with its domestic scale, unique personality and traders (furniture restorers, a traditional industry, squashed in among offices and apartments), and markedly different appearances. Here is the richness of variations within the overall frame that could be regarded as a collateral of architecture. On the one hand there is the long, powerful form of a single building type, and which, as Bernard Rudofsky says in *Architecture without Architects*, 'does not necessarily produce monotony' when 'deviations from standard measurements result in small variations which strike a perfect balance between unity and diversity'; while on the other there is a delightful freedom of expression – in many ways, a recall of the Georgian character where the front looks up to the community, the back to the individual, an excellent arrange-ment. The Haussmann schematic plan is, moreover, strong enough to embrace change: once more sheer size makes an unusual proposal not merely possible but absolutely right – magnificent ventures like the 1999 Jardins Wilson, 1.5-kilometre (0.93m) park turfing over the Al autoroute to restore the beauty of the Avenue du Président Wilson in St-Denis; or the Louvre Pyramid; or the enormous struc-ture of the Finance Ministry poking out over the Seine south of the Gare de Lyon; or the audacious grass pyramid of the Sports

Eight-storey apartment blocks, Bercy, Paris, France: architects Philippe Chaix and Jean-Paul Morel, 1993, overlooking huge new gardens designed by Patrick Berger.

Centre next to the fine, immensely long, eight-storey tiers of apartments by Philippe Chaix and Jean-Paul Morel that overlook new gardens as grand as the Tuileries by Patrick Berger, and, across the river, the tall, ghostly glass towers of the Bibliothèque Nationale. The elements are huge, every one of them: the apartments, finished in 1993, act as a side for the gardens as a terrace might, as such presenting itself as a gigantic dramatization of a London square.

Hardly surprisingly, Haussmann's influence spread – to Lyons, Toulouse, Avignon, Brussels, his plans copied in Rome and Philadelphia. Suddenly, all wanted a radial system; the imagination of his conceptions had an effect comparable to Palladio's on the theory of architecture of a couple of centuries earlier. After Haussmann, town planners everywhere were inspired to think big: Dan Burnham, the nineteenth-century architect of those 129 identical

Terrace architecture, The Hague, Holland: architect Martin Richardson, 2000. Following continental principles of apartment design, Richardson, in a competition winning scheme (1988), has achieved a coherent plan of streets leading into a tree planted square. Photographer Sjaak Henselmans.

House at Aldeburgh, Suffolk, England: architects H. T. Cadbury-Brown and his wife, Betty, 1964. This corner of the one-storey house depicts in a glance the theme – beautiful glimpses of garden landscape created by the architects (with much American tree planting) and sunlight from every possible position. Photographer Tom Miller.

architecture) and completed in 1973, a brilliant, complex, liquid landscape form. Like nearby Churchill Gardens, it had to be planned for a very high density; it was not an exercise in street architecture, rather a massive, interlocking jigsaw, pieces piling up like an Italian medieval village to make a fascinating community complete with shops, church, pub, offices, a school around the corner, a neighbourhood where you can escape into your own world, the reverse of exposure in tower block life. 'Liquid landscape', Darke's phrase, conjures up a picture of the structural form – hilly, jutting with outcrops of balconies like strata, a cliff. There's no loss of order: the combination of brick façades and a horizontal discipline defined by concrete floor-lines makes a frame for complex detail: within it, windows are dark openings, trees and bushes sprout from recesses

like foliage in a rock-face: landscape emerges as an inspiring, poetic image.

'We did other housing,' Darke said, 'but after 1980 it faded away with the Thatcher Government.' In the 1970s, they had been exploring the possibilities of terrace design all around the country, and as closely knit as Lillington Gardens. The loss of such archi-tects was an appalling casualty of political shortsightedness: 'People came from all over the world to look at work by wonderful archi-tects here who had really thought about how people wanted to live,' he said. But this was 1980, the year when design was suddenly seemingly removed from individual architects with the volume builder appearing on the scene. Oliver Cox, then in private prac-tice, said all their housing dried up after 1980. Cooper Close, flats designed by Leonard Manasseh and Ian Baker, was the last scheme for rent for the Greater London Council; the date, 1980. Sited on the noisy Waterloo Road near the Old Vic, the theme of the square

Private house, Highgate Village, London, England: architects Leonard Manasseh and Ian Baker, 1959. This work, the simplicity of appearance concealing an ingenious section, recalls the excellence of the post-war generation of English architects. Photographer Leonard Manasseh.

was beautifully exploited to preserve privacy and quiet: an ideal, inward focus to emphasise feelings of seclusion. 'Even better inside our flats than outside them,' tenants say, a compliment after being there for twenty years, a reminder too of Herbert Tayler's 'little architectural revolution' achieved by a regard for 'human dignity and privacy and convenience' so neglected in the disreputable tower block age. 'Still are,' Darke said.

Not always, however. A striking example is the fourth phase of an amazingly idealistic development adjacent to the National Theatre in London's Bermondsey. This is the work of the Coin Street Community Builders (CSCB), a non-profit-making company formed after a resolute campaign by a local action group had seen off the threat of an enormous commercial scheme in 1984 that would have blocked the surrounding neighbourhood's access to the river and wiped out any trace of a memory of its traditional character – light-industrial, dock-life, small residential streets. It was something of the spirit of this that the community wanted to recover in alternative proposals led by a determined and far-sighted young man from nearby Roupell Street, Iain Tuckett; when the Greater London Council transferred the ownership of the site to the CSCB for a nominal sum to accord with the promise of its use for social housing, Tuckett had a vision which set out a unique picture in the materialistic Tory years. From 1988 onwards, on this very large piece of land between Upper Ground and Stamford Street, and from Waterloo Bridge to Blackfriars, and including the eccentric, Art Deco Oxo Tower, an extraordinary development began to quietly unfold where the choice of architect was often decided by the holding of competitions.

Modesty is the general aim, a factor which assists the making of the design throughout ultimately satisfying; no imposition of contrived originality, the hallmark of much pretentious residential work; no grotesque stylistic tricks to irritate. Besides being truly concerned with the character of the place, there is a real determination (as Geoffrey Darke would have it) to understand how people wanted to live – hence the adoption of the terrace, of the square, the house and garden, a plain background of familiar street façades, an acceptable scale of three, four or five-storeys. This is the first step of Tuckett's big picture: architecture is made by people –

The square, Coin Street, Upper Ground, London, England: architects Haworth Tompkins 2002. The plan follows a traditional London form where houses have small private gardens which lead into the main square for those who live there. Modest, unfussy, this work of modern architecture is eminently good to live in. Photographer Morley von Sternberg.

give them a frame and they will complete it, a simple, infallible rule. Yet there is another theme of exceptional significance running throughout the scheme which is surely central to the life of any community: communal activities, the essential element consistently absent in the horrendous housing estates, and correspondingly present in some form or other in lovable old neighbourhoods. Together with the earliest housing of 1988 came Gabriel's Wharf; a leftover piece of land, suitable for future development, this has been temporarily transformed into a place for studios, bars, cafés round a courtyard and bandstand, and backed up by a full-size painted façade of a Georgian terrace. Then came the conversion of the Oxo Tower into shops, restaurants, museums, flats and offices, followed by the fourth phase, the square underway in 2001, of which the fourth side on to Stamford Street in particular pins down

the importance of the communal factor. Here is a building, separated from the square by a ramp down to a carpark, which is solely devoted to a social centre for people living in the community, but also for those who come in to work from outside it – arts facilities, sports, internet, library and so on. This structure stands on its own to make a specific point about its importance as more than a piece of a mixed development, a work apart which in addition protects the garden square from the racket of a heavy traffic route. There is something very special about this creation, special in the way that the introduction of shops, offices and a hotel is special at Le Corbusier's Unité d'Habitation in Marseilles – together with a nursery school, a swimming pool and a gymnasium on the roof of course. There is a connection.

The square itself, the winning design in a limited competition, is far more sophisticated than anything that has gone before, and is by Haworth Tompkins, the architects who have extensively restored the Royal Court Theatre in Chelsea. With great skill they have reduced a highly complex collection of different sized houses and flats to a simple red-brick exterior of the old warehouse variety contrasted with the delicacy of the interior scene, a recall of both docklands and home: a precious detail in a big picture.

There are other examples, one of which is the extension to the University of East Anglia by Rick Mather where 800 students' rooms have been added to Sir Denys Lasdun's buildings of 1968. Mather's, occupied in 1993, were designed as terrace houses, each for ten students over three floors, with a fourth for flats, developing Lasdun's plan to combine a community form with economy: a long, strong curving structure leads into the heart of the original, gently reflecting Lasdun's angularity before reforming as the sort of quadrangles found in old colleges in Oxford and elsewhere. This is the work of a true architect, and it is yet another reminder that there is no alternative in the search for quality. Imagine, for instance, the outcome if the volume builder had been let loose in Coin Street. It could have happened, given different guardians of design. As Martin Richardson observed: 'Returning from Europe, it's hard to believe that this generally wealthy, educated, socially responsible country can still be despoiling the cities, towns and

villages with housing of such an abysmal quality.' He made a comparison with Trabant, the East German people's car which, substandard and polluting, died as soon as the Berlin Wall came down: 'The UK house building industry has achieved the distinction of producing the Trabant housing of Europe.' Not a bad analogy: this industry will move in on the Thames Estuary, designated by government for a vast development to continue London Docklands, if the threat from flooding can be overcome. Remember the Dockland disaster? Parcels of land sold off to the highest bidders in the 1980s? No master plan as at Milton Keynes, no chief architect and planners, the consequent disjointed non-design? Verwood in Dorset, a town largely created by the building industry in the last twenty years and said to be the fastest growing in Europe, is an example of the threat. Unless the British Government takes a

Terrace architecture at Great Linford, Milton Keynes, England: architect Martin Richardson, 1975. The first of the architect's five works at Milton Keynes, his concern has always been to reproduce the enclosure and human scale of the street or square. Photographer John Walker.

firm grip on the coming building programme, sees to it that the meaning of design is understood, a kind of throwback to the formlessness of the ancient agglutinative type will follow, as if experience laboriously acquired over five millennia had gone suddenly missing: the people of the Indus civilization were, after all, among the first to see their settlements as an architectural whole, not as disorderly bits without an overall plan. Astonishingly, the Government proposes to do no such thing, instead taking the brake off developers, the power to intervene from local councils, so reducing English countryside to miniature museum pieces.

After the now marketable item of the 'terrace' comes the 'first new Victorian themed street' when 'Recreating a brand new Traditional London Terrace'. But what next? The 'new old village' in precious green fields? As a Countryside Residential rep put it: 'We are creating interesting street scenes such as one would expect to find in an old village'. Yet here's another thing: the call for tens of thousands of homes a year could bring back tower blocks, the damage the poor man's block did in the 1960s conveniently forgotten as they metamorphose as the rich man's skyscraper. As it is, London's centre is being battered to pieces by such developments as the horrendous monster on Vauxhall Bridge's south-west corner, a plan for a 180 metre-high (590 foot) residential tower next door, vast proposals for the City and alongside Waterloo Station, Chelsea Reach, Paddington Basin and London Bridge, others for Canary Wharf and ideas for skyscrapers all over the Greenwich peninsula to solve, say the architects (designers of the London Eye), the city's social housing problem. Here is the same old failed solution to homelessness (if that is the objective), the short-cut to achieving high densities which led straight to the great postwar building disaster. For those who argued that this alien form was out of date, it's sad, after Ronan Point, that there was a dream that all the menacing towers would be demolished and replaced by neighbourhoods with a human scale. Here was the opportunity to demonstrate how a residential scheme should be done: get out the old street maps of places eliminated by the terrible postwar redevelopment mania and start there, from where the evolution of the districts began.

That was the dream: an epic that would remove an aberration

that had become a nightmare – the dramatic decision by Birmingham and Glasgow to do away with huge chunks of towers proves that. But now, with four million houses or flats wanted in the next twenty years, the need to build became instantly urgent. Here was an emergency: so the Rogers Report on all aspects of the problem was commissioned, exhibitions were launched, newspaper articles written, dignitaries such as the deputy prime minister interviewed, or Ken Livingstone, London's mayor, who appointed Rogers as his architectural adviser, lobbied. For a moment, homes for the people were the topic of the day: necessity, it was believed, had forced realistic solutions into the open at last. Something had to be done and, it was idealistically hoped, no more mistakes made.

Copy lay around everywhere. Holland was the country to which searchlights first moved to fasten on possible material; after The Hague, Rotterdam, Amsterdam, Maastricht, Zaanstad. Yet looking this far at projects built in the last two decades or so is hardly necessary. Perfectly good stuff is nearer home. What of Greenwich's 'Millennium Village' now being laid out around a lake in green parkland? Planned by the excellent Anglo-Swedish Ralph Erskine of Milton Keynes neighbourhoods and Hammersmith's Ark fame, this so-called 'village' is a high-profile quarter on a 'brownfield' site overlooking the river in Dome-land; a cross between eight-storey apartment blocks and two- and three-storey terraces, it rejects extremes of towers and sprawl. Forget the 'village' promotion: this is an inner-city scheme for an urban setting. So is this an answer? Somewhat insensitive, yet better by far than a forest of skycrapers. But first things must come first: as 2001's president of the Royal Institute of British Architects, Marco Goldschmied, wrote in a letter to the *Guardian*: 'Design-led, holistic culture of community-based, integrated, environmentally viable homes on both brownfield and greenfield sites, such as have been achieved in Holland and Scandinavia, needs to be actively developed as a matter of urgency. Architects are available . . .' They are: for a start, Rick Mather, Howarth Tompkins and Nicholas Lacey – Lacey, whose fine Crown Reach crescent of flats on Vauxhall Bridge's north bank was one of the three national housing competitions won by him.

This brings one back to the importance of competitions: a general scarcity of them accounts, partly at any rate, for the quality of design

Crown Reach, Vauxhall Bridge, north bank, London, England: architect Nicholas Lacey, 1985. This remarkable design, won in a national competition, shows a real understanding of a river situation, a crescent form which embraces its direction, a lesson to the architects of the abominable building opposite (out of the picture). Photographer Carlo Roberti.

being often poor; to reverse this, the European lesson should be picked up – let competitions, national or international, decide the choice of architect for any important public work. Then there should be, as Goldschmied has stated, architects on local authority planning committees for guidance on design; secondly, all those running architecture and planning departments of cities, towns and counties should have the highest qualifications – as the chairman of the Milton Keynes Development Corporation, the late Lord

Campbell, said, if the right man is appointed at the top, the rest follows, and that was certainly borne out in Campbell's case. Since, however, residential design is a difficult area, its architects have to be the best around, and they have to be free to make architectural decisions; they should not be hampered in doing so by purely commercial considerations. This is the way to get first-rate results, developers discovering what they never knew they could have.

For a guide, one has only to look at what has been – Haworth Tompkins in Coin Street, Mather in East Anglia, Correa at Belapur, Utzon at Elsinore, Powell and Moya in Pimlico, H.T. Cadbury-Brown at Harlow; or, for that matter, at the fragments in old town centres, sometimes extending over entire districts, but always displaying a picture of sanity amid, often enough, one of utter confusion. Although made long ago, the essentials we require are preserved there – simplicity, reticence, disinterestedness and humanity, the work of eighteenth-century architects and builders who did it their way because it was the only way they knew. While rejecting any kind of return to the past, Richardson said never-theless that 'in a stressful and unpredictable world, I believe there is a need for calm, reassuring and friendly places'. Martin Hartung, the eminent Danish architectural writer, says he would, if in a posi-tion of influence, recommend that current policy, whether in Denmark or England, draws its inspiration from this model, given the clear language of our time that some, like Darbourne and Darke, managed so well. Yet to capture the essence of that archi-tecture, to revive the street form with its immense variety of heights, widths and densities, to achieve the variations that gave it a special strength, richness and extraordinary flexibility cannot be done without dispensing with out-of-date regulations which Herbert Tayler insisted were so destructive.

There are many, but those to do with angles of light are partic-ularly disruptive to compact neighbourhood planning: tower blocks demonstrated this, the scene at their base described by Philip Powell as 'nasty municipal deserts, their size and shape created by daylight protractors'. These tiresome rules, together with the irrational sepa-ration of building types – residential, education, industry, etc. – had the disastrous effect of pushing communities apart: feelings of isola-tion were intensified, subtleties in design precluded, acre upon acre

of valuable, desperately needed land recklessly wasted. Once the bureaucratic rules are removed, however, a return to street planning could well rectify the mistakes of the last century with something close to the medium-height buildings and dense neighbourhoods which the genius of the eighteenth century gave us. For Martin Hartung, London's Islington, much of it from that time and lucky to escape threats of demolition in the wayward 1960s, is one of his great favourites for terraces and garden squares – a quiet neighbourhood next to a busy centre with everything a community desires on its doorstep: shops, cafés, offices, entertainment, landscape, activity. This is the frame into which can be set the sparkle of architectural precious stones – public buildings, libraries, galleries, schools, town halls . . . In short, there is a future in the past.

House in Hampstead, London, England: architect Rick Mather, 1996. In a highly complex plan, the interior spaces retain an unusual restfulness, with light pouring through the centre from top to bottom via the glass staircase and reflected in the swimming pool at the base. Photographer Richard Bryant.

Bibliography

ABRAMS, CHARLES, *Man's Struggle for Shelter in an Urbanising World* (M.I.T. Press, Cambridge, Mass., 1965)
- *Forbidden Neighbours: The Future of Housing* (Kennicat Press, 1971)
ACKERMAN, JAMES, *Palladio* (Penguin, Harmondsworth, 1968)
ALDRED, CYRIL, *Egypt to the End of the Old Kingdom* (Thames & Hudson, London, 1965)
ALEX, WILLIAM, *Japanese Architecture* (Studio Vista, London, 1968)
AMAYO, MARIO, *Art Nouveau* (Studio Vista, London, 1966)
ANDERSON, JOHN, *Architecture of the Renaissance in Italy* (Batsford, London, 1927)
ARDREY, ROBERT, *The Territorial Imperative* (Collins, London, 1967)
ARENDT, ERICH, *Art and Architecture on the Mediterranean Islands* (Abelard-Schuman, London, 1968)

BALSDON, J.P. V. D., *Roman Civilisation* (Penguin, Harmondsworth, 1965)
BARLEY, M. W., *The House and the Home* (Vista Books, London, 1963)
BARROW, R. H., *The Romans* (Penguin, London, 1949)
BENEDICT, RUTH, *Patterns of Culture* (Houghton Mifflin, Boston, Mass., 1959)
BERLIN, ISAIAH, *Karl Marx* (Oxford University Press, Oxford, 1939)

BLAKE, PETER, *Frank Lloyd Wright: Architecture and Space* (Penguin, Harmondsworth, 1965)

– *Le Corbusier: Architecture and Form* (Penguin, Harmondsworth, 1965)

BLASER, WERNER, *Structure and Form in Japan* (Verlag fur Architektur, Zurich)

BLUNT, ANTHONY, *Art and Architecture in France* (Penguin, London, 1981)

BRAUN, HUGH, *Old English Houses* (Faber & Faber, London, 1962)

BROWN, FRANK, *Roman Architecture* (Studio Vista, London, 1968)

CANTACUZINO, SHERBAN, *Modern Houses of the World* (Studio Vista, London, 1964)

– *European Domestic Architecture* (Studio Vista, London, 1969)

CARVER, N. F., *Form and Space of Japanese Architecture* (Shokokusha Publishing Co, Tokyo, 1955)

CHERMAYEFF and ALEXANDER, *Community and Privacy* (Penguin, Harmondsworth, 1963)

CHILDE, GORDON, *What Happened in History* (Penguin, Harmondsworth, 1965)

– *New Light on Most Ancient East* (Routledge, London, 1958)

CICERO, *Cicero's Letters* AD 50

CLARK, KENNETH, *Civilisation* (BBC/John Murray, London, 1969)

– *The Gothic Revival* (Penguin, Harmondsworth, 1962)

CONDOR, JOSIAH, *Landscape Gardening in Japan* (Dover, New York, 1964)

CONNOLLY, CYRIL, *Les Pavillons* (The MacMillan Co, New York, 1962)

COOK, OLIVE & SMITH, EDWIN, *The English House Through Seven Centuries* (Thomas Nelson & Sons, London, 1968)

LE CORBUSIER, *Towards a New Architecture* (Architectural Press, London, 1970)

– *Concerning Town Planning* (Architectural Press, London, 1947)

– *The Modulor* (Faber, London, 1954)

– *The Complete Architectural Works of Le Corbusier*

Vol. 1 *1910–29* (Ed. Boesiger & Stonorow)

Vol. 2 *1929–34* (Ed. Boesiger)

Vol. 3 *1934–38* (Ed. Bill)

Vol. 4 *1938–46* (Ed. Boesiger)
Vol. 5 *1946–52* (Ed. Boesiger)
Vol. 6 *1952–57* (Ed. Boesiger)
Vol. 7 *1957–65* (Ed. Boesiger)
Vol. 8 *Last Works* (Ed. Boesiger)
(Thames & Hudson, London, 1966–70)
– *Le Corbusier Collected Works 1910–65* (Ed. Boesiger) (Thames & Hudson, London, 1967)
COTTRELL, LEONARD, *The Bull of Minos* (Pan, London, 1963)
– *The Penguin Book of Lost Worlds* Vol. 1 (Penguin, Harmondsworth, 1966)

DARWIN, CHARLES, *The Origin of Species* (Ed. Burrow) (Penguin, Harmondsworth, 1968)
DELACROIX, EUGÈNE, *The Journal of Eugène Delacroix* (Phaidon Press, London, 1951)

ELIADE, MIRCEA, *The Sacred and the Profane* (Harper & Row, New York, 1961)
– *Patterns in Comparative Religion* (Sheed & Ward, London, 1971)
ELIASON, GEORG, *Norske Hus* (Aschehoug, Oslo, 1950)

FORDE, C. D., *Habitat, Economy and Society* (Dutton, New York, 1963)
FRANKFORT, HENRI, *Art and Architecture of the Ancient Orient* (Penguin, Harmondsworth, 1970)
FRAZER, JAMES, *The Golden Bough* (Abr. ed.) (The Macmillan Co, New York, 1927)

GIDEON, SIEGFRIED, *The Eternal Present* Vol. 2, *The Beginnings of Architecture* (Pantheon, New York, 1964)
GUISEPPE, MAZZOTTI, *Palladian and other Venetian Villas* (Tiranti, London, 1966)
GOTCH, J. A., *The Growth of the English House* (Batsford, London, 1909)
GRAY, JOHN, *Archaeology of the Old Testament World* (Nelson, London, 1962)

GREGORY, R. L., *Eye and Brain* (World University Library, London, 1966)

GUTKIND, E. A., *Our World from the Air* (Doubleday, New York, 1952)

– *Community and Environment* (Watts, London, 1953)

VON HAGEN, VICTOR, *The Ancient Sun Kingdoms of the Americas* (Thames & Hudson, London, 1962)

– *The Hidden Dimension* (Bodley Head, London, 1969)

HAMILTON, G. G., *The Art and Architecture of Russia* (Penguin, London, 1976)

HAMMOND, P. E., *Sociologists at Work* (Basic Books, New York, 1964)

HASTIE, TOM, *Home Life* (Batsford, London, 1967)

HERBERT, JEAN, *Shintô: At the Fountain Head of Japan* (Allen & Unwin, London, 1966)

HILBERSEIMER, L., *Contemporary Architecture: Its Roots and Trends* (Theobald, Chicago, 1964)

HUXLEY, ALDOUS, *The Doors of Perception & Heaven and Hell* (Penguin, Harmondsworth, 1968)

HUYGHE, RENÉ (Ed.), *Byzantine and Medieval Art* in *Larousse Encyclopedia* (Prometheus Press, New York, 1964)

JACOBS, JANE, *The Death and Life of Great American Cities* (Penguin, Harmondsworth, 1961)

JOEDICKE, JÜRGEN, *A History of Modern Architecture* (Architectural Press, London, 1961)

JUNG, CARL, *Man and his Symbols* (Doubleday, New York, 1961)

– *Psychology and Religion* (Yale University Press, New Haven, Conn., 1938)

KITTO, H. D. F., *The Greeks* (Penguin, Harmondsworth, 1951)

MacDONALD, DWIGHT, *Against the American Grain* (Harcourt, Brace & World, New York, 1963)

MADSEN, S. TSCHUDI, *Art Nouveau* (World University Library, London, 1967)

MAGUIRE, PAUL, *From Tree Dwelling to New Town* (Longman Green, London, 1962)

MALLOWAN, M. E. L., *Early Mesopotamia and Iran* (Thames & Hudson, London, 1965)

MAU, AUGUST, *Pompeii: Its Life and Art* (Macmillan, London, 1904)

MEAD, MARGARET, *Continuities in Cultural Evolution* (Yale University Press, New Haven, Conn., 1966)

– *Cultural Patterns and Technological Change* (UNESCO, Paris, 1953)

MELLAART, JAMES, *Earliest Civilisations of the Near East* (Thames & Hudson, London, 1978)

MILLON, HENRY, *Baroque and Rococo Architecture* (Studio Vista, London, 1968)

MOORTGAT, ANTON, *The Art of Ancient Mesopotamia* (Phaidon, London, 1969)

MORRIS, DESMOND, *The Naked Ape* (Cape, London, 1967)

MUMFORD, LEWIS, *Sticks and Stones* (Dover, New York, 1955)

OLIVER, PAUL (Ed.), *Shelter and Society* (Barrie & Rockliffe, London, 1969)

PAINE, R. T., *The Art and Architecture of Japan* (Penguin, Harmondsworth, 1960)

PALLADIO, ANDREA, *I Quattro Libri dell' Architettura* (Domenico de' Franceschi, Venice, 1570)

PEVSNER, NIKLAUS, *Studies in Art, Architecture and Design* (Thames & Hudson, London, 1968)

– *Pioneers of Modern Design* (Penguin, Harmondsworth, 1960)

– *An Outline of European Architecture* (Penguin, London, 1943)

PIGOTT, STUART (Ed.), *The Dawn of Civilisation* (Thames & Hudson, London, 1961)

PLUMB, J. H. (Ed.), *The Renaissance* (American Heritage Publ. Co, New York, 1961)

RAPOPORT, AMOS, *House Form and Culture* (Prentice-Hall, Englewood Cliffs, 1969)

REDFIELD, ROBERT, *The Little Community* (University of Chicago Press, 1958)

– *Peasant Society and Culture* (University of Chicago Press, 1958)

Index